The Art of
Making Furniture
in Miniature

THE ART OF
MAKING
FURNITURE
IN
MINIATURE

WRITTEN AND ILLUSTRATED BY

Harry W. Smith

E. P. DUTTON, INC. · NEW YORK

Published in the United States by E. P. Dut-
ton, Inc., 2 Park Avenue, New York, N.Y.
10016

Library of Congress Catalog Card Number:
79-53324

ISBN: 0-525-93249-6 (cloth) 0-525-47713-6 (DP)

Published simultaneously in Canada by
Clarke, Irwin & Company Limited, Toronto
and Vancouver

10 9 8 7 6 5 4 3 2 1

First Edition

Dedicated to
my wife,
Marsha

Contents

Acknowledgments

I should like to thank the people who have been instrumental in getting my thoughts and methods into this book. First and foremost, my wife, Marsha, who has put up with me and this crazy business for all these years; my two children, Angela and Michael, who have always been patient and have often told their friends, "Don't bother our dad, he's trying to do the impossible again"; and Jean Bollar for her constant encouragement.

A special thanks to Ruth Glasser who helped get us started. I should also like to thank my editor, Cyril Nelson, for his valuable assistance and understanding. Cyril's knowledge of period furniture and his appreciation of the arts made writing this book an enjoyable experience. Finally, I owe a large debt of gratitude to the following individuals and museums for helping me with the projects illustrated in this book and for letting me sketch and measure their beautiful furniture.

Senior Blanchard; Jonathan Fairbanks, Museum of Fine Arts, Boston, Massachusetts; Frank Hollis; John Holverson, Portland Museum of Art, Portland, Maine; Beverly Kingsley; Joseph Marcus, Ebenezer Alden House, Union, Maine; Marius B. Peladeau, Farnsworth Museum, Rockland, Maine; and George Valluzzo.

Introduction

Welcome to the fascinating world of miniatures. This tiny realm that is ruled by giants has been my life for almost twenty-five years. When I began making furniture to scale in the late 1950s, there were only a few craftsmen and a handful of collectors. I am sure at that time none of us dreamed what a phenomenal hobby miniatures were destined to become.

Today, as I work in my harbor-view studio on the coast of Maine, I receive letters from people all over the country wanting answers to the various problems they have encountered in pursuing this marvelous hobby.

This book is an answer to those requests for help. It is a down-to-earth, realistic approach to the making of furniture in miniature. Its descriptions and techniques are those practiced by a master craftsman. What follows is not a series of miniature shortcuts but a comprehensive guide to creating fine furniture in miniature.

I shall take you step by step through all aspects of each piece, fully explaining every detail as we create nineteen projects from the Pilgrim through the Victorian periods.

These projects have been chosen with care and some are more challenging than others. I suggest that you do not attempt the more complicated pieces until you have mastered the simpler ones. Keep in mind that your ability will depend entirely on your desire to practice and expand upon this instruction.

It's like that age-old story of the boy who was asking directions from an old man in New York City.

"How do you get to Carnegie Hall?," the boy asked.

"Practice, son, practice," was the old man's reply.

The methods that follow are those I use; they have worked for me. However, this is not to imply they are the only methods. If you have been doing a similar task another way and have achieved satisfactory results, for heaven's sake, continue using it. After many years of making miniatures I must admit I have gotten into some ruts, and you need not tread in that rut if you have another path leading to the same goal.

One important thing to remember is there are no magic formulas, no pinch of this or dab of that and presto, you have a beautiful miniature. As in any work of art the main ingredients are practice, perseverance, and understanding. True, there are some hints that I shall pass on to you that will make life a little easier, but you must realize that creating a miniature is no different from creating anything worthwhile. It is my intention not only to assist the neophyte in the selection of tools and materials but also to present projects that will be challenging for both the novice and the advanced craftsman.

Anyone at any stage in the art of making furniture in miniature will find this book an aid to improving his or her work. I have made a special effort to use illustrations and photographs to help clarify areas that I feel the text alone would not. As you read through the chapters that precede the projects, experiment with the techniques discussed. Learn to master each detail before you attempt making the furniture illustrated. Make a mortise-and-tenon joint in a scrap of wood. Practice exercises such as this will not only be educational but a lot of fun. A tight-fitting joint held firmly by tiny pegs can be just as rewarding as a simple piece of furniture. The point is: be patient and learn how to do the simpler tasks before you spend hours on an actual piece of furniture. I love to experiment and consequently learn something new each time I do. I am sure you will find some parts of the more complicated pieces quite frustrating; if it is any consolation to you, so do I. There are times when nothing I do seems to go right, but if I leave it alone for a few hours, take a walk, or go for a short sail, when I come back, fresh, it will more than likely still be a battle. The question is not the battle but who will be the victor, and how sweet the victory is when you complete a priceless miniature done with your own hands!

If you are just becoming familiar with the tools and techniques of making furniture in miniature, I suggest that you begin with the less complicated projects such as: the Pilgrim joint stool, chapter 7; the Pilgrim spindle chair, chapter 9; the Queen Anne lowboy, chapter 12; the Chippendale mirrors, chapter 14; and the Victorian pie safe, chapter 20.

The Art of
Making Furniture
in Miniature

· I ·

Almost Twenty-Five Years

"Miniatures? Why miniatures?"

I am quite sure I will never know the answer. I do know it began years ago when two young art students met on Oak Street Beach in Chicago. I was sketching her and she was sketching me. The duel continued for some time. Finally, curiosity got the best of us and we compared drawings. We must have liked each other's work, for a short time later we were married. After a brief honeymoon I found a job as a commercial artist just outside the city, and Marsha went to work downtown.

One evening a few months later, the two of us began experimenting with some Christmas decorations. We created a tiny vignette depicting Santa and his reindeer in the center of a styrofoam wreath twelve inches in diameter, which we had covered with ruffled nylon net. I guess this project was our first miniature. Pleased with the way it had turned out, we made two more with different seasonal designs and hung them on a wall of our tiny apartment. They looked quite nice, maybe even good enough to sell. The next morning we packed them up and took to the streets to peddle our wares.

Our first attempt was at Marshall Field's, the large department store where Marsha was working. The buyer loved them, and with an order for three dozen I quit my commercial art job and began working on the first of our Barnstable Originals.

The wreaths sold well and everything looked great until the day after Christmas when the bottom fell out of the market. I had no job, the wreath business was finished, and on top of everything else I became quite ill. While recuperating from both the flu and our business setback, Marsha brought me a few scraps of wood and a pocketknife. From the scraps I carved a small country fireplace. Why a fireplace? Why not a model airplane or a model ship? Why a piece of furniture? I had never shown an interest in furniture before. To this day I have not been able to answer that question, but that fireplace was my first piece of miniature furniture, back in December 1959, and I have been creating miniatures ever since.

The unique thing about this first fireplace was my desire for authenticity. I wanted it to be as close to the original as possible. So close, in fact, that the inside had to be lined with small stones. This was not easy, when you consider that we were living on North Wabash Avenue almost in the heart of the Loop, Chicago's business district. In this area concrete was plentiful, but pebbles were very rare. Late one evening we descended the three flights of stairs into the alley behind our apartment and on our hands and knees began looking for six small, flat stones. The Playboy Lounge of that time abutted the same alley, and several of the girls appeared in the middle of our quest for the tiny stones. Marsha will never forget the look on my face when I glanced up to find a half dozen beautiful Playboy bunnies watching us. Naturally, they were all quite curious about what we were doing. We explained, and they too were down on all fours to join in the search. What a sight they were, cottontails bob-

1. Christmas wreath with three-dimensional scene.

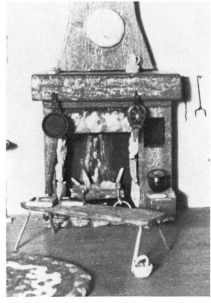

2. Early fireplace.

bing and ears flopping. After some time we found just the right stones, thanked our lovely assistants, and returned to our apartment to glue the stones inside the tiny fireplace.

As we admired the finished product and reflected on all that had happened in the past month, we decided to make miniatures our life. Our reasoning was that anything starting the way miniatures had for us must be pursued. Just like that: no money, no tools, just two determined young artists. For some reason our third-floor apartment in Chicago did not seem the place to begin such a daring adventure, so we moved to St. Louis, Missouri, where I had attended Washington University a few years earlier. We rented a second-floor apartment and purchased my first power tool, a full-size jigsaw. This saw presented one of many problems we were to encounter over almost a quarter of a century. When a full-size jigsaw with a one-third-horsepower motor is fired up, it has a great tendency to cause the floor to vibrate and therefore, the ceiling of the aspiring doctor who lived below us. Something had to be done, for my desire to work day and night was hampering his desire to get some sleep. The only solution was to place the jigsaw on eighteen inches of foam rubber. This worked quite well, it did not make the floor vibrate anymore, but it did sway back and forth making it very difficult to work. The solution was to put the stool on which I was sitting on eighteen inches of foam rubber, too. Therefore, as the saw swayed back and forth, so did I. Marsha is sure this is where I acquired my love for the sea.

Anyway, with the saw I was on my way. The first pieces of miniature furniture were crude but acceptable, and again Marshall Field and Co. in Chicago became our first client. A short time later the Country Store in the Jefferson Memorial in St. Louis was added

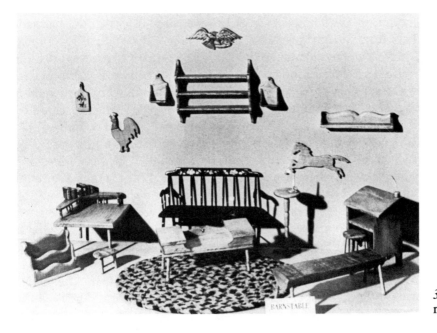

3. Deacon's bench and assorted early miniatures.

4. Provincetown grouping.

to our list. I began making my first production miniatures, working out of our tiny apartment. Soon we realized that the accuracy of the jigsaw on foam rubber left a lot to be desired, and the addition of other tools in the limited space was impossible.

Thus, we packed our belongings into a small U-Haul trailer and moved to Perrysville, Indiana, where Marsha's family had a large farm. No sooner had we set up a studio in the basement of my mother-in-law's house than the phone rang. It was a very pleasant lady from Block House, Inc., in New York City asking if I would be interested in producing my miniatures in quantities large enough for her to sell all over the country. I could not believe it, the proposal was too good to pass up. I had been making furniture for only a matter of months and already was being asked to be represented by a large toy distributor. Very shortly the orders started coming in. We added a few more tools to the workshop and began filling orders for such stores as F A O Schwarz and I. Magnin. Soon we were selling coast to coast. Then, Block House, Inc., asked me to make a series of kitchen, bathroom, and nursery furniture exclusively for them. The pieces were very inexpensive and very well received.

We added more tools and began working day and night trying to keep up with the increase in orders. We were becoming more and more aware that it was a lot easier to accept large orders than it was to produce hundreds and hundreds of an identical item. After a year what little spirit of creativity there had been in making the tiny tubs and lavatories was gone, and we decided to discontinue the inex-

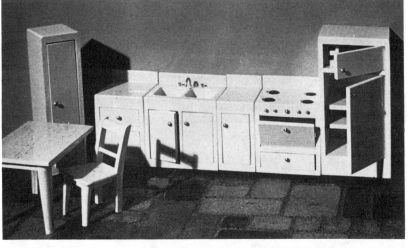

5. Kitchen.

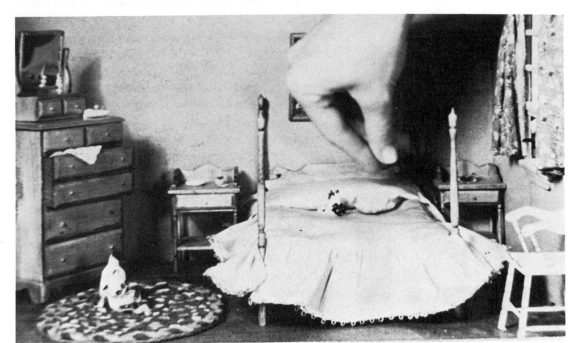

6. Bathroom.

7. Pine
bedroom.

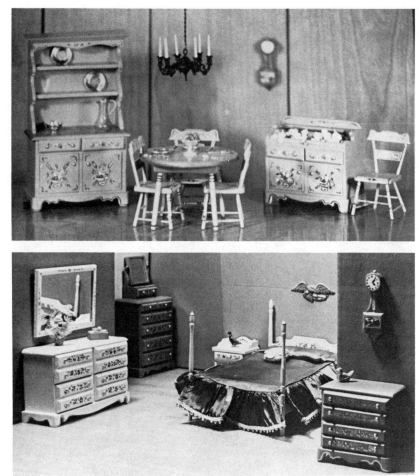

8. Dining room with hand-painted designs.

9. Bedroom with hand-painted floral designs.

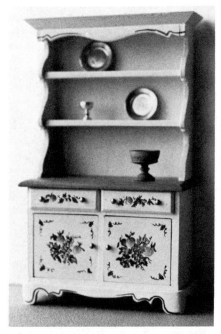

10. Painted hutch with hand-painted fruit designs.

pensive mass-production miniatures. We sold the rights to the kitchen, bathroom, and nursery lines to a retired colonel who had a fully equipped workshop and began work on a series of dining room and bedroom furniture, which I had recently designed. These pieces were available in pine, in Colonial blue, green, or white and were decorated with hand-painted designs. They were sold by Block House to the same dealers for whom we had been making the production pieces. I found the new line not only more profitable but much more creative. So creative in fact, that I attempted to make each piece better than the last. This desire to outdo myself presented another major problem. As I added more detail and refined each of the pieces, they became more and more time-consuming and consequently more difficult to produce in quantity. Something had to give; thus, a little over two years after we dropped the kitchen, bathroom, and nursery lines we stopped selling wholesale altogether.

We now dealt directly with our customers through a mail-order catalogue. In the early 1960s we released our first catalogue under the name of *Barnstable Originals*. Most of the catalogue requests came from a small advertisement we ran in *Hobbies* magazine. At the same time we built our own home, which included a beautiful well-lit workshop.

How well I remember those first few years in rural Indiana patiently waiting for the mailman to arrive with what we hoped would be an order or, better yet, a check to pay the bills. It had been a lot safer with the representative in New York, but there was a special thrill in being totally on our own, working solely under our own name, Barnstable Originals.

It was at this time that we held our first exhibit of miniatures—a far cry from the extravaganzas of today, but it was very exciting. I had talked the owner of a large grocery store in Covington, Indiana, into letting us place a card table just inside the entrance. Early on a Saturday morning we set up our display and stood proudly by our miniature creations. I learned a lot that day. Until then I was unaware of just how many groups and service organizations there are in this country. Everyone who passed the table wanted to know if it was a Cub Scout project or a Girl Scout display or possibly a new 4-H project. When I could corner someone long enough to explain what we were doing, he would listen intently to my descriptions of life as a miniaturist only to end the conversation with, "That's nice, but what do you do for a living?"

One of the greatest things that has happened to me over two and one half decades is that my miniatures have developed into a highly accepted art form, purchased by respected collectors as an investment.

That first show was hard on my ego, and I could not help but wonder if the American public would ever show an interest in tiny replicas of antique furniture. Weeks seemed like years, but slowly the orders began to come in, and my name began to be known.

Then one day I was asked by a gallery owner in Danville, Illinois, if I wanted to display my paintings and my miniatures in a one-man show. It was too good to be true: the gallery gave me several good write-ups in the area papers and arranged for an opening cocktail party. At the opening a man asked me if I would be interested in appearing on a talk show being produced by a CBS-TV affiliate in Champaign, Illinois. I was speechless for a moment, but when the host informed me the air time was six o'clock, I caught

11. Catalogue cover from early 1960s.

12. Working in shop, Perrysville, Indiana, in 1963.

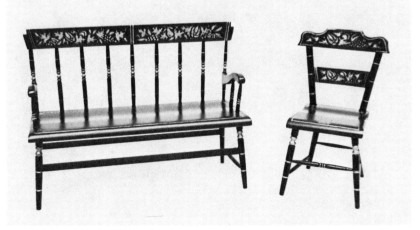

13. Deacon's bench and chair with stencil decoration.

hold of myself and quickly agreed. Six o'clock is almost prime time I told myself, everyone will be watching. A few days later, a letter of confirmation arrived, and as it turned out he meant 6:00 A.M. not 6:00 P.M. Very early that morning I drove 150 miles to the television station and did a half-hour show on miniatures to a few early-rising roosters.

More recently, one of the most unusual places I have displayed my work was a maximum-security state prison. A sculptor who was teaching woodworking to the inmates asked if I would mind showing them my miniatures and giving a talk. I never have learned how to say no, thus on the day of the demonstration I arrived at the prison gates with three boxes of miniatures and a twenty-four-by-thirty-six-inch Federal parlor. There must have been half a dozen checkpoints as I worked my way toward the shop area, and each one meant another search of the boxes and another group of puzzled

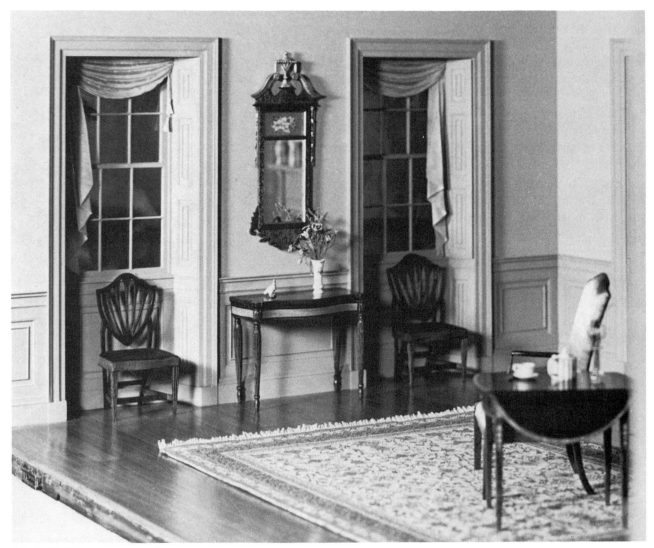

14. Spite House room setting.

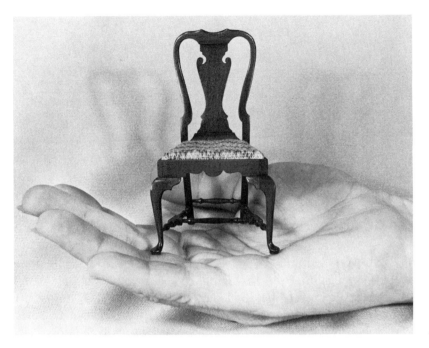

15. Queen Anne chair in hand.

guards. When I finally reached the prison yard, the guard pointed to the building on the opposite side.

"Shop's over there," he said and slammed the bars behind me.

It was three flights up. I had to carry everything down an iron fire escape, across the prison yard, and up a matching fire escape on the opposite side. It was quite an experience, and, I might add, very well received. It was the only time I had ever shown my miniatures to a truly captive audience.

In 1962, after three years of our making miniatures, our daughter, Angela, was born. The announcement read "Harry and Marsha Smith announce the creation of their greatest miniature!!"

For the next few years I did work for many well-known collectors, including the late Mrs. James Ward Thorne, and also sold selected pieces to our oldest client, Marshall Field and Co. in Chicago. Miniatures were beginning to grow in popularity. Here and there new artisans appeared.

One of the most difficult things was finding tools small enough to make my miniatures, which were becoming more and more refined. I spent hours rummaging through every nook and cranny of every hardware store trying to find a small something or other I could adapt to making miniatures. After a time store owners began to put Closed for Lunch signs on their doors when they saw me coming.

Tools were not the only unusual thing connected with the miniature business. Sometimes the people were a bit unusual too. I remember a client who wanted both her and her husband's portraits done in miniature. No sooner had I finished the two postage-stamp-size portraits than a rush letter arrived with several views of her dog, which she wanted sitting on her lap.

Another client and friend lives in California, and for years we

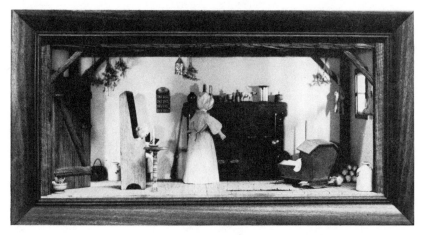

16. Colonial room.

did all of our communicating through our dogs. Her Chihuahua wrote to my Saint Bernard asking how everyone was and if her master would consider making a particular miniature. Of course, my Saint Bernard replied. The two even exchanged Christmas cards. Maybe that is what is meant by a business "going to the dogs."

As time went by my work became quite well known, and the collectors began seeking me out in person. My location in rural Indiana was no deterrent to the determined miniature collectors who wanted to spend an afternoon talking about their hobby. Many times, however, they had a problem in associating a twenty-five-year-old with the field of making miniatures. More often than not an out-of-state car would pull into the driveway and the occupants would see me working at the open window of my studio. They would watch me for a few minutes and then call out, asking if my father was at home. I probably should not admit it, but if I was in the middle of a difficult piece of furniture I would holler back that my father was out of town and would not be back for some time. Actually, my father *was* out of town, he lived in Chicago. Things have not changed much, even now, twenty years later on the coast of Maine. I am still asked the same question. Each year it becomes a little harder to pass the buck.

Last year a Texan in a red jump suit pulled his oversize camper into the drive and began adjusting the jacks that leveled the rig. When I confronted him, he informed me that he had driven all the way from the big country and wasn't moving until I had taught him how to make "them little critters."

Through the years I have made almost everything imaginable in scales ranging from one-hundredth of an inch equals one foot to full size. The most asked for scales are one-half inch equals one foot, one inch equals one foot, which is dollhouse scale, and three inches equals one foot. In the last scale I created some of my most memorable pieces. Memorable not only because of what the pieces were but for whom they were done and how they were used. Several years ago I went to the mailbox, and in among the bills and junk mail was a small envelope addressed to the Miniature Maker, Camden,

Maine. I opened the letter and at first glance it appeared to be empty. Then on turning it over, a tiny envelope no bigger than a postage stamp fell out. In the tiniest writing I have ever seen was written my address along with a stamp and tiny bird tracks across the lower corner. The return address read Captain and Mrs. T. Crane, No. 1 Upstairs, Greenwillow, East of the Sun, West of the Moon.

I carefully opened the minuscule flap and began reading the letter within. It was from Captain Thaddeus and Melissa Crane who were requesting me, in proper Victorian style, to make them a spinning wheel scaled at three inches equals one foot. Near the end of the letter my first clue to its origin came. I quote, "Shortly, Mrs. Tasha Tudor will send you some scale drawings . . . The Captain would have undertaken the measuring, only he lacks a proper rule. Besides measuring the spinning wheel would require both a ladder and a rope and these too we lack." I am sure many of you recognize the Captain and Melissa as characters in Tasha Tudor's beautiful books. As the Cranes and I wrote back and forth, they informed me of a second project that was beginning to take shape. Mrs. Tudor was preparing a full-length marionette production of *The Rose and the Ring*. By now Tasha and I had become close friends and began talking about different aspects of the play. She and her family were not only painting the scenery and creating dozens of marionettes but were even building a small theatre with a special stage on the end of the barn. My part in the production was to create an ensemble of eight musical instruments. These were to be played by eight Welsh corgi dog marionettes in the orchestra pit. I readily accepted the challenge and made a concert harp, a bass, a cello, a violin, a flute, a clarinet, a trumpet, and a trombone. Each instrument was made from the same materials as the original and each was an exact copy of its full-size counterpart.

Late one October afternoon a select group of friends, writers, and musicians sat in the tiny theatre and enjoyed a breathtaking play accompanied by a playful band of Welsh corgis.

In the more common one inch equals one foot scale I have made miniatures ranging from a three-sixteenths-of-an-inch-high etched scrimshaw tooth to a seven-inch-high black-lacquered highboy that was streaked with vermilion to imitate tortoise shell and embellished with gold-leaf designs. I have made several ship models each about two and one-half inches long and fully rigged with wire thinner than a human hair. The model of the whaler *Wanderer* included six longboats complete with carved thwarts, all of which fit on the eraser of a pencil.

One of the most unusual pieces I have made was a brass and rosewood elephant ladder. The six-inch-high uprights were covered with leather fastened by over 800 brass tacks and capped with brass endpieces. The rungs were of rosewood and pivoted to allow the entire piece to close into a cylinder that could be carried on the elephant's saddle.

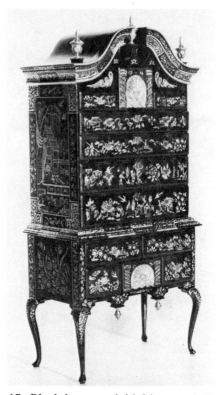

17. Black-lacquered highboy embellished with gold-leaf designs.

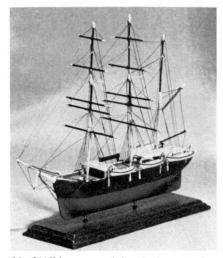

18. 2½″-long model of the whaler *Wanderer.*

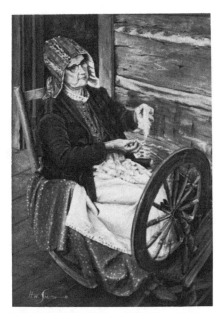

19. Spinning. 30″ x 20″ oil painting

20. Mending the Nets. 24″ x 18″ oil painting.

Late in the 1960s I began to concentrate on full-size paintings for the first time since college and was fortunate enough to have several one-man shows. We were on our way.

In 1972 we moved from Indiana to Camden, Maine, where we live today with our two children: Angela, who is a dancer, singer, and actress and Michael, who enjoys sailing, model making, and the bass guitar. I now am involved in many forms of the arts including painting, sculpting, wildlife carving, writing and illustrating books, and, of course, creating furniture in miniature and miniature room settings.

In the following pages I shall try to pass on many of the things I have learned: techniques, styles, secrets, little tricks. Most important, I take you through nineteen projects, step by step, from beginning to end, using photographs and drawings where necessary. The furniture drawings have been reproduced at the scale of one inch equals one foot (1″ = 1′), so all measurements can be taken directly from them.

Before we actually begin the individual projects, there are a few things I feel are important for you to know to succeed in·making fine miniatures.

It is my belief that the most valuable asset you can have is a good sense of proportion. The making of a fine miniature is really nothing more or less than the creating of delicate sculpture, a tiny work of art.

You must use more than just plans and tools to make it come alive. You must be able to distinguish the grace of one line from the awkwardness of another. You must learn to see the relationship of each of the parts to the whole. In short, you must learn proportions, balance, and composition.

Expressing yourself in three dimensions is one of the most rewarding forms of the creative arts, but it is also one of the most difficult. The need for proper proportions becomes even more important when an object can be viewed from all angles. How does one go about learning sensitivity to correct proportions? First, go to museums, antiques shops, and historical societies and study the examples of the masters firsthand. Look at as many pieces of fine furniture as you can and read as many good furniture books as possible. In short, learn what the masters did and did not do. If you are unfamiliar with the basics of design, perspective, and proportions, take a drawing course. Train your eye to see, to recognize at a glance when a line is in keeping with the rest of the piece. The ability to work with tools is useless, unless you train your eye as you train your hand. Hand and eye must work as a team, the hand executing the move, the eye telling it what and how much to do. It is this teamwork that makes or breaks a piece and separates the masters from the rest of the crowd.

I once talked to a man who said he made forty cabriole legs be-

fore he had four that were alike. This man would have spent his time much better by taking a few basic art courses and learning to see, rather than carving thirty-six extra legs. He obviously lacked that all-important sense of proportion. Learn to see the tiny differences in the curve of each leg. When I need four legs, I carve just that, four legs, and all four are as identical as four handmade objects can be. I have trained my eyes to see. This ability will also help you to pick full-size examples of furniture that are worth your time reproducing in scale. If you learn nothing else from this book but to work at coordinating hand and eye, it will have been well worth the investment.

Another thing I should like to touch on for a moment is the need for adequate tools and lighting. You cannot expect to create fine works of art without the aid of adequate tools. All too often a competent artisan becomes discouraged because of inferior tools. With the wrong tools even the simplest tasks become unbearable. I do not advocate running out and spending large sums of money, but I do believe that each individual should appraise where he or she is going and make the necessary purchases toward achieving that end. I do not mean to imply tools are everything. Many factors go into the making of a masterpiece.

Talent, dexterity, ingenuity, and even your frame of mind on any given day all play a large part in what you will be able to do. I have a very nice assortment of tools, and yet every once in a while I become convinced they have formed a union. They decide I have been unfair to the working class and go on strike. I have had days when every tool I turn on blows a fuse or just sits there belching out blue smoke. The more pressed I am for time, the more they enjoy challenging me.

It is true, however, that the better the equipment and supplies you have to work with, the better your end product will probably be. In this book I have attempted to discuss and use tools readily available to the craftsman.

A second and equally important requirement is adequate lighting. You cannot carve what you cannot see. The smaller the piece I am working on the greater the amount of light I use. Do not let the light reflect off shiny things around you, especially off a shiny tabletop. Put down a piece of matte, colored paper, it will not only cut the glare but will protect the tabletop. I work on a natural, laminated-maple butcher's block. It is strong, stable, and does not reflect the light. I use both fluorescent and incandescent light and I have a separate light for each tool. Contrary to popular belief I do not advocate the use of great magnification except under special conditions, such as the rigging of a tiny ship model with hundreds of $\frac{2}{1,000}''$ threads. A miniature is viewed with the unaided eye, and therefore should to a large extent be created by the unaided eye. This, of course, takes into account those who require some magnification to read or do close work. A miniature made under great magnification

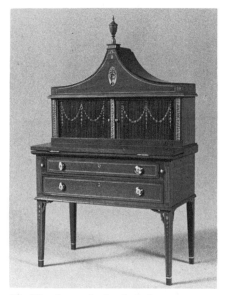

21. Tambour desk, closed.

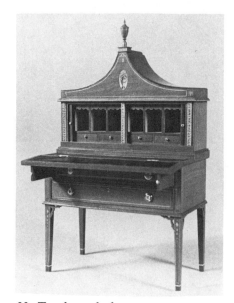

22. Tambour desk, open.

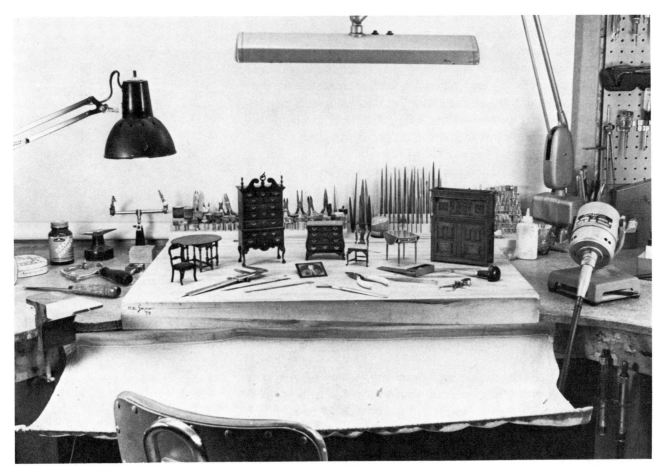

23. My workbench.

will seem cluttered when viewed with the unaided eye. Then, too, because it is impossible to see the entire piece when working through a magnifier, it is difficult to keep the part you are working on in proportion to the whole.

In conjunction with the above, having a special place to do your work is of the utmost importance. If you have to clear off the kitchen table every time you want to do something, the odds on getting it done right are greatly diminished. This does not mean you have to build a studio to make your miniatures, but it would be nice to have a place that is all your own, a place that you can shut the door on.

In this chapter I have tried to mention a few dos and don'ts, but no matter where you work or what your tools are, if you give yourself half a chance you will have a lot of fun and learn some things you did not know before.

The next chapters cover some areas of the art of making furniture in miniature that I feel deserve special attention. Read them. Study them. Take from them those things that will help you move farther ahead. If you find you disagree with something, try both your way and mine, for possibly somewhere in the middle is the best answer.

Do not be afraid to try, to experiment, to create on your own.

· 2 ·

Tools

The tools used for making miniatures are almost as fascinating as the miniatures made with them. I personally have a deep reverence for many of the special tools I use in creating my works.

The kind of tools you use will most assuredly have a direct bearing on the results you obtain. It is true that anything can be done with a few basic hand tools, but only if you are extremely patient and talented. In this chapter I shall give a brief description of the hand and power tools I use. It is not necessary for you to have all of the tools mentioned. I list those I feel are necessary to complete the projects and a few sources where they may be obtained in the Appendix.

HAND TOOLS

Let us start with the hand tools, for they are the simplest and usually the cheapest.

The ability to measure thickness, length, and diameter accurately is very important. These measurements are accomplished with several kinds of *calipers.* The vernier caliper is the most useful and versatile. It should be made of steel; show inside, outside, and depth measurements; and lock securely in place.

Two other calipers are the inside and outside bowspring. The inside measures the distance between two inside surfaces such as the opening for a drawer, while the outside measures the diameter or thickness of an object. All three of these calipers can be used to transfer measurements from the drawings to the work and to check the dimensions of different objects.

Another measuring device is a *micrometer.* This tool, which is shaped like the letter *P,* reads thickness or outside measurements down to $^{10}/_{1,000}''$. Although they are beautiful instruments and extremely accurate, micrometers are very expensive and very hard to read. If you have some extra money, invest in a direct-reading thickness gauge; its large clocklike dial reads the measurements

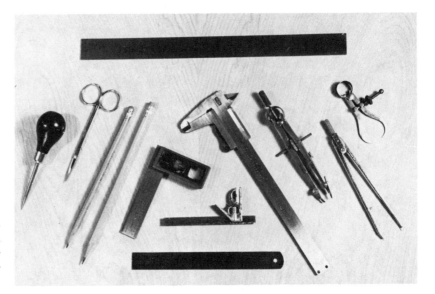

24. Measuring tools. *Top:* 12″ steel ruler. *Center* (l. to r.): awl, iris scissors, pencils, square, combination square, vernier caliper, compass, dividers, outside bowspring caliper. *Bottom:* 6″ steel ruler.

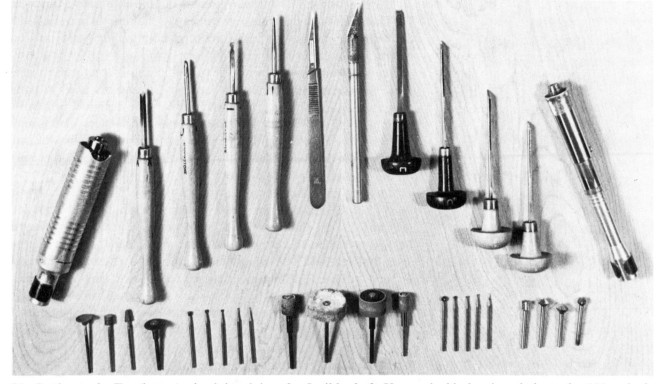

25. Cutting tools. *Top* (l. to r.): chuck handpiece for flexible shaft, V, round, chisel, veiner; lathe tools, #11 scalpel, #11 X-acto knife, assorted gravers, collet chuck handpiece for flexible shaft. *Bottom:* accessories for small power tools, 4 assorted grinders, assorted sizes inverted-cone dental burrs, ½″ drum sander, 1¼″ buffing wheel, 1″ drum sander, ⅜″ drum sander, assorted sizes round dental burrs, straight, 30°, 45°, and round heavy-duty burrs.

quickly and easily in thousandths of an inch. A good pair of dividers with sharp points and a reliable compass will also be put to good use.

I use several *steel rulers* marked in both sixty-fourths of an inch and hundredths of an inch. These are used to make straight lines, to check surfaces to be sure they are perfectly flat, and for measurements.

I use several sizes of *squares* from a 6″-long blade down to a 1″ blade. Believe it or not, my favorite and most used were made by the Marx Toy Company. One of these is a *combination square,* which means it shows both the right, or 90°, angles and 45° angles.

For marking wood I use a *#2 pencil* that I keep sharp by using a scrap of sandpaper. I use a carbide-tipped scriber and an awl for marking on metal. Occasionally, I use a knife in place of a pencil line when the lead could be accidentally sanded off.

A *#11 scalpel* is certainly my most-used hand tool. Buy the blades (nonsterile) in bulk from a local medical-supply house. Try to get the type with the T-ridged back, such as B-P's carbon-steel rib-back, for they are much stronger.

I also use a #11 and a #17 X-acto blade in the small handle and a #18 X-acto in the larger handle. I often grind down the last two to make special cuts.

I use an adjustable-frame *fretsaw* with blades in sizes from ⅝ to 10. The blades smaller than ⅝ break easily, making them difficult to cut with. I use a fine-toothed Zona saw and an X-acto #35 saw for cutting miters and small pieces.

Another cutting tool, which is of a slightly different nature, is a *graver*. Gravers come in all sizes and shapes and are used in both carving and small lathework. Although they are designed primarily for engraving on metals, their long, high-carbon-steel blades and special shapes make them very useful. If you are unable to find gravers, there are several sets of small turning tools and wood chisels on the market that will do nicely.

I use numbered *drills* from a #1 down to a #97. X-acto makes a plastic holder that holds bits from #61 to #80, which will be fine for our projects; for the larger sizes your hardware store should be of help. Remember, the larger the number, the smaller the bit. Occasionally I use broaches. *Broaches* are tapered, hardened-steel reamers that are used to enlarge existing holes. They come in all sizes from ³⁄₁₀₀₀″ up.

I use many different types and shapes of *files* from a coarse #0 cut to superfine #6 cut. You will need at least one set of *needle files* in a #2 cut. A set in #0 cut would also help.

In addition you will need several shapes of *rifflers,* which are small curved files set on either end of a square handle. Rifflers can do the jobs straight files cannot and are great for cleaning the curves and crevices of moldings, especially curved moldings. They are available either in sets or individually.

You will need one or two *barrette files* in a #2 cut, one 6″ and one 4″. I use many types of *burrs,* both dental and heavy duty. I buy the dental burrs from a dental-supply house in boxes of six. I am sorry to say, however, that they have become very expensive in the past few years. Ask your dentist for some; maybe he will trade them for a miniature. Several people have told me they have gotten their dentist's old burrs for nothing. How does that old saying go, "nothing is for nothing." Those old blades have spent their life cutting through metals, porcelain, and enamel. Let us face it, at best they are very dull. Dull dental burrs are of no more value than a dull knife. Pay for them if you have to, but get new ones. The burrs you will need are a few sizes of inverted cones, rounds, and flames. The suggested sizes are listed in the list of tools in the Appendix. Any others such as buds and cylinders and any style in the smoother finishing cut will be of great help; you cannot have too many. The heavy-duty burrs and sanding drums are easily obtained from your hobby shop. If you intend to make your own hardware, you will also need grinding points and cutting wheels, which are also available from your hobby shop or hardware store. All of the burrs mentioned above are used in both the Dremel Moto-Tool and the Foredom flexible shaft, which we cover when we get to power tools.

I have many different styles of *pliers,* some of which I have customized to do specific tasks. You will need a few different pairs: 5″

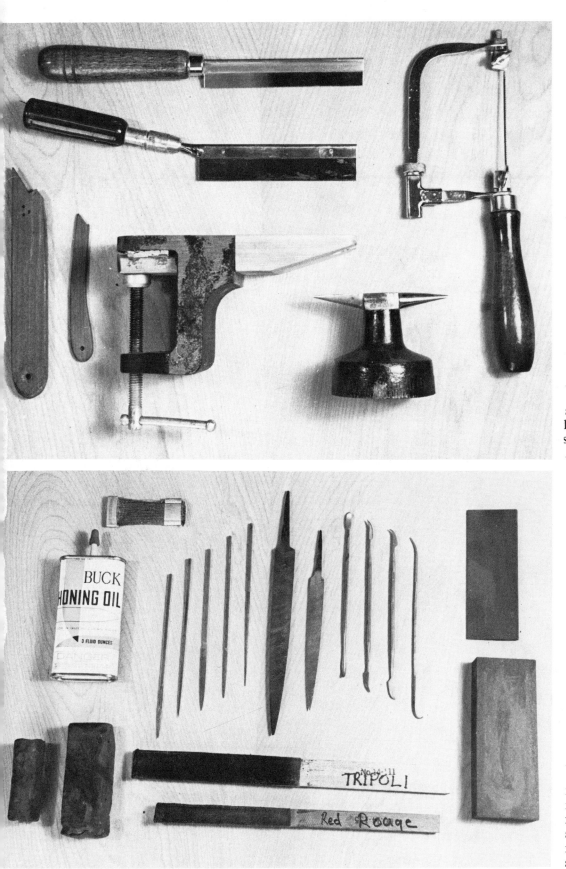

26. Miscellaneous tools.
Top: Zona saw, X-acto saw. *Far right:* fretsaw, large and small push sticks, bench pin, small anvil.

27. Filing and polishing. *Top row left:* honing oil, file brush, assorted escapement files, 8″ and 6″ barrette files, assorted rifflers, slipstone. *Bottom:* jeweler's rouge, tripoli, hand buffs, sharpening stone.

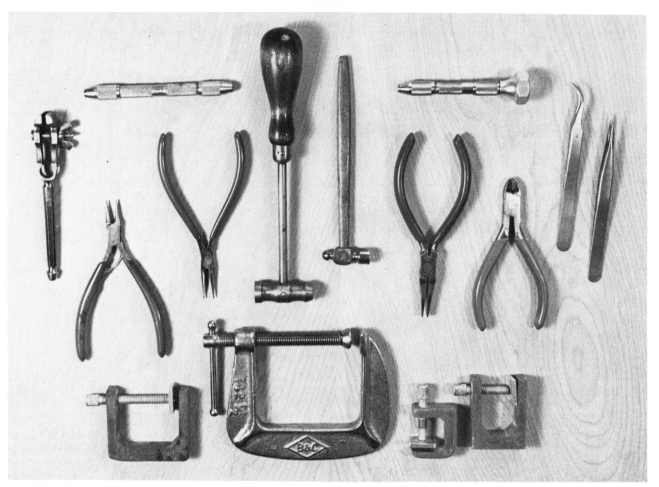

28. Clamping and hand tools. *Top* (l. to r.): hand vise, pin vise, round-nose pliers, chain-nose pliers, brass hammer, ball-peen hammer, pin vise, flat-nose pliers, diagonal cutters, curved tweezers, straight tweezers. *Bottom:* assorted clamps.

29. Pliers with a box joint.

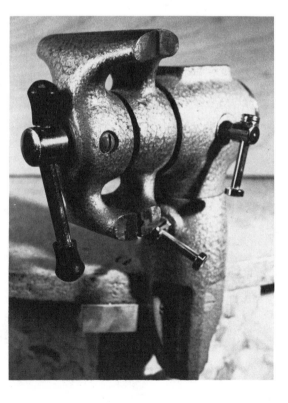

30. Adjustable bench vise.

chain-nose pliers for general purpose use, a 5″ round-nose for bending small wires, a 4½″ diagonal smooth cut, and a pair of small parallel-jaw pliers for holding pieces. One word of caution: cheap pliers are just that—cheap pliers. Get a good pair with a box joint and smooth jaws. Similar in use to pliers are *tweezers,* I use many different styles; you should have at least one straight and one curved pair about 4½″ long.

Keep a pair of household *scissors* handy and a pair of *iris scissors* for fine work. I have one pair of special surgical scissors with razor-sharp blades only ⅛″ long. They are used to cut the intricate hair-size threads on a 2½″-long, fully rigged ship model.

I find many uses for dental probes, nutpicks, brass and steel brushes, toothpicks, Q-tips, screwdrivers, and spring-loaded center punches. Keep a few pin vises on hand and a collet hand drill such as X-acto makes.

To make your own hardware, you will need a small pair of 4″ angled sheet-metal snips, grinders, and possibly a small soldering iron.

For holding and clamping objects I use everything from a 6″ metal *C-clamp* to rubber bands. A set of small C-clamps is a must as is an adjustable bench vise. Rubber-tipped spring clamps, locking pliers, and alligator clips are also very desirable to have on hand.

On the few occasions when I need magnification I use a special pair of *loupes* of the type that are used in eye surgery. There are also several styles of lightweight *headband magnifiers* that are very satisfactory. A jeweler friend of mine swears by them because he can just tilt them up out of the way when not in use. One caution about this or any type of eye loupe: be sure to get one with a long enough depth of field (the distance between the glasses and the object you are working on). Some magnifiers focus only inches from the work and do not allow room for the average tools, let alone the fact you have to bend over double to use them. You can also use regular magnifiers on a stand, but I find that these are never around when you need them and are awkward to use.

I use many styles of *hammers* from a tiny ball-peen with a head only 1″ long to a baby sledgehammer. You will need at least one small hammer and, if possible, a leather mallet.

POWER TOOLS

Unless you buy precut strips of wood, you will require some form of *circular table saw.* The circular saw strips the full-size lumber into miniature size. We shall discuss the procedure involved in chapter 4, "Working with Wood." Once you have stripped the large boards into a miniature lumberyard, you are ready to move on. As I mentioned earlier, this step can be eliminated if you purchase ready-cut lumber from your local hobby shop or from the firms listed in the Appendix. Also, you can have the boards stripped at a local mill or cabinetmaking shop. By doing this, you can get the stock cut into any thickness you desire.

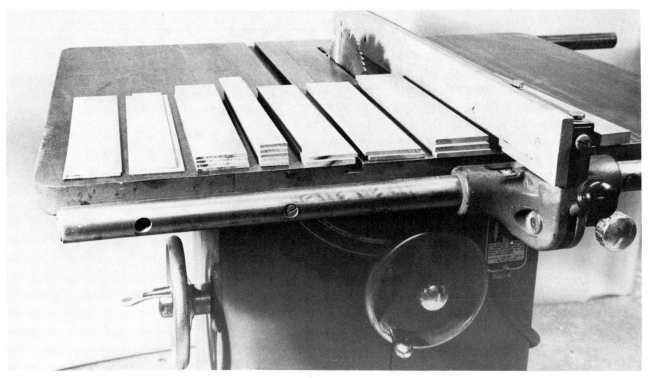

31. Stock on circular saw.

32. Jigsaw.

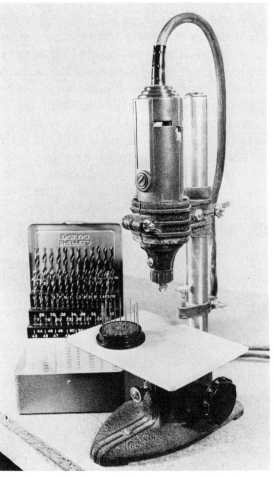

34. Dremel tool on drill stand and drill bits.

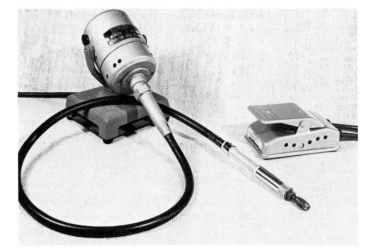

33. Foredom flexible-shaft tool.

The second tool you will need is a *jigsaw.* There are several types on the market, from the small Dremel Moto-Shop to the large floor models that are driven by a separate motor. The Dremel outfit includes a flexible shaft run off the same motor.

You can, of course, cut out most of the required pieces with a hand fretsaw.

A power tool I find almost indispensable is a *flexible shaft.* I use a Foredom bench model with a foot rheostat. The flexible shaft is a three-part unit consisting of a stationary motor, a flexible rotating shaft, and a handpiece. The motor is connected to one end of the shaft and the handpiece to the other. The handpiece holds various accessories, and because the shaft is flexible and lightweight, it is easily maneuvered and can do hundreds of tasks. The flexible shaft will aid in cutting, grinding, sanding, carving, polishing, and drilling, to name just a few. An alternative to the flexible shaft is Dremel's Moto-Tool but I find it too heavy and bulky to do intricate carving. For drilling, routing, and shaping, however, the Moto-Tool is perfect. Let us take a moment and describe the setup for each of these operations.

For *drilling,* I suggest you use one of Moto-Tool's drill stands; if you are lucky enough to find one of the older more accurate rack-and-pinion types, all the better. Better still is a small drill press such as is used in laboratories, but this is very expensive.

For *routing* and *shaping,* Dremel makes a special hand-held router attachment, which can be turned over and built into a small 5″ by 12″ table, which makes an accurate shaper. All of these operations, however, can be done on fancier and more expensive power tools. I have suggested the tools that I think are within the average person's budget.

The last of the power tools I shall mention is a *lathe.* In my shop I often use a jeweler's lathe; however, because I intend to use tools that I think most of you will have, I shall do all of the turnings in this book on the more common Unimat. If your lathe is another

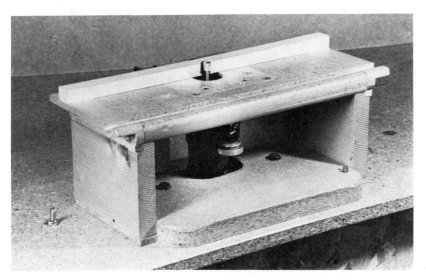

35. Shaper.

brand, do not worry, they all operate on the same principle, and the directions I give for a Unimat apply to any well-built small lathe.

One distinct advantage of the Unimat type of lathe is its versatility. Because the head can be changed from horizontal for turning to vertical for drilling and milling, this tool will eliminate the need for some of the others I have already mentioned. If you do not mind the setup time, there is no need to purchase the tools into which the Unimat is capable of being converted. I may show a hole being drilled on my small Moto-Tool drill stand whereas you may desire to convert your Unimat into a drill and do the same operation.

This type of tool can be used as a drill press, a jigsaw, a shaper, a planer, a machining lathe, a circular saw, and, of course, a wood-turning lathe.

In addition to those I have mentioned, I also have several small tools that just seem to sit in drawers. All of this equipment adds up to almost twenty-five years of making miniatures and, I might add, collecting tools.

As I stated earlier, we shall use only those tools readily available to you. In some cases maybe you and a friend can share a few tools. A group in Massachusetts I know has a central location for all their power tools, each member owning a different one but all sharing in their use. If you will remember from the last chapter, I made acceptable miniatures for quite a few years with a jigsaw and a Dremel flexible shaft.

With that settled, I should like to offer two words of caution. For heaven's sake, *BE CAREFUL!!* All power tools are potentially dangerous. I have two cut fingers to prove it. Always wear safety goggles and stay alert when you run any power equipment. As my son tells me when I start down to the shop in the morning, "Be alert, the world needs more lerts!"

Before I finish this chapter on tools, there are a few comments I want to make about their care. You cannot expect your tools to work well for you if you do not take good care of them. Keep them in a safe place. Keep them clean and keep them sharp. Each one of my hand and power tools has a special place in my shop and the larger ones are covered by custom-made covers. How elaborate your storage facilities are is unimportant. It could be a shoe box or a beautifully dovetailed hardwood cabinet. Just be sure to put your tools away after each use. This care not only lets you know where each tool is when you need it in a hurry but also keeps the tools out of the reach of children and, I might add, unknowing adults.

If you have power tools, keep the sawdust off them. Sawdust left to sit on metal parts collects moisture, which causes rust. Keep the tools, both hand and power, well oiled. I like WD-40, a lightweight oil in a spray can, for this. Be sure to let the oil evaporate before making dust or you will end up with a gooey mess. Keep the floor around your work area clean at all times. I know it takes a few minutes, but they will be well spent if you drop a tiny turning you have

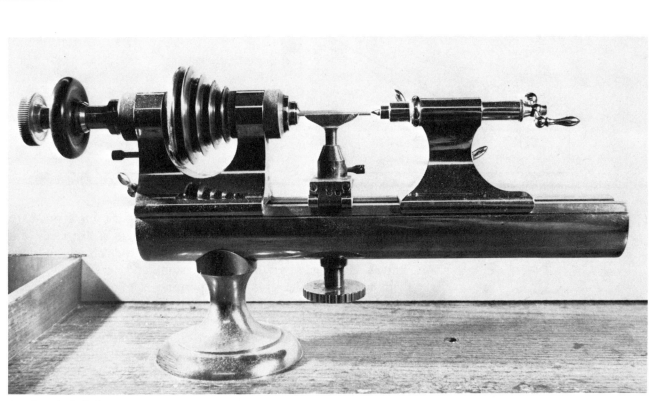

36. Jeweler's lathe.

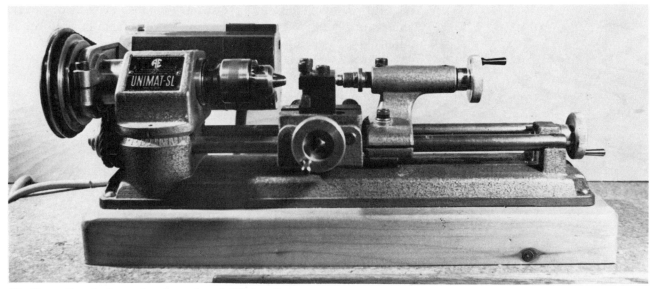

37. Emco-Lux lathe and universal tool (Unimat).

just spent forty minutes on and it is not lost in a pile of dirt and scraps.

Finally, keep all of your tools sharp. No one ever seems to be hurt by a sharp tool, it is the dull one that causes accidents. Not only is a dull tool more dangerous, a dull knife or graver rips the grain rather than cutting cleanly. This also applies to saw blades. A dull blade will splinter the wood and give a very messy and inaccurate

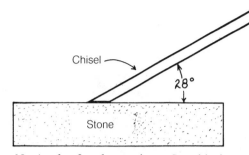

38. Angles for sharpening a flat chisel.

cut. Even awls, scissors, and screwdrivers must be kept sharp. Screwdrivers do not work well unless the edges are clean and square. The following steps will help you sharpen chisels and most knives. Use a good grade Arkansas stone and keep it well wetted with honing oil. The oil is very important, as it floats the steel particles away rather than allowing them to clog the stone.

Place the blade squarely on the stone and, holding it steady, move it across the stone in a figure-eight motion. Be careful not to rock the blade up and down as you go, or you will round the cutting edge. Follow this procedure on each of the cutting surfaces until there is a tiny wire or burr on the edge. This burr is then removed by stropping the blade across a piece of fine leather. Hold the sharpened edge of the blade toward you in a strong light. If it catches the light at all, repeat the entire process. Obtaining a razor-sharp edge is time-consuming, so protect your tools to keep them in good condition.

That about covers the general use of tools, we shall talk more about them individually as we work.

· 3 ·
Woods

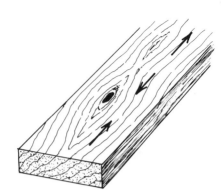

39. Arrows indicate the direction of the grain.

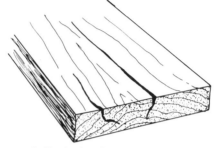

40. Splits in lumber.

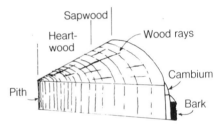

41. Nomenclature of the sections of a tree.

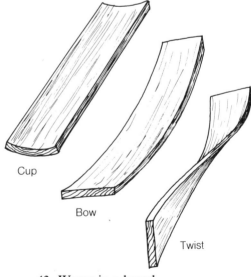

42. Warps in a board.

From earliest times, the majority of furniture made in the world has been made of wood. Availability, workability, strength, and beauty are all factors that have led to its universal appeal. The properties of wood allow it to be cut, bent, carved, turned, and joined by even the simplest of tools. Regional availability accounts for the use of different species in different areas of the country. Today we have at our fingertips woods from every corner of the earth.

Wood is divided into two major classifications: *softwood*, which comes from conifers or needle-bearing trees, and *hardwood*, which comes from deciduous or broad-leafed trees. There is an overlapping in both of these classifications, but for our purpose we need not confuse the issue. Some hardwoods such as mahogany, oak, and walnut are characterized by large pores and are often referred to as *open-grained*. These open-grained woods must be filled with paste fillers before finishing.

In the field of miniatures there is a general tendency to make one wood, such as basswood, do the job of all woods, giving it the appearance of walnut or cherry merely by staining. Personally, I have always made a point of using the same woods in my miniatures as were used in the full-size originals. In this book I shall continue to use that approach, for it is my feeling that stained basswood will never achieve the glow of natural hardwoods.

The biggest problem in using the different woods is that of grain. Unfortunately, there are no miniature oaks or maples, so we must use full-size lumber with full-size grain and texture to make furniture at 1/12 scale. For a miniature to be successful, this may mean discarding the portion of the board that is out of scale. True, this costs money, but nothing is more discouraging than spending hundreds of hours creating a work of art only to have it ruined by oversize grain. You must be equally careful of defects in the lumber. Knots, splits, and warps will all detract from an otherwise acceptable piece. If you cut your own lumber, you can remove the poor areas and concentrate on the fine-grained portions. Sapwood, that part of the tree nearest the outer bark, does not work or finish well and should be avoided. Buying prepackaged boards is somewhat risky. I would make the dealer open the package so I could inspect the wood, although I am sure this practice would not endear me to the hearts of the hobby shop owners. Wherever you get your lumber, make sure it is clear and *kiln-dried*. This process of drying the boards in ovens, where the temperature and humidity are carefully controlled, lowers the moisture content to around eight percent and lessens considerably the internal stress that warps lumber. If you buy boards from a lumberyard, you must remember the sizes given are for rough-cut planks. The board you get will be considerably smaller because of surface planing at the mill. A 1"-thick board will actually only be ¾", while a 2"-wide board will actually be 1⅝" wide.

Everything I have mentioned so far involves the purchasing of new lumber from a yard or in precut strips. Another source that I use whenever possible is the fine-grained lumber found in old furni-

ture. This lumber is dry, stable, works well, and takes a beautiful finish. The major drawbacks to this procedure are lugging the piece home and having the machinery to cut it up once you get there. This means full-size saws, planers, and sanders. You must also know your antiques before embarking on this path. I am an avid collector of antique furniture and I can think of no greater sin than destroying a beautiful heirloom, no matter what your intentions. I cut only those inconsequential pieces that have absolutely no value. A case in point is an old, broken violin given to me by a friend who owns a music shop. The poor thing was beyond all repair, but from it, I salvaged ebony, ivory, spruce, and some beautiful curly maple.

Before I describe some of the woods I use, there are a few points I should like to make.

The *grain* of the wood is the direction in which the fibers run. In straight-grained wood the fibers lie in a straight line generally parallel to the edges of the board. In cross-grained wood the fibers are at an angle to the edge. Wherever possible use straight-grained wood, especially on areas that will show, such as a top or drawer front. The *end grain* is that part of the board where you have cut across the fibers. The end grain should be avoided wherever possible: it will stain much darker and will not take the finish well. In many instances where the end grain shows, a facing board going with the grain is put over it. When sanding, carving, or planing a piece of lumber, always work with the grain. Finally, keep your tools razor-sharp. Dull knives and blades tear the fibers, leaving a splintered mess.

The following is a listing of some of the woods I use and a brief description of them:

Ash: A very hard wood, light grayish-brown and with pronounced figure.

Basswood: A creamy white fairly soft wood with a close grain that works easily and resists warping. I use it as a secondary wood for areas such as the interior of drawers and for my full-size wildlife carvings.

Birch: A hard, light-colored, close-grained wood. Most dowels are made of birch. I use this wood for many turnings.

Boxwood: An extremely dense, close-grained, very hard wood. I use boxwood when I need strength in a tiny carving or very tiny light-colored inlays.

Butternut: A member of the walnut family, light in color, fairly soft, and easy to work. Butternut must be filled after staining.

Cherry: A hard close-grained reddish brown wood. As do all of the fruitwoods, it works well, needs no filling, and takes a beautiful natural finish. This is one of my favorite woods.

Eastern white pine: This is a beautiful, light-colored softwood with a close, straight grain. It is easily worked and carved. I use this wood for full-size wildlife carvings, sculptures, and occasionally as a

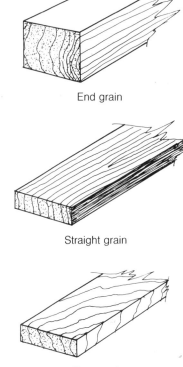

End grain

Straight grain

Cross grain

43. Grain of the wood.

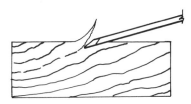

44a. Cutting against the grain splits the wood.

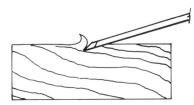

44b. Cutting with the grain leaves a smooth cut.

secondary wood in the carcasses of my miniatures. Pine is sometimes called deal.

Ebony: A rare Asian wood. It is usually black or dark brown and is very hard to work. I use ebony in musical instruments and inlays.

Hard maple: This wood is light brownish, close-grained, and very strong. The grain is fairly straight in most cases. Other maples such as bird's-eye maple, tiger maple, and curly maple have definite patterns and are beautiful with a natural finish. I use maple in the carcasses of my painted furniture.

Holly: A beautiful creamy-colored hardwood with almost no grain. I use this for fine detail work and in inlays.

Honduras mahogany: This is not a true mahogany, it is reddish brown in color, and has a fine texture, with some pores. It has a fairly good grain for miniatures but must be filled before finishing. Cuban mahogany is a better choice but it is very difficult to find.

Oak: A heavy, strong, light-colored wood with a rather open grain. It requires filling and is usually stained. Oak was used extensively during the sixteenth and seventeenth centuries.

Rosewood: A deep, red or ruddy purple hardwood with black streaks, easy to carve but it dulls knives quickly. I use this wood in furniture and some inlays. I find its oily qualities make it bothersome to glue.

Satinwood: A textured, light honey-colored, fine-grained wood used in inlay work.

Walnut: This is an outstanding furniture wood native to the United States. It is heavy, strong, and has a rich brown color and yet is lightweight. It is easy to work and takes a beautiful finish, but does require filling of the open pores with paste wood filler.

In the Appendix I list a few places to obtain lumber. There are many, many more but these will get you started. Be sure to check your local lumberyard and any cabinetmakers in town. You may be able to find all you need in his scrap pile.

Remember to choose your woods very carefully. I have seen the appearance of all too many fine pieces of furniture obscured by the poor selection of lumber.

Of course, the finish that you use on the lumber has a definite bearing on the final product, but I shall discuss that in chapter 6.

Remember to wear a respirator when you are working with exotic lumbers. Ebony, boxwood, satinwood, rosewood, and several others are quite toxic and can cause breathing and respiratory problems. The few seconds it takes to put on an inexpensive mask will be well worth it.

· 4 ·

Working with Wood

To create fine miniatures you must have a basic knowledge of woodworking. In this chapter I shall describe several of the techniques involved.

To begin, the full-size stock obtained from the lumberyard must be reduced to ½12 scale. This can be accomplished with an 8″ or 10″ circular power saw. The larger the blade the wider the strips of scale lumber you will be able to cut.

If you already own a circular saw, you are more than likely well versed in the dos and don'ts of ripping lumber. However, let me run through a few points I believe are important. First and foremost, be careful! Stripping pieces 2″ to 3″ high and only ½32″ thick can be very dangerous. Always protect your eyes by wearing safety goggles and *always* use a push stick. A *push stick,* as the name implies, is a dispensable wooden finger used to push the stock through the saw. It should be made of hardwood, tapered to the same thickness as the board you are cutting, and long enough to keep your hands well away from the blade. Never wear loose-fitting clothes around any power tool. These precautions are obvious, but it is the obvious, the things we are most aware of but momentarily forget, that causes accidents. I have cut the tips of two fingers by failing to do what I know is right. The biggest culprit is hurrying, not taking the time to think. Take a moment to check everything before you turn on any power tool.

Second only to safety is sound equipment that is lined up square and true. In ripping very thin strips of lumber, a fractional error will make each strip thicker at the top than at the bottom. This uneven lumber will plague you throughout the entire piece. To avoid this be sure the rip fence is perpendicular to the table and parallel to the blade. Keep the hollow-ground combination saw blade sharp and raised only slightly above the top of the stock you are cutting.

Although a circular saw can be used for many operations, cutting the initial stock is its most important function. If you do not own a circular saw, I suggest you purchase precut strips from one of

45. Push stick.

46. Safety equipment. (l. to r.): face shield, goggles, glasses with safety lenses, face mask, assorted push sticks.

47. Squares on a circular saw to check to see if the blade and the rip fence are parallel.

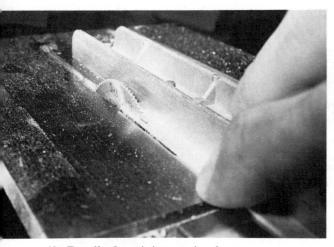

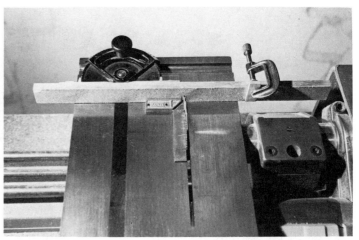

48. Detail of a miniature circular saw.

49. Miter gauge with a hardwood extension and a stopblock.

the companies listed under suppliers in the Appendix.

While I am on the subject of circular saws, I should mention the *mini-saw*. There are several types on the market. Three I am familiar with are Dremel, Jarnow, and Unimat. Safety and accuracy are as important on the mini-saw as on a roaring 12″ industrial saw. Do not be lulled into a sense of false security because it is smaller. Be careful!

I have been using Unimat's saw attachment for many years and find it accurate enough to cut strips well under 1/64″ square. When cutting very thin strips, always work with the grain and use a hollow-ground blade with at least ten teeth per inch of circumference, such as Unimat's metal-cutting blade.

One deficiency in many of the other small table saws is their *miter gauge.* They are quite flimsy and are difficult to keep accurate. Be sure to check them often with a square to make sure they are perpendicular to the blade. The addition of a wood strip to the miter gauge will extend it to support work on the far side of the table. To prevent the stock you are cutting from creeping into the blade, giving it a diagonal cut, glue a piece of 150 grit sandpaper to the face of the miter gauge extension. The roughness of the abrasive will hold the work securely. If you have several pieces that must be cut to the same length, clamp a small stopblock to the miter gauge extension. This stop works equally well with mitered or straight cuts and will ensure that all pieces are identical (upper right, fig. 49).

When a piece of wood is initially stripped on the full-size circular saw, it should be larger than you need so it can be trued on a planer or the small saw. Be sure to leave enough stock for sanding. When a large flat board must be cut into many tiny pieces, sand it to a final finish before cutting. If you must strip pieces 1/16″ or less, cut them off a wide board rather than stripping down a piece close to the finished width. The smaller piece will catch in the blade and splinter. In all cases, use a push stick and watch your fingers.

When using a power jigsaw, use the largest blade that will turn

50. *Fretsaw being used on a bench pin.* 51. Miter box made of hardwood.

the radius you are cutting. The foot of the saw should touch the work but not press tightly against it. Use adequate light that does not cast a shadow from the blade or the foot onto the line you are cutting. Look slightly ahead of the blade to anticipate how the work should be guided. When using all power saws, do not force the work, let the blade do the cutting. The methods used on a power jigsaw also apply to a *hand fretsaw.* Use adequate lighting and steady even pressure. Support the work on a bench pin, as shown in figure 50, with the teeth of the blade facing the frame handle. The teeth should face away from the handle when cutting work held in a vise or clamp.

The Zona saw is a flat, fine-toothed *handsaw* used for making straight cuts such as dovetailing, or in a miter box. Again, the teeth should face the handle if you are using a bench pin to pull the work against the surface with each cutting stroke. I have two saws with the teeth on one facing in the opposite direction from the teeth on the other.

If you do not have a *miter box,* figure 51 will help you make one similar to mine.

Begin with a block of straight-grained maple 6″ long, 1½″ wide, and 1″ high. Cut a groove ½″ deep and ¾″ wide the length of the block. This will leave two walls ⅜″ wide and ½″ high on either side of the opening to guide the saw blade. Using a combination square, mark the 45° angles and the center line. To make sure the cuts are perpendicular to the base, mark guidelines down the side where each line meets the edge. Either a Zona saw or an X-acto saw can be used to make the center and the miter cuts along the guidelines. All three cuts should be slightly deeper than the bottom of the groove. This miter box should be large enough for any small molding. Should a larger one be necessary, make it in the same manner.

Drilling a miniature hole requires a drill that is solid and accu-

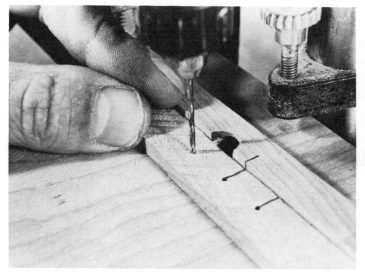 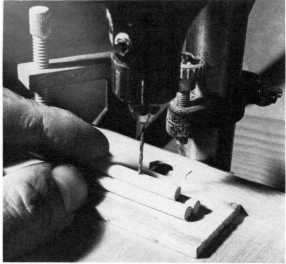

52. Drilling evenly spaced holes with the aid of the stop line on the drill fence.

53. Dowel jig for drilling holes in round stock.

rate. The slightest leeway in the table can cause a tiny drill bit to move off center and ruin the stock. When nailing two pieces of wood together, drill the hole slightly smaller than the nail in softwood and slightly larger than the nail in hardwood to allow for the expansion of the fibers. To drill a series of evenly spaced holes, make a pencil mark on the drill fence the distance you want the holes apart. Drill the first hole, move the stock down until it lines up with the pencil mark, then drill the second. Continue this procedure until you have the necessary number of holes. When first setting up your drill, cut a piece of ⅛″-thick plywood or maple somewhat larger than the metal table on the drill. Attach the board to the original table with double-faced masking tape. This will give you a replaceable surface to work on and allow you to clamp special jigs to the top. When drilling holes in a dowel, glue two equal-size dowels side by side on a scrap of wood. The trough between the two will cradle the dowel to be drilled and hold it securely. Always check to be sure the drill is on the highest point of the stock and that you have set the proper depth before turning on the drill. To ensure that the drill does not wander from the spot you desire, make a small depression with a sharp awl where you want the drill to enter. I often use double-faced masking tape to hold the special jigs to the drill table.

The *drill press* can also be used to do many shaping operations. By clamping a fence to the table directly behind a burr, you can create any kind of molding. Most moldings will require several cuts using a different burr for each. With a little practice you can duplicate any design. To cut the wood cleanly, be sure to push the molding into the burr from the proper direction. When shaping curved molding such as the top of a highboy, the fence must be replaced by a small steel pin protruding from the table surface. The pin enables you to pivot the molding in any direction. As with the straight pieces you will have to make several passes to complete the design. The

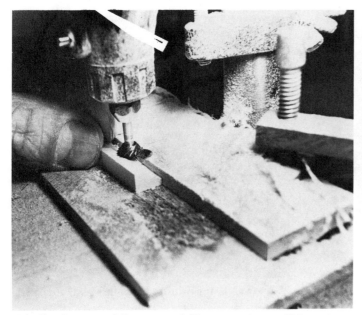

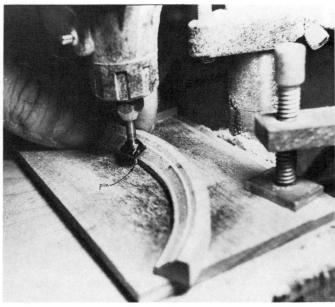

54. Cutting a molding on a drill press using a 45° cutting burr.

55. Cutting a curved molding using a pin set in the drill table to guide the stock.

main thing is to move the molding the same way on each pass to avoid cutting into the area you have just made. In shaping any curved design, it is important to know which way the grain is running. Wood has great strength in the direction of the fibers or with the grain but with few exceptions is quite weak across the grain. If you are working on a molding that changes direction, making an important area weak, either miter in another piece of wood to stay with the grain or use a grainless type such as boxwood.

Another machine used to shape wood is the *shaper*. This tool uses a Dremel Moto-Tool and router attachment built into a small inexpensive table. See figures 56 and 35, page 23, as guides. Either

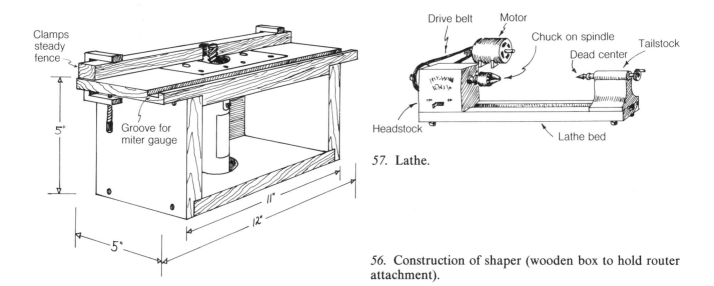

57. Lathe.

56. Construction of shaper (wooden box to hold router attachment).

screw or tape a board the length of the tabletop to the edge guide, which has now become the shaper fence. This setup will enable you to make almost any type of cut in any size miniature stock.

The *wood lathe* is indispensable for making the projects in this book. It does not really matter what lathe you use, just so long as it holds the stock securely, rotates the stock without wobbling, and the headstock and the tailstock line up with each other. When I began making miniatures, the only lathe I had was an old Sears model over three feet long. I put an adjustable chuck on the spindle and began to work. Needless to say I could not do on that lathe what I can do on my jeweler's lathe, but you have to start somewhere. Unimat's wood- and metal-turning lathe is accurate enough to do almost anything in miniature. There are several brands on the market in all price ranges. Get the best you can afford, a lathe is not the place to save a few dollars. The lathe you purchase should have variable speeds, be strong enough to turn metals, and be accurate enough to turn a toothpick to one-tenth its original diameter. If you are fortunate enough to have a jeweler's lathe, fantastic!

58. Adjustable chuck.

60. Three-jaw chuck.

Average Cutting Speeds (R.P.M.)				
MATERIAL	0 - 5/16" dia.	5/16" - 3/4" dia.	3/4" - 1" dia.	1" - 2" dia.
TURNING AND MILLING				
Steel	1400	950	590	310
Al. ~ Brass ~ Copper	1700	1400	950	500
Wood	2200	1700	1400	950
DRILLING W/ HIGH SPEED DRILLS				
Steel	1700	1400	950	310
Al. ~ Brass ~ Copper	2200	1700	1400	950
Wood	2200	1700	1400	950

59. Lathe speed chart.

Figure 59 will help you in choosing the correct speed for each diameter of stock you are turning. You will note that a piece of metal requires a slower speed than a piece of wood of the same diameter. There are several devices designed to hold stock in a lathe. A three-jaw chuck is great for holding dowels or cylindrical objects but it will not hold square pieces on center. A four-jaw chuck will clamp on a square stock but, because each jaw is tightened independently, it is very difficult to center the work accurately. I suggest rounding the end of the square piece with a knife or file so it can be centered in the three-jaw chuck. After the roughly rounded end is clamped in the lathe, turn the opposite end, near the tailstock, with a straight chisel. When this is completed, remove the stock from the lathe and rotate it 180°. You will now have an accurately turned cylinder in the chuck.

61. Four-jaw chuck.

Begin with the largest chisel possible and work down to the smallest. Hold the tool loosely in your right hand and use the thumb and index finger of your left hand to control the blade. Work slowly,

removing only small amounts of the stock at a time. If a turning has both round and square areas, separate them with a veining or parting tool first. Follow the veiner with a straight chisel and round the appropriate sections. The turning will now be part dowel and part square stock. With the lathe off, use a pencil to mark the design of the turning on the doweled area.

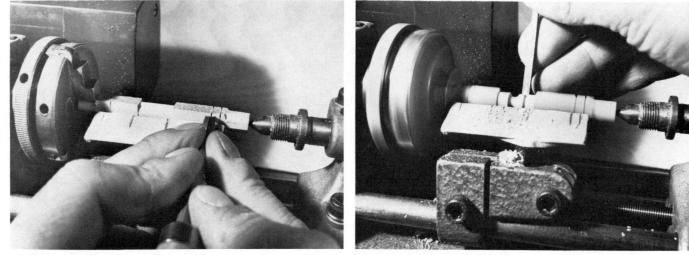

62. The proper way to hold a small lathe tool.

64. Shaping a turning with a small file.

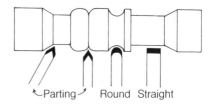

63. Cuts made by different lathe tools.

Cut the design using the differently shaped chisels or gravers. Keep your cutters sharp and your tool rest high enough so you are cutting the wood rather than scraping it off. When the design is roughed out, use needle files and 220 grit aluminum oxide sandpaper to finish the turning.

One of the most difficult lathe operations is creating several pieces that are exactly alike. Here are a few hints that may help. Separate the round and square areas, as just described, for the number of pieces that must match. When all of the blanks are ready, chuck one into the lathe and turn it completely using the pattern in the book as a guide. When you are pleased with the final results, remove the turning from the lathe. This first leg can now be used as a three-dimensional pattern. Place it alongside the remaining blanked-out pieces and, using a square and a pencil, mark each important line of the original turning on the blanks. These lines will give you station points to work from as you turn each succeeding piece. Stop now and then and lay the pattern piece on the work to check how you are doing. To keep diameters the same, use a caliper. Check as you go along, taking the measurements from the first and matching it against the one in the lathe.

A second way to mark the blanks is to transfer the lines from the original turning onto a piece of tape applied to the tool rest. The lines on the tape will tell you where to start each tool for each cut.

A third method is to jigsaw a template out of thin plywood, making a negative copy of the design. The stock is turned on the

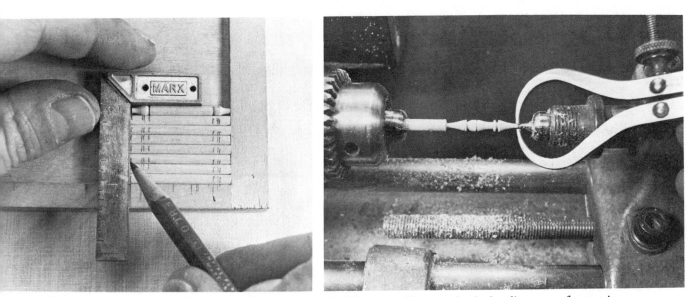

5. Marking areas to be turned from a master turning. 66. Using a caliper to check the diameter of a turning.

lathe until the negative template and the positive turning match perfectly.

If the turning requires another operation on the lathe, do not cut off the throwaway portion that has held it in the chuck until you have completed that operation. The extra length will give you something to hold onto while you drill or carve the turning and will allow you to put it back into the lathe for the final sanding.

To turn a long slender peg, chuck a hardwood dowel into the lathe. Use a dowel that is larger than the finished diameter to give added strength while you are turning. Begin cutting the portion nearest the tailstock and completely finish it, including sanding, before you move toward the headstock. Cut away a little bit more and finish it. Keep this up until you have completed the entire turning. If you try to turn the entire piece at once, the dowel will be too weak and will snap off when you apply pressure to it. *Practice!* My reason for writing this book is to teach you how to make fine miniatures. Any learning situation requires homework, and although I am not there to check up on you, you must do your homework before you can hope to master the lessons.

67. Turning a long slender piece of stock.

Most of the drawings in this book are scaled so that $1'' = 1'$. Any measurements you require can be taken directly from the book. Keep in mind that even the slightest variation in size caused by blade width, accuracy of tools and measurements, and so forth, may require you to custom-fit pieces described in the materials list. There are several ways to transfer the patterns in this book to the wood. First, make a tracing of the design on vellum. This tracing can then be glued with rubber cement, either directly to the lumber you are going to use for the furniture, or to a thin strip of wood for a template. An advantage of using a template is that it can be used over and over again. Remember to cut just outside the line if you have laid the pattern on the actual wood to allow for sanding and just in-

68. Examples of templates.

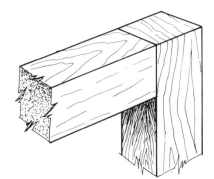

69. Butt joint.

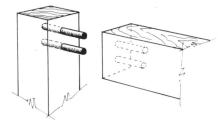

70. Pegged joint.

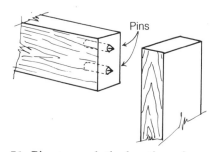

Pins

71. Pins to mark the location of pegs.

side the line if you are working on a template. The reason for making the latter smaller than the actual drawing is to allow for the width of the pencil lead when you trace around it.

Save your templates and mark on each what piece it belongs to. The old cabinetmakers had dozens of them hanging from the rafters of their workshops.

If you do not want to cement the tracing paper directly to the wood, graphite paper can be used.

A most important point: no matter how you transfer the designs from the book to the wood make sure you trace the curves and arches carefully.

MAKING JOINTS

Before beginning work on the projects, I want to explain the different types of wood joints that will be used and how to make them. This will not only make the drawings easier to understand but will eliminate the need to repeat the same steps for each project.

Let us begin with the simplest, the *butt joint*. As the name implies, a butt joint is merely two pieces of wood butted together and held in place by glue. It is the weakest of all joints and should be avoided whenever a strain will be exerted on the joint. If you feel you cannot do some of the more complicated joints, the butt joint is always there; however, your miniature may not stand the test of time if entirely held together in this manner.

One way to strengthen the butt joint is by the *addition of pegs*. It is difficult, however, to align the holes for the pegs in the adjoining pieces. To accomplish this, drill the holes in the end of the butting piece first. Push short, snug-fitting pins into the holes so they barely protrude. Align the two pieces exactly the way you want them, and push the joint together. This will force the points of the pins into the adjoining piece marking the center of the holes for the other end of the pegs.

One step better than the butt joint and considerably stronger are the *dado,* the *rabbet,* and the *groove* joints. These three differ only in their location. The dado is cut across the grain in the center of the board, the rabbet across the grain on the end of the board, and the groove with the grain the length of the board. All these are usually cut to a depth equal to one-half the thickness of the stock. The dado and the rabbet are used to hold shelves or parts of the frame whereas the groove is used where large areas are butted together.

All three of these joints can be cut on the drill, the shaper, the circular saw, or by hand. The drill and the shaper work identically, except that the former has the cutter above the work and the latter below it. Use a straight-sided burr for cutting any of these joints. Be sure the burr is the correct size so the abutting stock will fit snugly into the slot. Push the stock slowly through the machine, keeping it tight against the fence and the rotation of the burr. If you use the circular saw, you must lower the blade to the correct height and make several passes, moving the rip fence with each pass. If you cut the joint by hand, carefully mark both sides of the opening with a square, then clamp a piece of wood along the line to use as a guide for your handsaw. Hold another piece of wood against the inner edge of the saw and make your cut. Repeat this procedure on the other side. Finish by cleaning out the waste wood with a chisel the width of the opening.

Never glue together any part of the piece of furniture until you are sure all parts that relate to each other fit perfectly.

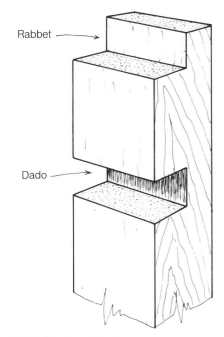

72. Rabbet and dado cuts.

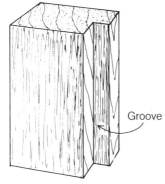

73. Groove cut.

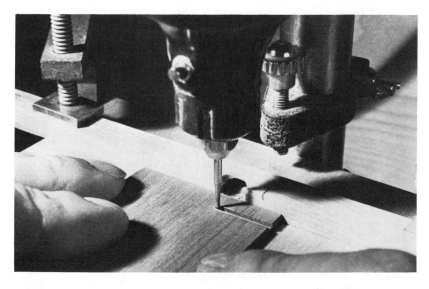

74. Cutting a dado on a drill with an inverted-cone dental burr.

The best and by far the strongest joint is the *mortise-and-tenon.* It is used to join legs and rails of tables, chairs, and chests. It is also used in quality frame and panel construction. The mortise-and-tenon is made in a wide variety of forms, of which we are concerned with only a few. The one we shall use most often is called the *blind mortise-and-tenon.* This is a completely concealed joint. As the name

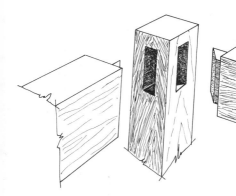
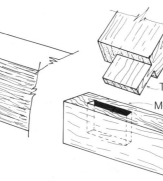

75. Mitered mortise-and-tenon on a leg post.

76. Blind mortise-and-tenon joint.

77. Mistakes in cutting a mortise-and-tenon joint.

implies, these joints consist of a rectangular hole cut in the leg, called a mortise, and a matching rectangular tongue cut on the end of the stretcher, called a tenon.

When making this joint, do not cut the mortise too close to the edge or the top of the work, or it will be very weak and break out. When cutting the tenon, make its length at least two and one half times its thickness. Always make the mortise first while the leg is still a square piece of stock. Do not wait until you have cut the cabriole leg. Carefully mark where the mortise is to go, then, using an inverted-cone burr the size of the opening, set the drill press to the proper depth and bore holes into the stock at either end of the marked opening. When these holes have been drilled, move the stock back and forth against the fence, lowering the burr with each pass until the stock between the end holes has been removed.

Set the stretcher alongside the mortise and mark the dimensions of the opening onto the stretcher stock. Be sure to allow for the tenons when cutting the stretcher length.

The tenon is cut on a shaper using a heavy-duty square burr.

78. Cutting a mortise on a drill press.

79. Cutting a tenon on a shaper.

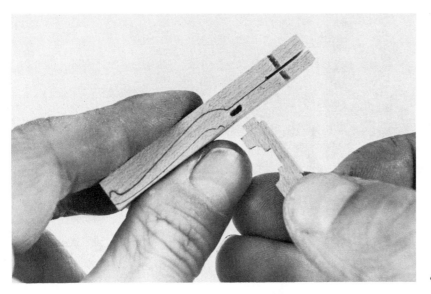

80. Checking the fit of the tenon.

The burr is raised to cut off one-fourth of the thickness of the stock. This cut is made on all four sides. A square block of scrap wood is used to push the stock through the cutter. This block not only works as a push stick it also keeps the stock perpendicular to the fence. Practice on scraps of wood until you get it down pat.

A *miter joint* is a joining in which the pieces to be joined are cut at an angle. The most common miter has both pieces cut at a 45° angle, thus when glued together they form a right, or 90°, angle. Most miters are butt joints; they can however be pegged, lapped, or even mortised-and-tenoned.

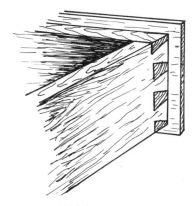

81. Miter joint.

The last joint I shall mention here is the *dovetail*. For some reason people think of this joint as the most difficult. Actually almost the opposite is true. The dovetail consists of two parts: the tail, which is cut on the end of one board; and the pin, which is made on the side of the other. Dovetails are generally cut at an 11° angle or about a 6:1 ratio. I use an inverted-cone dental burr to make the pins on the drawer front. Chuck the burr into the drill press and set the fence to control the depth of the cut, which is the thickness of the drawer side. The only difficult part is spacing the cuts so the pins are symmetrical in design. To do this, mark where each cut should be made. Place a rectangular piece of wood against the fence to keep the drawer front from moving sideways as you push it into the burr. Make sure the board is on the side against the rotation of the machine, then slide the work along it into the burr. Move the board over until the center line of the next tail is in position and make your next cut, and so on until you are finished. Use a medium speed both for safety and to keep from burning the wood. When the drawer front has been completed, lay the side of the drawer against the pins and at right angles to them. Mark the location of the pins on the side. This indicates where the tails should be cut and how deep.

82. Dovetailed drawer.

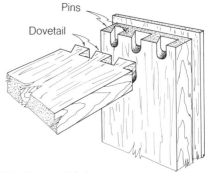

Pins

Dovetail

83. Dovetail joint.

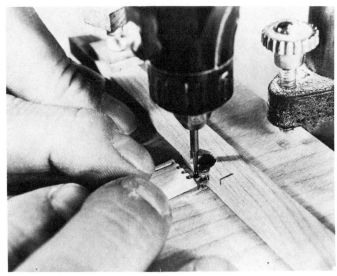

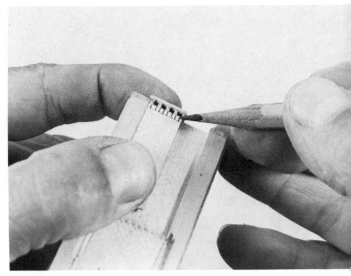

84. Making pins on a drawer end with an inverted-cone dental burr.

85. Marking dovetails on a drawer side.

86. Chamfer.

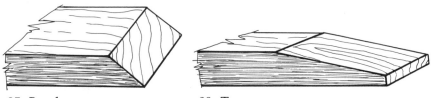

87. Bevel.

88. Taper.

Using the flat handsaw or jigsaw, cut the diagonal lines of the tails. With a small chisel the size of the back of the pin, chop out the third side. Carefully round the inside edge of the tails to match the circular cut of the burr, and there you have it, a dovetailed joint.

There are three angled cuts I should like you to recognize, they are: the *chamfer,* which removes the sharp edge from a board; the *bevel,* which cuts through the board's entire thickness; and the *taper,* which gradually reduces the thickness of the board toward the end.

Most of the joints I have just discussed have one thing in common: the need for something to hold them together. After you have decided what joint to use, you must decide how you are going to hold it. In the days before synthetic and chemical glues most joints were held together either with glues made from animal hides or by pegs. Pegged joints have been around for ages and are very reliable. Any joint, large or small, can be pegged, from the delicate stretchers in a chair to the massive beams of an old barn.

The joint most often pegged is the mortise-and-tenon. After you are sure the joint fits properly, mark the location of the pegs with an awl. Push the joint tightly together, drill the holes, and with a mallet, drive the pegs through the entire joint letting them stick out on both sides. Sand the pegs until they are flush and you will have a strong joint. Even with pegs most joints should be glued.

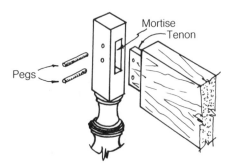

89. Pegging a mortise-and-tenon joint.

GLUING THE JOINTS TOGETHER

The following list will help you choose the correct glue for each situation.

Aliphatic resin glue is a white glue sold under many names. I use Franklin's Titebond and am very pleased with the results. Although the glue is white when wet, it dries clear and cleans easily with water prior to drying. It is quite strong and sets up quickly. One note, *all* excess glue must be removed before staining, as the finish cannot penetrate the resin and will leave areas of raw wood on your work. Make sure all pieces fit perfectly and are dust free, then apply glue to both surfaces, position the work carefully, and apply pressure. Do not break the initial tack by repositioning the work, or the glue will not hold properly. Adding more glue to that already starting to dry will just make a mess. If the joint breaks, remove all residue of the first gluing and start again on the clean wood. In short, get it right the first time or you will have problems.

Contact cement is a neoprene-based liquid that forms a tight bond without clamping. It must be applied to both surfaces and allowed to dry for fifteen minutes or so before the pieces are pressed together. A word of caution, once you have positioned the two pieces they cannot be moved; be sure they fit properly and position carefully before applying pressure. This glue is great for large flat areas but is not intended for small butt joints where great pressures can be applied to the joint.

Epoxy glue is an extremely strong two-part glue used for a sound joint between any two surfaces. Equal parts from each tube are combined just before use. I use a five-minute epoxy, which has more than sufficient holding power for miniature work.

Instant-set glue is a relative newcomer to the market. This adhesive instantly bonds almost any surface, including human skin. For this reason you must be very careful or you may spend some time living much closer to your miniature then you had planned. A drawback to this miracle glue is it is not gap-filling and thus the pieces must have a perfectly snug fit.

Plastic-resin glue is made in powdered form from urea-formaldehyde. It is mixed with water just before use. It is very strong and easy to use, with a quick action. However, the joints must fit tightly together as it is not a gap-filling glue.

90. Glues.

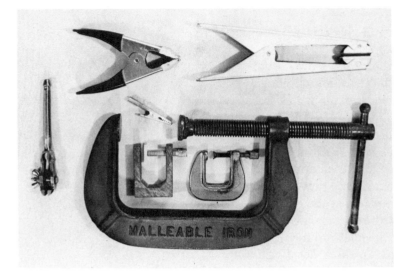

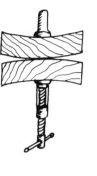

92. Incorrect and correct methods of clamping two pieces of wood together.

91. Clamps (l. to r.): hand vise, spring clamps, C-clamps.

With few exceptions, the process of gluing requires holding the bonding pieces together until the glue sets. Over the years I have found the only clamps that will do exactly what I want with just the right amount of pressure are my hands. I have sat through many a muscle spasm holding a piece under pressure until I was sure I had frozen in that position. Most of the mechanical clamps used in miniatures are variations of the C-clamp, from very small ones to large industrial clamps that open to about 8″. These large clamps will hold a highboy carcass or a dresser base together.

Always use scraps of wood between the metal and your work and be careful not to tighten the clamps too much. Most glues take time to set, so leave the piece alone for a few hours while you do something else. Occasionally, I use the vises on my large woodworking bench to clamp flat areas, and rubber bands hold some pieces together very well. If you are clamping a large area, use thick boards between the work and the clamp. The boards will thus apply even pressure over the entire surface.

Finally, there are the rubber-tipped spring clamps. These are very useful in holding the edges of tabletops down and veneers in place.

CARVING THE WOOD

Nothing separates the truly great miniature from the average one more than the carving on it. In this book there are several pieces that involve very elaborate carving. Before attempting them, you will have to practice the techniques involved and gain confidence with your tools.

There are two ways to do miniature carvings: with knives and chisels, and by machine. On many carvings I use a combination of both methods. First, you must carefully outline what you want to do on the piece to be carved. This can be done by any of the methods mentioned in the paragraph on transferring designs (see pp. 39–40).

Once you have the design on the wood and are pleased with the flow of the lines and the overall composition, you can begin carving. If the work is to be applied rather than carved directly onto the finished piece, you must jigsaw or fretsaw out the design. If several applied designs are alike, they should be held together with double-faced tape or rubber cement and cut out as one. This is not only faster but assures that all will be the same size and shape.

How to hold the tiny pieces is a problem in doing applied carvings. They can either be attached to a larger more manageable piece of wood with double-faced masking tape or be glued directly to the carcass and carved as though they were part of the original board. The reason I often carve them separately is to eliminate the chances of marring the piece to which they are applied. Once the tiny pieces are attached to a board you can hang onto, carving becomes much easier.

Whether you use a #11 X-acto knife or my favorite, a #11 scalpel with a T-ridged blade, hold the handle in one hand as you would a pen and guide the carving with the thumb and forefinger of the opposite hand. Work in the direction of the wood grain and keep your tools sharp, and I mean *razor-sharp*. Some carvings can be so detailed that a dull knife will tear the fibers and destroy them. When you have finished with the overall carving, use riffler files and sandpaper to remove any rough spots and clean up the design. For concave areas use a gouge or a rounded graver, working with the grain at all times. This often means changing the direction of your cut several times in a comparatively small area. If the carving is extremely small, you may have to use the flexible shaft and dental burrs to keep from splintering the wood.

I have always used a Foredom with a foot rheostat and have never had any problems. The Foredom flexible shaft has several interchangeable heads that snap off and on. The two heads I regularly use are the #30 adjustable chuck and the #8 collet-type chuck. Both of the heads have ball-bearing drives. If you purchase the #8 head, consider getting the #8D with the flex-spring shaft, as it is much easier to hold for long periods of time.

Carving with the flexible shaft and dental burrs has many distinct advantages, the most important being that the high-speed burrs are not greatly affected by the grain of the wood. In general the burr will cut in any direction with ease, a knife may not. Another advantage of the flexible shaft is speed, especially on very hard steel, and it will make easy work of boxwood, ebony, or even oily teakwood. Burrs are available in dozens of shapes, and by using them in different combinations you can create any carving or molding design you desire.

The disadvantage of using a power tool to re-create hand carvings is the lack of sharp clean lines. By nature a burr must rotate to cut, and that rotation leaves curved edges that are soft and mushy. A knife or chisel leaves the crisp lines of an heirloom treasure. The answer is a combination of power and hand tools. I use the flexible

93. Applied carving stock glued to a drawer for carving.

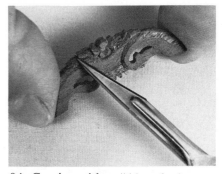

94. Carving with a #11 scalpel.

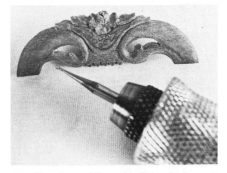

95. Carving with a flexible shaft and round dental burr.

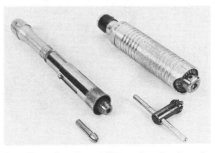

96. Foredom's collet chuck handpiece and #30 adjustable chuck.

shaft to rough out the design and to get into tiny grooves and curves, and I finish every carving with knives that yield crisp edges. Finishing the carving is a job for rifflers, files, and sandpaper. The rifflers will smooth the surface yet keep the shape of your carving. Remember: do not oversand!!

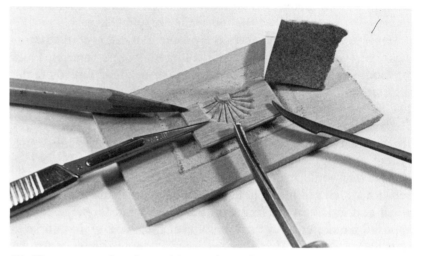

97. The stages and tools used in carving a fan ornament.

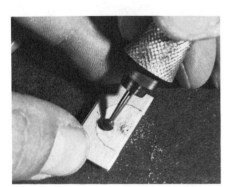

98. Roughing the fan area with a round burr.

99. Scoring the fan rays with a knife.

100. Rounding the fan carving with a riffler file.

So far we have discussed only applied carvings. More often than not we shall be carving directly into the piece of furniture. When carving directly into a piece of wood, such as a drawer front, you eliminate the problem of tiny carvings flying around the room and getting lost on the floor. However, the piece will still be easier to work on if you secure it with double-faced tape to a scrap of wood large enough to hold onto. An example of such a carving is the fan on the front of the Queen Anne lowboy. Figures 97 through 100 show the carving in each of several different stages. As mentioned earlier, carefully transfer the design onto the wood. Using the flexible shaft or a large gouge, scoop out the overall outline of the shape of the fan. When this is done, draw in the fan rays with pencil lines and, using a #11 blade or a V-shaped parting chisel, cut along each line, starting at the edge of the fan and working toward the center. This means cutting across the grain as you work away from the center, so be careful not to chip off parts of the fan. Next with the #11 blade soften each side of the rays until they are rounded. Be very careful not to lose the separation of each ray where they meet at the center. When the entire fan is roughed out, use a square-faced riffler file to round each ray. Riffler files are a must for miniature carvings, as their curved ends allow you to get into areas a straight file will never reach.

Finish the carving with a small piece of 150 grit, aluminum oxide open-coat sandpaper followed by a 220 grit. When the carving is perfectly smooth, sharpen the line where the rays meet with your #11 blade. As I have said before, do not get carried away with the use of sandpaper on the carvings or the edges of your furniture.

Nothing shows the work of an amateur more than having every crisp line overrounded by too much sanding. Keep your work fresh and alive. Use a sanding block on flat areas.

If I were to take a poll to find out the most difficult part of a Queen Anne or Chippendale piece of furniture, the answer would undoubtedly be the cabriole leg. The *cabriole leg* is cut from a piece of square stock and consists of three parts: the foot, the leg, and the upright extension that supports the top and sides of the chair or carcass. During the eighteenth century the design of the foot went from the simple pad of the Queen Anne period to the elaborately carved claw-and-ball of the Chippendale period. At the height of the Chippendale style the knee as well as the foot was ornately carved.

To begin, cut a piece of square stock slightly larger than the maximum width of the leg and as long as indicated by the template (see fig. 102). On vellum, carefully trace over the pattern in the book, making sure that you retain the grace of the curves. If the leg is to be carved like the one on the Philadelphia highboy, be sure to make allowances on the pattern. Glue the pattern to a piece of thin plywood and carefully jigsaw it out, making it slightly smaller than the drawing to allow for the pencil width. When cut, smooth out the lines until you have a perfect template. Lay the template on the leg stock, lining up the straight inner edge and trace around it, making sure it does not move. Trace around the template again on the adjoining side of the leg. At this time cut in any mortises that are required. If you attempt to do them after the cabriole leg is cut out, it will be difficult. Set up the drill and make all necessary joints now. When these are complete, set the foot on the jigsaw for the thickness of the leg and begin cutting just outside the lines. Do not cut on the lines; leave a little extra to sand off. The trick to cutting out the cabriole leg is not to cut all the way down any one line. Leave a tiny bit of stock holding the piece on so you can cut the pattern on the adjoining side. When one side is cut out, with the exception of the tiny areas that are still holding it in a square, turn the leg 90° and cut around the pattern on the adjoining side in the same manner. After you have cut along every line, go back and finish the little areas that were holding everything together.

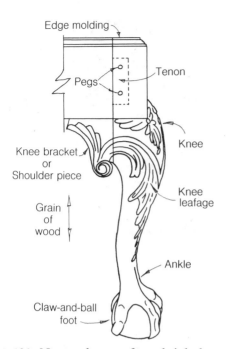

101. Nomenclature of a cabriole leg.

102. Marking a cabriole leg with a template.

103. Cutting a mortise in cabriole leg stock.

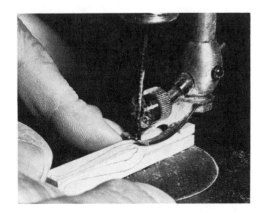

104. Jigsawing a cabriole leg.

105. Using a scalpel to round the edges of a cabriole leg.

When all of the legs are cut out, check each joint to make sure everything fits perfectly. Now is the time to discover mistakes, not after hours of carving. If everything fits, begin to remove the sharp square edges with your #11 blade. Be careful cutting near the ankle where the cross grain is weak.

To make sure the four legs are alike, carve each one only part-way then compare it with the rest. If one is slightly different, make the others match it. Continue cutting a little at a time from each one, comparing them often. The advantage in so doing is that you have not removed all the excess from any one leg until all are matched.

When they are all alike, use a file and smooth them down. Finish each leg with a 220 grit paper. Remember, slight differences are acceptable; it is the overall grace of the lines that is important. They are hand-carved and no two pieces of handwork will ever be exactly the same.

106. Using a file to round a cabriole leg.

107. Final sanding of a cabriole leg.

· 5 ·

Working with Metal

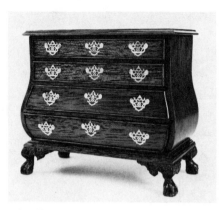

108. Brass escutcheons on a bombé chest.

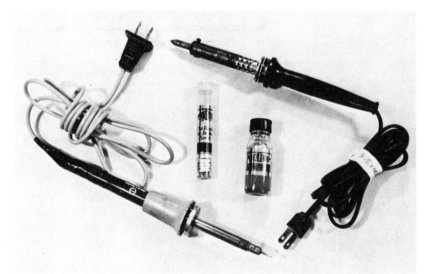

109. Soldering equipment. Pencil soldering iron, solder, flux, heavy-duty soldering iron.

Very little working knowledge of metals is required to do the projects in this book. Although the hardware on the examples is custom-made to match those on the original pieces, finished hardware can be purchased at your local hobby shop. Nonetheless, I should like to make a few brief comments about metals and how they can be used.

From earliest times metals have been employed to enhance the appearance of objects. The hardware on a Chippendale highboy is an integral part of the entire design. Some pieces are so embellished with brass escutcheons that they appear almost to be made more of metal than of wood.

The metal most often used in American furniture is brass. Brass, an alloy of copper and zinc, is malleable and ductile. Brass requires a coat of lacquer to prevent oxidation. As are all sheet metals, brass is measured by gauge; the higher the number, the thinner the sheet.

Small pieces of metal are generally held together by solder. *Solder* is a metal alloy used, when melted, for joining metal parts or surfaces. By using solders that melt at different temperatures, several joins can be made in the same area. Soft solders are made from tin and lead and melt at low temperatures; hard solders are made from silver, copper, and zinc and melt at much higher temperatures. All soldering requires the use of a flux. *Flux* is a liquid or paste that retards oxidation when the metals are heated and allows the solder to flow into the joint. Most of the work done by miniaturists will be with soft solders; therefore, the low heat produced by a soldering iron should be sufficient. I have found Tix solder, which has a low melting point but is quite strong, to be very satisfactory. Be sure all surplus silver solder is removed from any joins.

When joining two pieces of metal, make sure both surfaces are clean and fit together well. Apply flux to the join, then place the soldering iron on one side of the join and the solder on the other. Ap-

plying heat to the back of the join causes the solder to flow between the two pieces by capillary action. If the iron and the solder were held on the same side of the join, only the outer edge would bond.

The use of epoxy glues and the instant-set superglues are two other methods of joining metals together. These glues have the advantage of joining not only metal to metal but metal to wood, glass, or any other nonporous surface. Both glues have outstanding holding power although the superglues require a snug fit.

As mentioned above, brass is quite malleable, which makes it ideal for shaping or turning on a lathe. General metal turning requires a sound lathe equipped with a carriage and a threaded feeding attachment. These allow the cutter to be held securely as you move it slowly across the stock. Remove only a small amount of metal at a time, feeding the cutter slowly and evenly into the rod. Use only soft brass and be sure it is chucked securely into the head-

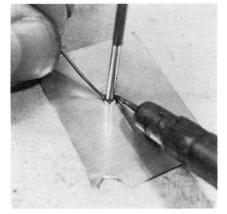

110. Soldering: Note how the solder and the iron are on opposite sides of the piece being soldered.

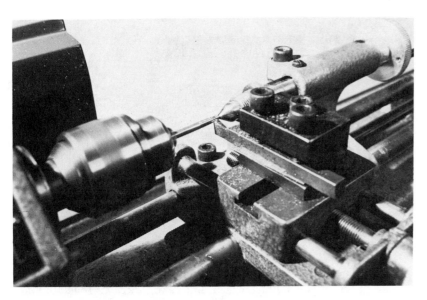

111. Turning a piece of metal on a lathe.

stock. For intricate turnings I use graver's tools as cutters. They are available in dozens of shapes and are hardened to hold a sharp edge, even against metals. It is important to use the correct lathe speed, however, or the tool may overheat and lose its temper (see chap. 4 fig. 59, p. 37).

If you require a very tiny turning, use a piece much larger than the diameter of the finished piece. The larger rod will not bend under the pressure of the cutters. If the turning is to be quite long, do only a small portion at a time beginning at the end nearest the tailstock. Completely finish that portion, including polishing, before you move toward the headstock. To finish a brass turning, start with the appropriately shaped #2 needle file and even the area. Follow the file with 400 grit sandpaper, then 600 grit wet-dry paper. When all milling marks have been removed, polish the piece with a hand buff rubbed with tripoli. Wash the tripoli from the turning and complete the polishing with a hand buff rubbed with red jeweler's

112. Polishing hardware held in a hand vise.

rouge. All polishing should be done on the lathe at a slow speed and all residue from the polishes removed by washing the piece in soap and water. When the brass is clean and shines like gold, coat it with clear lacquer.

Any hardware you purchase for your miniatures should be polished in a similar manner. Hold the hardware between your fingers or in a pair of parallel-jaw pliers and buff it with a flannel buffing wheel charged with tripoli. The buffing wheel is run on a flexible shaft at a very slow speed. Follow the tripoli with a second buffing on a wheel charged with red jeweler's rouge. Wash the finished hardware in soap and water to remove all polish, then lacquer it. Note, do not mix the tripoli and jeweler's rouge wheels; mark which is which and keep them separated.

Always wear protective goggles whenever you are working with metals. The precautions mentioned for circular saws in chapter 4 apply to all power tools.

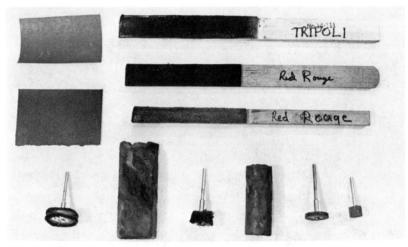

113. Polishing equipment. 600 grit wet-dry paper, hand buffs, 400 grit wet-dry paper, tripoli buffing wheel and cake, jeweler's rouge buffing wheel and cake, small grinding wheels.

THE CONSTRUCTION OF PULLS FOR DRAWERS

Some of you may be curious how I make my hardware. The process, although not extremely complicated, is very time-consuming. I begin with a rod of hardened steel. After drawing the design of the hardware I want to scale, I glue a paper pattern to the top of the steel rod. With emery wheels and grinders, I slowly cut away the metal until I have created a tap of the required design that runs about ¼″ down the rod. When the edge of the design is clean and sharp, I polish the top surface and prepare to cut the backplate from a brass sheet of ³⁄₁,₀₀₀″ thickness. Before stamping out the blanks, I polish the entire sheet of brass, thereby eliminating the need to polish each tiny piece. I then place the brass, polished side down, on a ¼″-thick strip of lead or a large block of very hard wood, either of which will act as the die. The tap is then set on the brass and given a healthy blow with a hammer. The blow cuts the brass and presses

114. Cutting a die to make brass escutcheons.

the blank into the lead. Bending the lead strip releases the blank, and the backplate is ready for drilling. If you have used a hardwood block, the stamping must be carefully removed with a chisel.

When as many pieces have been punched out as are needed, I stick them to a scrap board with double-faced masking tape and drill the holes for the pins that hold the bails (or handles) to the backplates. The ends of the bails are tapered on a lathe, then bent by hand into shape. The pins are also turned on the lathe and then drilled with a #80 drill. You may find it easier to drill the hole in the brass stock before turning out the pin on the lathe. When all the parts are completed, the pull is assembled, polished with red rouge, washed, and lacquered. The entire process is very tedious; but there it is, you are welcome to it.

THE CONSTRUCTION OF HINGES

The construction of tiny brass hinges is not so difficult as you may think. The biggest problem is the fact that they are quite weak and will take little abuse. Their size and the weight of the brass stock make them extremely delicate.

The following series of illustrations shows how I make brass hinges. The same techniques would apply no matter what shape the hinges are.

115. Using a die to stamp out brass escutcheons; note the lead strip under the brass sheet to impress the stamping.

116. Stages of hinge construction.

Most of my hardware is made from $^{3}/_{1,000}$"- or 3-mil-thick brass. Figure 116 illustrates the several stages involved in the construction of a tiny hinge. In figure 117 you can see one of the secrets of making the rolled portion of the hinge so small. The 5" pliers have been custom-ground and -filed. The lower portion is left quite strong and flattened on the face. The upper portion, however, has been reduced to the thickness of a heavy sewing needle. This reduction must be done slowly and carefully. The metal must not become hot and turn blue. Overheating will remove the temper from the steel and allow it to bend easily. Remove the metal a bit at a time. The nice thing about spending time on making a tool like this is it should last forever.

The use of the tool should be obvious. The thin brass stock,

117. Rolling the edge of a piece of brass with custom-shaped pliers.

118. Closing the loop of a hinge.

119. Hammering a piece of solder into a thin strip.

120. Soldering a hinge loop.

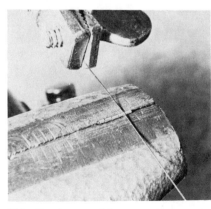

121. Cutting out hinge sections.

which has been cut into strips of the proper width, is held in the jaws of the pliers and bent around the needle end (see fig. 118). As you bend the brass around the pliers, you will eventually reach a point where the heavy jaw hits the flat portion of the strip. The loop must be closed by moving the pliers farther back on the stock and continuing to roll it. When the loop is closed, slide a piece of steel wire into the loop as shown at the top center of figure 116. Note that I have bent the top of the wire over to keep it from falling out. Now use a pair of parallel-jaw pliers to tighten the loop around the wire.

The next step is to solder the loop shut. I use Tix solder, which comes in short round pieces. Figure 119 shows how the round solder must be hammered into a thin flat piece. The solder is then cut into tiny sections. One small section of solder is laid against the join as shown in figure 120, after a small amount of Tix-flux has been brushed on the join.

To solder the join, heat must be applied to the area of the metal opposite the solder. The solder is then pulled into the join by capillary action (fig. 120). Do not use too much flux or solder. If you do, you will fill the entire loop and solder the opening completely shut. If this should happen in a small area, a tiny drill can be used to clean the opening.

After the metal has cooled, the different sections of the hinge can be sawed out as shown in figure 121. These cuts are made in exactly the same location on both sides of the hinge. See the top right of figure 116. After completing the cuts, your hinge should look like the two pieces in the lower left of figure 116.

Finally, the two pieces are joined with the wire used earlier. The wire is crimped at each end so it will not fall out.

You can cut the hinge to any width you desire and fasten it with tiny nails, tiny screws, or a combination of fasteners and epoxy glue.

Before I leave the subject of metal I should like to mention one other process. Metalcasting either by vacuum or by centrifugal force has a great many possibilities. By carving a slightly oversize master from wood, metal, or wax, any number of copies can be produced. Unless you own your own casting equipment, however, you must send away to have the molds and the casting made, which is a fairly expensive process. You may have to clean sprues and burrs from each casting and polish it as you would the original, but the time saved will be well worth the expense.

· 6 ·
Finishing

When all the hours of carving, shaping, and gluing are over and you hold in your hand a completed miniature—except for the finishing—you are half-done. That statement seems a bit harsh, but it is true. Putting the finish on your miniature is fifty percent of the work. All the perfectly matched joints, flawless dovetails, and exquisite carvings you have executed will go unnoticed if they are covered by an inferior stain or a drippy coat of varnish.

A professional finish begins with your choice of a piece of beautifully grained wood that is in scale with the miniature you are creating. Some areas of a board will be perfect and others just passable: use the finest grain for the top and front and the wider grain for the sides and back. The insides of the piece are generally made from a secondary wood, such as pine or basswood. Be very careful of chips, splits, and warps in the wood you select. It would be disastrous to spend hours on a piece of miniature furniture only to have the stain bring out featherlike separations in the wood. If you are in doubt about how the wood will finish, stain and varnish a small area before you start. If it looks good, go ahead, if it does not, look for another piece of wood. After you have selected and cut your lumber, the next step is to prepare it properly for the finish.

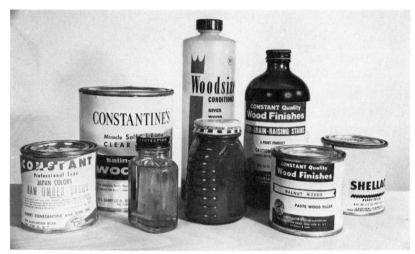

122. Stains and finishes.

SANDING

In many cases this preparation begins before the individual pieces are cut out. After the boards are stripped to the proper thickness on the circular saw, they can be sanded to various degrees of smoothness depending on where they are to be used. Large boards with flat areas need only be roughly sanded, while those that will be cut into several tiny pieces should be sanded to a finished smoothness.

Do not glue together small pieces unless they are ready to be stained. Tiny pieces are much easier to finish unassembled. I use aluminum oxide open-coat paper for all of my sanding on wood. I prefer the natural open-coat paper to the black wet-dry type. If the boards are rough or show saw marks, begin with 100 grit paper followed by 150 grit, then 220 grit. Everything should have a final

sanding with a 320 grit open-coat paper before staining or varnishing. Fold your sandpaper as shown in figure 123 or use a sanding block. Make sure the sanding block is square and flat. Use a 4″ by 6″ piece of ¾″ maple or plywood and staple the paper to the back of the block. Be sure to pull it as tight as you can to eliminate any possible cup along the edges. Always sand *with the grain;* remember that for every stroke you sand against the grain you will have to sand twenty strokes with the grain to remove it. If the pieces are very small, rub the wood over the sandpaper block rather than the block over the wood; this will prevent rounded edges. Do not sand areas that are to be glued together; the sawdust goes into the pores of the wood and reduces the strength of the bond.

When you think you have an area perfectly smooth, hold it up to the light and check for imperfections. You must remove all the flaws now, as the stain and varnish will amplify defects you can barely see in the unfinished wood. After the piece is fully assembled, be sure *all* the glue has been removed from the entire piece. This means you have to clean the glue from inside the carcass also. Do not spend hours on a piece of furniture only to leave glue slopped under a drawer. Be particular; it takes a few minutes but the time is well worth the crisp professional results. It can be said, "It's what people don't see that makes a great miniature."

When the glue has been removed, carefully sand the piece again with 320 grit paper, paying special attention to the corners and curves. When you are convinced you have done a good job, dust the piece carefully with a *tack cloth.* This is a piece of cheesecloth lightly saturated with varnish, producing a sticky surface that attracts dust. Tack cloths can be purchased at your local paint store or from Albert Constantine (see Appendix). When the rag is new, it is folded into a tight square, open it up all the way, unfolding each layer until you have a loosely crumpled cloth that will be able to reach into even the tiniest corner. When the miniature is dust free, coat it with a wash made from one part shellac and seven parts denatured alcohol, or with any good wood sealer that has been somewhat thinned. This initial wash seals the wood, raising and stiffening any fuzzy grain so it can be sanded off. When the sealer is dry, sand the entire piece again with 320 grit open-coat paper. Change the sandpaper often, as it will quickly clog with the sealer. The miniature should now be as smooth as glass and ready for varnishing. Dust it again with a fresh tack cloth and carefully examine all surfaces. If you find a flaw, repeat the last few steps. Do not look for shortcuts now, you have spent too many hours on your miniature.

VARNISHING

The next operation is vital to obtaining a good finish. The area in which you spray or brush the *varnish* must be absolutely dust free. This means cleaning the area thoroughly and wet-mopping the floor. Clean anything that could allow dust or lint to settle on the wet varnish. Your clothes, too, should be clean and lint free. The

123. How to fold sandpaper sheets.

124. Sanding small pieces.

125. Using a tack cloth to remove dust.

ideal place is the bathroom. Run the hot-water shower for a few minutes until the room fills with steam, let the steam settle, as it does it cleans the air. Another must is maintaining a temperature above 75°. Varnish sprayed when it is cold will dry to a pebbled rather than a smooth finish.

Assuming you have accomplished the above, stir the varnish thoroughly, never shake it. Shaking causes bubbles that are difficult to brush out. Buy the best red sable brush you can get your hands on. Properly cleaned and cared for, it will last for many years. Do not overlook the importance of a quality brush. It is impossible to obtain a professional finish with a cheap brush that leaves streaks or loses bristles. Do not use a brush that is too small for the area you are covering. A ¼″ sable for small areas and a ½″ to ¾″ sable for the large areas will do nicely.

126. Applying varnish.

Dip the bristles of your brush only halfway into the varnish. Never let the medium get into the ferrule of the brush, for it will be impossible to clean out, and when it hardens it will drop into the finish. Start in the middle of a flat area and brush in one direction toward the edges. Brushing back and forth in two directions will dull the finish. Overlap your strokes slightly so they will flow together. If you later find you have missed a spot, *do not* go back to it, you will only make a mess of the now-tacky older surface. Any misses can be covered on the next coat. Remember to varnish every surface on the piece. If you leave an area unvarnished, it will attract moisture, which will cause it to warp.

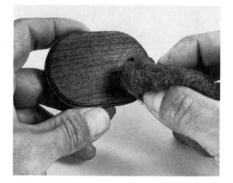

127. Using steel wool to smooth a varnished surface.

Now comes the true test of your patience. Put the varnished piece aside and leave it alone until it has thoroughly dried. This means not even peeking at it for at least two days. *It must be thoroughly dry* before you proceed to the next step.

When the varnish is dry, sand the piece lightly with 600 wet-dry paper or rub it lightly with fine steel wool.

Do not sand too heavily along the edges or in the corners. You can easily cut through to the raw wood with just the slightest pressure. When you have removed the gloss from the entire piece, clean off all dust and lint with a tack cloth. Do not leave sticky fingerprints where you have held the piece in your hand, they will not varnish out. When it is perfectly clean, apply a second coat in the same manner as just described and let it dry for at least two days. On most pieces two coats will be all that are necessary. If you feel there are areas that still need work, sand the piece lightly again, use the tack cloth, and apply a third coat. Remember the longer you let the varnish dry between coats, the better the finish will be. A week would be ideal.

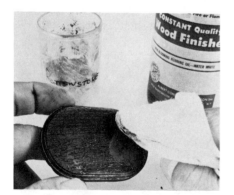

128. Smoothing a varnished surface with rottenstone and rubbing oil.

When the final coat of varnish is dry, wrap a soft rag around your index finger and lightly rub the entire piece with rottenstone powder and nonblooming rubbing oil. This will produce a beautiful sheen. When you are sure all areas have been rubbed equally, use a clean rag and remove all traces of the oil and powder from the sur-

face. The final step is to apply a paste wax, such as Goddard's or any brand containing carnauba wax. Let it dry slightly, then buff with a scrap of cotton flannel or muslin buffing wheel attached to a flexible shaft. Be very careful when buffing that you do not allow the rag to catch on a leg or finial and break it off. You should now have a finish that will last for generations to come. It will have taken some time and elbow grease, but the finish will be as beautiful as your cabinetwork and will make your miniature a treasure you can be proud of.

Before continuing, let me emphasize two points. Do not buy cheap varnish or cheap varnish brushes. Buy the highest grade of both you can find, the cost will be slight compared to the workability and longevity they will give you. Store the varnish in the original can placed upside down on the shelf; this keeps air out of the container. Clean your brush properly in thinner, followed by soap and water, until all traces of the varnish are removed and it lathers easily.

Until now, I have only discussed brushing the varnish on. Another method used by most professionals is a spray or airbrush finish. A sprayed finish is superior to a brushed one. It is easier to apply uniformly, and it is quicker. One drawback is the expense of the spray gun and the compressor. Two others are adjusting the viscosity of the varnish so that it sprays evenly and applying too heavy a coat in tight areas. Each of these disadvantages can be mastered with time. When you have mastered the art, the resulting finish is unbelievably smooth and beautiful.

I use an airbrush that is capable of spraying all media. It can be adjusted to cover a wide area or a tiny dot. Almost all finishes must be reduced with thinner to spray properly, and several very thin coats are a must. Be sure the area is dust free and the temperature above 75°. When working with spray equipment of any kind, wear a face mask and have plenty of ventilation. Proper ventilation is important when working with any of the finishes mentioned in this book.

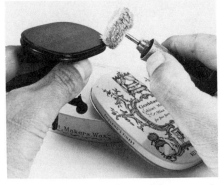

129. Polishing a surface with wax and a buffing wheel.

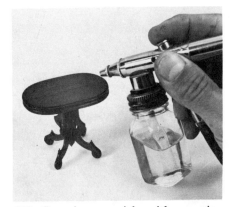

130. Spraying varnish with an airbrush.

SHELLACKING

Another popular finish, which is versatile, easy to apply, and dries very rapidly, is *shellac*. Shellac's natural gloss can be cut down by steel wool or rubbing compounds, such as pumice stone or rottenstone used with the nonblooming oil mentioned above. A high gloss can be obtained by applying a coat of paste wax. A disadvantage of shellac is its relatively short shelf life. If it is over six months old, it may not dry properly; for this reason it should be bought in small quantities. High humidity will also affect shellac, causing it to cloud over as it dries. Never use shellac straight from the can; thin it with denatured alcohol, up to a ratio of 7:1 for wash coats. The application of shellac is the same as that just described for varnish.

STAINING

Varnish or shellac alone give a natural finish, occasionally, however, wood must be stained to obtain the color we desire.

I use two types of *stain*, an oil-base wiping stain and a penetrating stain that does not raise the grain. The oil-base wiping stain is brushed or wiped on the furniture with a rag, allowed to set for a few minutes, then wiped off. The longer you let it set, the darker the finish. Do not do too large an area or it will dry and you will have a mess on your hands. Wiping stains are made by many companies and are available from most paint stores. I make my own from Japan colors, turpentine, linseed oil, varnish, and japan drier. The penetrating type is made by Albert Constantine, and as the name implies, penetrates the wood without raising the grain. This feature is very desirable but you must be careful to test the color on a scrap or inconspicuous area before starting to stain. Once this stain is applied there is no removing it, and it has a tendency to be very dark, especially on a nonsealed end grain. It can be reduced with a special thinner, but cannot be mixed with other types of stain. I must warn you again to test it or any finish on a scrap first. Once the stain has dried for two days or more, it can be varnished over as described above.

Some woods such as oak, mahogany, and walnut have a very porous grain and must be filled with a paste wood filler prior to finishing. The filler should be tinted with Japan color and thinned down slightly with turpentine. Again, Albert Constantine carries everything you will need. The color should be slightly darker than the color of the stain, as it will lighten as it dries. After the piece of furniture has been stained and the stain has thoroughly dried, mix the filler to the consistency of thick cream. You will want it thinner for small pores, thicker for large pores. Mix only as much as you can use at one time. Apply the mixture with an old stubby paintbrush or coarse rag, working it well into the pores of the wood both with and across the grain. After the gloss has disappeared, in about ten to twenty minutes, wipe all the surplus from the entire surface. Finish with a softer cloth going with the grain of the wood. When every pore is filled, let the piece dry for two days. If some pits still show, a second coat is needed, repeat the above thinning of the filler down to accommodate the smaller pores.

When the paste filler is completely dry, seal it in with a wash coat mixed in a ratio of 1:4 of shellac and denatured alcohol and proceed to finish the piece as described above. Occasionally, a piece of wood will have very small pores, in which case a coat of shellac mixed 1:1 with denatured alcohol may be all the filler you will need. Let the finish dry, then sand the piece down to the bare wood. Special care is necessary when finishing pieces that have light wood inlays, such as the Pembroke table. On these pieces the mahogany must be stained and filled, but the satinwood banding and the bellflowers must remain light. To preserve their color, carefully coat the lighter wood with shellac prior to finishing the base wood. It will

131. Applying paste wood filler.

132. Removing paste wood filler with a coarse rag.

still be necessary even with this protective coat to dodge the inlaid areas as you stain and fill the mahogany to protect the hours invested in the delicate designs. Once the darker wood has been finished and has been allowed to dry for at least three days, the entire piece can be varnished as previously described.

GOLD-LEAFING

A last area I should like to touch on before we begin work on the projects is *gold-leafing.* Somehow, whenever I mention this finish, it conjures up King Tut and the wealth of nations. This is just not the case. The twenty-four-karat gold leaf required to do the edgings on the mirrors in this book will not cost over a few dollars, and the application of the gold is not that complicated. Assuming that you have prepared the surface in the same manner as you would an area to be stained, the section to be gold-leafed must be painted. Gold leaf is pure gold that has been hammered so unbelievably thin that the slightest breath will cause it to crumple into a tiny worthless ball. Gold leaf comes in books of twenty-five 4″-square sheets, which are either loose or lightly stuck to a paper backing. I suggest you buy the lightly stuck sheets because they are much easier to handle.

Because gold leaf is so incredibly thin it reflects the surface under it. Therefore, it is necessary to underpaint the area you intend to leaf. A red undercoat will give an Oriental feel and yellow or white will magnify the gold itself. I like to use a bright red, but it is a matter of personal choice. Once the enamel has dried, the paint is covered with a gold size, a form of varnish. Synthetic size is fine for our purpose and dries to the necessary tackiness in about an hour, depending on the humidity. Be careful to paint on the size only where you want to place the gold leaf and make sure it does not creep away from the edges. If it does, recoat that area immediately. When the size is dry to the touch, you are ready to apply the gold leaf. Remove one of the sheets of gold from the book and place it facedown on the size. Using a soft brush, tap the gold into the size and lift up the paper. If the size has dried to the proper tack, only the gold will stick. Continue this process until you have covered the entire area, then set the piece aside for two days to allow the size to dry thoroughly. Do not varnish or wax the finished gold leaf, it will never tarnish and loses much of its sparkle when covered.

In concluding these chapters on the general construction and finishing of your miniatures, let me again emphasize the need to practice. The projects that follow are listed within each furniture period from simple pieces to very elaborate, difficult ones. Try the simpler ones at the beginning of each period first and slowly progress to such masterpieces as the Philadelphia highboy.

133. Gold-leaf sheets, size, and sable brushes.

134. Lifting loose gold leaf with a brush; notice how the slightest movement crumples the very thin leaf.

PILGRIM PROJECTS
1660-1720

· 7 ·

Joint Stool

Joint Stool

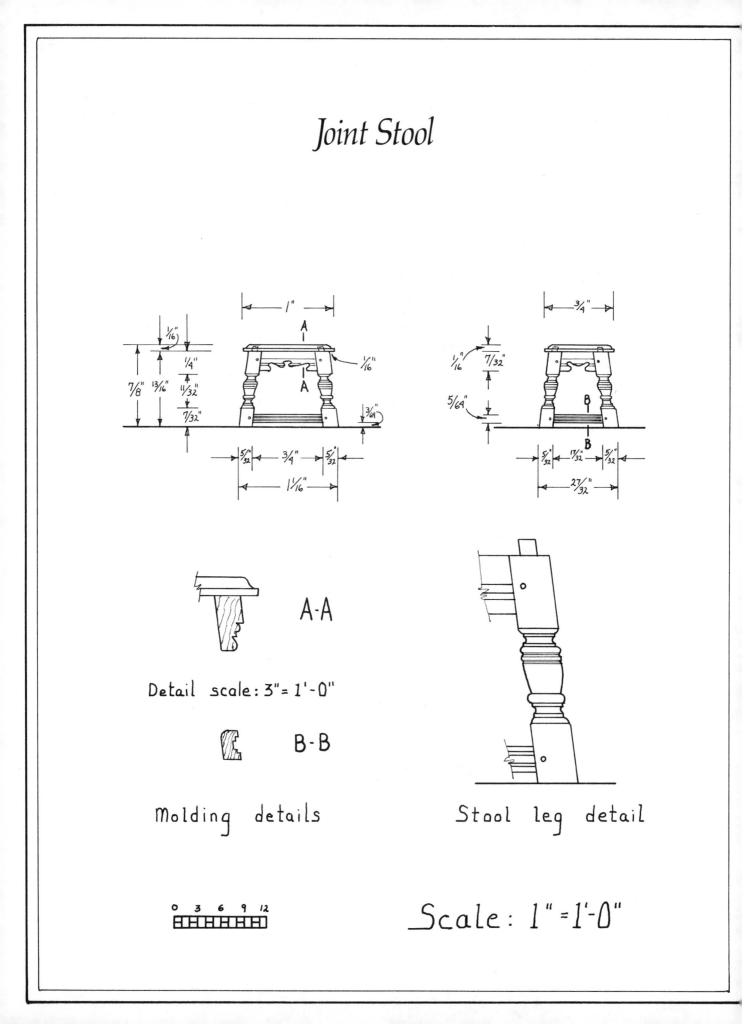

A-A

Detail scale: 3" = 1'-0"

B-B

Molding details

Stool leg detail

0 3 6 9 12

Scale: 1" = 1'-0"

MATERIALS LIST			
oak	*thickness*	*width*	*length*
4 legs	5/32″	5/32″	1½″
1 top	1/16″	3/4″	1″
4 upper stretchers	3/32″	1/4″	6″
4 lower stretchers	1/16″	5/64″	6″

The main construction of the joint stool consists of four turned legs held together by eight carved stretchers in sixteen mortise-and-tenon joints (fig. 136).

The first task is to cut the rough stock for the legs and the upper and lower stretchers. The stretchers must be cut to the correct width and thickness to ensure the proper size mortises in the legs. Do not cut the stretchers to their finished length, however, until the molding designs have been completed. It is easier to cut one long piece of molding than several shorter pieces. Begin by cutting two strips of walnut, oak, or cherry, whichever wood you have chosen for the stool. One strip must be 1/4″ wide, the other strip 5/64″ wide. Each piece should be at least 6″ long. These two pieces will later become the eight stretchers.

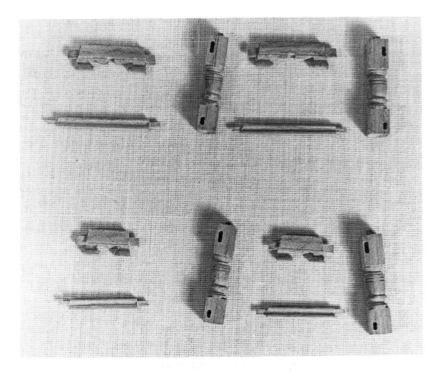

136. All the pieces needed.

With the side stretchers cut, we can concentrate on the four legs. Cut six pieces of stock 5/32″ square and 1½″ long. The extra length is necessary to chuck the stock into the lathe. You will notice I am recommending that you cut six legs, this will give you two extra pieces

to use for setting up the different cuts or in case you have a problem with the turnings. I much prefer having a few extra pieces than having to set up an entire set of operations a second time and hope they match the first.

Using the plans as a guide, mark the square and round areas of the leg on one of the pieces of leg stock. See the top piece in figure 137. When the first piece is marked correctly, lay it alongside the other legs and mark them at the same locations using a pencil and a square as shown on the gateleg table in chapter 10, figure 193, page 97.

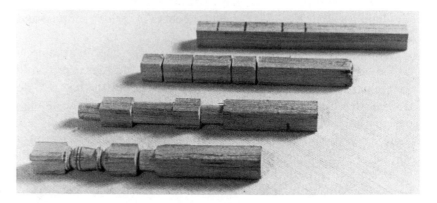

137. Four stages in making the legs.

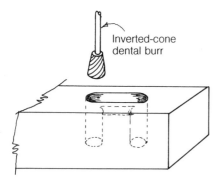

138. Cutting the mortise into the leg.

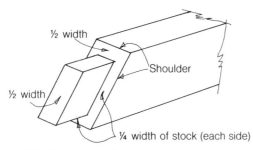

139. Tenon on the stretcher.

You are now ready to cut the mortises in the rough leg stock. Set up your drill press as shown for the press cupboard in chapter 11, figure 209, page 107.

To cut the mortise, push the leg stock against the fence and the left stopblock and slowly drill down the depth of the mortise (usually ⅔ the thickness of the stock) with an inverted-cone dental burr (fig. 138). Raise the burr out of the stock, move the stock against the right stopblock and drill a second hole. You should now have two holes at each end of the mortise. Now the wood between the two holes must be removed, by slowly lowering the burr a bit at a time and pushing the stock back and forth along the fence between the two stopblocks.

After making a test cut, check the mortise against a piece of the rough-cut stretcher. Remember, the tenon must be considerably smaller than the rough stock (fig. 139). If it looks correct, cut the mortises in the rest of the legs. If not, reset the fence or the stopblocks and test-cut again. You can see why a few extra pieces are handy to have while you are setting up the different cuts. Continue this procedure until you have cut every mortise in the adjacent sides of each leg.

You are now ready to turn the legs (see plans, leg detail). Figure 137 illustrates the four different stages in turning the joint stool leg. After you have scored each of the pencil lines with a parting chisel, turn the areas that are to be round with a square chisel, followed by a flat file. When you have removed the last turning from the lathe, use the plans to mark the different parts of the turned design on one

of the roughed-out legs. Place all of the legs together, then with the aid of a square continue these lines to the other legs (see chap. 10, fig. 194, p. 97).

Most of the turnings on the joint stool leg are cut with a small, square lathe knife as shown in figure 140. The two half-round areas on either end can be done with a small round file as shown in figure 141. The turnings are finished with 150 grit and then 220 grit aluminum oxide open-coat sandpaper.

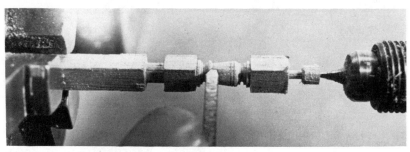

140. Leg on the lathe with a knife.

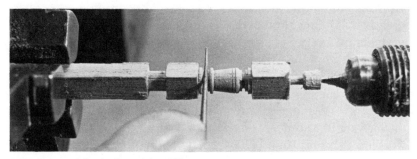

141. Leg on the lathe with a file.

When the legs are completed, you can proceed to the stretchers. To cut the molding on the stretcher stock set up the drill as described in chapter 4, pages 35 and 36. Both the top and the bottom molding are cut with both inverted-cone and round dental burrs (see plans, details A-A and B-B, and fig. 142).

After the moldings have been cut and cleaned with riffler files, the stock can be cut to size and the tenons cut on either end. As I mentioned earlier, use the plans for the exact measurements of the stretchers. Be sure to add ³⁄₃₂″ to each end for the tenons. Set the circular saw, or if you are cutting the tenons by hand, your bevel gauge, to 7° and cut the 6″ boards you have just shaped to the proper lengths. Cut one extra piece of each to use as a test piece.

When the pieces have been cut, set up the shaper with a square burr to cut the tenons.

Figure 143 illustrates the use of a guideboard on the shaper, which has been cut to the same 7° angle as the ends of the stretchers. (The square is placed in the illustration merely to indicate the angle of the guideboard.) The cutter is raised to one-quarter the thickness of the stock (approximately ¹⁄₆₄″), and a cut is made on either side of

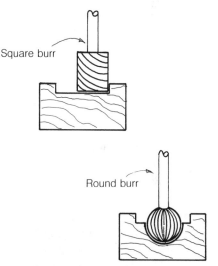

Square burr

Round burr

142. Shaping the stretcher.

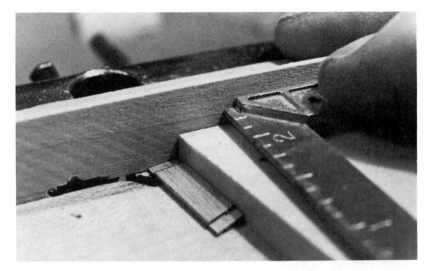

143. Cutting the tenon on a shaper.

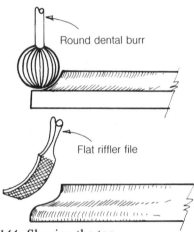

144. Shaping the top.

145. Drilling holes in the top for the leg pins.

the board. Refer again to figure 139. When all of the side cuts have been made, the bottom (the longest edge of the board) of the tenon can be cut using the same fence setting but raising the cutter to make a ½²″ cut. To cut the top of the tenon, the fence must be moved back slightly so all four shoulders will be flush. The tenons on the lower stretchers are very tiny; be careful not to break them off in handling or while assembling the stool.

When all the tenons are complete, dry-fit the stool carcass to check how each piece fits. Next, jigsaw out the design on the upper stretchers. Clean the jigsaw work with files and sandpaper. When the legs and the stretchers have been completed, the majority of the work on the joint stool is finished. The top of the stool is cut from ½₆″ stock and the edge is shaped on the shaper or drill press as shown in figure 144. Cut the top curve with a round dental burr and round the lower curve with a flat riffler file. Finish the top with sandpaper, being careful not to lose the sharp edges.

Place the top on the dry-fitted carcass and indicate the location of the pegs on the underside of the top with a pencil.

You will note the pegs go into the top at an angle. This angle presents two problems: drilling the holes and making the top of the legs fit flush against the top of the stool. To drill the holes at the proper angle, cut a piece of scrap board at a 7° angle and place it on the drill table under the stool top. This slanted drill table will allow you to drill the necessary angled holes (fig. 145). Use a drill bit slightly smaller than the pins on the end of the legs and set the stop on the table so you do not drill completely through the top. Note how the top is held on the drill in figure 145.

When the legs are turned on the lathe, the shoulders are perpendicular, or 90°, to the sides. Before the piece can be fully assembled, the top of the legs must be cut at an 83° angle so they will butt against the top of the stool (fig. 146). An X-acto knife with a #11 blade can be used to remove the excess (the darkened area in the sketch). Be careful not to cut off the peg.

Once again dry-fit the entire stool to be sure everything fits properly. *Now* is the time to discover an error—*not* after you have the piece glued. If everything is perfect, glue the stool together. Work quickly so you can level the legs on the table and square them to each other before the glue dries. Be sure the top is pushed down snugly against the shoulders of the legs.

After the glue is dry, mark each of the sixteen peg locations with an awl. Set up the drill press with a #67 drill bit and drill each of the peg holes ³⁄₆₄″ in from the inside edge of the leg. Now, sixteen ¼″-long pegs, ¹⁄₃₂″ in diameter, must be turned on the lathe. When turning tiny pieces such as these pegs, begin with stock that is considerably larger than the finished work, in this case ⅛″ or even ³⁄₁₆″ in diameter. Chuck the stock in the lathe so that only ⅜″ protrudes beyond the three-jaw chuck. Turn the end of the dowel farthest from the chuck to ¹⁄₃₂″ diameter. File and completely sand this area before beginning work on the stock closer to the chuck. When the end of the stock is ¹⁄₃₂″ in diameter, turn another small area in the middle of the protruding ⅜″ and finish it. Finally, the balance of the ⅜″ can be completed. Move another ⅜″ of uncut stock out of the chuck and repeat the operation. Continue this procedure until you have completed 1″ or so, then cut off the ¹⁄₃₂″ dowel you have made and start again (fig. 147).

To peg the joints, roll the end of the dowel in glue, then quickly force it into the hole. Leave some of the peg protruding on either side of the leg. When the glue is dry, cut each dowel flush with the leg using a razor-sharp knife (fig. 148). Leave just a bit of the peg showing above the surface of the leg.

Your joint stool is now ready to finish. If you have made the piece out of oak or walnut, use a wiping stain, seal the wood, and fill the grain with a matching paste wood filler. If you have used cherry, apply a natural finish as described in chapter 6, pages 59 to 61. The completed joint stool will be a perfect companion to the spindle chair detailed in chapter 9.

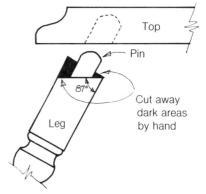

146. Cutting the leg to fit against the top.

147. Detail of turning ¹⁄₃₂″ pegs on the lathe.

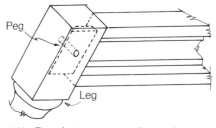

148. Pegging a mortise-and-tenon joint.

149. Finished paneled cradle.

· 8 ·

Paneled Cradle

Paneled Cradle

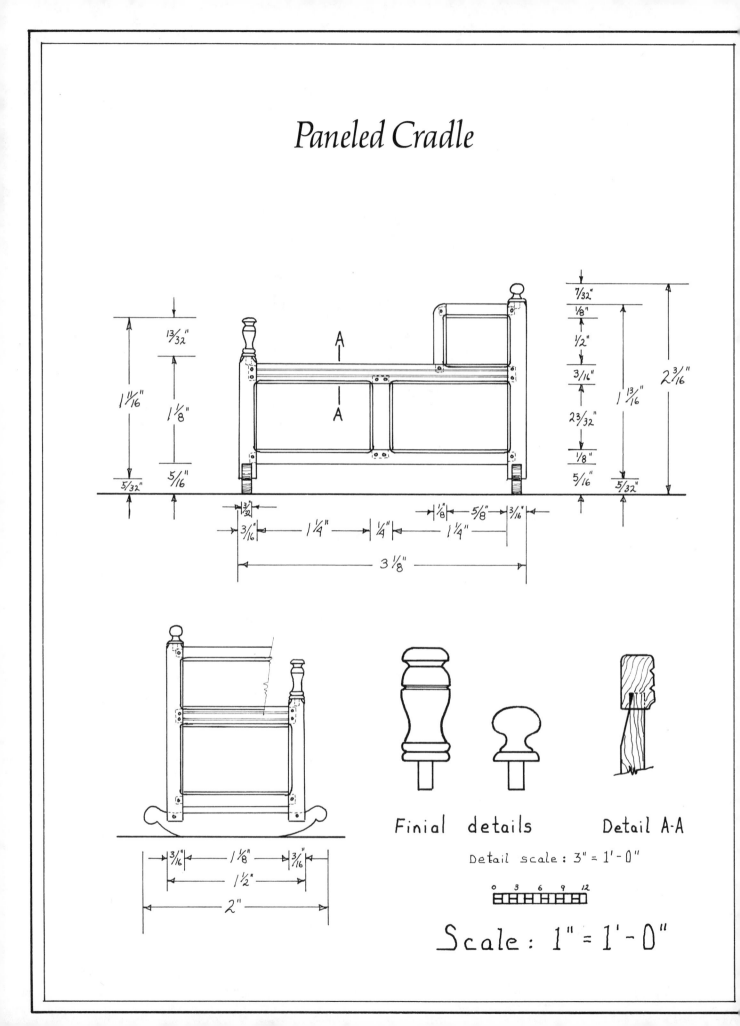

Finial details

Detail A-A

Detail scale: 3" = 1'-0"

Scale: 1" = 1'-0"

MATERIALS LIST			
oak and pine	*thickness*	*width*	*length*
4 legs	³⁄₁₆″	³⁄₁₆″	3″
2 upper side rails	⅛″	³⁄₁₆″	3″
2 lower side rails	⅛″	⅛″	3″
2 upper front and rear rails	⅛″	³⁄₁₆″	1⅝″
2 lower front and rear rails	⅛″	⅛″	1⅝″
1 top front rail	⅛″	⅛″	1⅝″
2 side center stiles	⅛″	¼″	²⁹⁄₃₂″
2 top side stiles	⅛″	⅛″	¹¹⁄₁₆″
2 top side rails	⅛″	⅛″	¹³⁄₁₆″
pine			
2 front and back panels	³⁄₃₂″	²⁷⁄₃₂″	1¼″
4 lower side panels	³⁄₃₂″	²⁷⁄₃₂″	1⅜″
2 upper side panels	³⁄₃₂″	¾″	⅝″
1 upper back panel	³⁄₃₂″	⅝″	1¼″
2 rockers	³⁄₃₂″	⅜″	2¼″

The extensions at the head of this pine-paneled oak cradle were to keep drafts from the infant. The large turnings on the posts at the foot and the gracefully scrolled rockers were used to rock the infant to sleep either by hand or by foot. The cradle has nine chamfered panels and is held together by thirty-two pegged joints. Each of the four posts has several mortises and a blind groove that are cut in adjoining sides. Figure 150 illustrates the work that lies ahead. Do

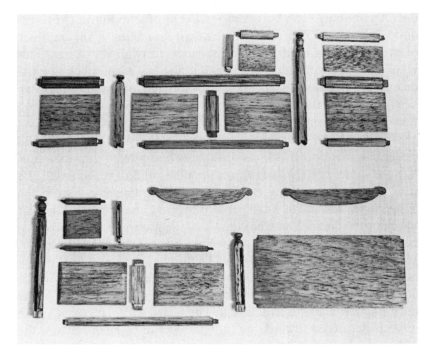

150. All the pieces needed.

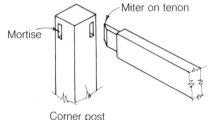
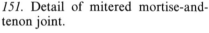

Mortise

Miter on tenon

Corner post

151. Detail of mitered mortise-and-tenon joint.

Sides

Corner post

152. Detail of mitered mortise-and-tenon joint.

153. Cutter used for a groove.

not despair, however; once you have learned to cut the mortise-and-tenon joint, this piece will go together quite nicely.

To begin with, cut the rough lumber as shown on the materials list and the plans. You will need three thicknesses of lumber: ³⁄₁₆″ square oak stock for the corner posts, ⅛″ oak stock for the carcass, and ³⁄₃₂″ pine stock for the nine panels.

Remember, each tenon on either end of the stretchers is ¹⁄₁₆″ long. The measurements shown on the materials list allow for the tenons.

If you are in doubt about how a mortise-and-tenon joint is constructed, review that section in chapter 4, pages 41 to 43, and make several practice joints. Keep trying until the operations involved become almost automatic.

When you are confident of making accurate mortise-and-tenon joints, you can begin the construction of the cradle. The four corner posts will be worked on first. Carefully mark the location of each mortise on the posts and rails, using the plans as a guide. The mortises on the corner posts must be cut near the outside edge to keep the posts and the side rails flush (fig. 151). An inverted-cone dental burr is used in a drill press for cutting the mortise. The placement and size of the mortise must be marked on the stock. Use the plans to mark the location of each joint. Drill to the depth of the tenon at both ends of the proposed opening, then move the stock back and forth against the fence, lowering the cutter a bit at a time until the entire mortise is completed.

All of the tenons on this cradle are ¹⁄₁₆″ long, this means the distance between the shoulders of the tenons will be ⅛″ shorter than the overall measurements. The ends of the tenons that go into the corner posts must be mitered at a 45° angle to butt together inside the post (fig. 152). The tenons are cut on a shaper using a heavy-duty square burr. The burr is raised to cut off one-fourth the thickness of the stock. This cut is made on all four sides. A square block of scrap wood is used to push the stock through the cutter. This block not only works as a push stick it also keeps the stock perpendicular to the fence. When all of the mortise-and-tenon joints have been cut, dry-fit the carcass together and check to make sure that all four legs sit flat on the floor and the carcass is square.

The finials on both the front and rear legs can either be turned directly on the post or turned separately and pinned into the posts. Use the detail sketches shown on the plans and turn the finials. Be sure to sand the turning completely before removing it from the lathe. When the finials have been completed, the grooves that hold the chamfered panels can be cut. All of the grooves are cut in one of two ways. Figure 153 shows one setup using the drill press to cut the grooves. The small saw blade can be purchased from a dental-supply house or a hobby shop. Note that the drill fence is set to the depth of the groove, and the lines on the fence on either side of the burr indicate where to end the cut. The board with the groove cut in it has been turned toward you in figure 153 so you can see how the

lines on the fence indicate where to start and stop the cut. The right side of the board is lined up with the line on the right side of the burr. This illustrates how a blind groove is cut.

A second method for cutting grooves is shown in figure 154. Here the shank of the cutter controls the depth. The lines on the table indicate where the groove starts and stops.

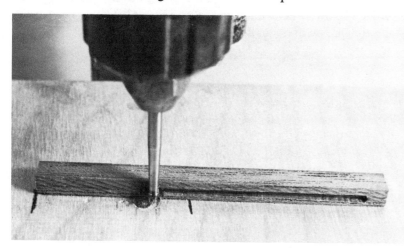

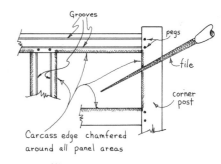

155. Filing the chamfer around the panels.

154. Cutting the post groove.

Once all of the grooves have been cut, the carcass of the cradle can be dry-fitted together again to mark the size of the pine panels. The panels should be 1/32″ larger on all four sides than the finished opening. If they are too large, cut them down to fit. If they are too small, cut new panels. Before you disassemble the cradle, the outer edge of each opening must be slightly chamfered with a file (see the shaded area, fig. 155; see also the enlargement of the pieces, fig. 156). It is rather difficult to hold the pieces together without any glue while you file the edges, but if you are careful it can be done. This is no time to rush.

Figure 157 illustrates how the chamfers are sanded on the

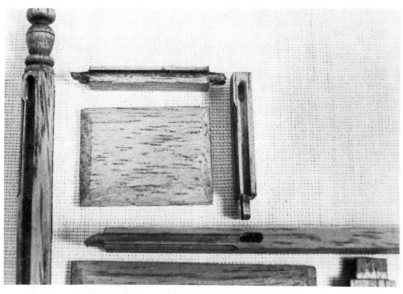

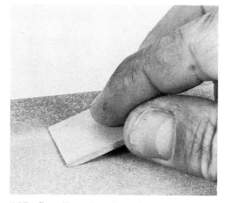

157. Sanding the chamfer.

156. Detail of the chamfer on the panel.

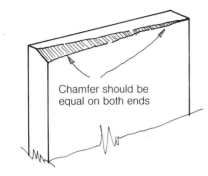

158. Incorrect chamfer.

panels. Be careful to hold the board at the same angle each time you pull it across the sandpaper. Apply pressure evenly to the edge of the board to cut the same amount off the entire length (fig. 158).

Before we can begin the final assembly there are three more series of cuts to make. The first are the decorative grooves on the 3⁄16″ upper rails. The plans and figure 155 show the location of the grooves. Figure 159 illustrates the setup necessary to cut the grooves. Make the cuts with a small, cone-shaped dental burr.

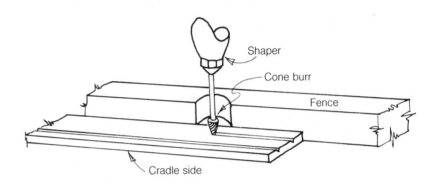

159. Cutting a decorative groove in the side.

The second series of cuts are the grooves needed to set the bottom into the lower rails. As you will notice at the lower right of figure 150, the bottom must first be chamfered in the same manner as the panels and then small notches taken out of each corner to go around the legs. Before cutting these notches, the groove for the bottom must be cut in the lower rails (fig. 160). This groove should be 1⁄32″ deep. Set up a small, inverted-cone dental burr in the drill press and cut all four bottom rails, two short and two long. Now assemble these pieces into the legs. Mark where the matching grooves cut should be made on the inside corner of each leg.

160. Groove in the side for the bottom

Carefully cut this groove by hand with a #11 X-acto or scalpel knife. Notice that in figures 160 and 161 this groove is not cut all the way across the post. It runs from the vertical-panel groove to the inside edge. When all of the cuts are completed, assemble the lower portion of the cradle and cut out the corners of the cradle bottom until they fit snugly into the entire grooved system.

The final series of cuts are the dadoes across the bottom of the legs that hold the runners. These are best cut by hand with a Zona saw after you have jigsawed out the runners. The runner should fit snugly. A small square file will help make the dadoes the proper size and flat on the bottom. Be sure you cut the dadoes going in the proper direction (see fig. 161).

161. Post and bottom.

The cradle can now be glued together. Remember the left and right sides of the posts and rails are different because of the grooves, mortises, and chamfers. If you are in doubt, reassemble the entire cradle and mark the direction of each piece.

I suggest that the carcass be final sanded and stained before assembly. When a piece has so many small areas to glue all at the same time, it is very difficult not to have extra glue drying somewhere on the work before you can get to it. If the wood is already stained, you will not have to worry so much about it.

First, glue the sides together. Make sure they are square and flat, then set them aside to dry. When the sides are dry, the entire cradle including the bottom must be glued together at one time. Before the glue sets, make sure all of the joints are snug, all four leg posts stand flat on the floor, and the piece is square.

When the glue has dried, the holes for the tiny pegs must be drilled. The $3/16''$ and wider boards require two pegs per joint. The $1/8''$-wide boards only one peg per joint. Use a #67 drill bit. When all of the holes have been drilled, the rockers can be glued on and their peg holes drilled.

I have described the method of turning the $1/32''$-diameter pegs in several other chapters (for example, fig. 147, p. 73).

When pegging the joints, be sure to leave enough of the peg above the surface of the wood to cause a slight bump. This bump will make the pegs show when the piece is restained, just the tiniest hair above the surface will do.

When all of the glue is dry, lightly sand the entire piece with 320 grit sandpaper and restain it. Let the stain be darker in the corners of the panels and where the pieces come together. This technique gives the cradle character and makes it look old and used. After all, a paneled Pilgrim cradle would be over 300 years old by now. You might also make wear marks on the rockers where years of rocking babies would have taken their toll.

162. Finished spindle chair.

· 9 ·

Spindle Chair

Spindle Chair

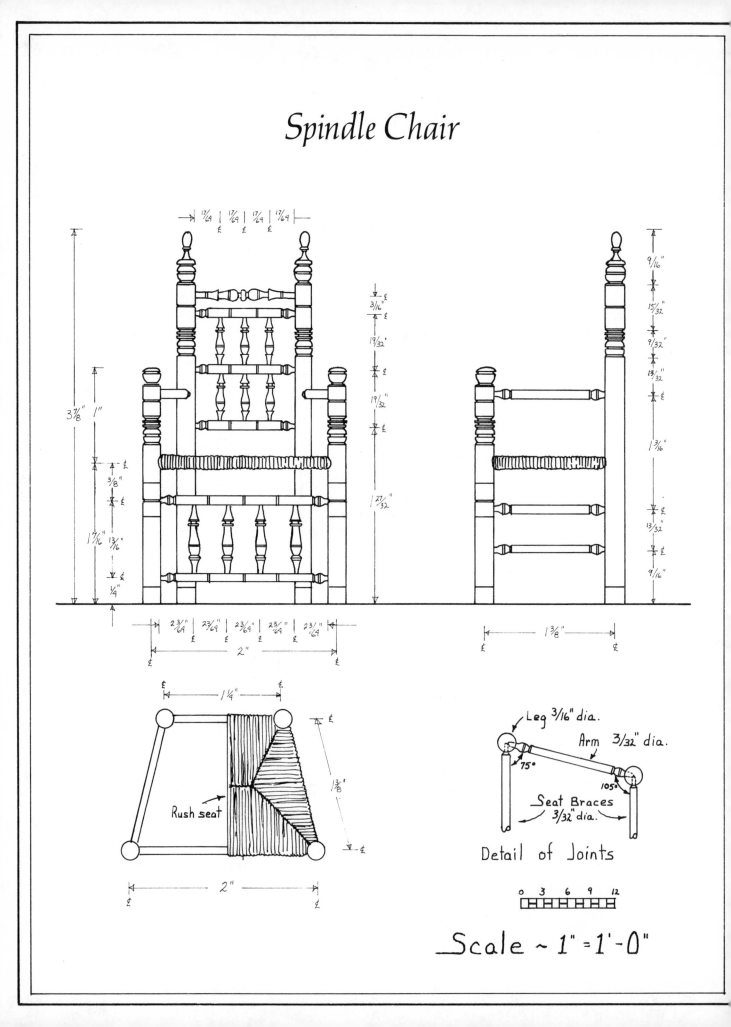

Rush seat

Leg 3/16" dia.

Arm 3/32" dia.

75°

105°

Seat Braces
3/32" dia.

Detail of Joints

0 3 6 9 12

Scale ~ 1" = 1'-0"

MATERIALS LIST		
birch or ash	*diameter*	*length*
2 rear leg posts	³⁄₁₆″ dowel	4⅝″
2 front leg posts	³⁄₁₆″ dowel	3¼″
6 rear stretchers	³⁄₃₂″ dowel	2″
3 front stretchers	³⁄₃₂″ dowel	2¾″
8 side stretchers	³⁄₃₂″ dowel	2⅛″
6 rear spindles	³⁄₃₂″ dowel	1¼″
4 front spindles	³⁄₃₂″ dowel	1½″

Note: Each of the measurements given includes approximately ¾″ extra length to hold the stock in the lathe.

The more I researched this delicately turned chair the more names I found for it. The common name is a Brewster chair, owing mostly to the spindles between the lower stretchers. The more generally accepted name for all types of turned chairs is a *spindle chair.*

The materials list for the spindle chair consists of only one 21″-

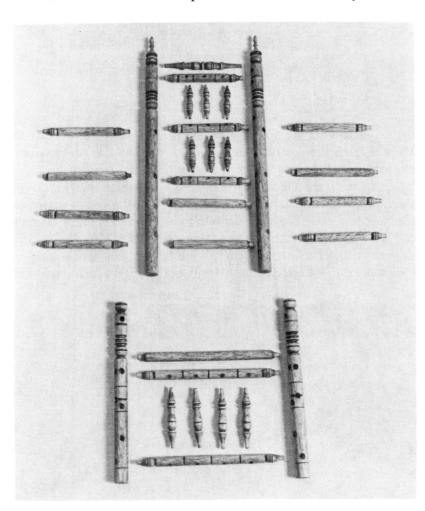

163. Parts unassembled.

long ³⁄₁₆″-diameter dowel and one 60″-long ³⁄₃₂″-diameter dowel. Birch dowels are readily available in 36″ lengths and can be purchased from most lumberyards or hobby shops. If you desire to make this piece from ash or maple, you will have to turn your own dowels on the lathe. The four posts or legs are made from the ³⁄₁₆″-diameter stock. The spindles and stretchers are turned from ³⁄₃₂″-diameter stock. Figure 163 illustrates the turnings involved.

Because all of the turnings in this chair are basically the same, the series of illustrations that follows applies to all of the turnings. Space does not permit the repetition of the steps for each design.

It has been my experience that the easiest way to get several pieces to look alike is to complete the first, a master, then mark the others from it. As each succeeding piece is turned, it is constantly matched against the master. This matching is done partially with rulers and caliper, but mostly by a visual comparison of the completed master against the piece being turned on the lathe. I shall use the lower spindles as an example (fig. 164). The first step is to mark

164. Detail of the lower spindle.

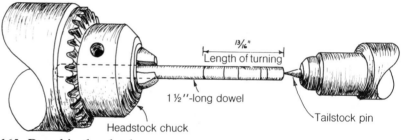

165. Dowel in the chuck.

the major cuts on the dowel using the plans as a guide. Be sure to allow enough room on the right end for the point of the tailstock and on the left end to chuck the stock into the headstock of the lathe. In this case the overall height is ¹³⁄₁₆″, therefore the dowel should be approximately 1½″ long (fig. 165). After the locations of the basic turnings have been marked, locate the center of the dowel's end with an awl for the tailstock dead center (fig. 166). Figure 167 shows the first cuts being made on the major lines with a parting tool. Notice how the tool is held firmly in the fingers and against the

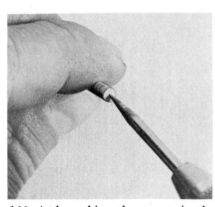

166. Awl marking the center in the end of the dowel.

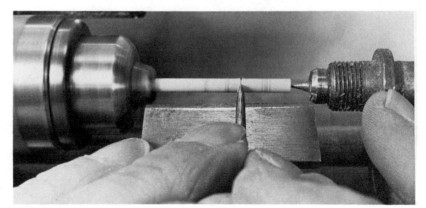

167. First cut on a turning with a parting tool.

tool rest. You can also see the other major lines to the left and right of the chisel.

Figure 168 illustrates the use of a small straight chisel to begin the design. Notice how all of the lines have been indicated with the parting tool.

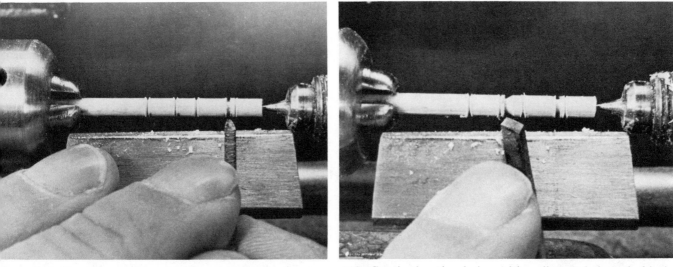

168. Roughing out areas with a straight chisel. 169. Continuing the design with a diamond-shaped chisel.

Figure 169 shows how a diamond-shaped chisel is used to begin cutting a curved area. Look again at figure 164 and at the lower spindles in figure 163 to get an idea of where you are going.

In figure 170 rough cuts are made with a round chisel. The bulb area in the center is beginning to take shape.

Figure 171 continues the use of the round chisel by turning down the two ends.

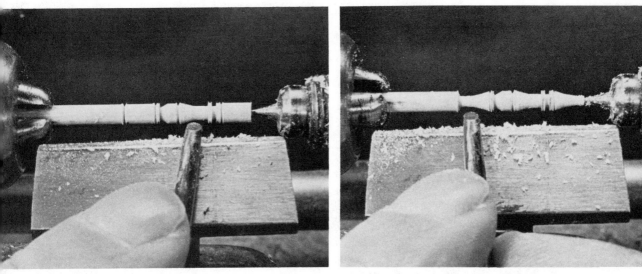

170. Using a round chisel. 171. Continuing with a round chisel.

Because the turnings are so small, it is very difficult to obtain all of the desired shapes with chisels alone. Figure 172 shows the use of a flat file to round over the lower portion of the bulb. Figure 173 illustrates the use of a half-round file to finish shaping the tapered ends. Be sure to use coarse enough files, beginning with a 0 cut and finishing with a 2 cut.

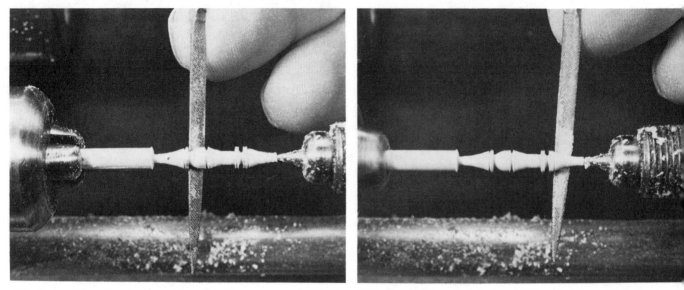

172. Smoothing the design with a flat file.

173. Smoothing the design with a half-round file.

A tiny triangular file is used in figure 174 to round over the small collar near the top of the turning. Figure 175 shows the use of 220 grit sandpaper. Sandpaper is used while the lathe is rotating to finish the turning.

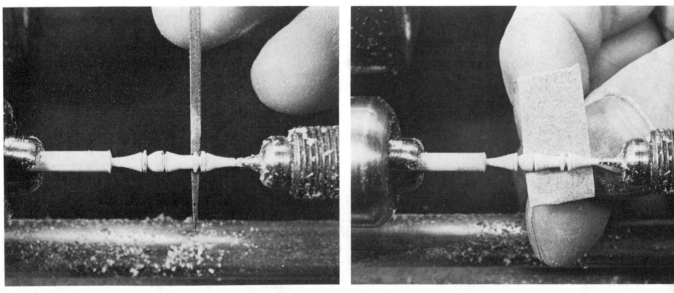

174. Smoothing the design with a triangular file.

175. Finishing the turning with sandpaper.

In figure 176 an outside bowspring caliper is used to make sure both ends are the same diameter as the holes into which they must fit.

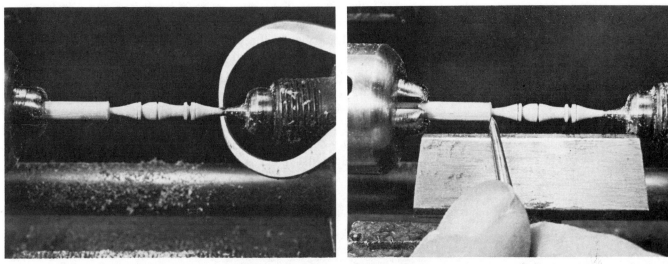

176. Checking the end diameter with a caliper.

177. Cutting the turning from the lathe with a parting tool.

The final step is to cut the turning free with a parting tool, as shown in figure 177. The above method is used on all of the turnings in this chair.

Figure 178, although of a different turning, illustrates how, after the original has been completed, a square is used to mark the design on the remaining dowels. You will notice I have held the dowels against two boards that are fastened at right angles to each other. I must stress that the more accurately you mark the succeeding dowels from the master, the more alike they will all look. As you repeat the steps shown in figures 165 through 177 on a new piece of stock, constantly check your work against the master to be sure they match. Train your eye to recognize slight differences in each turning. Keep your hand steady. Figures 179 and 180 will help you with the leg turnings.

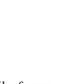

179. Detail of rear leg finial.

180. Detail of front leg.

178. Marking other spindles from the first turning.

Once all of the turnings have been completed, it is time to drill the appropriate holes for assembly. Use the plans as a guide and mark the center line of every hole on each leg and stretcher. Remember that the front of the chair is wider than the back; therefore, the holes for the side stretchers must be drilled at a different angle on the front post from the one on the back post. See the sketch in the lower-right corner of the plans. It should be noted that the angles indicated on the plans—that is, 75° at the front post and 105° at the back post—may vary with each chair and should be carefully checked with a protractor before the actual holes are drilled.

To hold the turnings while you drill the holes, glue two spare dowels of the same diameter as those you are drilling side by side on a piece of wood. This jig will hold the turned stock and slide back and forth against the drill fence (fig. 181).

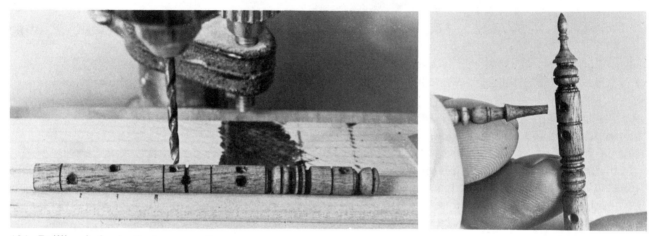

181. Drilling holes in the legs on a jig.

182. Assembling the chair.

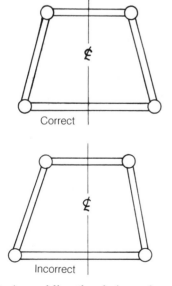

183. Assembling the chair on the center line.

After all the holes are drilled, again use the plans and figure 163 as a guide. Dry-fit the entire chair together. If done properly, the chair should stand freely without any glue.

When you are positive everything fits properly, glue the back assembly together and then the front assembly together (fig. 182). Make sure the finished assemblies lie flat on the table and are square (fig. 183). When the glue is dry, the side stretchers and arms can be glued in place. The chair carcass is now complete. Make sure the piece is balanced on its center line and sets squarely on the floor.

Let the glue dry for at least two days before you begin to finish the wood or weave the seat. If you desire the chair may be left the light, natural color of the wood, or it may be stained a darker color. In either case the finish must be fully dry before the seat can be started (see chap. 6, pp. 59–61).

The original seat for this type of chair was made of rush, but rush is very difficult to work with in this scale. One suggestion is to use a coarse-weave thread that has been dyed a rush color.

The biggest problem in weaving the seat is pulling the material

so tight that it begins to distort the chair and bow the stretchers. There must be a happy medium between leaving the seat material too loose and pulling it too tight.

Because the chair seat is not a perfect square, individual strands must be glued along the two side rails until a square area is obtained. Figures 184 and 185 illustrate the process of making the seat area square. Notice how each strand is glued to the inside of the left side stretcher, taken around the left front leg, across the front of the chair, around the right front leg, and then glued to the matching spot on the right side stretcher. Figures 186 and 187 show this process at a later stage. You can see how the open area of the chair will be a square by the time it reaches the back leg.

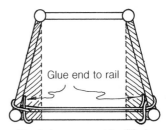

Shaded areas must be filled before material can be woven around all four legs

184. Detail of weaving the seat.

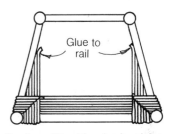

Continue filling triangles by gluing strips to side rails until square is formed in center

186. Detail of weaving the seat.

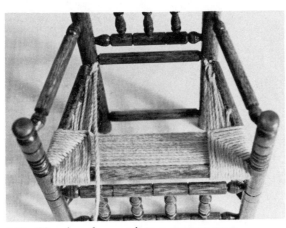

185. Weaving the seat into a square area.

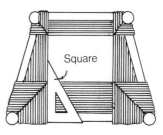

Use a square to keep the edges uniform and to push the weave together

188. Detail of weaving the seat.

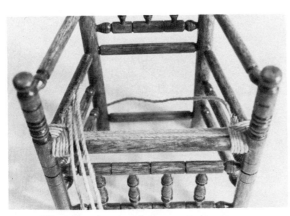

187. Weaving the seat into a square area.

Figure 184 illustrates the manner in which the thread is woven around each post to create the seat. Figure 188 illustrates how the weaving progresses around the rear legs. Notice how a square is used to keep the strands perpendicular to each other. As you weave, you will fill the side stretchers before the front and rear ones are filled. Figure 189 shows the figure-eight weave used to fill the center portion. When the seat is complete, tuck the end of the thread into the middle of the seat and glue it.

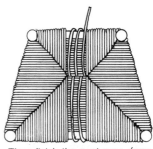

Then finish the seat area, form a figure eight around the front and rear stretchers

189. Detail of weaving the seat.

The finished seat can now be varnished lightly to help hold the strands in place. A clear spray varnish is very good.

You now have a Brewster, or spindle, chair. The joint stool (chap. 7) will make a perfect companion for this chair.

190. Finished gateleg table, open.

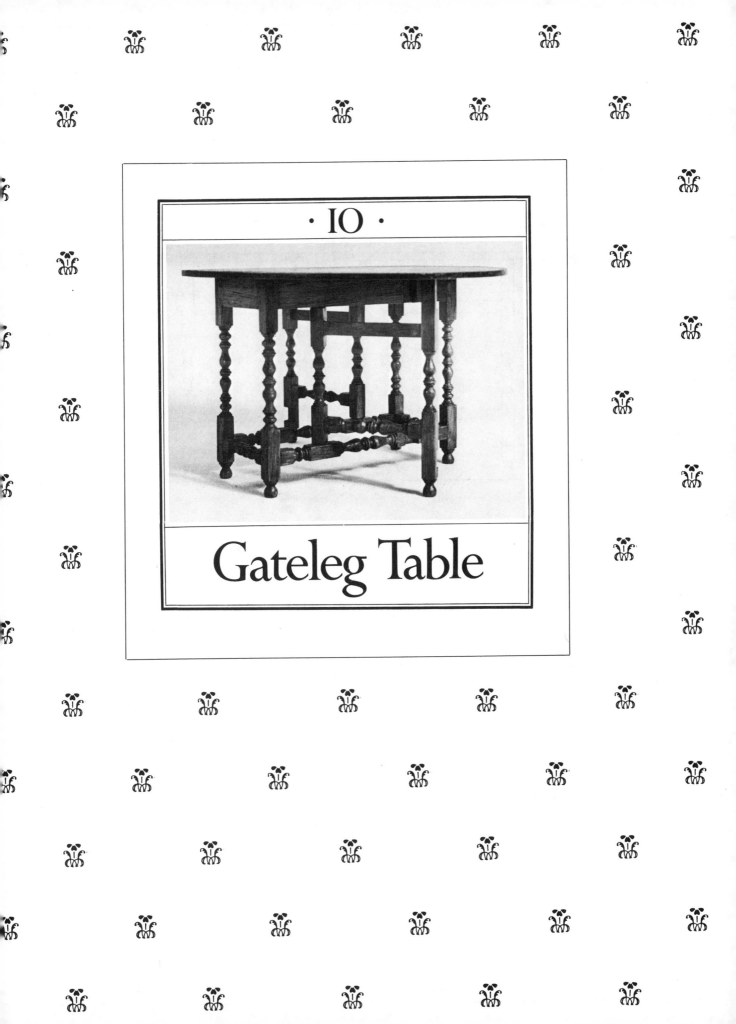

· IO ·

Gateleg Table

Gateleg Table

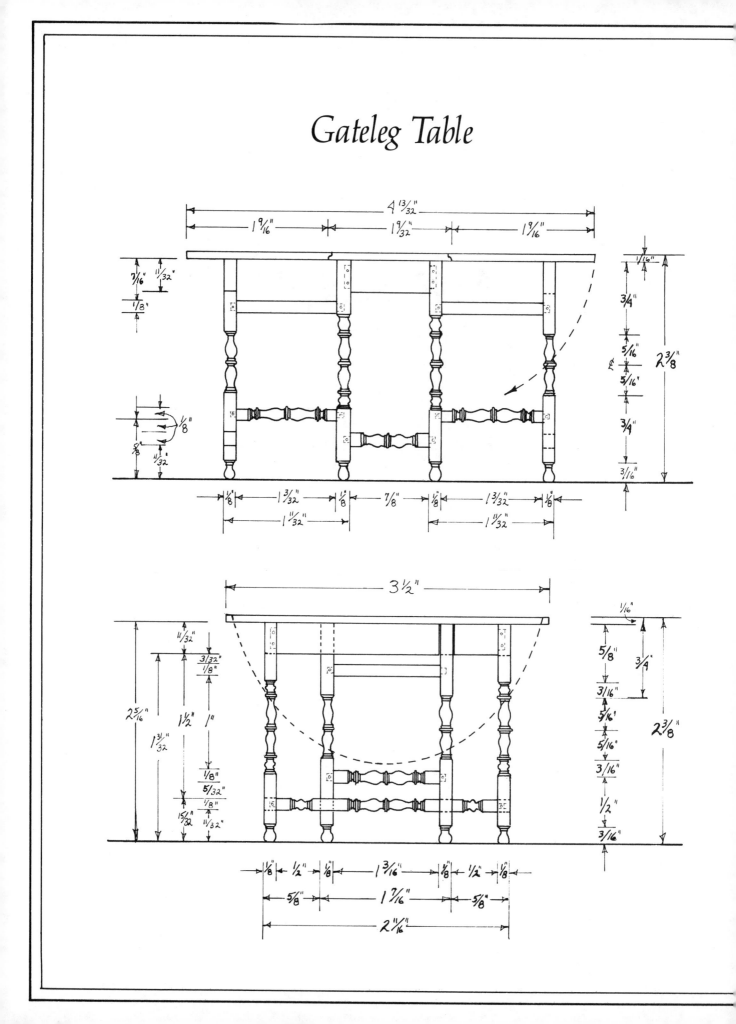

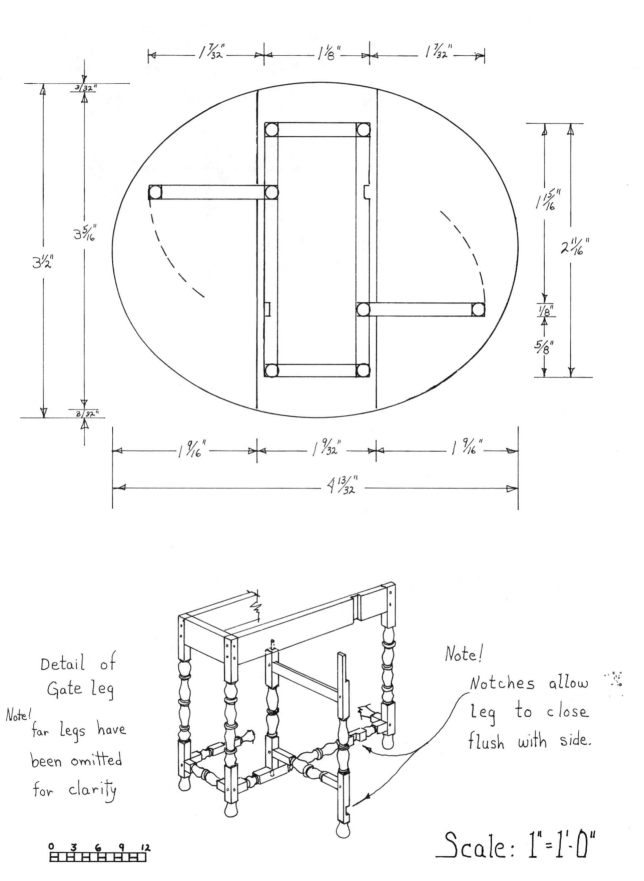

1 $\frac{7}{32}$" 1 $\frac{1}{8}$" 1 $\frac{7}{32}$"

$\frac{3}{32}$"

3 $\frac{5}{16}$"

3 $\frac{1}{2}$"

$\frac{3}{32}$"

1 $\frac{15}{16}$"

2 $\frac{11}{16}$"

$\frac{1}{8}$"

$\frac{5}{8}$"

1 $\frac{9}{16}$" 1 $\frac{9}{32}$" 1 $\frac{9}{16}$"

4 $\frac{13}{32}$"

Detail of
Gate leg

Note! far legs have
been omitted
for clarity

Note!
Notches allow
leg to close
flush with side.

0 3 6 9 12

Scale: 1"=1'-0"

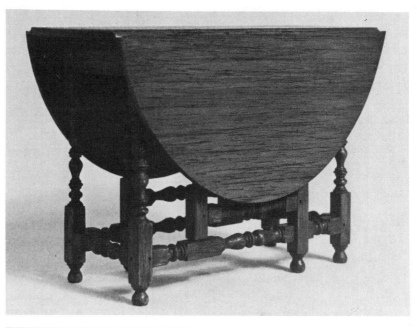

191. Finished gateleg table, closed.

MATERIALS LIST			
oak or walnut	thickness	width	length
8 legs	⅛″	⅛″	3″
2 side stretchers	⅛″	⅛″	4″
4 end and leg stretchers	⅛″	⅛″	2″
2 side stretchers	⅛″	¹¹/₃₂″	2⁹/₁₆″
2 end stretchers	⅛″	¹¹/₃₂″	1″
2 top leaves	¹/₁₆″	1⅝″	3¾″
1 top	¹/₁₆″	1⁹/₃₂″	3¾″
2 leg stretchers	¹/₁₆″	⅛″	1⁹/₃₂″

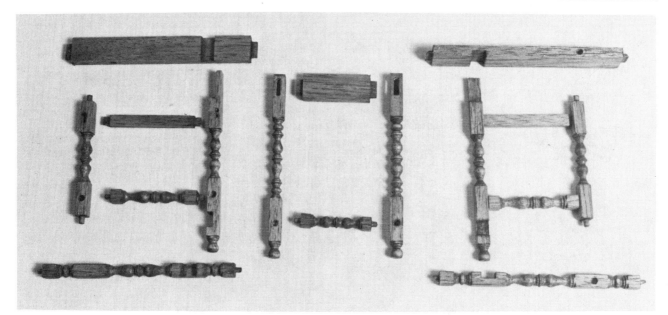

192. Basic pieces.

The gateleg table is basically a series of lathe turnings held together by pegged joints. As you can see from the materials list, the stock should be very easy to obtain. The entire piece requires only two sizes of stock, ⅛″ and 1/16″. Oak, walnut, or cherry can be used. Obviously the wood you choose will have a direct bearing on the finished color. If you desire the table to be dark, use walnut; for a light finish, maple or oak would be a better choice.

Figure 192 illustrates the different turnings and portions of the table in various stages of construction. Only the top stretcher is held by mortise-and-tenon joints. The balance of the pieces are held by pins that have been turned on either end of the turnings. These pins are then secured in place by a wooden peg running through the joint.

The first step is to rough-cut the lumber as indicated in the materials list. All of the turnings are made from ⅛″-square stock. Three-inch-long pieces will be used for the legs. Four-inch-long pieces are used for the two side stretchers. The 2-inch pieces will be for the end stretchers and the horizontal turnings on the free-swinging legs.

I have mentioned several times that it is advisable to cut one or two extra pieces of each size stock. This is especially true on the legs of the table. Thus if you make a mistake, another piece will already be marked exactly the same as the original. As you can see in figure 193, I am marking an extra piece of each of the three different turnings: end legs, swinging legs, and pivot legs. The *X*s in the photograph indicate the areas that are to be turned round. The balance of the turning will remain square. Notice in figure 193 how all of the legs and their extras are marked together. This will ensure that they are all the same height and that all areas that are similar, such as the bottom turnings, will match.

Figure 194 shows the same pieces of stock after the round areas have been turned down. Again, all of the pieces will be marked at the same time so that everything will match. Notice the lower three turnings in figure 194. These three pieces (actually we shall use only two) will be considerably shorter than the others when completed, but are left the same size until all areas are matched.

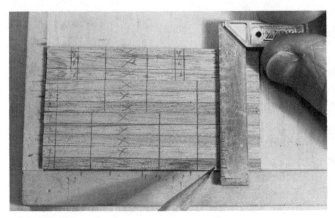

193. Marking the legs on square stock.

194. Marking the turnings on the round portion of the leg.

Now each leg design can be turned using the appropriate knives and small files. If you are in doubt about what tool to use, see the series of illustrations in chapter 9, Spindle Chair project, pages 86 to 89. Be sure to final sand each turning before you remove it from the lathe. The turnings on this table are a multiple of the vase-and-ball motif. Once you have mastered the design, the table will be quite easy.

Figure 195 shows the mortise being cut in one of the swinging legs. In the foreground you can see the tenon on the stretcher. This tenon is being used, along with the plans, to determine the exact size of the mortise. An inverted cone of the same diameter as the width of the tenon is used to cut the mortise. Once the length of the tenon has been marked on the leg, drill a hole to a depth of three-quarters the width of the stock at either end of the mortise area. These holes, made with the dental burr, mark the ends of the mortise. Now the center of the mortise between the two holes must be removed by making a series of left-to-right passes, lowering the burr after each pass.

Figure 195 also shows the location of the dado and the rabbet cuts that must be made on the swinging leg. Both of these cuts are made on the drill using the proper size heavy-duty straight-cut burr. Each is cut halfway through the stock. The hole above the dado seen in figure 195 is for the pin, which is turned onto the lower stretcher. This hole is drilled three-quarters of the way through the stock. These operations are done on both swinging legs.

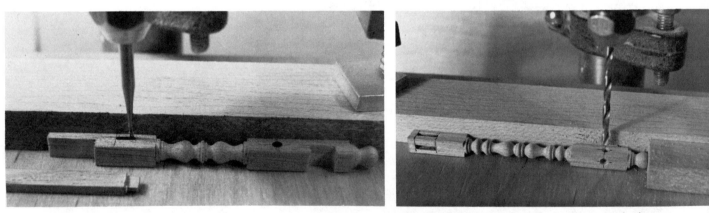

195. Cutting a mortise in the leg. *196.* Drilling holes for the lower turned pieces.

Figure 196 illustrates the drilling of the stretcher holes in adjacent sides of the end legs. Note the matching mortises at the top. Notice how the lines indicating the top and bottom of the mortise and the center line of the pinhole are brought around onto the adjacent surface so the cuts in the two sides will match. To ensure that all holes and mortises are cut in the same spot on each leg, a stopblock is clamped against the fence at both extremes of the cut. These blocks stop the leg from moving too far to the left or right and keep each mortise the same size and in the same location. See the right side of figure 196.

In figure 192 you can see the pins turned on the end of the stretchers. It is important that these pins be the same length, approximately $\frac{3}{32}''$ long, and exactly the same diameter. Use a pair of outside bowspring calipers to check the pin diameter while the piece is still on the lathe. The drill used to bore the holes for the pins should be slightly smaller than the pin diameter. This will make each pin fit snugly.

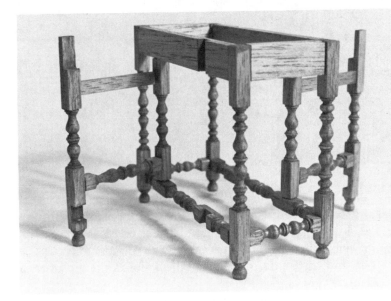

198. Rule joint.

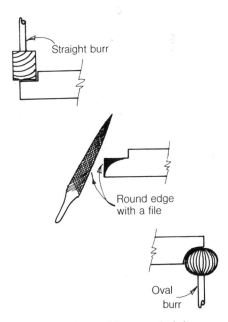

197. Table carcass assembled without glue.

Figure 197 shows the table held together by the mortise-and-tenon and pin joints only. No glue has been used at this stage. Figure 197 also illustrates how the notches cut into the gateleg mesh with the notches cut into the stretchers, thus allowing the leg to fit flush against the side of the table. The legs must swing freely on the inner turning's pins and push flush against the side without excess pressure or binding.

Once you are satisfied that all the joints fit, the carcass can be disassembled, given a final sanding, and stained. While the stain is drying you can begin work on the top. It is cut from three pieces of $\frac{1}{16}''$ stock. Before the oval can be cut, the rule joints must be made (fig. 198).

The tabletop is cut on both sides as shown in figure 199. The first cut is made with a straight burr on the shaper. The shaped edge is then rounded off with a flat file or a riffler file. The edge of the leaf is shaped to fit against the cut just made in the top. This is done by using a round dental burr that will match the cut·made on the edge of the top (fig. 199). After the rule joint has been completed, the three pieces of the top can be held together with tape, the oval traced on them, and the shape jigsawed out. Cut the oval carefully to make a graceful curve around the top (see chap. 19, figs. 460 through 462, p. 209).

It is now time to make the four hinges. Refer to the section on making hinges, chapter 5, pages 55 and 56.

199. Steps in making a rule joint.

Straight burr

Round edge with a file

Oval burr

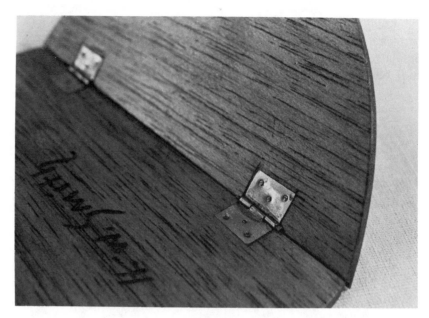

200. Top and hinges.

The finished hinges must be mortised into the top so the inner edge of the leaf will remain flush with the bottom of the top when the leaf is down (fig. 200). The hinge is then put into place with epoxy and held with tiny flathead pins. Be sure you do not epoxy the hinge itself shut. If you desire, you can file a slot in the top of each pin to simulate screws.

The top can now be stained and attached to the carcass. Be careful not to glue the swinging gatelegs shut when gluing the top into place.

A final note on this table concerns its size. The table as shown in the plans is quite small. If you desire you can increase its overall size by increasing the length and width. Also, many tables of this type had a long drawer at one end. The drawer can easily be added by replacing one of the endpieces with two pieces $\frac{1}{16}''$ wide by $\frac{1}{8}''$ deep at the top and bottom of the $\frac{11}{32}''$ space (fig. 201). The drawer itself will then be $\frac{7}{32}''$ high by $\frac{7}{8}''$ wide (see chap. 12, figs. 270 through 272, pp. 129–130, for construction details). Remember to add a pair of drawer glides under the carcass (fig. 201), and a mushroom knob turned from the same wood used for the table.

Drawer glide

Drawer opening

201. Optional drawer.

202. Finished press cupboard, front view.

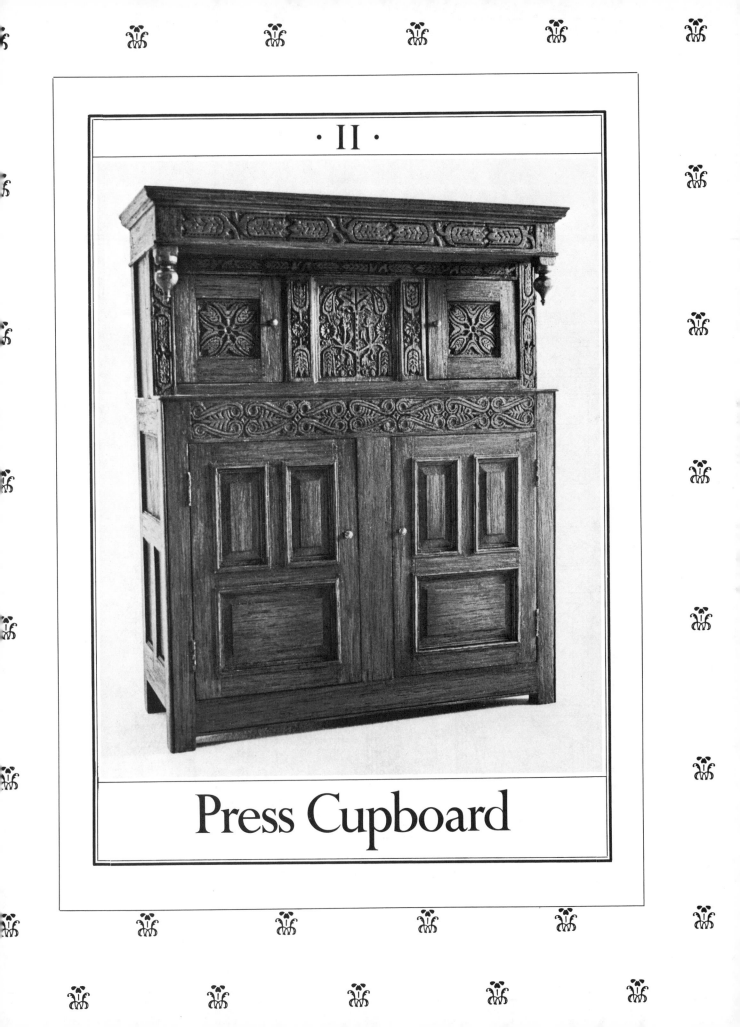

· II ·

Press Cupboard

Press Cupboard

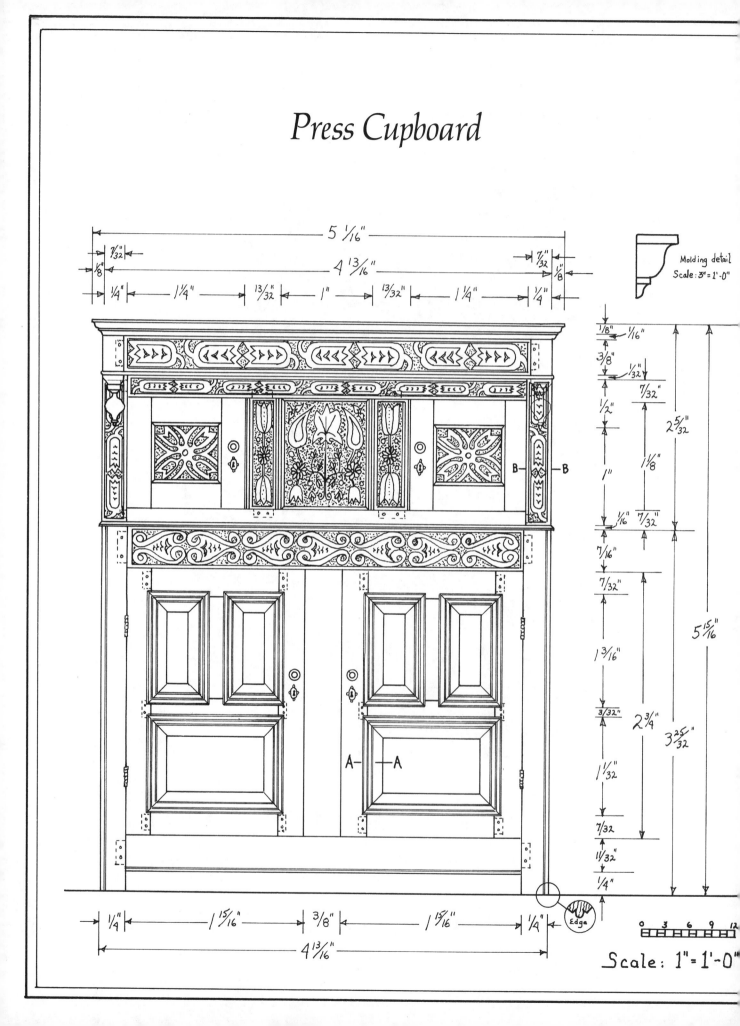

Molding detail
Scale: 3" = 1'-0"

Edge

Scale: 1" = 1'-0"

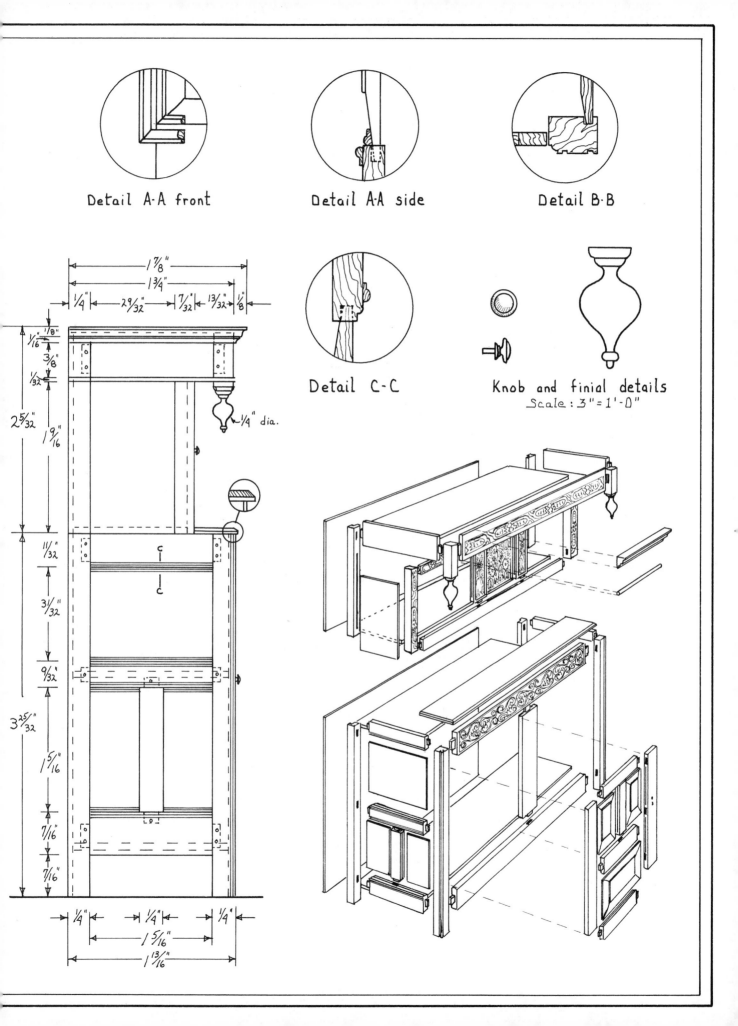

Detail A·A front

Detail A·A side

Detail B·B

Detail C-C

Knob and finial details
Scale: 3" = 1'-0"

MATERIALS LIST

oak	thickness	width	length
base			
SIDE — 4 corner posts	¼″	¼″	3²⁵⁄₃₂″
2 stretchers	³⁄₃₂″	¹¹⁄₃₂″	1⁹⁄₁₆″
2 stretchers	³⁄₃₂″	⁹⁄₃₂″	1⁹⁄₁₆″
2 stretchers	³⁄₃₂″	⁷⁄₁₆″	1⁹⁄₁₆″
2 center stiles	³⁄₃₂″	¼″	1⁹⁄₁₆″
4 panels	¹⁄₁₆″	⅝″	1⅜″
2 top panels	¹⁄₁₆″	1¹⁄₁₆″	1⅜″
FRONT — 1 front carving	³⁄₃₂″	⁷⁄₁₆″	2⁹⁄₁₆″
1 lower front stretcher	³⁄₃₂″	¹¹⁄₃₂″	2⁹⁄₁₆″
1 front vertical	³⁄₃₂″	⅜″	3″
1 top	³⁄₃₂″	1⅝″	4⁹⁄₃₂″
1 shelf	³⁄₃₂″	1⅝″	4⁹⁄₃₂″
1 bottom	³⁄₃₂″	1⅝″	4⁹⁄₃₂″
1 front top (chamfered)	¹⁄₁₆″	¹⁵⁄₃₂″	4⅞″
1 back	¹⁄₁₆″	3²⁵⁄₃₂″	4⁹⁄₃₂″
DOORS — 4 stiles	³¹⁄₃₂″	⁹⁄₃₂″	2¾″
4 top and bottom rails	³⁄₃₂″	⁹⁄₃₂″	1⅝″
2 center rails	³⁄₃₂″	⁷⁄₃₂″	1⅝″
2 center stiles	³⁄₃₂″	⁷⁄₃₂″	1⁵⁄₁₆″
4 top panels	¹⁄₁₆″	⅝″	1⅛″
2 lower panels	¹⁄₁₆″	1″	1⁷⁄₁₆″
top			
2 back corner posts	¼″	¼″	2³⁄₃₂″
2 front corner posts	¼″	¼″	1⁹⁄₁₆″
2 end posts with turning	¼″	¼″	1½″
2 top horizontals	³⁄₃₂″	½″	1⁹⁄₁₆″
2 side panels	¹⁄₁₆″	1″	1⁹⁄₁₆″
1 top horizontal carving	³⁄₃₂″	½″	2⁹⁄₁₆″
1 upper carving	³⁄₃₂″	⁷⁄₃₂″	2⁹⁄₁₆″
1 lower horizontal	³⁄₃₂″	⁷⁄₃₂″	2⁹⁄₁₆″
2 vertical carvings	³⁄₃₂″	¹³⁄₃₂″	1⅜″
1 center panel	¹⁄₁₆″	1″	1⅛″
1 bottom	¹⁄₁₆″	1³⁄₁₆″	4⁹⁄₃₂″
1 top	¹⁄₁₆″	1⅝″	4⁹⁄₃₂″
1 back	¹⁄₁₆″	2³⁄₃₂″	4⁹⁄₃₂″
1 crown molding	³⁄₁₆″	⅛″	12″
4 stiles	³⁄₃₂″	⁹⁄₃₂″	1⁵⁄₃₂″
4 top and bottom rails	³⁄₃₂″	⁹⁄₃₂″	1″
2 panels	¹⁄₁₆″	¹¹⁄₁₆″	¹³⁄₁₆″

Note: Materials do not include small moldings. The top, bottom, and back of both sections may be cut from several random-width boards.

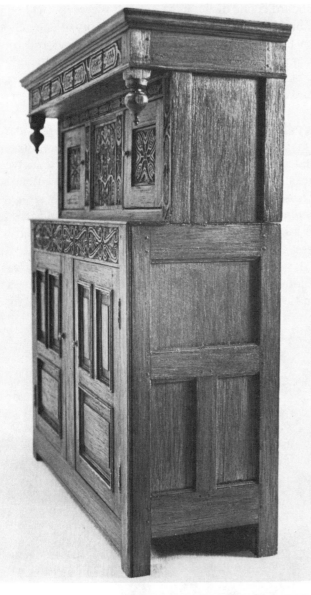

203. Finished press cupboard, side view.

204. Detail of the carving.

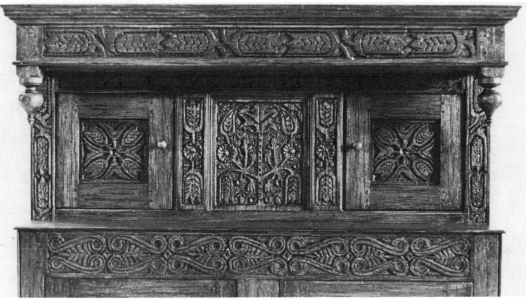

The press cupboard is one of the most difficult pieces in this book. It requires ten hand-carved panels, sixty-eight mortise-and-tenon joints, seventeen inset panels, several different moldings, and four brass hinges. This miniature should not be attempted until the other smaller Pilgrim pieces have been mastered. However, I recommend that you read and study its construction, for it contains a wealth of information.

It is difficult to make an accurate materials list for this cupboard because of the many interlocking pieces involved; therefore, do not precut pieces that must fit inside the carcass, such as doors, shelves, panels, and backs. These items should be custom-fitted after the frame of the carcass has been completed.

The press cupboard is made of either oak or walnut and it is in two pieces. The lower carcass will be constructed first, followed by the upper carcass, carved panels, and finally the doors.

Figure 205 shows the pieces involved in making the lower carcass sides. The joints involved are shown on the right and the assembled side on the left.

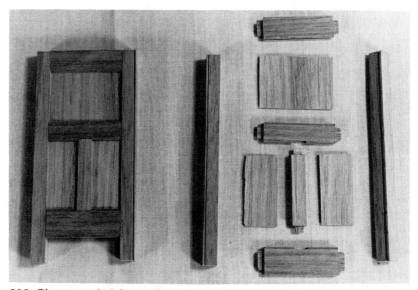

205. Pieces needed for each side.

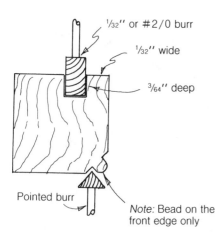

1/32'' or #2/0 burr

1/32'' wide

3/64'' deep

Pointed burr

Note: Bead on the front edge only

206. Detail of the groove and the bead on the corner post.

The first cuts will be the four 1/4''-square corner posts. Cut several lengths of 1/4'' by 1/4'' stock so the posts on the top section will match.

Set up the shaper to cut the groove for the tapered panels. This groove may be cut the full length of each post as shown on the right post in figure 205. The groove should be 1/32'' wide, 3/64'' deep, and 1/32'' from the outside edge of the post (fig. 206). All of the panel grooves in this piece are cut the same way. Next cut the six 3/32''-thick stretchers (six because you are doing both sides at once) and the two 3/32'' center stiles. Remember 1/8'' must be allowed on each end of all pieces that have tenons. That means these pieces must be 1/4'' *longer* than the finished measurements given on the plans. The measurements given in the materials list allow 1/4'' for the tenons. Cut

grooves in the manner described above into the stretchers and stiles. Remember to groove only one side of the top and bottom stretchers. When the grooves have been cut, shape the tiny molding onto the inside edge of the stretchers using a small, inverted-cone and round dental burrs. Again, do not shape the outside edge of the top and bottom pieces (see figs. 205 and 207).

Figure 208 illustrates the proper method for cutting the tenons. The push block at the right must be square with the shaper fence. Hold the piece to be cut snugly against both the fence and the push block with your left hand, while moving the block with your right hand.

The length of the tenon is not so critical as the measurement between the two shoulders (marked A in fig. 208). This distance will be the finished length when the piece is constructed.

Once all of the tenons have been cut (see fig. 205), you can begin cutting the mortises.

Figure 209 illustrates my setup for cutting a mortise. After the location of the mortise has been marked on the corner posts, an inverted-cone dental burr is drilled $5/32''$ deep into the stock at either end of the marked area. The center area between the two holes is then removed by moving the piece back and forth against the tool fence, lowering the burr with each pass.

Do not worry about the rounded edges of the opening. This is a case where a square peg will fit into a round hole! Notice how the fence (fig. 209) ensures that all of the mortises are the same $1/32''$ from the edge of the stock.

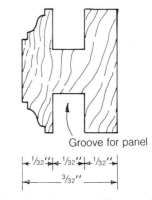

Groove for panel

$1/32''$ $1/32''$ $1/32''$

$3/32''$

207. Detail of the molding and the groove on the center stretcher.

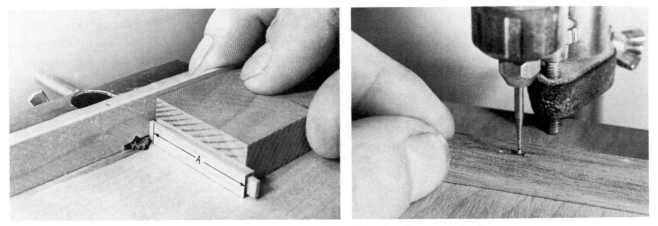

208. Cutting a tenon.

209. Cutting a mortise.

Now, the groove for the back must be cut into the two rear posts. Figure 210 shows how this operation is done on the shaper. Be careful to make the cuts so the groove and the mortise are facing the proper direction. Figure 211 shows how a corner post will look when the groove and the mortises have been cut.

To cut the decorative bead down the outside edge of the front post, use a riffler file or a dental burr setup in the shaper, followed

210. Groove for the back.

211. Detail of the corner post.

by a riffler file to round over the leading edge (see plans and fig. 206).

You should now be ready to dry-fit the sidepieces. If all the joints are snug and square, take the measurements for the three panels (see plans and fig. 205). Use a vernier caliper to measure the distances. Allow enough stock for the panels to fill the grooves. It is better to make the panels too large and have to cut them down, than to have a loose fit with cracks showing. After the panels have been cut, their sides must be tapered to fit into the 1/32" grooves. Figure 234 in the section on making doors illustrates the method used to cut a taper (p. 115). A scrap piece of tapered stock is placed under the panel so it can be shaped at the proper angle. To ascertain the amount of stock you should remove will require some experimenting. The taper should be long and slightly less than 1/32" thick at the edge. Once you have the angle worked out, the setup can be used for the other panels on the cupboard.

Before the side can be assembled, the molding shaped onto the center and the lower stretchers must be removed in the area where the stile and the stretcher intersect (fig. 212). This is done by pushing the tenon into the mortise as far as it will go (until the shoulder hits the molding). Mark the area that must be removed, then carefully cut the extra molding away with an X-acto knife and a flat file.

When all of the joints and panels fit and everything has been sanded smooth as silk, you can glue the two sides together. Be sure they lie flat, are perfectly square, and match when held side by side.

It is time to move on to the front of the cupboard (fig. 213). The difficult part is the carving on the top stretcher. There are no grooves on these pieces so you can go right to the tenons.

Once the tenons have been cut, the design for the carving can be laid out on the upper stretcher. The easiest way to accomplish this is to trace over the design on the plans, using tracing paper and a soft

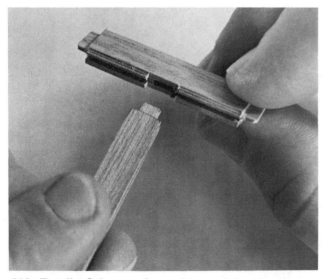

212. Detail of the mortise-and-tenon joint showing the molding.

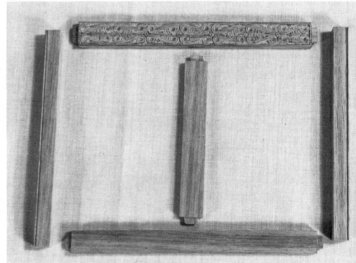

213. Pieces needed for the front.

pencil. The paper is then centered on the panel and glued in place with rubber cement. If you desire, the design can be transferred directly to the wood by one of the methods described in chapter 4, pages 39 and 40. There are advantages and disadvantages to both ways. Using the tracing paper makes the design easier to see and cut around, but as you rout the background, the paper will tear and gum up the tool. If you trace directly onto the wood, the tools work more easily, but the design smudges and is difficult to see, especially on dark wood. Use your own judgment.

Once the pattern is on the panel, the design must be scored with a #11 X-acto knife or a #11 scalpel. This is illustrated in figure 230 (carving the panel in the upper door). After the entire design has been scored, the smallest round dental burr you can obtain is put into the drill press. Using a fairly high speed, rout around the design to a depth of 1/64" (see fig. 231). When this is completed, remove the stock from the background of the design with a larger inverted-cone dental burr (fig. 214). The most difficult part in carving these tiny designs is controlling the wood so that the whirling burr does not cut away more than you had intended. The only way you can master this method of low-relief carving is by *continuous practice*. Do not give up. It is difficult to do, but it most assuredly can be done. When you have completed the background, add any details and finish the design with riffler files and sandpaper. Be careful not to oversand the piece. All of the carvings on this cupboard are done in the manner just described. With the carving completed, the mortises can be made for the center stile and stretchers. After the mortises are completed, dry-fit the front and side pieces so the back can be cut. Custom-fit the back so the carcass is square and sets level. The top, bottom, and shelf boards of the base can now be cut. Each must be custom-fitted by cutting a notch in each of the four corners so that the edges butt against the sides. Figure 215 shows the notches cut in

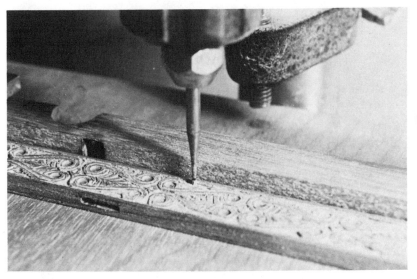

214. Routing the background of the carving.

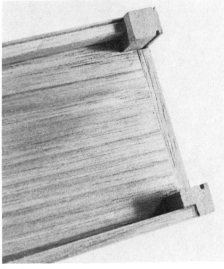

215. Detail of the bottom of the lower carcass.

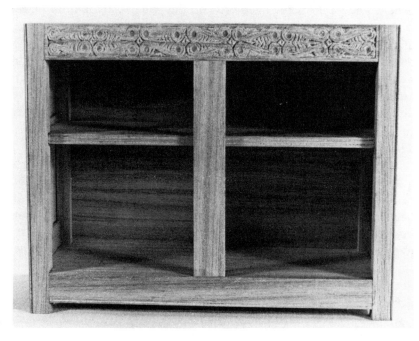

216. Assembled lower carcass.

the bottom. Figure 216 shows the pair of grooves that must be cut into the leading edge of the shelf. These may be cut either on a shaper using a tiny round burr or by hand with a riffler file.

The lower carcass can now be glued together. Check to make sure it is square and set the assembly aside to dry.

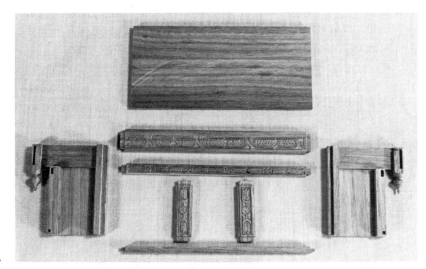

217. Pieces needed for the top carcass.

The pieces involved in the upper carcass are illustrated in figure 217. As with the base, the two sides are made first. The ¼″-square back posts must have the same groove and dado cuts as were made on the back posts of the base (see the top of fig. 206 and figs. 209, 210, and 211). The front post butts into the upper stretcher and is grooved to accept the side panel (fig. 218). This piece also has two

mortises cut into it to accept the tenons of the middle and lower front stretchers. The mortises, however, should not be cut until the tenons have been made on the front stretchers. This post must also be carved on the front surface with a tulip motif, using the low-relief method just described (see right side of front plan, detail B-B, and fig. 204).

When the front post is completed, cut a tenon on the ends of the side top stretchers and on the ends of the three front stretchers. It is necessary to do all three front stretchers at the same time to ensure that the front of the carcass will be square. With these tenons complete, the front posts and the finial end posts can be mortised. The finial end post is mortised on two adjacent sides. Be sure to mark the location of the mortises from the end of the not-yet-turned finial. Do not be misled by the length of the stock, a portion of which is there merely to hold the post in the lathe so the finial can be turned. One mortise must match the top tenon made on the side top stretcher and the other mortise must match the tenon made on the front top stretchers. Remember to make the front stretcher's mortises face each other to ensure a left and a right post.

After the mortises have been cut, the drop finial can be turned on the end of the post and the finished post cut off to the proper length with a Zona saw (see plans and figs. 225 and 232). Now you can dry-fit the sides together and measure for the panel. Cut the panels to fit, and taper the top and two sides (do not taper the bottom of the panel) in the same manner as was done on the base. Check the fit of the panels and then glue the two side assemblies together (see fig. 218).

Figures 217, 225, and the front plan illustrate the detailed carving work to be done on the two upper stretchers and the two center stiles. The detail in figure 219 will also assist you in carving the center stiles. The center flower on the stile has a raised "button" center, and each petal is cupped toward the middle. These cupped areas and the four circular designs around the flower are made with a small, round finishing dental burr. A #11 scalpel is then used to add the star burst effect. Figure 204, the plans, and figure 219 illustrate

218. Detail of the top side.

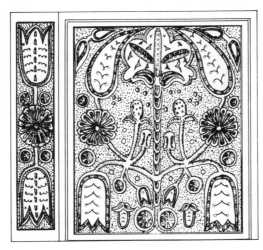

219. Detailed sketch of the center carving.

the upper carcass carvings, all of which are done in the same manner as described above.

After the stretchers have been carved and sanded, cut the back to fit in the back-post groove and dry-fit the top carcass together (figs. 220 and 221). With the basic carcass held together by hand, measure for the top and bottom. After cutting these two pieces, again dry-fit the entire assembly and mark the location of the pinholes that will serve as door hinges (figs. 222 and 223). Drill the pinholes in the top and bottom boards in the places indicated by the marks you have just made.

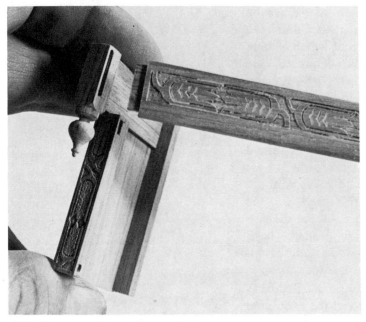

220. Front mortise-and-tenon joint.

221. Detail of the back and the post of the upper carcass.

222. Detail of the top showing holes for the pin hinges.

Door
pin
hinges

223. Location of the pin hinges in the top.

Figure 224 illustrates how the hole for the pin is continued through the top piece, allowing the door to be added after the upper carcass has been assembled. When the doors are installed, the pin hinge can be pushed through both the top and the top carved stretcher into the door. The large hole in the top shown in figure 224 can then be filled with a small dowel. Figure 224 also shows how the top and bottom are notched to go around the four corner posts. The top carcass can now be glued together.

Figure 225 shows the finished top carcass just before the top and bottom are glued in place.

224. Top view of the upper carcass.

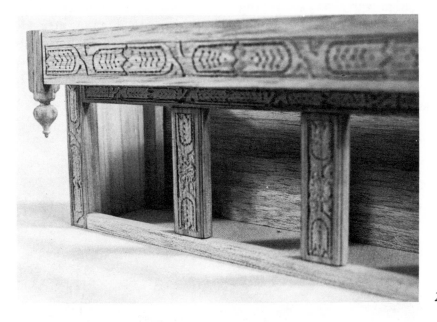

225. Top partially assembled.

The carving of the center panel is the most difficult part of this press cupboard. I have described the method to you. With figures 204 and 219 as your guides, practice until you get the effect you desire. There are twenty-six flowers and geometric designs on this panel, which is just over 1″ square, so do not rush it. Practice the methods I have previously described pertaining to low-relief carving. When you have finished the panel, it can be glued into place.

The sides and top of the panel are framed in a tiny molding as shown in figure 219. Figure 226 shows the profile of this molding, which is only ½″ square. It is virtually impossible to hand-hold this tiny strip of wood against a shaper burr traveling at several thousand rpms. It is the type of thing you would do only once. The way I make a tiny molding like this is to shape it on the edge of a large piece of stock, then saw the stock down to the molding's finished size (fig. 226). A razor-sharp knife must be used to miter such a small molding. A dull blade will crush the wood and the design under its pressure. Use a new #11 scalpel blade. When the panel has been set in place, glue the mitered molding around it. Be careful of excess glue.

You have now completed the frames of the upper and lower car-

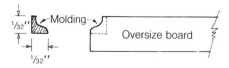

Shape tiny moldings on a larger board; then cut out the molding on a circular saw or by hand

226. Detail of cutting a small molding.

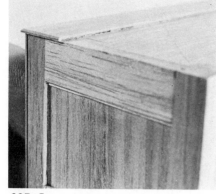

227. Lower carcass top.

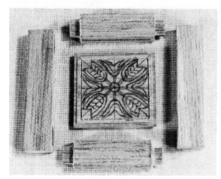

228. Pieces needed for each top door.

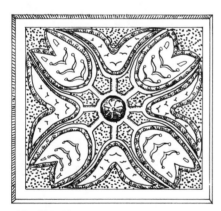

229. Detail sketch of the door carving.

casses. Place the two pieces together and mark where the finished top should go on the lower carcass (fig. 227). Cut the top to fit and chamfer the edge as shown in figure 227 and in the detail of the side elevation in the plans.

The construction of the upper doors is fairly simple, so do them first. They consist of two stiles and two rails mortised and tenoned together around a carved center panel. Be sure you make the frame large enough to fit snugly into the carcass opening (fig. 228).

Figure 229 is a detail of the upper door carving while figures 230 and 231 illustrate the tools used to carve the panel. Score around the design with a #11 scalpel (fig. 230), then using the smallest round dental burr you can find, rout away the background in the area adjacent to the knife cuts (fig. 231). Finish the design by routing away the remainder of the background wood and add the carved details (see fig. 214). Finish the design with riffler files and sandpaper, being careful not to round over the sharp edge of the design.

Figure 232 shows the finished door on its pin hinges.

The bottom doors have no carvings, but they are as complicated as the upper doors.

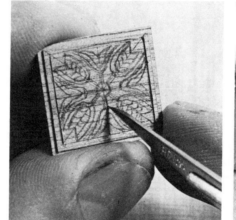

230. Scoring the door carving.

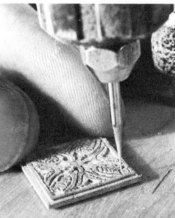

231. Carving the relief design with a tiny dental burr.

Figure 233 shows the basic construction for the lower door. First, cut the four outside stiles and six rails. Second, cut the tenons on either end of each rail in the same manner as described early in the project (fig. 208). Line the tenons up with the outside stiles and mark the location of the mortises. After the end mortises have been cut, dry-fit the outer doorframe and locate the center line of the center rail. Now cut the mortise for this rail and again dry-fit the door together. Next cut the center stile to fit between the upper and center rails and shape a tenon on either end, making sure the shoulders fit tightly between the rails. Finally, mark the location of the mortises on the rails and make the cuts. When all the mortise-and-tenon joints are completed, the center groove for the panels can be cut in each piece as was done on the cupboard side (see figs. 206 and 211,

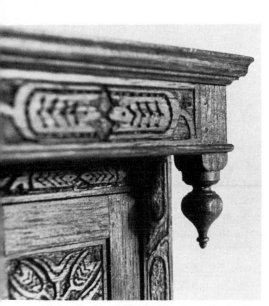

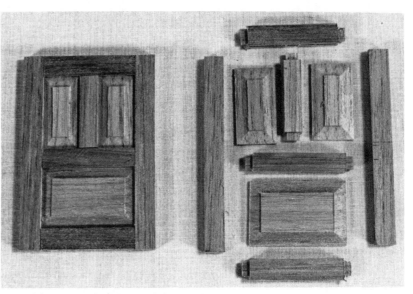

232. Detail of the finished top including the door.

233. Pieces needed for each lower door.

pp. 106 and 108). Remember not to cut a groove on the outer edge of the doorframe.

The doors are now ready for the center panels. Dry-fit the entire piece and using your vernier caliper measure the opening for each panel. Allow approximately ½₂″ extra on each side to fit into the grooves and cut the six panels from ⅟₁₆″ stock. Figure 234 illustrates how to set up the drill for cutting the taper that creates the raised center of the panels. The angle of the stock under the door panel controls the angle of the taper. Lower the cutter far enough into the stock to cut both the bevel and the raised center panel in one operation. *Always* make the two cuts that will run across the grain first and follow them with the cuts that run with the grain. This procedure reduces chipping on the finished piece. Any chipping that takes place on the edge of the stock while cutting across the grain will be removed when cutting with the grain.

When the panels have been carefully sanded, especially the cross-grain cuts, the doors can be assembled. Make sure every joint pulls up tight. Use a bench vise or clamps if necessary. Be sure the door is square and lies flat. Clean off any excess glue and allow the doors to dry.

Before applying the door molding, every joint on the press cupboard must be pegged. Turning the very tiny ½₂″ dowels used in pegging the joints is rather difficult. The easiest way is to use a ⅛″-diameter dowel and turn down only ⅛″ or so at a time. Completely finish each little area, including sanding, before moving the stock out farther from the lathe headstock. When you finish one area, pull out another ⅛″ or so and start over, turning the dowel until it is ½₂″ in diameter (fig. 235). Keep this up until the length of the turned ½₂″ dowel is an inch or two long, then cut it off and begin again. When you have enough pegging stock, mark the location of the pegs with a

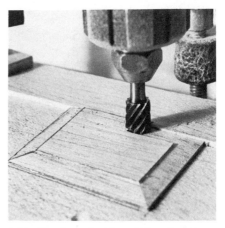

234. Cutting the bevel in the door panel.

235. Turning a tiny peg.

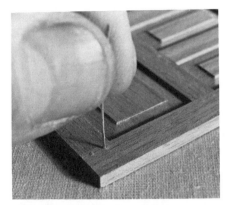

236. Pegging the door joints.

237. Molding used on the door.

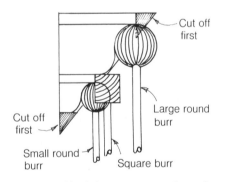

238. Detail of the cutters used on the crown molding.

sharp awl, then drill each mark with a #67 drill bit. Apply a spot of glue to the tip of the 1/32″ dowel and push it into the hole (fig. 236). Cut the dowel flush with the carcass and then lightly sand the entire piece.

With the pegging completed, details A-A front and A-A side (see p. 103, plans) will serve as guides to cutting the molding for around the door. As described earlier, make the molding on the edge of a larger piece of stock, then cut the stock down to make the proper size molding.

Figure 237 illustrates the size of the molding used on the doors. Remember, use a sharp knife to cut the miters. Detail A-A on page 2 of the plans (p. 103) illustrates how the inside molding faces away from the center of the panel, while the outside molding faces toward the panel.

This molding can also be used on the rails on the sides of the lower carcass (see detail C-C, p. 103, plans). The inside molding has already been cut into the horizontal stock, so you need add only the outside piece.

The last pieces of molding are the crown molding and the bead around the top of the cupboard. The detail on the plans and front elevations will guide you in cutting these. The top molding will require several passes with both round and straight dental burrs. Figure 238 shows the stages involved in cutting the top piece, beginning with a beveled stock.

The lower bead is made by simply sanding over the edge of a 1/32″ piece of stock and then stripping it down to a 1/32″ by 1/32″ bead molding (fig. 239).

The final operation required on the press cupboard is attaching the brass hinges and knobs. The construction of the hinges has been fully discussed and illustrated at the end of chapter 5. Once the hinges are completed, both the inside edge of the corner post and the edge of the door stile must be mortised to allow for the thickness of the metal. The hinges are then epoxied and pinned to both the cupboard and the door. Great care must be taken not to glue the hinge or the door shut.

The knobs are turned on the lathe from 3/32″ brass or oak stock (see chap. 22, fig. 508, p. 235). Use the detail on the plans as a guide. Figure 240 illustrates both the hinges and the knobs on the finished piece.

You should now be ready to sand the entire piece lightly, checking for excess glue as you go. When the cupboard is smooth and uniform, it can be stained. Use a tack cloth on both sections before applying a warm brown wiping stain. Let the stain set for a few minutes, then carefully wipe it off, leaving the corners, the edges of the moldings, and the background of the carved areas somewhat darker than the rest of the carcass. Let the stain dry for at least three days. A week is even better.

When the cupboard is completely dry, lightly rub the wood with % steel wool. Be careful not to snag the grain of the wood or rub too

hard and remove the stain. Use a tack cloth on the piece again. If any steel wool remains, pick it off with a tweezers or remove it with a magnet. Varnish the cupboard with a high-grade semigloss varnish and let dry for another three or four days. When the varnish has thoroughly dried, rub it lightly with rottenstone and a nonblooming rubbing oil. Clean the surface, then wax and buff the finished piece.

Sign and date the bottom, for you will have just created a masterpiece of scale miniature furniture that will be treasured for generations.

239. Sanding the bead molding on the edge of the board.

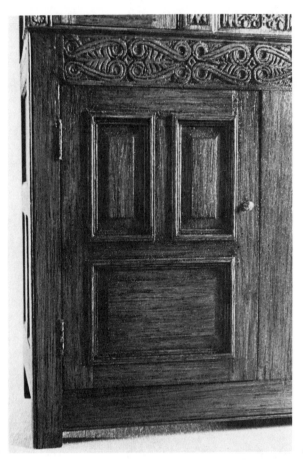

240. Finished lower door.

QUEEN ANNE
PROJECTS
1720-1755

241. Finished lowboy, three-quarter view.

· 12 ·

Lowboy

Lowboy

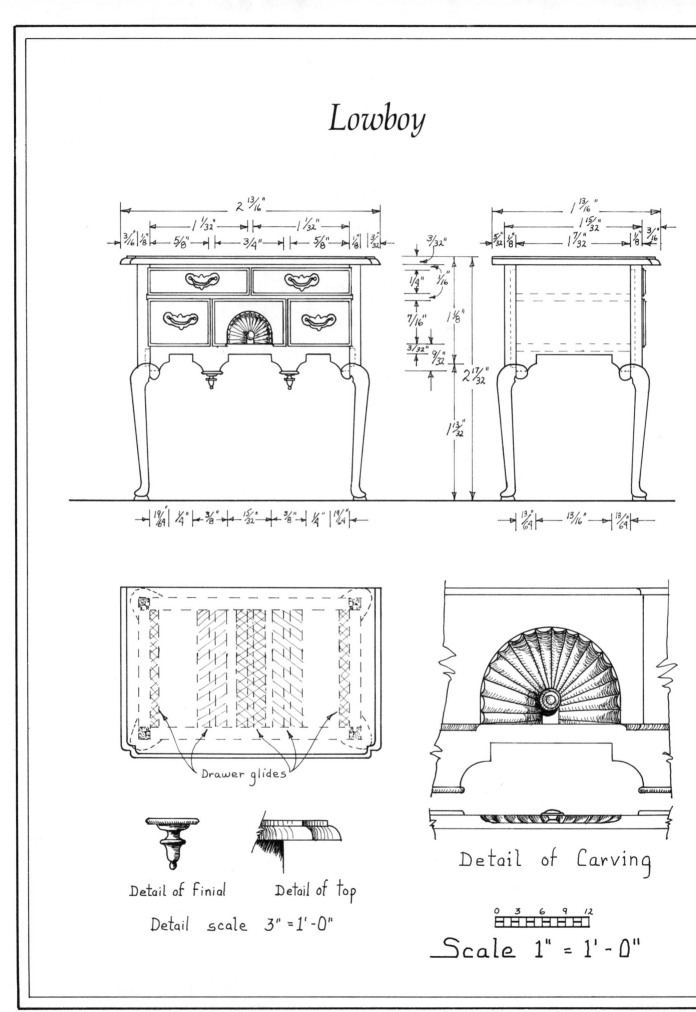

Drawer glides

Detail of Finial Detail of top

Detail scale 3" = 1'-0"

Detail of Carving

Scale 1" = 1'-0"

MATERIALS LIST			
maple or cherry	*thickness*	*width*	*length*
2 sides (includes tenons)	1/8″	1 3/32″	1 11/32″
1 back (includes tenons)	1/8″	1 3/32″	2 9/32″
1 apron (includes tenons)	1/8″	9/32″	2 9/32″
4 legs	5/16″	5/16″	2 7/16″
1 top	3/32″	1 13/16″	2 13/16″
1 top stretcher	1/16″	1/8″	2 5/32″
1 center drawer stretcher	1/16″	1/8″	2 9/32″
2 lower vertical dividers	1/16″	1/8″	17/32″
1 upper vertical divider	1/16″	1/8″	5/16″
4 side drawer glides	1/16″	1/8″	1 1/4″
3 center T drawer glides (cut from 4″ piece)	3/16″	5/16″	4″
2 apron finishing boards	1/64″	3/16″	3/16″
2 apron filler boards	1/16″	5/32″	7/32″
2 drop finials	3/16″	3/16″	2″
2 upper drawer fronts	3/32″	9/32″	1 3/32″
2 lower side drawer fronts	3/32″	1/2″	11/16″
1 center drawer front	3/32″	1/2″	13/16″
2 upper drawer interiors	3/32″	1/4″	8″
3 lower drawer interiors	3/32″	7/16″	12″

Drawers interiors are of 3/32″ softwood and drawer bottoms of 1/32″ softwood.

This Queen Anne–style lowboy with its pad-foot cabriole legs and carved center fan is a delicate piece of furniture that will go well in any setting. This miniature is not extremely difficult to make and can be assembled with either butt joints or mortise-and-tenon joints, depending on what stage of miniature furniture making you are at. It is not necessary to make special brasses unless you desire to. Several companies are making small Queen Anne–style drawer pulls at a very reasonable cost.

The first step in this piece is to rough-cut the several thicknesses of stock you will need. If you are purchasing precut stock, choose close-grained maple or cherry wood in 1/16″, 3/32″, 1/8″, 3/16″, and 5/16″ thicknesses. You will need a few odd-size thicknesses, but they are small pieces that can be stripped out of larger stock.

When you have the proper fine-grain wood, cut the apron, all the drawer dividers, the sides, the back, the legs, and the drawer-glide stock, using the materials list for the proper dimensions. Trace the apron cutout pattern from the plans, transfer it to the apron stock, and jigsaw out the design. True up the curves with a round file and the flat areas with a 6″ barrette file. The tenons can now be cut on the ends of the apron. Set up the shaper with a straight burr.

242. Cut the tenon on the end of the apron.

243. Cut dadoes for the drawer glides in the side.

Adjust the burr to a height of ¹⁄₃₂″ above the shaper table so that it will remove one-fourth of the ¹⁄₈″-thick stock. Set the shaper fence to make a cut ¹⁄₁₆″ into the length of the apron stock. Use a square piece of scrap stock as a push block and make a ¹⁄₁₆″-long by ¹⁄₃₂″-deep cut on all four sides of each end of the apron (fig. 242). The finished tenons should protrude ¹⁄₁₆″ from either end of the apron, which should be 2⁵⁄₃₂″ between the shoulders of the tenons.

The next step is to cut the back and the two sidepieces. Note that the measurements for these pieces given on the materials list include the extra length required to cut a tenon on either end. It is not necessary to mortise-and-tenon such a large area together. A butt joint between these pieces and the legs would be sufficient. If you do not desire to mortise-and-tenon the side and back joints, be sure to subtract ¹⁄₈″ from the length of both measurements before cutting the stock.

Once the pieces have been cut, the cutout design on the lower portion of the sides can be transferred from the plans to the stock. Jigsaw out the design and clean the edges of the cuts with the appropriately shaped files. The dadoes for the drawer glides and for the drawer dividers can now be cut into each side.

Set up the drill as shown in figure 243 using an inverted-cone burr slightly less than ¹⁄₁₆″ in diameter to make a cut ¹⁄₁₆″ wide and ¹⁄₁₆″ deep. Cut both sides before moving the fence for the next cut. Be sure to feed the work from left to right in the rotation of the burr.

If you have decided to mortise-and-tenon the back and sides into the legs, figures 244 and 245 illustrate the procedure. Use the same

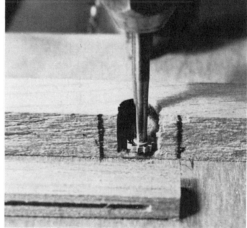

245. Cutter used to cut the long mortise in the leg stock for the side tenon; note that the scrap piece shown in the illustration has been turned toward you to show you how the cut looks.

244. Drill setup to cut the tenon on the side of the stock.

inverted-cone burr that was used for the side dadoes. Use a fence that is perpendicular to the table and almost as high as the stock. This will give you a solid surface against which to hold the work securely. Cut one-quarter the thickness of the stock from all four surfaces of each end. Figure 245 shows the type of saw that is used to cut the long mortise in the leg stock. Notice the lines on the fence to the right and left of the blade, they indicate where to begin the left

and right cuts. The stock in the foreground in figure 245 has been turned toward you to show how the finished cut looks.

The next step in the construction of the lowboy is to make the four pad-foot cabriole legs. The legs are cut from pieces of stock that are 5/16″ square and 2 7/16″ long. Make a template of the leg out of 1/32″ maple stock using the plans as a pattern. I have found that the templates are less likely to slip as you trace around them if 220 grit sandpaper is glued to the surface. After you have jigsawed out the template, use files to make the shape graceful and true. Lay the template on the 5/16″ leg stock and trace around it on adjacent sides of the stock (fig. 246). When the patterns have been laid out on the leg stock, cut the straight portion of the legs on the circular saw (see chap. 23, fig. 520, p. 242). This will ensure that the surfaces are

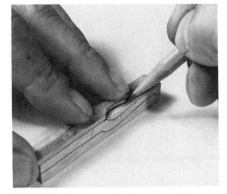

246. Trace around the template on the leg stock.

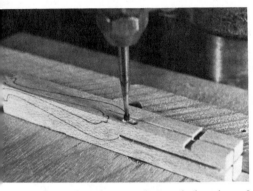

247. Cut the mortise and the slot of the dovetail joint on the leg stock; note that straight cuts have been made on a circular saw.

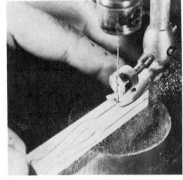

248. Jigsaw out the cabriole leg; note that straight cuts on the leg can be made on a jigsaw if desired.

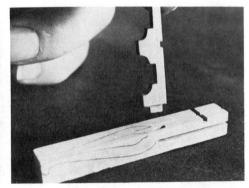

249. Check the apron tenon for fit in the leg mortise.

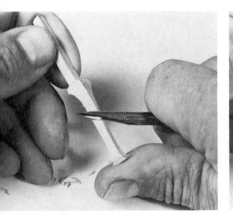

250. Rough out the cabriole leg with a #11 scalpel.

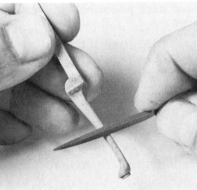

251. Round the cabriole leg with a small file.

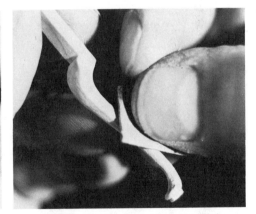

252. Finish the cabriole leg with sand-paper.

square and straight. Set the rip fence to the proper width and mark on the saw table where the cut should end. Figure 247 shows the finished cut. If you are concerned about making a straight cut with the circular saw, it can be done with the jigsaw, as shown in figure 248. Figure 247 also shows the slot for the center-drawer stretcher dovetail and the mortise for the tenon on the apron. Both cuts are

made with an inverted-cone burr. Be sure the two legs are cut for a left and a right assembly. As you cut the mortise, check the tenon on the apron for fit (fig. 249). Having finished all the cuts necessary for the joints on the leg, the square stock can be jigsawed along the lines of the leg (fig. 248). Cut around each surface of the leg but leave a small area uncut that will hold the stock together until all the cuts have been completed (see chap. 16, fig. 339, p. 163). When the leg has been jigsawed out, all of the surfaces will be square. Use a #11 scalpel to round the lower portion of the leg and foot (fig. 250). After the round portions have been roughed out, smooth them with a small file (fig. 251). The final stage in the shaping of the leg is the use of sandpaper to finish all of the curves and blend the areas into a graceful design (fig. 252).

With the legs completed, we can return to the sides of the lowboy and glue the four $\frac{1}{16}$"-thick drawer glides into the side dadoes (fig. 253). The front-drawer stretchers and the apron must now be slotted to accept the dovetailed ends of the vertical drawer dividers (fig. 254). Use the plans as a guide and the same tool setup as shown in figure 243. Be sure the dovetail slots are in exactly the same location on both the upper and lower horizontal members, or the vertical dividers will not be parallel to the sides. Use a barrette file to cut the ends of the vertical dividers to the shape of a dovetail that will fit into the slots just cut in the horizontal members. Dry-fit all of the dovetail joints and check the drawer openings to be sure they are the proper size. When everything is correct, the front assembly can be glued together (see fig. 254).

Before gluing the carcass together, lay the front assembly on top of the backpiece and mark in pencil on the back where the drawer dividers intersect. These lines will position the center drawer glides on the back when they are glued into the carcass.

The front assembly can now be glued to the mortised pair of cabriole legs, and the back can be glued to the remaining pair of legs. Be sure both units are perpendicular and that the inside edges of the legs are parallel to each other. When the front and back units are dry, they can be glued to the sides, and the basic carcass has thus been assembled.

Cut the three center drawer glides from the $\frac{3}{16}$" by $\frac{5}{16}$" stock. The T is shaped by making two cuts on the shaper using a large straight burr. Each section of the T should be $\frac{1}{16}$" thick (fig. 254). Custom-fit the T-shaped stock to a pressure fit between the intersection of the drawer dividers in the front and the back. When the three pieces fit properly, glue them into place (fig. 255).

Now the top can be cut to size and the notch cut out of the front corners (see plans, top view). The edge of the top is shaped on the shaper using a straight burr as shown in figure 256. The burr is raised so that the edge of the stock rides along the shank of the burr while the lower section of the burr cuts the wood. The corner of the top will have to be squared using a #11 X-acto knife (fig. 257). The leading edge of the top is rounded with a riffler file as shown in fig-

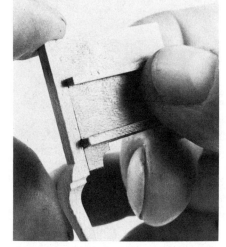

253. Assemble the sidepieces on the cabriole leg; note the drawer glides on the side stock.

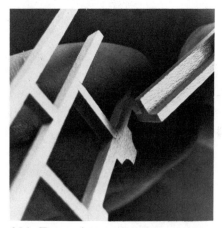

254. Front pieces ready to assemble on the legs; note the T-shape drawer glide.

255. Front pieces assembled on the legs; note the dovetail joints and the location of the drawer glides.

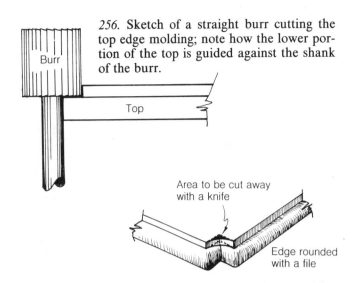

256. Sketch of a straight burr cutting the top edge molding; note how the lower portion of the top is guided against the shank of the burr.

257. Area of the top to be cut away with a knife.

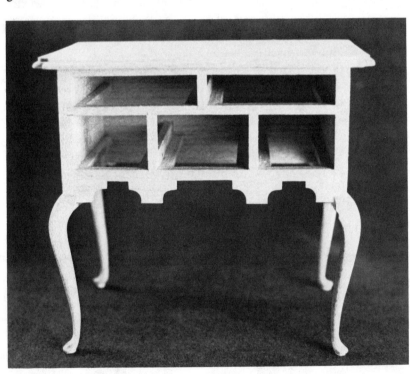

258. Round the edge of the top with a flat riffler file.

259. Basic carcass.

ure 258. When the top has been completely sanded, it can be glued into place. Figure 259 shows the carcass at this stage.

A piece of scrap wood ³⁄₃₂″ square and approximately 6″ long is necessary to add the shoulder pieces to each side of the cabriole legs. Preshape the top of the 6″ board as shown in figure 260, then place the shaped edge against the leg, and in pencil draw the proper arc for the shoulder piece on the scrap. This tiny piece is cut off of the scrap with a fretsaw along the arc and glued into place against the

260. Cabriole leg bracket; notice how the bracket is shaped and fitted on the end of the long stock—an easy way to hold a piece of stock.

261. Detail of the filler boards on the apron used to square off the finial area; notice how the knee brackets are glued to the sides and the apron.

leg (fig. 261). The process is then repeated, preshaping the end, fitting it to another shoulder area, marking the arc, and sawing the piece out. Keep this up until all eight shoulder pieces are in place. When the glue is thoroughly dry, sand the shoulder pieces so they become an integral part of the cabriole leg.

The next step is to cut the two filler boards that go behind the cutout area on the apron. Glue these pieces in place as shown in figure 261. File the top of the filler board and the apron flush so the finishing board will fit squarely on both surfaces. Cut the 3/16"-square finishing board from 1/64" stock and taper the edges on both sides to form a V-shaped edge (see plans and fig. 262). The easiest way to form the V-shaped edge is to hold the tiny pieces at a 45° angle and draw them across a piece of 220 grit sandpaper. Repeat this process on all four edges of both surfaces. The finishing boards can now be glued in place (figs. 261 and 262). Use the plans and figures 262 and

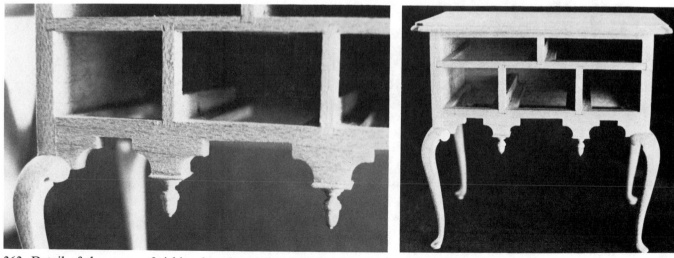

262. Detail of the square finishing board and the drop finials on the apron.

263. Finished carcass.

263 and turn the two drop finials from ³/₁₆″-square stock. Turn a ¹/₁₆″ pin on the top of the finial, then drill a ¹/₁₆″ hole up through the center of the finishing board into the apron, then glue the peg on the finial into the hole. Be sure both finials match before you glue them in place. Figures 263 and 264 show the finished carcass.

The drawers for the Queen Anne lowboy have a flange along the edge that stops them from being pushed into the carcass. The same shaper arrangement will cut this flange and the separate raised portion on the front of the drawer. Figure 265 gives the dimensions of the cuts. Figure 266 illustrates how the flange and raised front are cut on the shaper using a straight burr. Round over the front edge of the flange with a flat riffler file as shown in figure 258.

264. Side view of the finished carcass; notice how the top overhangs both in front and in back.

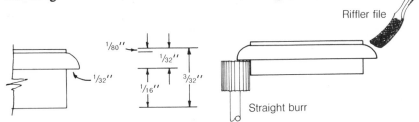

265. Dimensions for the drawer flange.

266. Shaping the drawer flange.

The next operation is to carve the fan motif into the center drawer. Use the plans and figures 267 through 269 to help you along. I have described the method of doing this type of carving in chapter 4. If you are in doubt, reread pages 46 to 49 that deal with carving. Chapter 23, figures 536 through 541, page 247, will also assist you.

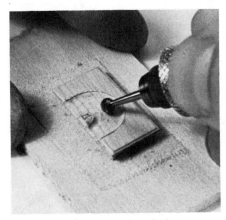

267. Rough out the fan design with a round burr.

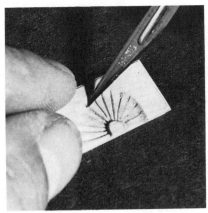

268. Score the fan rays with a #11 scalpel.

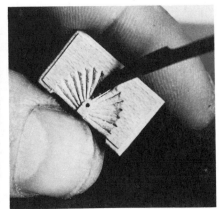

269. Finish rounding the fan rays with a riffler and sandpaper.

When the carving is complete, the pins of the dovetail joint can be made on the side of the drawer fronts. Figure 270 shows the proper setup on the drill press using an inverted-cone burr and a guide block. Figure 271 shows the dovetails being marked on the drawer sides. These dovetails are cut out with a Zona saw and a small chisel. The final cuts on the drawer pieces are made on the

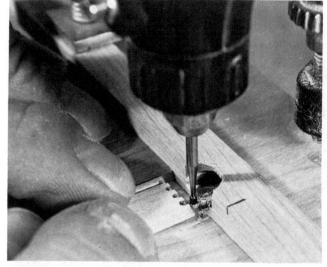

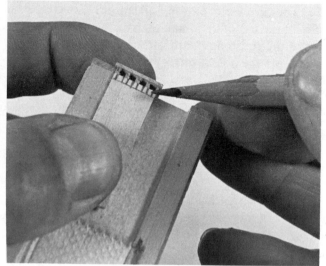

270. Make the pins of the dovetail joint on the drawer with an inverted-cone burr.

271. Mark the dovetails on the drawer side.

272. Cut the groove in the drawer sides, back and front for the bottom.

shaper using a small inverted-cone burr. Cut a groove for the bottom on all of the drawer pieces, including the drawer fronts (fig. 272), and a rabbet across the inside back edge for the drawer back. When these cuts have been completed, the drawer bottoms can be cut to fit each drawer and the pieces glued together.

The lowboy is now ready to be given a final sanding, stained, varnished, and waxed.

→
273. Finished side chair.

· 13 ·

Side Chair

Side Chair

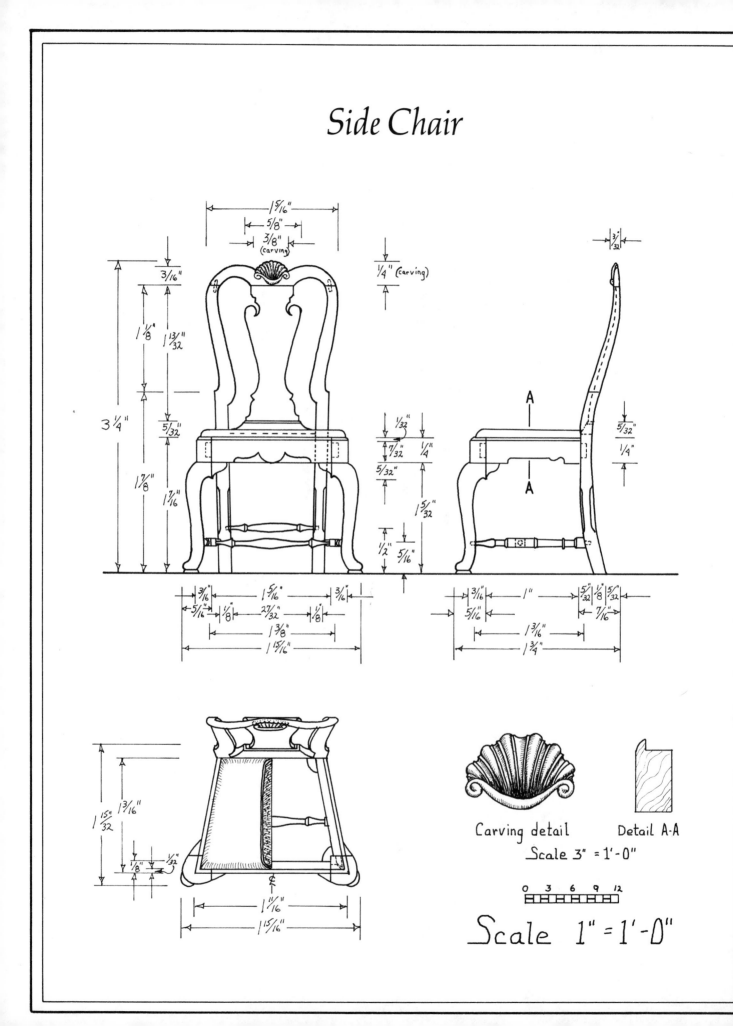

Carving detail
Scale 3" = 1'-0"

Detail A-A

Scale 1" = 1'-0"

MATERIALS LIST			
walnut or cherry	*thickness*	*width*	*length*
2 front legs	5/16''	5/16''	1 7/16''
2 rear legs	3/8''	3/8''	3''
2 side stretchers (includes tenon)	1/8''	1/4''	1 1/8''
1 front stretcher (includes tenon)	1/8''	1/4''	1 7/16''
1 back stretcher (includes tenon)	1/8''	7/16''	1 1/16''
1 crest rail	1/8''	5/16''	1 5/8''
1 splat	5/32''	3/4''	1 13/32''
1 rear rung	1/8''	1/8''	1 3/4''
1 center rung	1/8''	1/8''	2 1/4''
2 side rungs	1/8''	1/8''	2''
4 knee brackets (cut from a single piece)	3/32''	1/4''	8''
1 chair seat (softwood) (may vary with finished chair)	3/32''	1 5/8''	1 1/8''

Note: Each rung measurement includes approximately ¾'' extra length to hold the stock in the lathe.

This Queen Anne side chair is a masterpiece of design, from the delicate cabriole legs to the grace of the spoon-back splat and the carved shell. It is by far one of my favorite pieces.

Before you can begin constructing this chair in miniature, the walnut or cherry stock must be cut into the dimensions shown in the materials list and the eight templates shown in figure 274 must be cut from 1/32'' hardwood. Each of these templates can be obtained by tracing over the appropriate portion of the chair plans and transfer-

274. Templates necessary to construct the chair.

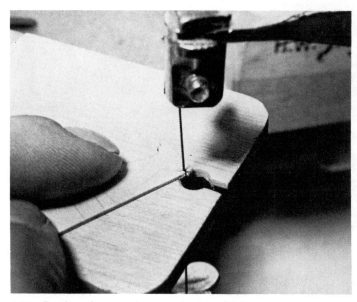

275. Cutting the template on the bench pin.

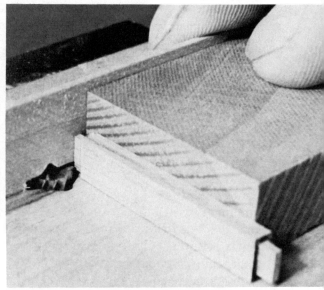

276. Cutting the tenon on the stretcher.

277. Detail of the angled tenons on the side stretcher.

ring the designs to the 1/32″ wood. The templates on the extreme left, numbered 1 and 2 in figure 274, are both for the back leg. The crest rail of the chair is template 3, and the splat is 4. Template 5 is for the back stretcher, 6 for the side stretchers, 7 for the front stretcher, and 8 for the cabriole leg. When all of these have been transferred to 1/32″ stock, carefully fretsaw them out as shown in figure 275 and file them until they have smooth flowing lines. You will notice in figure 274 that I have drawn arrows on one side of several of the templates. These arrows indicate the side of the template that I think is the most graceful, therefore I trace around only that side, flipping the template over to trace it on the opposite end of the stock. This technique assures me that both sides of a piece to be cut will be symmetrical. With the templates completed, the construction of the chair can begin.

The first pieces to make are the stretchers. Notice that the ends of the side stretchers must be cut at an 11° angle and that both ends are parallel to each other. Use the appropriate templates shown in figure 274 and trace the cutouts on the stock. When all of the patterns have been transferred to the stock, set up the shaper with a straight burr adjusted to make a 1/32″-deep by 1/16″-long cut in the end of the stock. When the shaper is set, cut a tenon on either end of the front stretcher (fig. 276). The tenon should be one half the thickness of the stock. The tenons on the side stretchers must be cut at an 11° angle because the chair seat is narrower at the back than at the front (see figs. 277 and 288). To accomplish this, the miter gauge on the shaper must be set 11° off perpendicular. With the gauge set properly, make the top and bottom tenon cuts on both side stretchers. Rotate the miter gauge 22° and make the opposite 11° cut on the bottom of the stretchers. The balance of the tenon must be cut by

hand using the two original cuts as guides. Use a Zona saw and a 6″ barrette file to complete the angled tenons. Remember, the finished tenons must be at the same 11° angle as the shoulders.

The back stretcher has straight tenons front to back, but the sides are tapered top to bottom because of the flare in the back legs. Set the miter gauge 1° off perpendicular and make cuts on the two sides. The top and bottom must be finished by hand (see fig. 289). I should note here that the angle of these cuts may vary slightly, depending on the thickness of your stock and how close your measurements are. Do not worry too much about them, adjustments can be made when the pieces are dry-fitted.

The seat groove on the inner top edge of all but the back stretcher is cut on the shaper, using the same straight burr used for cutting the tenons (see fig. 277). After the seat groove is cut, the outside edge is rounded over to form a quarter-round molding into which the chair seat will fit (see figs. 288 and 295). When the molding has been sanded, the area on each stretcher that must be jigsawed is cut out. The arcs on the back stretcher must also be jigsawed out, then the area between the arcs must be gradually tapered with a ½″ sanding drum to reduce the stock where it meets the base of the splat (see fig. 288). The upper stretchers are now complete.

The next step is the making of the front cabriole legs. Trace around template 8 in figure 274 on adjacent sides of each piece of leg stock. Before jigsawing out the legs, cut the mortises in each leg to match the tenons on the stretchers (see upper left, fig. 278). When cutting the mortise for the side stretchers, remember that the upper square portion of the leg must be beveled at an angle to match the angle of the side stretcher. Therefore, cut the side mortise flush with the inside edge of the leg (see fig. 288).

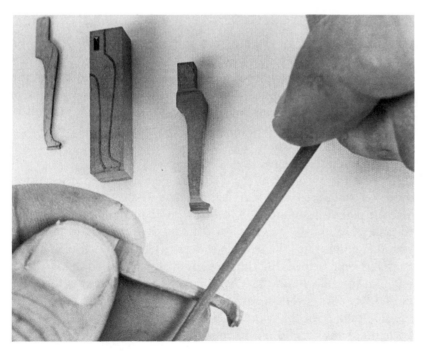

278. Stages of cabriole leg construction.

279. Stages of rear leg construction.

280. Detail of the holes and mortises in the rear leg for the stretchers.

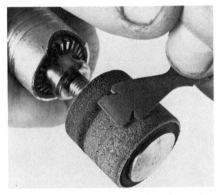

281. Sand the "spoon" in the splat.

282. Completed splat.

283. Turned rungs.

When the mortises have been cut and the tenons dry-fitted to check for a proper fit, the legs can be jigsawed out and finished (see fig. 278, and chap. 12, figs. 248 through 252, pp. 125 and 126).

The rear legs are the next pieces to be made. Use templates 1 and 2 in figure 274. Trace around template 1 on one side of each piece of leg stock, then place the two surfaces with drawings side by side so they mirror each other and trace template 2 on the top surface of each of the two pieces of stock. Be sure the template 2 tracings face each other to ensure having a left and a right back leg (see fig. 289).

When the patterns have been properly transferred, use the plans to mark the location of the side and rear mortises. Dry-fit the front legs with the front and side stretchers and check the markings for the rear mortises. When the side stretchers are parallel to the floor, the mortises can be marked and then cut on the drill, using the same setup as was used on the cabriole legs. Check the depth of each mortise carefully by lining up the cutter's maximum depth with the lines traced from the templates. Remember the mortises will cut through waste stock before reaching what will be the final cutout leg (figs. 279 and 280). Figure 279 illustrates the stages in shaping one of the rear legs. When the mortises are completed, the legs can be jigsawed out, sanded to match with a 1″ drum sander, and completely sanded with 220 grit sandpaper.

Now the seat and leg portion of the chair can be dry-fitted and the location of the holes for the turned rungs marked on each leg. Be sure all of the upper stretchers are parallel to each other and to the floor; use the plans as a guide. With the front and side stretchers on the cabriole legs, mark the angle at which the leg must be drilled for the rungs to match the angle of the side stretchers. Also, mark where the cutout on the top of the leg must be made for the seat cushion (see fig. 288). Detach the stretchers and cut the notch out of the top of the cabriole legs with a #11 scalpel. Go slowly; too much pressure may split the top of the leg. Drill ³⁄₆₄″-diameter holes halfway through the lower cabriole leg area at the location of the rungs. Be careful not to drill through the leg.

To make the splat, trace around template 4 in figure 274 on the rough splat stock and jigsaw out the shape. Cut both sides the same way, especially around the ears of the splat, for they are difficult to reshape. The spoon shape of the splat is achieved with a 1½″ drum sander on a flexible shaft (fig. 281). Make the spoon shape follow that of the chair sides (see figs. 282 and 287).

Before the crest rail of the chair can be made, the turned rungs must be completed and the legs, rungs, and stretchers assembled. Use the plans and figures 283 through 286 to turn the rungs. Be sure to turn a ³⁄₆₄″ pin on the ends of the square areas and to taper the round end that joins the front legs to ³⁄₆₄″ (fig. 284). After the center rung has been turned, the square ends must be beveled to match the angle of the side rungs (fig. 285). The most difficult cut is the compound bevel (a bevel cut in two directions on the same end) where the side rung joins the rear leg. These compound cuts must be made by hand, being careful not to cut off the end peg (fig. 286).

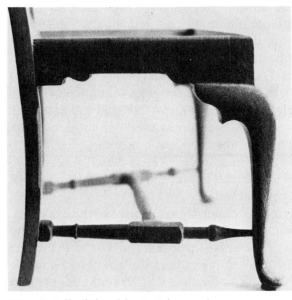

284. Detail of the side stretcher and rung.

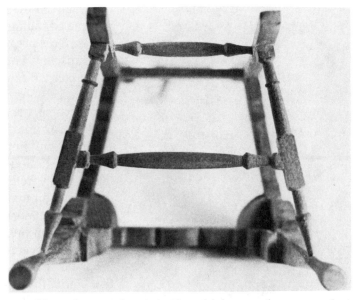

285. View of rungs showing mitered joints on the rung and at the rear legs.

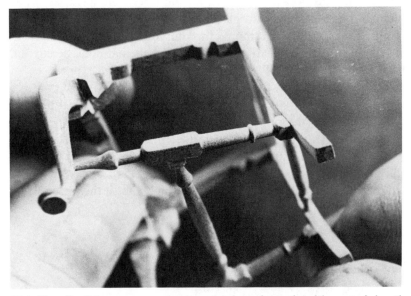

286. Detail of the compound mitered joint where the side rung joins the rear leg.

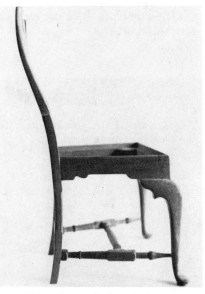

287. Side view of the chair carcass showing the rake in the back.

When all of the stretchers, rungs, and legs have been cut, sanded, and dry-fitted, the carcass, minus the splat and the crest rail, can be assembled. Figure 287 shows the rake in the rear legs of the chair. Figure 288 shows the corner blocks placed between the front and side stretchers. These blocks give added stability to the chair. When the carcass glue is dry, the template for the crest rail can be drawn on the rough stock for the crest rail and checked for proper fit against the top of the legs. If any alterations in the design are required to make the crest rail fit properly against the top of the rear legs, make them now and then jigsaw out the crest rail.

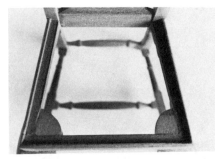

288. Stretchers assembled on the chair; note front corner braces.

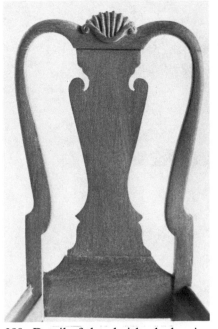

289. Detail of the chairback showing the legs, the splat, and the crest rail with shell carving.

290. Detail of the top of the chair showing the roll in the back.

To attach the crest rail to the legs, small dowels must be drilled into the adjoining surfaces of both the crest rail and the legs and the two surfaces pegged together. This must be done very carefully, for any slips now would be disastrous. Follow the series of illustrations in chapter 23: figures 531, 533, and 534, page 246. When the crest rail and sides have been dry-fitted on the pegs, round the two until they become a graceful curve (see figs. 287, 288, and 289 and chap. 23, figs. 542 and 543, p. 248). At this time check the fit of the splat. Before assembling the top of the chair, the center shell design must be carved. Follow the plans and figures 289 and 290. If you are having difficulty, refer to chapter 23, figures 536 through 541, page 247, for details on making miniature carvings.

Begin by transferring the design from the plans to the chairback. Next rout out the basic shape with a small round burr. At this stage you should begin to see the scroll shape and the start of the ribs in the shell. Now use the smallest round burr you can obtain and further clarify the design. Use a #11 scalpel to sharpen the edges of the shell and scroll carvings. Finish the design with a small riffler file and 320 grit sandpaper. When the carving is completed, the crest rail can be glued into place with pegs on the top of the back legs. The splat can now be glued into place.

Only one operation remains in completing the construction of this Queen Anne side chair—the knee brackets that must be cut and shaped on each side of the cabriole legs. The knee brackets, or shoulder pieces as they are often called, are shaped on the end of a ³⁄₃₂″ by ¼″ piece of stock (fig. 291 and chap. 12, fig. 260, p. 128). Round over the end and one side until it matches the shape of the knee, then mark the bottom design (see plans and fig. 291) on the stock with a pencil. Cut along the line using a fretsaw and the stock held against a bench pin, then glue the bracket in place. When all four are in place and the glue is dry, sand them until they become an integral part of the cabriole leg knee.

291. Detail showing the end of the stock from which the cabriole leg knee bracket was cut.

The chair is now ready for the chair seat. Figures 292 through 295 illustrate the making of the seat. The seat block is cut from softwood and is made approximately ½₃₂" smaller than the seat opening on all four sides (fig. 292). This gap allows for the thickness of the material. If the fabric you are using is extremely thick or thin, adjust this opening accordingly.

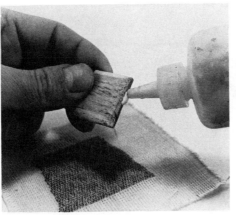

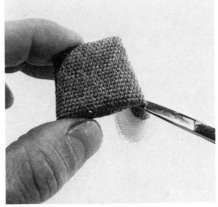

292. Shaping the rough seat block.

293. Applying needlework to the seat block.

294. Cutting the excess fabric from the seat.

To cover the block, apply a thin line of white (nonstaining) glue along the lower edge of the block, then pull the edges of the material over the block and hold them in the glued area (fig. 293). Once the glue begins to hold, pull the corners tight and clip off the excess material. Finish cutting the material flush with the seat bottom using a #11 scalpel (fig. 294). Cover the bottom with a piece of black cloth and you have a beautiful custom-fitted seat (fig. 295).

If you desire, you can construct a seat frame (instead of a seat block) filled with batting and covered with muslin, which is then covered with the seat fabric. Either way, I am sure you will be very proud of your Queen Anne side chair.

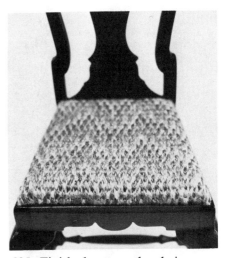

295. Finished seat on the chair.

CHIPPENDALE
PROJECTS
1760-1790

296. Finished mirrors.

· 14 ·

Two Mirrors

Two Mirrors

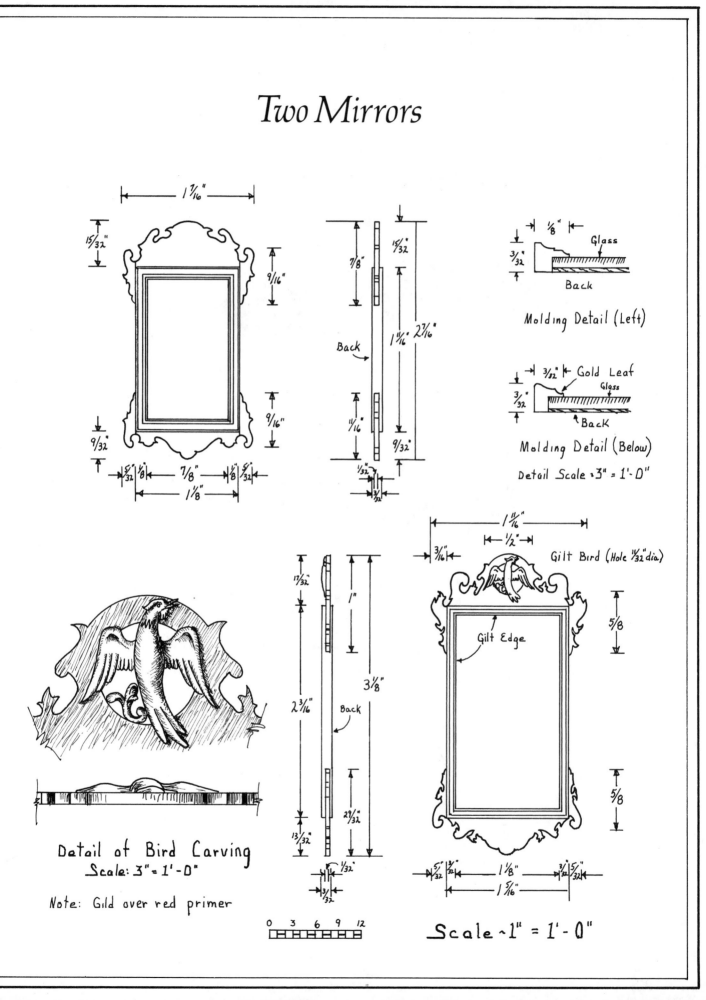

1⁷⁄₁₆ "

15⁄₃₂ "

9⁄₁₆ "

9⁄₁₆ "

9⁄₃₂ "

5⁄₃₂ " ⅛" 7⁄₈ " ⅛" 5⁄₃₂ "

1⅛ "

Back

15⁄₃₂

7⁄₈ "

1¹¹⁄₁₆ " 2⁷⁄₁₆ "

¹¹⁄₁₆ "

9⁄₃₂ "

1⁄₃₂ "

3⁄₃₂

⅛"

Glass

3⁄₃₂ "

Back

Molding Detail (Left)

3⁄₃₂ " Gold Leaf

Glass

3⁄₃₂ "

Back

Molding Detail (Below)

Detail Scale = 3" = 1'-0"

17⁄₃₂ "

1"

2³⁄₁₆ "

3⅛ "

Back

2⁹⁄₃₂ "

13⁄₃₂ "

1⁄₃₂"

¼"

3⁄₃₂

1¹¹⁄₁₆ "

½ "

3⁄₁₆ "

Gilt Bird (Hole ¹¹⁄₃₂" dia)

Gilt Edge

5⁄₈

5⁄₈

5⁄₃₂ " 3⁄₁₆" 1⅛ " 3⁄₃₂" 5⁄₃₂ "

1⁵⁄₁₆ "

Detail of Bird Carving

Scale: 3" = 1'-0"

Note: Gild over red primer

0 3 6 9 12

Scale ~1" = 1'-0"

MATERIALS LIST FOR EACH MIRROR			
cherry or mahogany	*thickness*	*width*	*length*
frame	³⁄₃₂″	³⁄₃₂″	10″
fretwork	¹⁄₃₂″	¾″	8″
1 back	¹⁄₆₄″	1¼″	2¼″
carving (boxwood)	¹⁄₁₆″	1″	1″

In this chapter we shall deal with two mirrors. The mirror illustrated in the upper portion of the plans is a fairly simple example of the Chippendale style; the mirror in the lower portion is a more complex Chippendale example featuring a carved and gilded phoenix in the pediment. These two pieces are constructed identically.

The materials list for *both* mirrors is the same. The pieces consist of a frame decorated with fretwork on the top and bottom. I suggest using a dense fruitwood such as cherry or maple. These woods are strong and will not break on the tiny cross-grain cuts.

The first step is to cut the frame molding on the shaper. The scale drawings in the upper right-hand corner of the plans will aid you in the selection of burrs to cut the designs (fig. 297). When you have finished shaping the molding, cut a groove on the inner edge to hold the mirror and back. Refer again to the scale drawings in the upper right-hand corner of the plans. When the shaper work has been completed, the molding must be finished with riffler files and sandpaper. Only after the entire 10″ strip of molding has been finished and is ready to be stained and gilded should the miters be cut.

The miter box described in chapter 4, figure 51, page 34, will be necessary to cut the miters. Carefully mark the length of each piece, using the plans as a guide. It is very important that the miters are cut at exactly a 45° angle and that the opposite sides are exactly the same length. It is important that you practice this step many times on scrap stock before you cut the actual molding.

When all the miters have been cut, turn the pieces wrong side up and hold them together. This may take an extra pair of hands, so talk someone into assisting. While the four pieces are together, mark on a scrap board, which has been cut to the thickness of the back groove, the exact size of the opening. Carefully cut the board on these lines, making sure that all four corners are perpendicular to each other. Check each corner with a square. This board will be used as a guide in gluing the four pieces together. Put Titebond glue on each of the four miters. Set the frame piece on the square board as though it were the mirror and apply pressure (fig. 298). The board will keep each piece aligned. Make sure no glue gets on the board, or it will be impossible to remove. Once the tack of the glue begins to set up, check to make sure the frame is square and remove the board. Be sure the frame lies perfectly flat. Check it again with a square, then set it aside to dry.

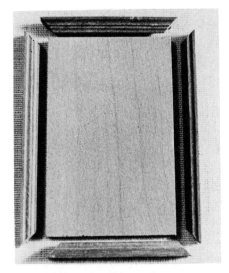

297. Burrs to cut the molding.

298. Gluing the sides using a center board as a guide.

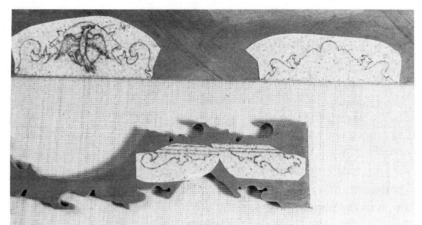

299. Tracing of the cutouts on the scrap stock.

The scrollwork pieces around the frame are cut from 1/32" stock. As you can see from figure 299, I try to find scraps of stock for this purpose. Figure 299 also shows how the design is transferred to paper and then glued to the wood. Stack the wood so that both left and right sides can be cut at once, then use rubber cement to hold the paper and wood together. You may find it advantageous to stack three pieces. This will give you a few extra pieces, but they will come in handy should you make a mistake.

Use either a power jigsaw with an ultra-fine blade or a fretsaw and cut out the designs slowly and carefully. Do not try to rush the blade, for you will only succeed in breaking either the stock or the blade, or both. Keep your eye slightly ahead of where you are cutting. In other words, look where the blade is going to cut not where it has already cut. Learn to anticipate the turnings in the design.

To cut out the hole in the phoenix bird mirror, predrill the backpiece with a 1/8" bit, then insert the blade through the hole and make the cut.

Once the design is cut out, clean all the edges with files and rifflers, and sand. Be careful not to round the edges. Leave them clean and sharp.

The next step is to glue the top and bottom pieces into place. Use a piece of stock 1/32" thick under the scroll pieces, to raise them into the proper position. This guide will true up the distance along the entire frame. When the glue holding the top and bottom pieces is dry, sand the ends of these pieces until they are flush with the sides of the frame. Now the side scroll pieces can be glued into place. Be sure to use the 1/32" guide and to clean up any excess glue. When the glue is completely dry, the mirror can be stained and finished. After the varnish has dried for several days, the gold-leaf edging can be applied.

Use a 2/0 or smaller brush and carefully apply quick-drying size to the inside cove on the molding. In an hour or so the size will be ready for the leaf.

Once you have the gold leaf out, do not cause any sudden air currents, for any breeze will crumple the leaf into a tiny ball of gold.

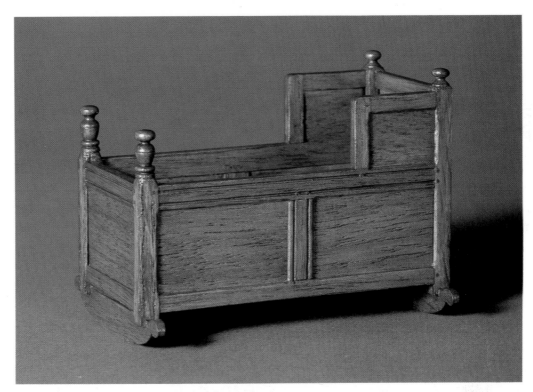

Paneled Cradle. H. 2 3/16″ ; W. 3 1/8″.

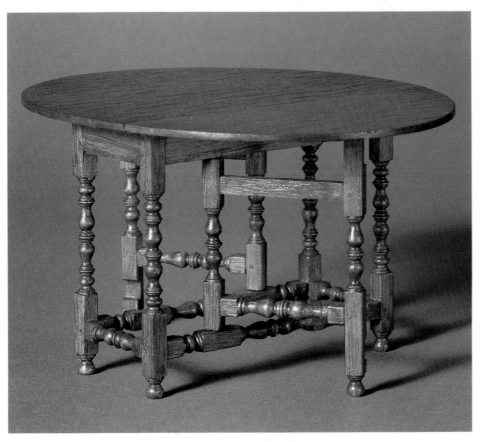

Gateleg Table. H. 2 3/8″ ; W. 3 1/2″.

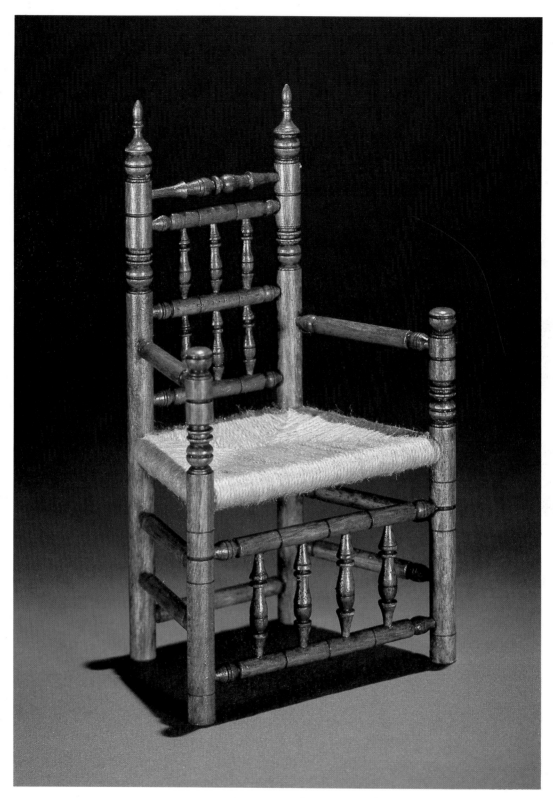

Spindle Chair. H. 3 7/8″ ; W. 2 7/32″.

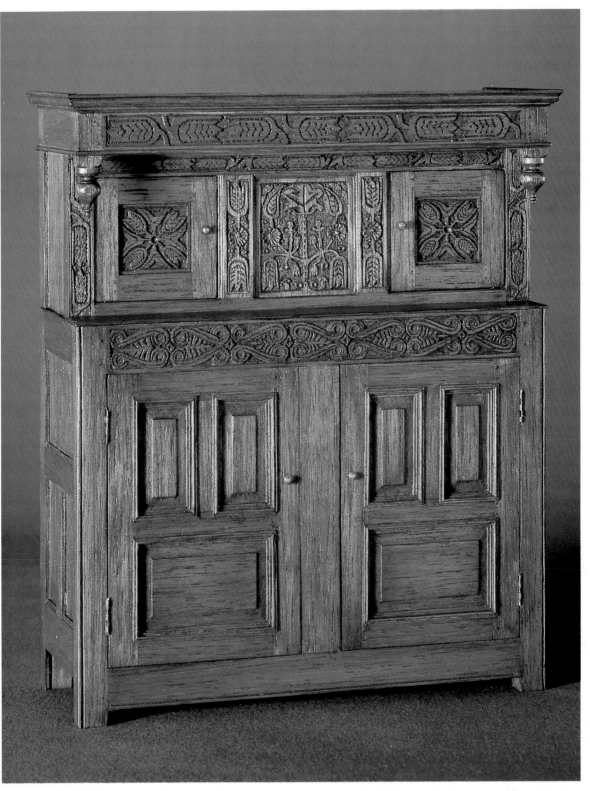

Press Cupboard. H. 5 15/16″ ; W. 5 1/16″.

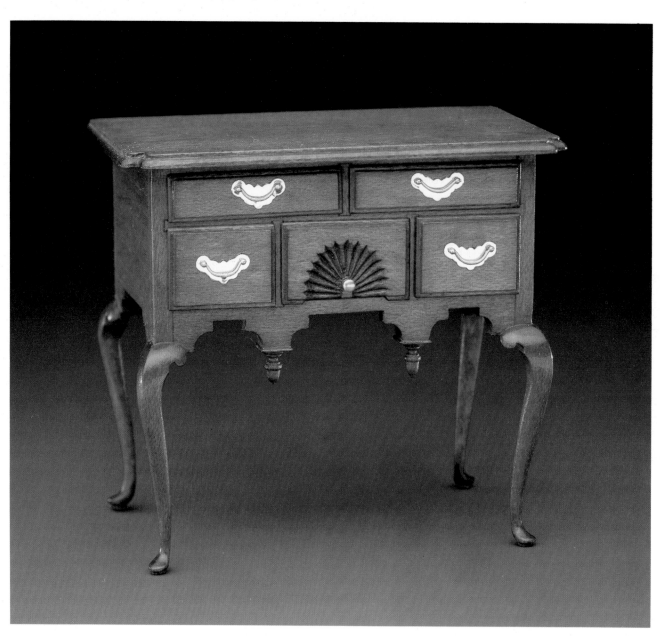

Lowboy. H. 2 17/32″ ; W. 2 13/16″.

Side Chair. H. 3 1/4″ ; W. 1 15/16″.

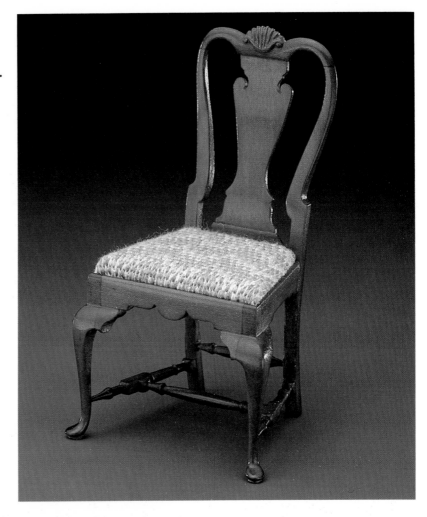

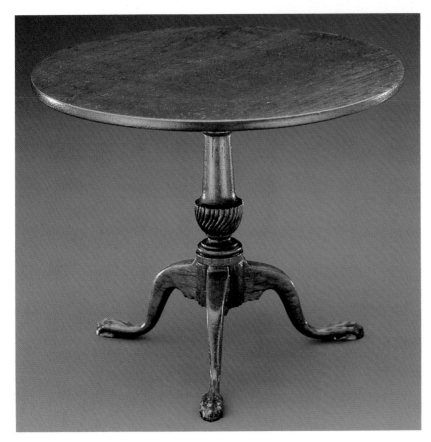

**Tilt-Top Tea Table. H. 2 7/16″;
Diam. 3″.**

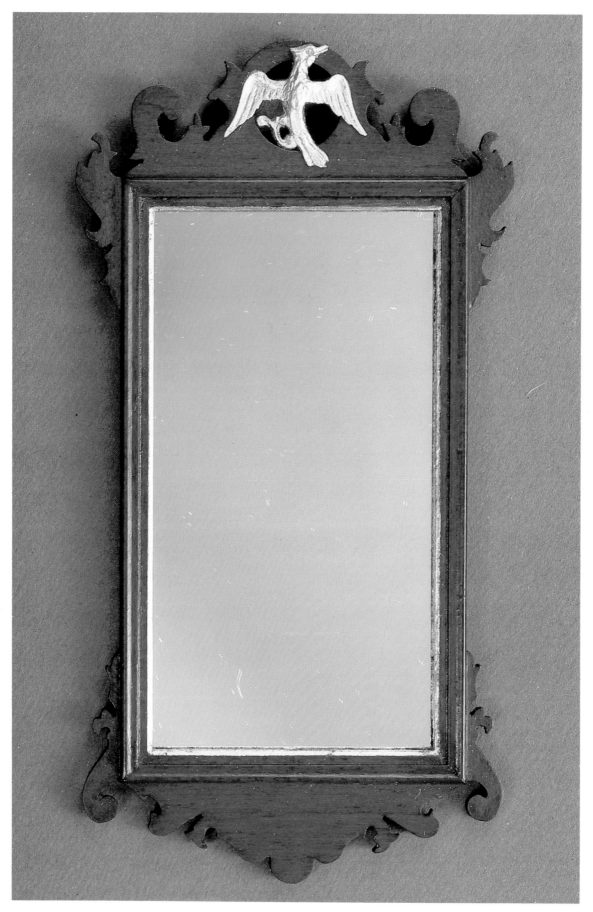

Mirror. H. 3 1/8″ ; W. 1 11/16″.

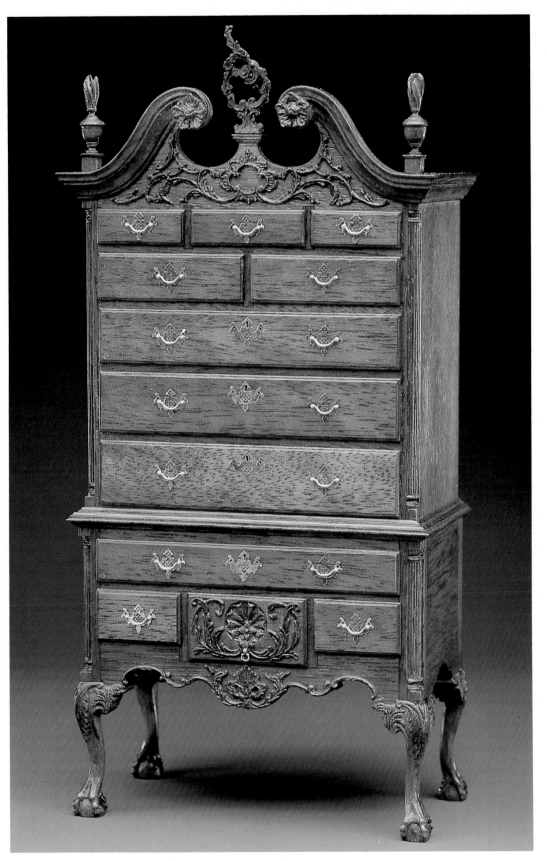

Broken-Pediment Highboy. H. 7 23/32″ ; W. 3 29/32″.

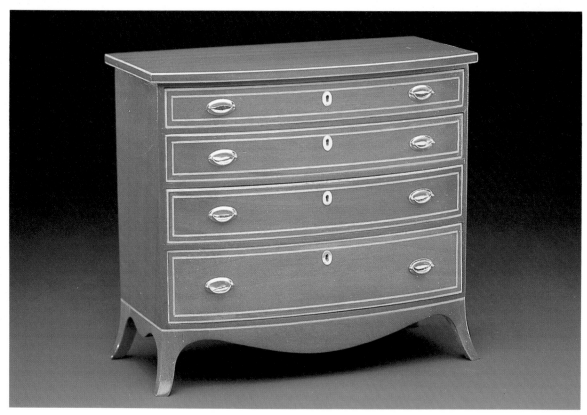

Bombé Chest. H. 2 15/16″ ; W. 3 1/2″.

Bracket-Foot Chest. H. 3 3/32″ ; W. 3 1/2″.

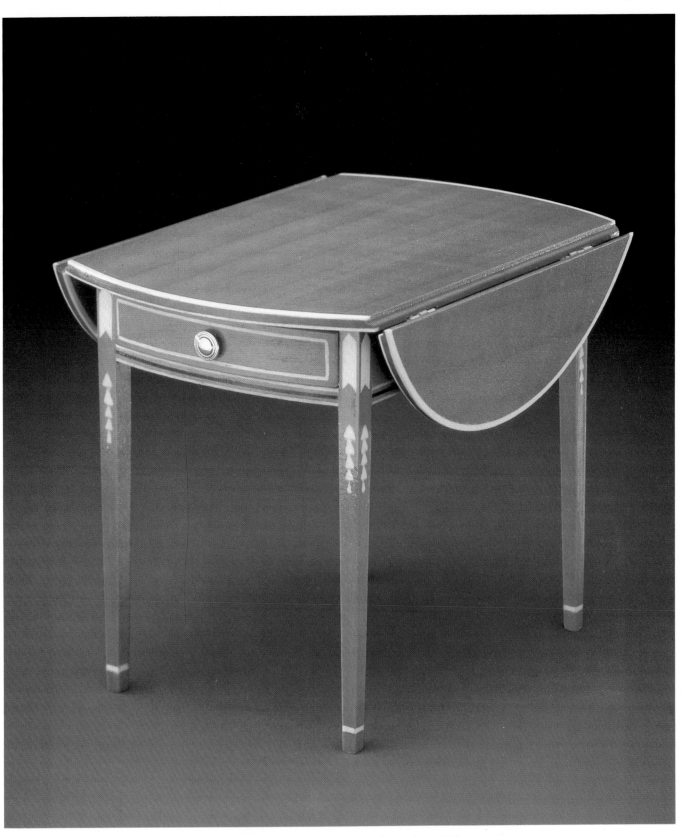

Pembroke Table. H. 2 3/8″ ; W. 3 7/16″.

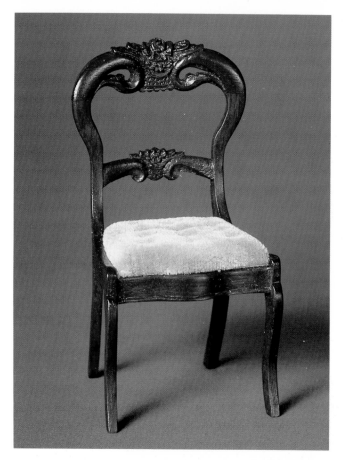

Balloon-Back Side Chair. H. 2 15/16″ ; W. 1 5/8″.

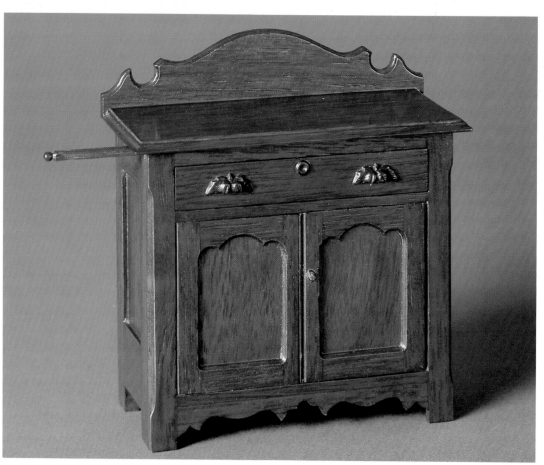

Washstand. H. 3 1/32″ ; W. 2 23/32″.

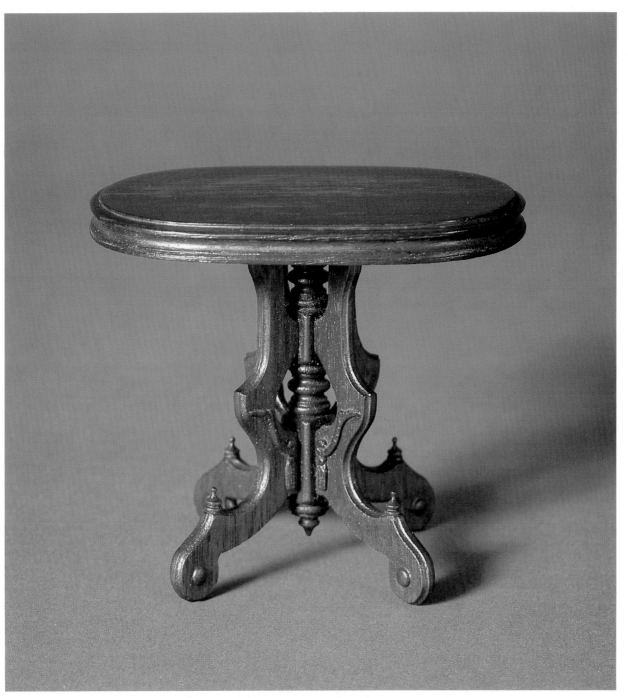

Center Table. H. 2 7/16″ ; W. 2 23/32″.

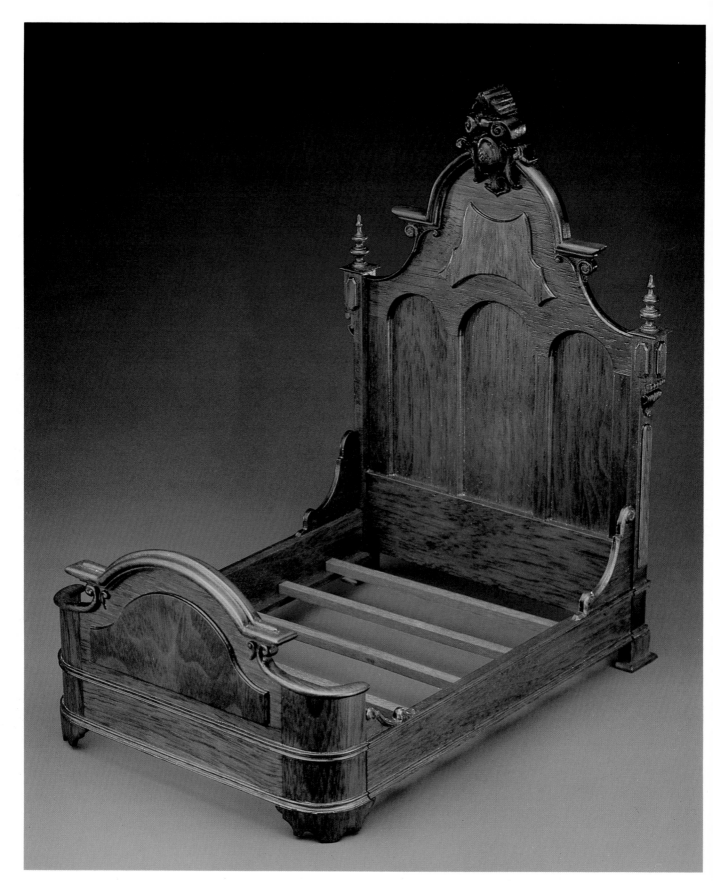

Renaissance Revival Bed. H. 7 31/32″ ; W. 5 15/16″.

Pick up the gold leaf on a dry brush charged with static electricity from your hair and press it into the size. Continue until the entire edge is completed. *Do not* varnish over the gold. Varnish will only dull it.

To finish the mirror, cut a piece of thin mirror glass, such as that found in a compact, to fit the opening. Then glue a paper-thin piece of rough-sawed wood over the mirror back with contact cement.

I use a small wire for a hanger. Each end is bent, then stuck into a hole drilled into the back of the frame and then held with epoxy (fig. 300).

This completes the small mirror. The larger mirror, however, requires an additional step for the carved phoenix. The outline of the phoenix is first jigsawed out of a scrap of boxwood then carved with dental burrs and a #11 knife. Boxwood is the only wood I know that is dense and hard enough to hold together for this tiny carving.

There is little I can do to show you exactly how to carve the phoenix. The two details at the lower left of the plans should be carefully studied. Figure 301 will also help you. Also, read the section on carving the rose back in chapter 23, figures 536 through 541, page 247.

300. Detail of the hanger on the back.

301. Carving of the phoenix bird with a #11 knife.

When the bird is finished and completely sanded, coat it with gold-leaf size. Let the size set for approximately one hour, then apply the gold leaf as described earlier. After the giltwork has dried for at least two days, glue the carving into place over the hole. Again, *do not* varnish the gold leaf, as it dulls the shine.

This completes the two Chippendale mirrors. The larger, more elaborate mirror is an ideal piece to hang over the bombé chest detailed in chapter 16.

⟶

302. Finished tilt-top tea table, top down.

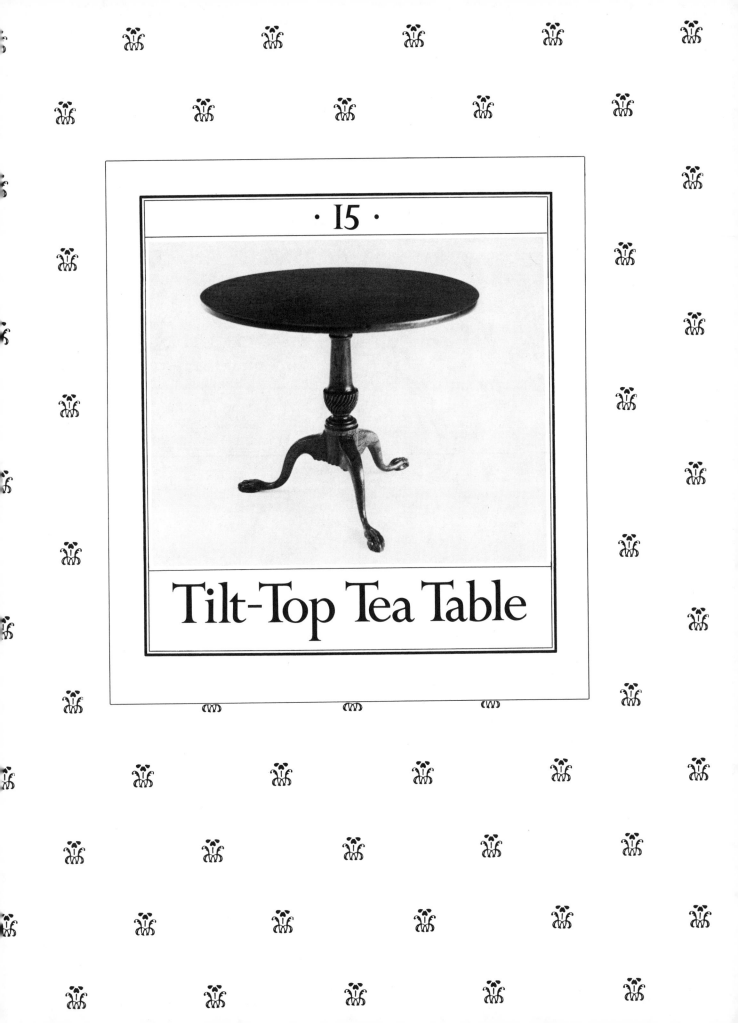

· 15 ·

Tilt-Top Tea Table

Tilt-Top Tea Table

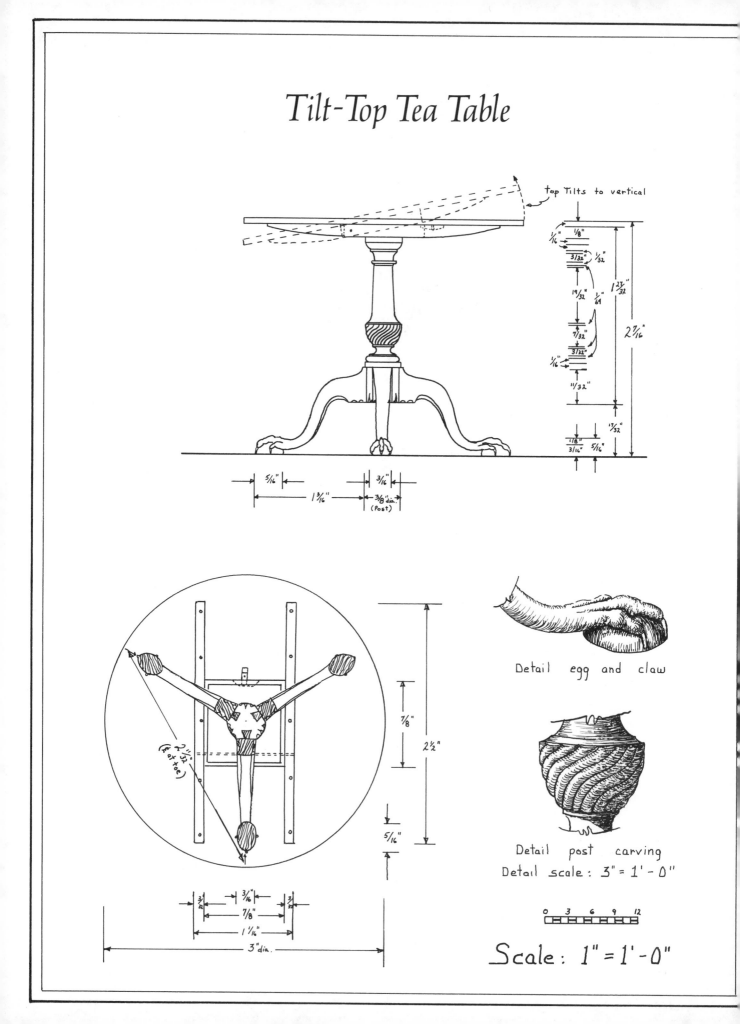

top Tilts to vertical

Detail egg and claw

Detail post carving
Detail scale: 3" = 1'-0"

Scale: 1" = 1'-0"

MATERIALS LIST			
mahogany	*thickness*	*width*	*length*
3 legs	³⁄₁₆″	⅞″	1⅜″
1 top	¹⁄₁₆″	4″	4″
1 center post	½″	½″	4″
1 post block	⅛″	⅞″	⅞″
2 top braces	³⁄₃₂″	⅛″	2½″
1 latch	¹⁄₁₆″	³⁄₃₂″	¼″

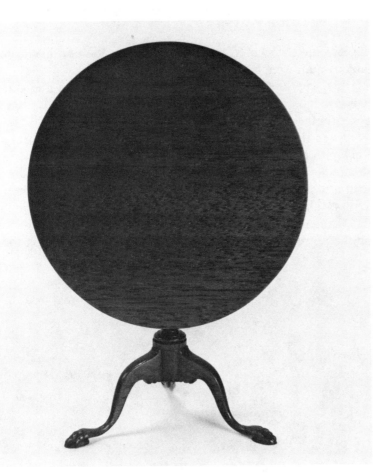

303. Finished tilt-top tea table, top up.

Some time ago I was discussing furniture with a friend of mine who collects antiques. When I mentioned I was looking for unusual furniture to do in miniature, he took me by the arm and led me to his sitting room. "This is an outstanding piece," he said, pointing to a beautiful tilt-top tea table. As you can see, I could not resist it and added the table to the list of projects for this book.

This Chippendale table has low graceful egg-and-claw feet that radiate from a turned center post, the center bulb of which has a swirled reeded motif. The simple solid top tilts 90°, allowing it to be placed in the corner after tea. With the exception of the carving on

304. Rough turn the center-post stock.

305. Score over the major turning areas with a parting tool.

the feet and the swirled reeding, the construction of this tilt-top tea table is quite simple.

First, cut the rough stock in the materials list from fine-grain mahogany. It is important that the wood does not have large open pores that will interfere with the small carved designs.

When the wood is cut to size, chuck the ½″-square center-post stock into a lathe. Use a flat, wood-turning chisel to turn down the square stock into a mahogany dowel (fig. 304). Follow the chisel with a 6″ or larger 0-cut barrette file and then 150 grit sandpaper. With a caliper check to be sure the finished dowel is $^{13}/_{32}$″ in diameter. Using the plans as a guide, mark the major areas of the turning on the dowel, then score over these marks with a parting tool (fig. 305).

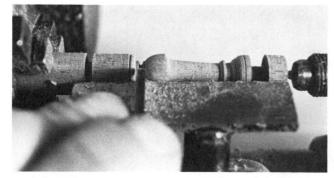

306. Cut the design with a round lathe tool.

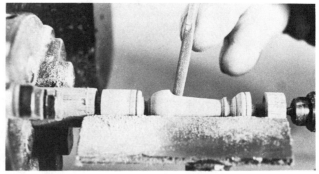

307. Shape the design with a small file.

The center post can now be shaped using the plans and figure 306 as guides. Figure 306 shows the groove below the bulb being turned with a small, round lathe tool. Remember to turn a $^{5}/_{32}$″-diameter peg, $^{3}/_{16}$″ long, on top of the post to secure the post to the post block (see right side, fig. 306). When the basic shapes have been attained with lathe tools, the finer details are brought up by using flat, round, and half-round needle or escapement files (fig. 307). The turning is then completely sanded while still on the lathe using 150 grit sandpaper followed by 220 grit sandpaper (fig. 308).

Before cutting the post off the waste stock that is holding it in the

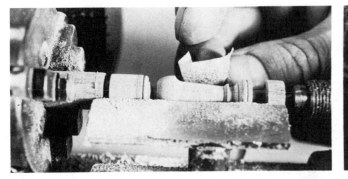

308. Finishing the turning on a lathe with sandpaper.

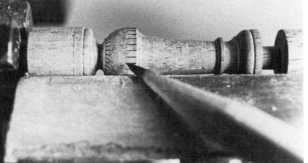

309. Mark spacings on the turning for reeding.

lathe, the center-bulb reeding must be marked. Hold a pencil against the tool rest as shown in figure 309 and mark the center bulb in ½₂″ increments around the circumference. Mark only the top and bottom of the bulb, do not draw a line its full length, remember the reeding is swirled and not straight. The turning can now be cut from the waste stock and removed from the lathe.

The next step is to connect the top and bottom ½₂″ marks in a swirled fashion. This is accomplished by picking a mark on the *bottom* of the bulb and connecting it with a mark three spaces to the right of the corresponding mark directly above the mark on the top of the bulb (fig. 310). Notice the simple jig that is used to hold the center post. Now comes the hard part: score over the pencil lines with a #11 scalpel or an X-acto knife; the difficulty lies in making the knife follow the pencil lines and not the grain of the wood (fig. 311). The cut begins with the grain, then moves at a diagonal across the grain, ending with the grain again, thus creating the swirl. It is the across-the-grain portion of the cut that is difficult. This area is also the weakest part of the carving: the more the carved reeding is developed the thinner the stock becomes and thus the more likely it is to chip out.

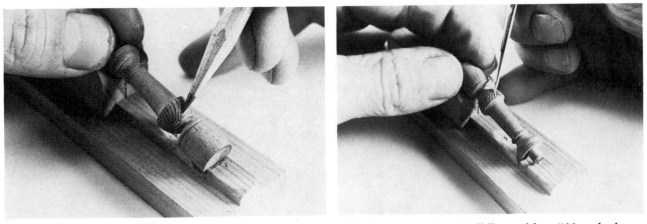

310. Connect spacing off-center lines to form the swirl design; note the jig to hold the turning.

311. Score over the pencil lines with a #11 scalpel.

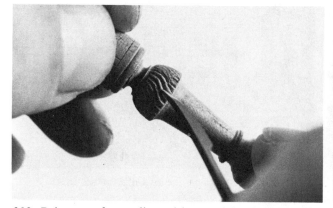

312. Bring out the reeding with a straight riffler file.

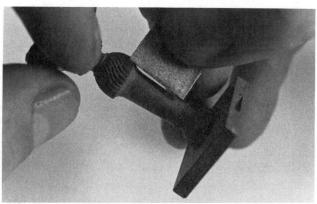

313. Finish the swirl reeding with sandpaper; notice the notch in the top piece for the top latch.

After several passes with the knife the reeding should be formed enough to be rounded with a small, flat riffler file (fig. 312). After the reeding is rounded, the carving can be finished with 220 grit sandpaper (fig. 313).

Now that the swirled reeding is completed, the dovetail slots for the legs can be cut into the bottom section of the post. Figure 314 illustrates the use of a jig that has one side cut out to match the silhouette of the post's turnings, and the other side cut perpendicular to the fence. A second fence is clamped at right angles to the drill fence (far right, fig. 314). The turning is fitted into the silhouette cutout while the straight side of the block is held against the extra fence. This setup keeps the ⅜″-long slots cut by the burr parallel to the edge of the post. On the circumference of the post make three matching slots, one at 120°, one at 240°, and the last cut at 360° (see fig. 320). When the slots have been cut, the area of the post on either side of each slot must be flattened so the end of the leg will fit flush against it (see figs. 319 and 320).

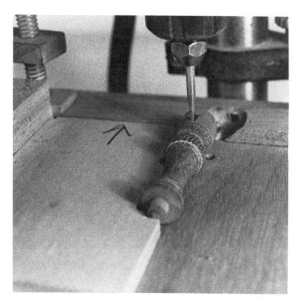

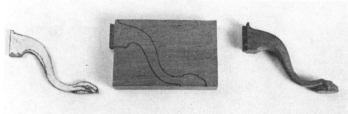

315. Stages in carving a serpentine, egg-and-claw-leg; notice the dovetail is cut before the leg is jigsawed out.

314. Cutting a dovetail slot in the base of the turning for the legs; notice the jig cutout to match the profile that feeds the work into the inverted-cone burr.

The turned post is now complete, and work can begin on the three legs. Figure 315 shows the steps involved in making an egg-and-claw leg. The template is shown on the left, the dovetailed stock in the center, and the finished leg on the right. Although these legs are quite elongated, their construction is similar to the cabriole leg description given in chapter 4, figures 104 through 107, pages 49 and 50. The dovetail cut into the post end of the leg is unique, however. The important part is to cut the dovetail first and then jigsaw out the leg. The dovetail is cut on the drill press using an inverted-cone burr (see chap. 12, fig. 244, p. 124).

After the dovetails have been cut on the end of the stock, the side profile legs can be jigsawed out. The top profile must be cut by hand using burrs and files. Use the elevation and bottom view (lower left) on the plans as guides to shape the legs. Work on the three together so they can be compared to each other as you progress. Once the shape of the legs has been obtained, the egg-and-claw feet can be carved. The basic layout of the egg-and-claw is achieved with a #11 scalpel (fig. 316). Cut away only a small amount of wood at a time. It may sound obvious, but it is much wiser to work slowly, to cut away a small bit at a time than to attempt patching an area that has been carved too deeply. When the legs have a look similar to a claw clutching an egg, finish the carvings with small riffler files and sandpaper (fig. 317). Figure 318 shows a finished egg-and-claw carving.

Before the legs can be assembled, the decorative cuts must be made on the flat area underneath the knee and on the bottom of the center post. Use a #11 scalpel and a small, round burr to carve these designs (see fig. 321).

Now the three legs can be attached to the center post (fig. 319). Be sure that the legs divide the circumference of the bottom of the center post into equal thirds (fig. 320). It is also important that the center post be perpendicular to the floor (fig. 321).

316. Carve the egg-and-claw foot with a #11 scalpel.

317. Finish the egg-and-claw carving with a small, straight riffler.

318. Finished egg-and-claw foot after sanding.

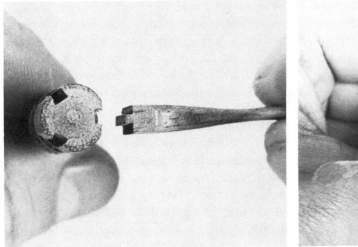

319. Fitting the leg dovetail into the post.

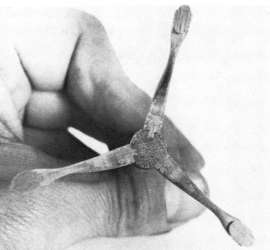

320. All three legs assembled on the post.

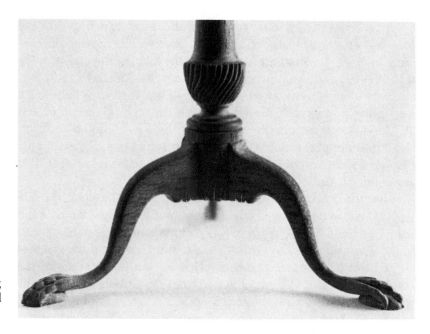

321. Detail of the finished legs and post; notice the carved design on both legs and post where they meet.

322. Top post piece; notice the hole for the top pin hinge.

The post block can now be cut, and the hole can be drilled in the center for the center-post peg. Before the block is sanded, drill holes into opposite sides near the upper edge of the post block for the top hinge pins (fig. 322). Use a #74 drill bit and drill the holes carefully; they are so close to the edge that any slip will either crack the wood or break the tiny drill bit in the hole. When the holes are completed, sand the block, especially the end grain, and glue it to the center post. Be sure the block is turned on the post pin so that when the tabletop is tilted upright, it centers on an imaginary line drawn between two legs (see fig. 302). The upright top should not center on just one leg.

The tabletop is cut from a single piece of 1/16" stock. Choose this piece of wood carefully, not only for grain but also for any warp or cup in the wood. Jigsaw out the circle and sand the edges smooth.

Cut the two top braces and taper the ends as shown in the plans and figure 323. Cut two small pins so they protrude 1/32" beyond the sides of the post block. Center the top braces on either side of the post block, making sure the top of the brace is flush with the top of the post block. Apply pressure to the braces forcing the protruding pins into them, thus marking the location where the hinge holes should be drilled. After drilling the holes, check their location using small pins for the hinges. The braces can now be sanded and glued to the underside of the tabletop. It is important that the braces fit over the post block and that they run across the grain of the tabletop to help keep the top from warping (see fig. 323). The assembled braces should look like those in figure 324. Before permanently hinging the top to the post block, a hold-down latch must be made. This latch is shaped like a squat T and is held in place by a small pin driven into the tabletop (fig. 325). To check the location of the latch,

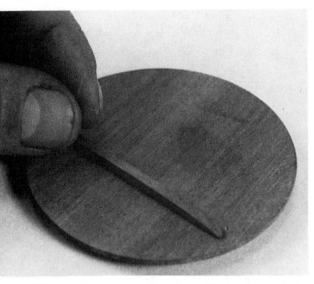

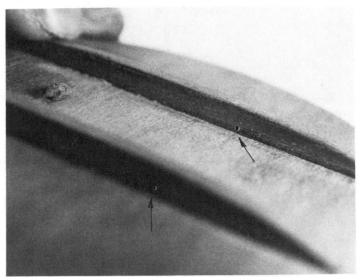

323. Apply the support strip to the top; note that the strip runs across the grain of the top.

324. Arrows indicate holes drilled in the top braces.

temporarily assemble the pin hinges in the post block. Center the top over the post block and push a pin through each of the top braces into the corresponding hole drilled into the post block (fig. 326). The latch can now be accurately placed. Locate the area on the post block where a groove for the latch must be cut (see right side of post block, fig. 326).

Remove the hinge pins from the top braces and secure the latch in the proper spot. Use a #11 X-acto knife and a flat riffler file to cut the groove in the post block for the latch.

The top can now be hinged permanently to the post block by pushing the hinge pins flush with the top braces (see fig. 326).

The Chippendale tilt-top tea table can now be given a final sanding with 320 grit sandpaper and finished as described in chapter 6, pages 59 to 63.

325. Detail of the turn latch that holds the tabletop down.

326. Completed top assembly showing the pinned hinge.

→ *327*. Finished bombé chest, three-quarter view.

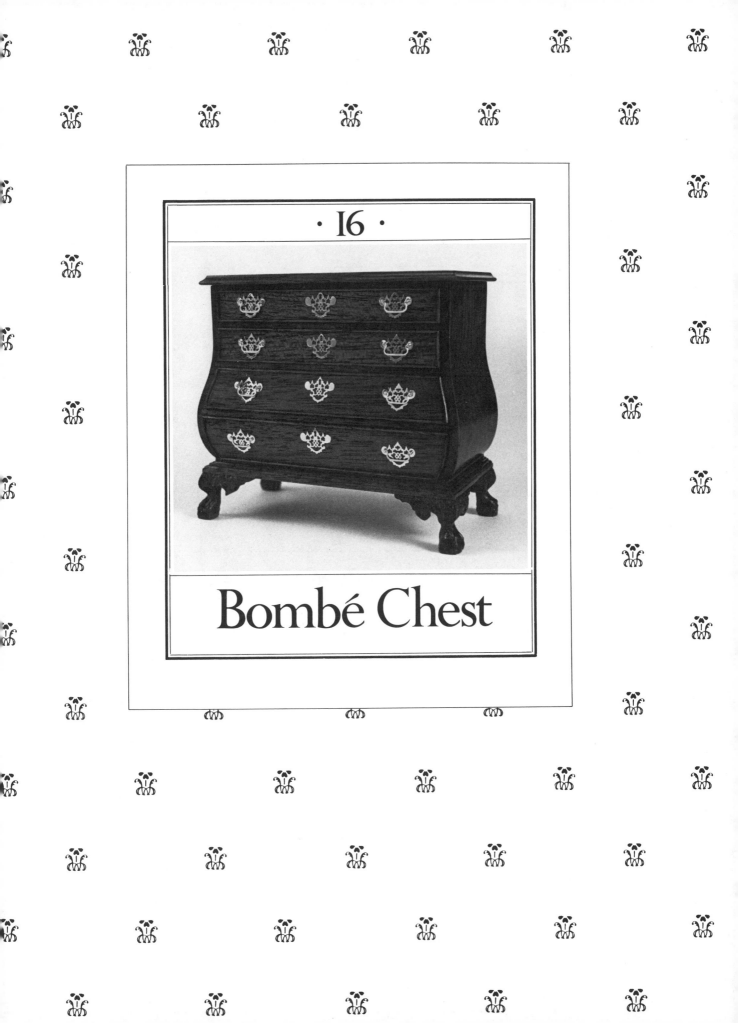

· 16 ·

Bombé Chest

Bombé Chest

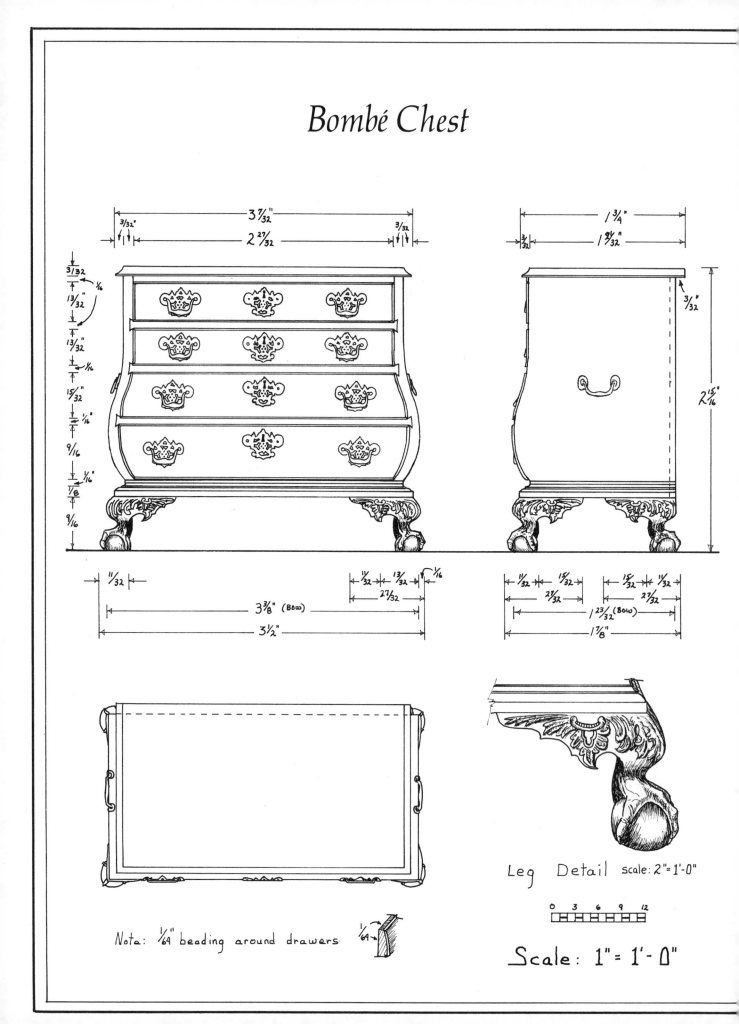

Leg Detail scale: 2" = 1'-0"

0 3 6 9 12

Nota: 1/64" beading around drawers

Scale: 1" = 1'- 0"

MATERIALS LIST			
mahogany	*thickness*	*width*	*length*
2 sides (finish to ³⁄₃₂″ thickness)	⁵⁄₁₆″	1¾″	2⁹⁄₃₂″
1 top	³⁄₃₂″	1¾″	3⁷⁄₃₂″
1 top drawer divider	¹⁄₁₆″	¼″	2¹⁵⁄₁₆″
1 second drawer divider	¹⁄₁₆″	¼″	2³¹⁄₃₂″
1 third drawer divider	¹⁄₁₆″	¼″	3³⁄₁₆″
1 base	³⁄₁₆″	1⁹⁄₁₆″	2²⁷⁄₃₂″
1 top stretcher	¹⁄₁₆″	1³⁷⁄₆₄″	2²⁷⁄₃₂″
1 backboard (total width)	¹⁄₁₆″	2⁹⁄₃₂″	3³⁄₁₆″
4 legs	⁹⁄₁₆″	1″	1″
1 base molding	⅛″	⁵⁄₃₂″	10″
1 top drawer	⅛″	1³⁄₃₂″	2²⁷⁄₃₂″
1 second drawer	⅛″	1³⁄₃₂″	2²⁷⁄₃₂″
1 third drawer (finishes to ⅛″ thick)	⁵⁄₁₆″	1⁵⁄₃₂″	3⅛″
1 bottom drawer (finishes to ⅛″ thick)	⁵⁄₁₆″	⁹⁄₁₆″	3⅛″
1 drawer beading	¹⁄₆₄″	³⁄₃₂″	36″
6 drawer glides (cut from a 12″-long piece)	¹⁄₁₆″	¼″	12″

Drawer interiors are of basswood or pine: lower two drawer sides from ¼″ stock; all other drawer sides and backs from ³⁄₃₂″ stock. Drawer bottoms from ¹⁄₃₂″ stock.

328. Finished bombé chest, side view.

A bombé chest is an unusual piece of furniture because both the front and the sides swell in a kettlelike shape. This Chippendale bombé chest in the Museum of Fine Arts in Boston, Massachusetts, also boasts elaborate brass Chippendale escutcheons, which are an important contribution to the overall style of the piece. The construction of this miniature is challenging because the bowed sides must be shaped from an oversize piece of stock, and the pierced escutcheons must be made from thin pieces of brass.

To begin the chest, rough-cut the stock pieces from fine-grain mahogany using the materials list as a guide. Be sure you use the finest kiln-dried mahogany you can obtain.

The first step is to reduce the oversize side stock to the necessary bowed shape. To do this accurately, you must cut both an inside and an outside template as shown in figure 331. These templates are made of ½″ plywood or other scrap stock, using the profile of the chest shown in the front view of the plans.

Once the templates are completed, the process of reducing the ⁵⁄₁₆″-thick stock to the finished ³⁄₃₂″-thick shape of the chest involves the stages illustrated in figure 329. The piece to the far left in figure 329 shows where the straight areas have been cut on a circular saw. These cuts can be made by hand if a circular saw is not available. Be

329. Stages of shaping the sides.

careful not to cut into the area of the flare. Mark the stock with the template before making any cuts. The next step is to begin shaping the flare with a 1″ drum sander held in a flexible-shaft machine (fig. 330). Work slowly, constantly checking what you have done against the templates (fig. 331). It is important that you not only watch the shape of the flare but that you also make sure the sides are not dome-shaped or cupped. Use a straightedge as shown in figure 332 to be sure the surface you are working remains flat.

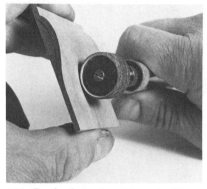

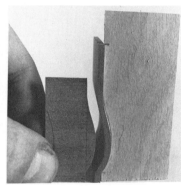

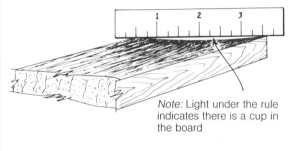

Note: Light under the rule indicates there is a cup in the board

330. Basic shape is achieved with a 1″ drum sander.

331. Make templates to check the progress of the side shape.

332. Sketch of the method of checking for a cup or a dome in the stock.

333. Finish the side with sandpaper wrapped around a 1″ dowel.

Once the shape of the flare has been attained, finish sanding the side with 150 grit open-coat aluminum oxide sandpaper wrapped around a 1″-diameter dowel (fig. 333). Follow with 220 grit paper in the same fashion.

When you have finished, both sides must be symmetrical. If you have used the templates as guides, there should be no problems. The dadoes for the drawer glides can now be cut into the sides. Figure 334 illustrates how these cuts are made on the shaper. An inverted-cone dental burr, slightly smaller than the 1/16″ stock used for the drawer glides and dividers, is used to make the dovetail-shape cuts. As figure 334 shows, the cutter will have to be raised to make the

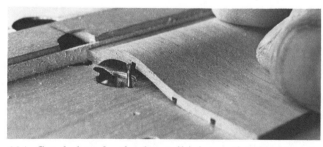

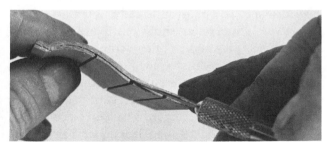

334. Cut dadoes for the dovetail joint on the shaper; note that the blade must be adjusted for different cuts.

335. Use a #11 knife to cut the groove for the back.

dado in the flared portion of the side. The 1/16″-deep dado for the back must be cut by hand with a #11 X-acto knife (fig. 335). Cut the stock away a little at a time. Be especially careful when cutting with the grain along the side, for if you put too much pressure on the blade, you will cut through the wood completely.

Before the drawer glides can be set into the dadoes in the side, they must be shaped to fit. Set up the shaper with a small inverted-cone burr and cut a dovetail along the length of one side of each glide that will fit snugly into the dado cut into the side of the chest (fig. 336).

When the glides have been glued to the sides, the drawer dividers, which have been dovetailed on the ends to match the glides, can be glued into place along with the base and the top stretcher (fig. 337). It is to be noted that the top stretcher board protrudes 1/64″ beyond the front edge of the sidepiece. Only the top piece protrudes in this manner, the other four front structural members are flush with the front edge of the side (see plans, side view).

With the front and the sides of the basic carcass assembled, the back can be cut from 1/16″ stock to fit into the handmade groove on the back edge of the sides (fig. 338).

The carcass can now be set aside and the glue allowed to dry while work is begun on the four carved legs. Figure 339 shows one of the legs just prior to being completely cut out on the jigsaw. Notice the tiny areas of uncut stock that have been left to hold the block together until all the cuts have been made. Also notice how the upper cut on the left side of the block, indicated in figure 339 by the arrow, does not follow the pattern line below the knee. This cut is made from the edge of the knee to the center of the foot to avoid cutting the ear on the knee bracket at too sharp an angle inward. Remember, the saw is cutting the entire side of the leg at once. The area below the knee must be hand-shaped to the proper angle after the piece has been cut out.

Figure 340 illustrates the different stages in carving the claw-and-ball foot. The piece on the far left shows the area under the knee sanded to the proper angle and the foot rounded over. The next piece shows the ball roughly indicated by the use of a #11 scalpel. In the third piece from the left the claw-and-ball have been fully developed with rifflers and the scalpel. The completed leg on the far right has been carved on the knee and the knee bracket with a flexible shaft and a tiny round burr and finished with riffler files and sandpaper.

336. Detail of dovetail on drawer glide.

337. Insert the dovetailed drawer dividers to butt against the drawer glides.

338. Cut the back to the shape of the opening; note that the back consists of several pieces glued together.

339. Leg block showing the areas left uncut to hold the pieces together. Note the gap in the cuts on the front of the foot (arrow) so that the ears will not be cut in at too sharp an angle.

340. Stages in carving the ball-and-claw foot.

341. Cut away excess stock from leg.

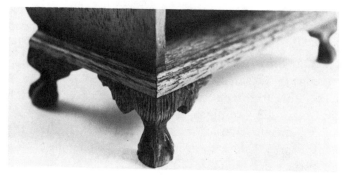

342. Burrs used to shape the bombé chest molding.

343. Detail of the legs glued to the carcass and lower molding.

The finished leg must now have the excess stock sawed from the backside, as shown in figure 341.

The next step in the construction of the bombé chest is to shape the molding around the base of the carcass. This work is done on the drill using the burrs shown in figure 342.

When the molding has been shaped and finished with riffler files and sandpaper, it can be mitered and glued into place at the base of the carcass. Once the glue on the molding has dried, the four finished legs can be glued into place as shown in figure 343.

The final step on the carcass is the shaping of the top. A small round burr is used to make the top portion of the cyma curve, and a straight riffler file is used to round over the bottom of the curve. Sand the top carefully and glue it into place. Notice how it overhangs the carcass on all four sides (see plans and fig. 328).

It is now time to begin the drawers. The top two drawers are done in the same fashion as all the other drawers in this book. The bottom two drawers, however, are like no others (see figs. 348 and 349). I shall therefore describe the construction of only the two bottom drawers.

After you have rough-cut the stock to the dimensions shown in the materials list, use the same template as used on the inside of the chest sides to draw a matching curve on the ends of each drawer. Cut the ends of the drawers on these lines and custom-fit each into the carcass. You will now have two blocks of wood that fit into the drawer opening. Carefully line up each drawer front with the front of the carcass and mark a pencil line on each surface where it meets the carcass. These lines are shown in figure 344. Remove each block from the carcass and mark the ³⁄₃₂″ drawer width on the edges of the boards. These two groups of lines indicate the outside and the inside of the finished drawer. Use a 1″ drum sander on a flexible-shaft machine and sand the inside of the drawer until it is flush with the inside set of lines. The drawers on the left in figure 344 have been brought to this stage. The groove for the bottom of the drawer and the pins of the dovetail joint can now be made. It is easier to make these cuts while the face of the drawer is still square. When you have

344. Make dovetail pins on the drawers after the inside of the drawer has been shaped.

completed the pins of the dovetail, the face of the drawer can be sanded to match the outside curve of the carcass (fig. 345). Figure 345 also shows the groove cut into the edge of each drawer to hold the 1/64″ banding. This banding can be made to go the entire thickness of the drawer if you desire. I make it this way for two reasons.

First and foremost, it is very difficult on a compound curve (a surface curving in two directions at the same time) to fit a drawer exactly when the thickness of the banding must be allowed for. Using my method the drawer is fitted perfectly as a solid piece and only a portion of the edge is removed for the banding.

The second reason is the tendency of the banding to splinter or tear off when the burr cuts into it to make the dovetail pins.

Therefore, I cut a 1/16″-high by 1/64″-deep groove around the finished drawer, into which I glue the tiny strip of banding. The grooves are cut on the shaper using a tiny inverted-cone burr (see chap. 18, figs. 428 and 429, p. 197). Be sure to do this operation also on the top two drawers while the shaper is set up. The grooves on the ends of the two lower drawers will have to be cut by hand because of the compound curves. Once the grooves have been completed, cut several long strips of 1/64″ stock, 5/64″ wide, and round over one edge to form a bead that will protrude beyond the drawer face (see chap. 11, fig. 239, p. 117, and fig. 346). Use a new, sharp #11 blade and miter the pieces of 1/64″ stock to the proper size along the top and bottom of each drawer. The banding for the side of the drawers must be shaped to fit the front and back curves from a wider piece of 1/64″ stock and then taped in place to match the face of the drawer curve, when glued. When the strips have all been secured, sand the outside edge of the banding flush with the edge of the drawer and make sure all the drawers fit properly.

The construction of the insides of the two lower drawers is as unique as their fronts are. The sides must be sanded from 1/4″-thick rough stock to a finished thickness of 3/32″. This is accomplished in the same manner as the drawer fronts. Mark the ends with the side template and sand the convex curve in the bottom drawer sides and the concave curve in the other drawer sides. When this is complete, cut an arc in the front edge of the sidepieces so it will butt against the drawer front when both pieces are in their correct upright position (fig. 347). Now the dovetails can be cut on this arc to match the pins on the drawer front (fig. 348). Finally, the back end of the drawer side must have a curved hand-cut rabbet cut into it, and the ends of the drawer back must be cut on a curve to match the sides. The finished drawers should look like those in figure 349. Needless to say, once you have mastered the construction of the lower drawers on this bombé chest, most other drawer construction will be child's play.

The finishing of the mahogany wood is covered in chapter 6, pages 62 and 63. Choose the color for staining the wood carefully. The mahogany of this era would be a rich, warm brown tone, not the ruddy tone of twentieth-century mahogany. If you are in doubt

345. Cut a tiny groove around the drawers for 1/64″ banding.

346. Detail of the drawer with finished banding.

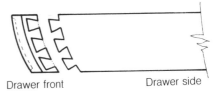

Drawer front Drawer side

347. Sketch showing how the drawer side is curved to butt the drawer front.

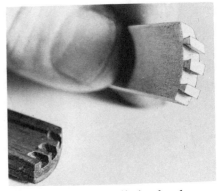

348. Cut the dovetails in the drawer side to match the curve of the drawer front.

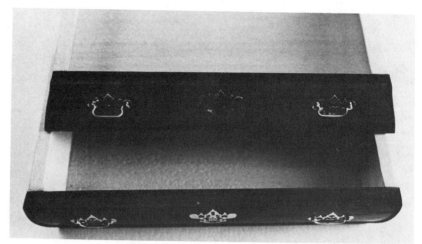

349. Detail of the convex- and concave-shaped lower drawers.

about the proper color, visit a museum or an antiques shop where American Chippendale furniture is exhibited.

The delicate, pierced-brass escutcheons (fig. 350) for this piece of furniture are extremely difficult to create, the open design being stamped out of $^4/_{1,000}''$-thick brass (see chap. 5, pp. 54–55). The optional pair of side handles shown in the plans may also be added to the bombé chest. These large bails were often made as an aid in moving the bombé chest.

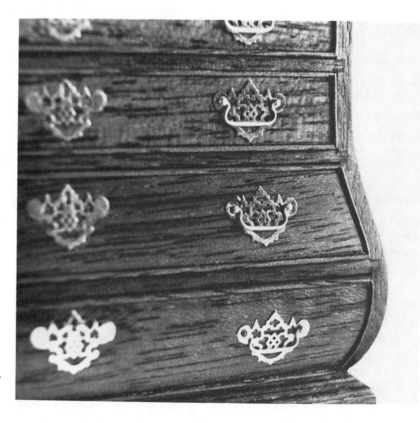

350. Detail of the hardware and drawer banding.

→ *351.* Finished broken-pediment highboy, three-quarter view.

Broken-Pediment Highboy

Broken-Pediment Highboy

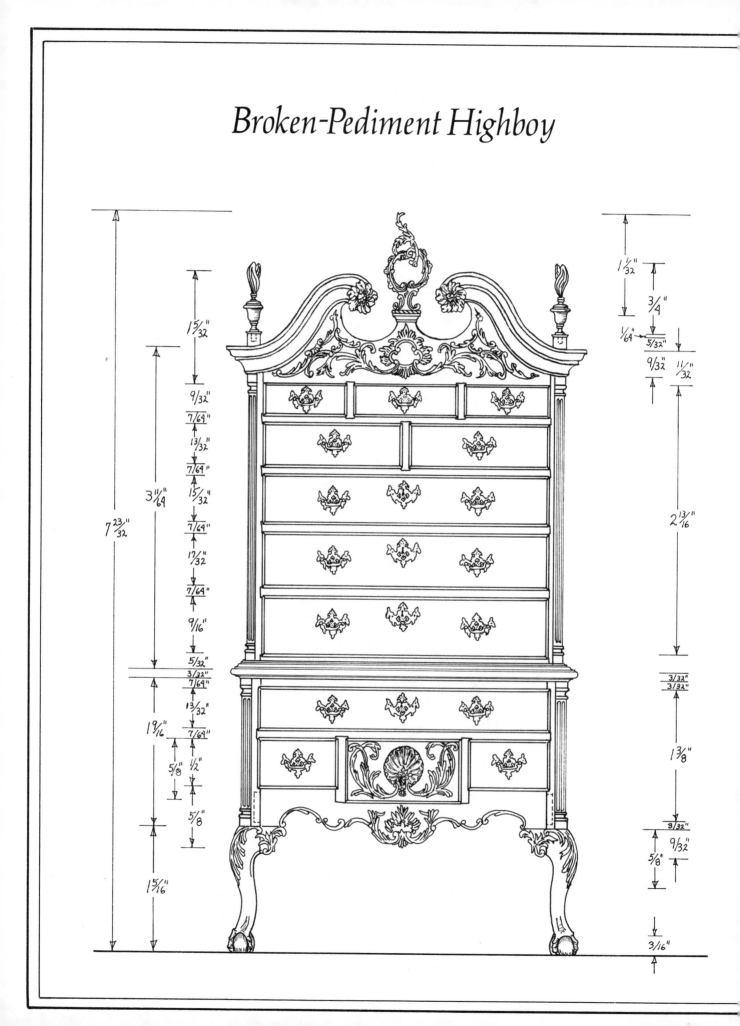

Side view

Top view

Quarter column detail

Center pull detail

Drawer detail

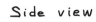

Scale: 1" = 1'-0"

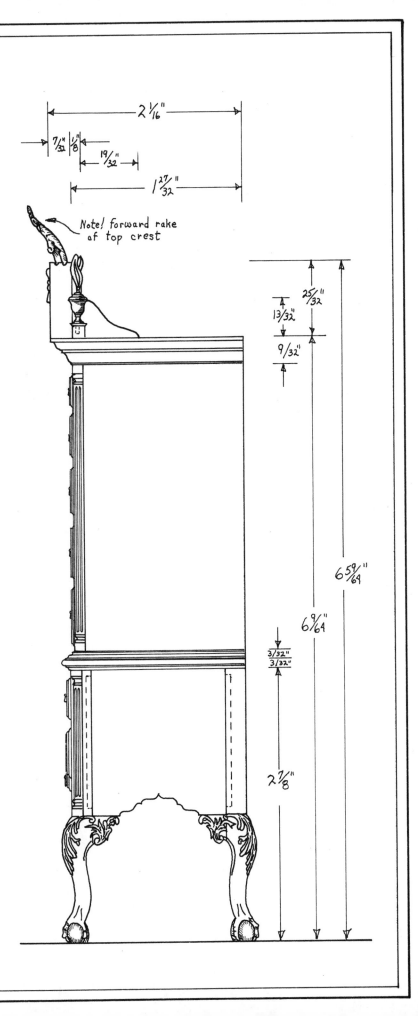

2 1/16"

7/32" 1/8"

19/32"

1 27/32"

Note! forward rake
of top crest

25/32"

13/32"

9/32"

6 59/64"

6 9/64"

3/32"
3/32"

2 7/8"

MATERIALS LIST			
mahogany	*thickness*	*width*	*length*
base			
4 legs	⅜″	⅜″	2⅞″
1 apron	⁷/₃₂″	¾″	3¹¹/₆₄″
1 drawer divider	³/₃₂″	⁷/₃₂″	3¹¹/₆₄″
1 front top brace	³/₃₂″	⁷/₃₂″	3⁵/₆₄″
2 vertical drawer dividers	³/₃₂″	⁷/₃₂″	2²/₃₂″
2 sides	⁷/₃₂″	1¹⁷/₃₂″	1⁷/₁₆″
4 side drawer glides	³/₃₂″	⁵/₁₆″	1²⁹/₆₄″
2 center drawer glides (cut from one 4″ piece)	¹⁵/₃₂″	½″	4″
1 back	⁷/₃₂″	1¹⁷/₃₂″	3¹¹/₆₄″
2 side quarter columns (cut from one 4″ piece)	⁵/₁₆″	⁵/₁₆″	4″
2 column ends	⅛″	⅛″	³/₃₂″
8 knee brackets	³/₃₂″	⅜″	⅜″
1 top	³/₃₂″	2″	3²³/₃₂″
1 top molding (mitered to fit)	³/₃₂″	⅛″	10″
1 top drawer	⅛″	¹⁴/₃₂″	3⅛″
2 side bottom drawers	⅛″	¹⁷/₃₂″	⅞″
1 center drawer	⅛″	2¹/₃₂″	1⁷/₃₂″
top			
2 sides	³/₁₆″	1²⁷/₃₂″	3¹¹/₃₂″
1 top	⅜″	1⅝″	3⅛″
1 bottom	⁵/₃₂″	1²⁵/₃₂″	3⅛″
4 drawer dividers	⁷/₆₄″	⁵/₁₆″	3⅛″
1 scroll backboard	⅛″	1⁵/₁₆″	3⅛″
2 top post blocks	³/₃₂″	³/₃₂″	¹¹/₃₂″
2 bottom post blocks	³/₃₂″	³/₃₂″	³/₁₆″
8 side drawer glides	³/₃₂″	⁵/₁₆″	1¹⁵/₃₂″
2 top vertical drawer dividers	³/₃₂″	⁵/₁₆″	1³/₃₂″
1 middle vertical drawer divider	³/₃₂″	⁵/₁₆″	1⁷/₃₂″
1 back (can be several pieces)	¹/₁₆″	3⁵/₁₆″	3¼″
2 scroll backboard braces, large	⅛″	¹³/₃₂″	1⁹/₃₂″
2 scroll backboard braces, small	¹/₃₂″	⅛″	³/₃₂″
3 center drawer glides	⅜″	⁷/₁₆″	8″
2 quarter columns (cut from one 4″ piece)	⁵/₁₆″	⁵/₁₆″	4″
2 finials	⁵/₁₆″	⁵/₁₆″	1½″
2 finial posts	⁵/₃₂″	⁵/₃₂″	⁵/₃₂″
2 finial post caps	¹/₆₄″	³/₁₆″	³/₁₆″
1 crest base	³/₃₂″	⁵/₃₂″	⁵/₁₆″
1 center crest	⅜″	¾″	1½″
1 crest back brace	³/₁₆″	³/₁₆″	⅝″
2 top ogee moldings	⁷/₃₂″	2″	4″
2 top side moldings	⁷/₃₂″	⁹/₃₂″	6″
2 molding rosette plugs	⁵/₁₆″	⁵/₁₆″	³/₁₆″
2 rosettes (cut from one 2″ piece)	⅜″	⅜″	2″
2 outside top drawers	⅛″	¹¹/₃₂″	²⁹/₃₂″
1 center top drawer	⅛″	¹¹/₃₂″	1⅛″
2 second drawers	⅛″	¹⁵/₃₂″	1½″

mahogany	thickness	width	length
top			
1 third drawer	1/8″	17/32″	3 3/32″
1 fourth drawer	1/8″	19/32″	3 3/32″
1 bottom drawer	1/8″	5/8″	3 3/32″

All applied carvings from 1/64″ stock; all drawer interiors from 3/32″ softwood; all drawer bottoms from 1/32″ softwood.

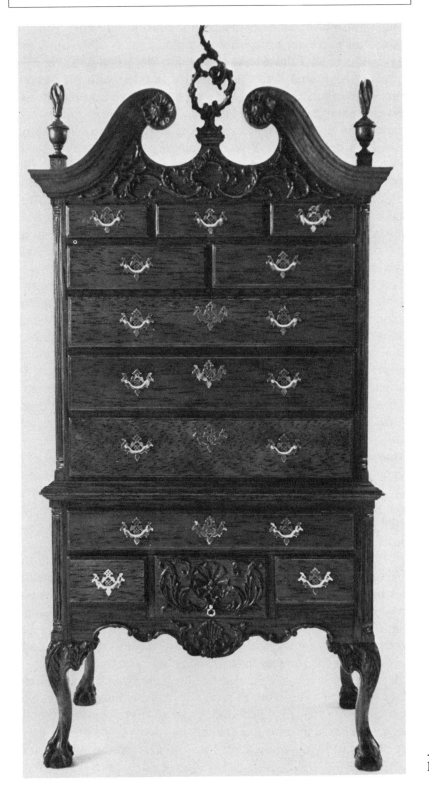

352. Finished broken-pediment highboy, front view.

The original of this magnificent Chippendale broken-pediment highboy is in the Museum of Fine Arts, Boston, and is considered to be one of the finest examples of a Philadelphia highboy. It is flawless in design and proportion and constructed of beautifully figured mahogany.

Creating a miniature of this superb piece of furniture is a challenging adventure that should be undertaken only after you have gained the necessary experience by building many of the other projects in this book. I should like to mention that I assume anyone who is ready to proceed with this project is familiar with the basics of miniature cabinetmaking; therefore I shall not go into full detail in the elementary areas of construction, but rather refer you to those chapters in this book that explain the steps involved. Before proceeding, I hope that all of you, no matter at what stage of creating miniatures you are, will read this entire chapter and study the illustrations *before* beginning construction.

To begin the project, rough-cut the stock for the highboy base as indicated on the materials list. Because there are so many pieces involved, cut only the base pieces at this time. It is very important that you choose your mahogany carefully. It must be close-grained with as small pores as possible. Many of the applied carvings are only 1/64″ thick, and large pores would make the mahogany very difficult to work. If you are using old wood, be sure it is not so dry that the wood is brittle. For years I saved an extremely old piece of beautifully figured Cuban mahogany waiting for just the right piece of miniature furniture to make from it. When I finally cut into the block of wood, it crumbled into coarse powder before my eyes. The wood had become so brittle with age it was useless. The wood you select must be kiln-dried and free of checks and hairline cracks. After you have chosen the lumber and rough-cut the stock, work can begin on the construction of the base of the highboy. The construction of the carcass base is very similar to the construction of the Queen Anne lowboy described in chapter 12, figures 242 through 255, pages 124 through 127. I suggest you read this chapter before you continue if you are unfamiliar with the methods involved. I shall refer to this chapter often in the construction of the highboy base.

Figure 353 illustrates the stages in carving a claw-and-ball foot. Using the plans as a guide, transfer the leg design to a piece of 1/32″ hardwood, which will be used as a template. Jigsaw out the template and trace around it on two adjacent sides of each piece of leg stock (fig. 353 and chap. 12, fig. 246, p. 125). When the pattern has been drawn on the leg stock, the mortises must be cut for the apron, sides, and back tenons. Use an inverted-cone burr and the drill press (see chap. 12, fig. 247, p. 125) to cut the apron mortises. The longer mortises can also be cut with this setup, or by using the small saw blade shown in chapter 12, figure 245, page 124. Whichever method is used, make sure the mortises are only 3/64″ deep. If you go any deeper on the front legs, you will cut into the area of the side columns.

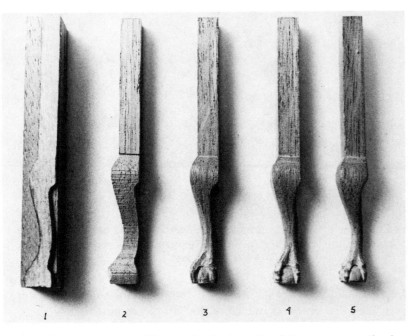

1 2 3 4 5

353. Stages in the making of the claw-and-ball cabriole leg.

Using the plans as a guide, mark the length of the tenon on the leg before making any cuts. The slot on the two front legs for the drawer divider is cut with a ³⁄₃₂″-diameter straight burr. Mark the location carefully, then cut the slot on the drill press as shown in chapter 12, figure 243, page 124. Chapter 12, figure 247, page 125, shows how the finished cut should look. When the mortises are complete, jigsaw out the four legs, cutting along the template lines. Cut slowly and carefully; wandering off the line can mean recutting and mortising a new leg. Remember to leave small uncut areas to hold the stock together until all cuts have been made. Step 2 in figure 353 shows how the leg should look when jigsawed out. In step 3, figure 353, the leg has been rounded with a knife and files, and the claw-and-ball has been roughed out. Step 4, figure 353, shows the claw after using both round and flat riffler files to bring out detail in the claws. In step 5, figure 353, a #11 scalpel has been used to separate the claw from the ball and to define the toes. This leg has been sanded with 220 grit sandpaper to finish the carving. These five steps must be followed on each of the four legs (see chap. 12, figs. 250 through 252, p. 125).

The next step is to cut out the eight knee brackets and glue them into place on the cabriole leg. On the left in figure 354 the bracket is shown cut on the rough stock. In the center of figure 354 is the cut-out bracket, and the right side of figure 354 shows the bracket glued into place, sanded to match the knee, and with the leafage design penciled in. A vernier caliper with a depth gauge is used to check the location of each knee bracket (fig. 356). It is important that each bracket be exactly the same distance from the top of the leg to be sure it butts against the apron, sides, and back. Figure 355 shows the rough knee brackets glued to adjacent sides of the leg. Figure 356 shows the brackets sanded to match the curve of the knee. Check the apron, sides, and back to be sure each knee bracket is set in the

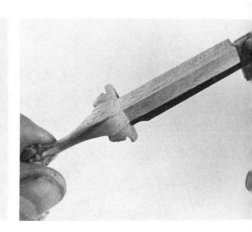

354. Stages in the making of the knee bracket on the cabriole leg.

355. Rough knee bracket placement on the cabriole leg.

356. Sanded knee brackets with a depth gauge checking the placement.

proper place. If necessary, add to or remove tiny amounts of stock from the knee brackets to ensure that all pieces butt tightly against them while fitting flush with the top of the leg.

Figure 357 shows a simple jig holding the leg while you are carving it. The hole in the jig allows the leg to set flat. At this time the groove for the quarter column should be cut in the upper portion of the leg. This groove, which begins ⅛″ above the knee, must be cut by hand ⅛″ in on either side of the straight section of the leg. Mark the stock, then using a steel straightedge as a guide, score the area to be cut away with a #11 knife (fig. 358). When you have scored ¹⁄₁₆″

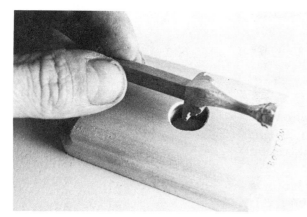

357. Jig for holding a cabriole leg while carving it.

358. Use a knife and a straightedge to cut the groove for a quarter column.

deep, carefully cut away the stock between the edge of the leg and the line. A perpendicular cut must be made across the leg ⅛″ above the knee to end the groove. When you have cleaned out the necessary ¹⁄₁₆″ of stock, forming a shallow groove, score down the balance of the ⅛″ depth and remove the remaining wood to create the completed groove. The ⅛″ depth cannot be scored at one time, or the leg will crack. Finish the two inside surfaces with a flat riffler file (fig.

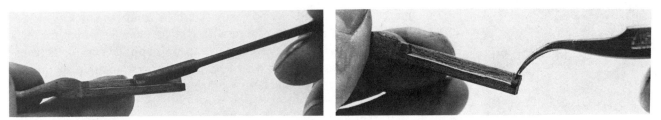

359. Flatten the bottom of the quarter-column groove with a flat riffler file.

360. Glue the column end block in the groove.

359). After you have completed the groove, glue the column end block at the top of each column (fig. 360). You now have an open area ⅛″ square and 1¹¹⁄₃₂″ long in each front leg, which will contain the quarter columns (see figs. 362 and 368). When the brackets are all in place and finished flush with the knee, the leafage design can be drawn on each side of the leg, (see right side, fig. 354). Be sure the designs on either side of the leg match and that the designs on the individual legs match each other. It is much easier to change a pencil line now than to change a line carved into the mahogany later. Figure 361 shows in detail the designs to be carved into the legs. It is not necessary to carve the side of the knee or knee brackets that face toward the wall. Yankee conservatism considered it a misuse of time to elaborate on areas that could not be seen. Along with figure 361, use the plans and figures 362, 367, 368, and 412, page 186, to assist you in carving the legs. If you need assistance with the actual process of carving, see chapter 23, figures 536 through 541, page 247.

When you have completed all four legs, you can proceed to the construction of the carcass. The first step is to cut a ³⁄₆₄″ tenon on either end of the apron, sides, and back. The sizes given in the materials list include the additional ³⁄₃₂″ necessary for both the tenons.

Shape the tenon on either end of the apron as shown in chapter 12, figure 242, page 124. Next shape the tenon on either end of the back and sidepieces as shown in chapter 12, figure 244, page 124. Be sure the tenons fit into the previously cut mortises. I always cut an extra sidepiece that I use to check the setup of the machine; this way any necessary adjustments can be made without ruining the actual carcass stock. This same extra sidepiece can be used to check the drill press to cut the dadoes for the drawer glides (see chap. 12, fig. 243, p. 124). When you have completed all of the above cuts, the design on the sides and the apron can be jigsawed out (see plans and figs. 365 and 366).

Be sure the width of the opening for the center drawer includes the two ³⁄₃₂″ vertical drawer dividers, and jigsaw out the slots for these pieces in the apron. Cut ³⁄₃₂″-wide by ³⁄₆₄″-long slots in the horizontal drawer divider to match the location of those in the apron. The lower front assembly can now be glued together (see fig. 365).

Figure 363 shows four pieces of ¹⁄₆₄″ stock temporarily held together with rubber cement. These pieces can now be cut out as one. Be sure to use household rubber cement, which lightly holds the

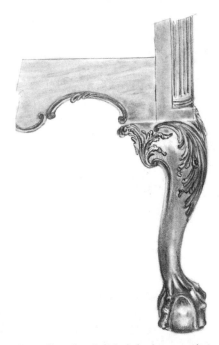

361. Sketch of cabriole leg carvings.

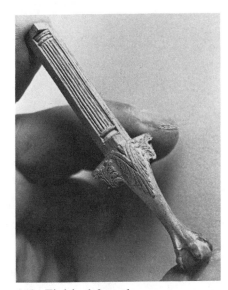

362. Finished front leg.

363. Several ¹⁄₆₄″-thick boards held together with rubber cement so they may be sawed as one piece.

364. Fretsaw out the tiny carving blanks.

pieces together and can be easily removed from the stock. This adhesive should not be confused with contact cement, which makes a permanent bond. The design of the apron's applied carving is transferred to tracing paper, which is then rubber-cemented to the top piece of ¹⁄₆₄″ wood. Because you are cutting several pieces at once, any duplications in the design need be traced from the plans only once. The two C-shaped scrolls (see fig. 365) on either side of the center design will be identical if you use the stacked-board method I have just described. The tiny pieces of applied work are then carefully cut out using a fretsaw. Hold the work against a bench pin and use an ultra-fine-toothed blade with the teeth pointing toward the handle (fig. 364). This technique is used on all the applied carvings on this piece of furniture.

When the applied pieces for the apron are cut out, carefully separate the ¹⁄₆₄″ pieces of stock with a knife and glue them into place (see fig. 382, p. 180). Cutting four pieces at once not only gives you matching left and right pieces but also provides extras should you damage any before they are glued to the carcass pieces. When the applied pieces are glued onto the apron, the front assembly should look like figure 365.

The applied pieces must now be carved, using small, round and inverted-cone burrs, a #11 scalpel, and small riffler files. Figures 384 and 385, page 180, illustrate the use of the cutting tools on applied carvings; figure 366 is a detail of the area being carved.

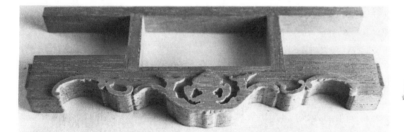

365. Lower carcass apron with rough applied work.

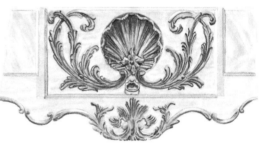

366. Detail sketch of the lower drawer and apron carvings.

When you finish the applied carving, the base carcass can be assembled. Glue the back to the back legs and the apron assembly and the top brace to the front legs. Be sure the assemblies are square and the inside edges of the legs are parallel to each other. Allow several hours for the glue on these pieces to dry and then assemble them with the two sides. Again, make sure everything is square and that the legs all set flat on the floor before the glue sets up (fig. 367).

Figure 368 shows the compound center-drawer glides. These glides are cut on the shaper using a heavy-duty straight burr. Be sure to check the height of the outside and inside glides against the assembled carcass. A finished glide is shown at the lower right in figure 368. Cut the two pieces to a custom fit from the piece of 4″ stock and glue them into place inside the carcass.

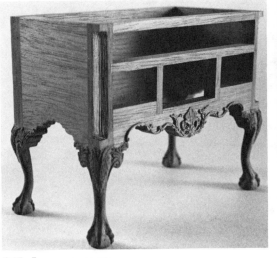

367. Lower carcass.

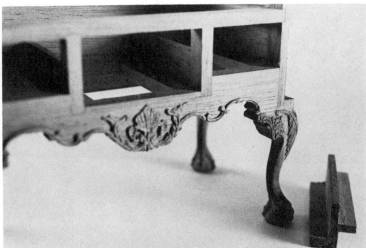

368. Lower carcass; note the compound drawer glide (lower right).

Figure 369 is a detail of the top molding of the base. As the illustration shows, the lower part of the design is cut into the edge of the carcass top, the balance is a separate piece of molding that is mitered and glued to the top (fig. 370). Do not miter the molding until you have constructed the basic upper carcass. The upper carcass must fit snugly into the opening created by the molding.

With the exceptions of the top molding discussed above, the quarter columns, and the drawers, which will be made at the same time as the corresponding pieces on the upper carcass, the lower carcass is now virtually complete.

To begin the upper carcass, rough-cut the stock using the highboy top section of the materials list as a guide. The first step is to cut the rabbets for the top and bottom and the dadoes for the drawer glides using the same drill press setup as was used on the sidepieces of the base (fig. 371). Next, cut the groove for the back on the shaper (fig. 372). Use a heavy-duty straight burr, cutting the groove 1/16″ deep and 1/16″ wide. The final cut to be made in the side is the groove for the quarter column. This is a simple operation compared to the

369. Sketch of the base moldings.

370. Finished top and molding on the lower carcass.

371. Sides of the upper carcass showing the dadoes for the horizontal pieces and the groove for the back.

373. Upper carcass side showing the groove for the column and the end blocks.

372. Shaper setup for cutting the groove for the back and the column in the carcass side.

374. Detail of the side drawer glides.

grooves cut into the legs. Use the same shaper setup as you used for the back groove, adjusting the burr to cut a ⅛″-square groove (fig. 373). Next, cut the top and bottom post blocks and glue them into place (figs. 373 and 374). Now the side drawer glides can be glued into position (fig. 374). The top, bottom, and backpieces can now be assembled to form an open boxlike structure.

The scroll-top backboard is cut from ⅛″-thick stock after the appropriate template has been made (fig. 375). Note that in figure 375 I have marked the right side of the template. I use only one half of the template design to be sure both sides of the finished piece will be identical. Trace around one-half the design, then flip the template over and trace the same half of the design on the other half of the stock. The design can now be jigsawed out (top, fig. 375).

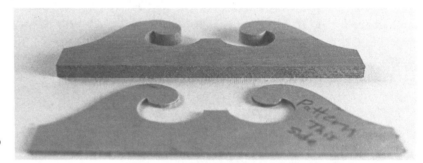

375. Template and rough-cut scroll-top backboard.

After you have sanded the ogee scrolls smooth and rounded over the back edges of the upper portion of the scroll, cut the drawer dividers and dry-fit them in the dadoes in the basic carcass for size. When they all fit snugly, the upper two must be slotted for the vertical drawer dividers. Set up the shaper to the width of the side drawers plus the ³⁄₆₄″ of the side dado and cut a ³⁄₆₄″-deep slot into both the scroll-top backboard and the top drawer divider. These slots must match exactly, or the vertical members will be at an angle.

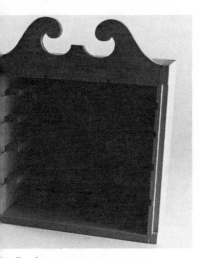

. Basic upper carcass.

377. Detail of setting the vertical drawer dividers in the carcass.

378. Detail of the T-shaped center drawer glides.

Dry-fit the pieces and check the fit; if they match, glue the scroll-top backboard into place (fig. 376). Reset the shaper to cut a slot into the center of the two upper drawer dividers. Be sure the slot is on the opposite side of the two just cut in the top divider (fig. 377). When all of the slots have been cut, the drawer dividers can then be assembled. Figure 377 shows the notch taken out of the top two vertical drawer dividers. The higher portion fits into the slot, the lower portion butts against the top board.

After the three vertical drawer dividers have been glued into place, the center-drawer glides can be shaped with a heavy-duty burr on the shaper (fig. 378). These pieces are then cut to fit between the drawer dividers and the back and glued into place (fig. 379).

The next step is to cut the scroll backboard braces and glue them into place as shown in figure 380. This completes the basic highboy top carcass, now the applied moldings, columns, and carvings must be added.

379. Finished drawer dividers with the drawer glides installed.

380. Braces for the scroll-top backboard.

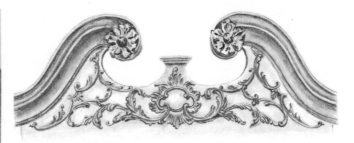

381. Sketch of the upper applied carving.

The top applied carving (fig. 381) is cut out in the same fashion as those for the base. First, temporarily glue several pieces of 1/64"-thick mahogany together (see fig. 363, p. 176). Next, transfer the applied designs on the plans onto tracing paper and rubber-cement the

tracing paper to the stack of 1/64" stock. Carefully fretsaw out the design as shown in figure 364, page 176, then separate the 1/64" cutouts with a #11 scalpel (fig. 382). When all of the cutouts are complete, glue them to the carcass (fig. 383). Notice I have indicated in pencil the location of the top ogee moldings to ensure that the applied work will be placed properly.

The process of carving the tiny scrolls must be done with great care. There must be no excess pressure applied to the cutter or it will either cut away too much of the delicate design or slip and cut into the carcass. Take your time, carving designs of this size is tedious, but the results (see fig. 404, p. 184) are well worth the time. Begin by roughing out the basic elements of the design with a small round burr. Separate the different scrolls and delineate the major veins that run through the larger areas of the design (fig. 384). Figure 381 should help you in carving this design. When the elements of the design have been separated and molded with rotary burrs, use a #11 scalpel to carve the finer details and sharpen the round edges left by the burrs (fig. 385). The finished carving is shown in figure 404.

382. Use a knife to separate the cutouts held together with rubber cement.

383. Rough applied carving glued to the carcass.

384. Beginning the carving with a flexible shaft and a round burr.

385. Finish the applied carving with a #11 scalpel and riffler files.

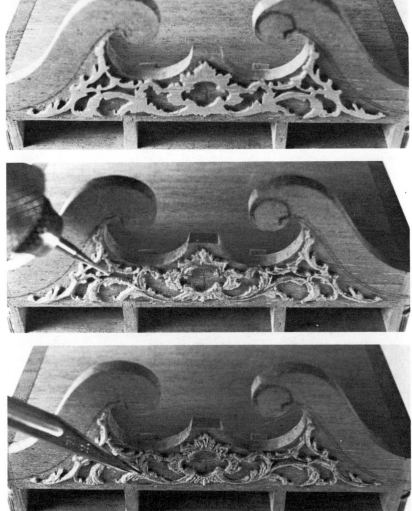

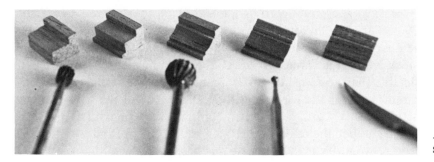

386. Stages and burrs used to cut the top straight and ogee moldings.

Figure 386 illustrates the different burrs used to shape the straight and ogee moldings around the top of the upper carcass. The drill press setup for the ogee-shaped molding is the same as that used for the molding on the Victorian Renaissance Revival bed (chap. 24, fig. 554, p. 259). The rough-cut molding is shown at the top of figure 387 along with the turned dowel needed for the base plug onto which the rosette is glued. The finished molding and the plug are shown at the bottom in figure 387. Remember to cut the straight pieces of molding that go along the side of the carcass before you change the different setups used on the ogees. The straight molding is not cut against the pin, instead a fence is used to guide the stock. Cut a tiny groove into the fence into which the pin can set so the edge of the fence will be flush with the leading edge of the pin. This will ensure that the two moldings will be of the same design. After the molding has been shaped, a 9/32″ flat-bottomed hole is cut into the top scroll (lower right, fig. 388). Use a flat burr at a slow speed to make this hole. Be very steady of hand when making this cut, any side movement will cause the burr to grab the edge of the molding and splinter it. When the holes have been completed, turn a 9/32″-diameter dowel from the 5/16″-square rosette plug stock (fig. 388). Dry-fit this dowel into the hole and mark the height to the top of the molding. Cut the dowel at this mark and glue the plug into place (see bottom, fig. 387). Now the two grooves around the outside edge of the scroll can be shaped using a round burr in a flexible shaft. These grooves end at the apex of the scroll (fig. 389). The other end of the ogee molding must now be mitered to meet the side molding. This must be done very carefully, as a wrong cut will mean cutting the ogee over again. Line up the curved molding in the exact position you want it, then mark in pencil where the molding hangs beyond the edge of the carcass. Draw the line of the side down the flat inner edge of the molding, then cut the miter, keeping this line perpendicular to the bottom of the miter box. Be sure the miter is facing in the proper direction (see plans). When the miters have been cut, glue the ogee molding onto the carcass. When the glue is dry, miter the side moldings and glue them onto each side of the carcass. Always miter the side molding last; if any custom-fitting is required to match the miter joint, it can easily be done on the straight piece, and there is plenty of extra stock. When the side moldings are dry, sand their back ends flush with the back of the carcass.

387. *Top:* rough-cut ogee molding and turned plug; *bottom:* finished molding.

388. Hole drilled in the ogee molding to glue in the rosette plug.

389. Sketch of the rosette and the edge of the arch molding.

390. Stages in the making of the rosette.

391. Sketch of the finial.

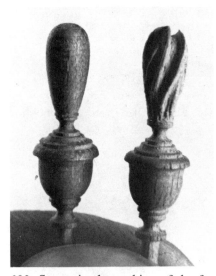

392. Stages in the making of the finial.

The rosettes are turned on the end of a ⅜" mahogany dowel (fig. 390). Turn the buttonlike shape using a round lathe knife. Do not remove the turning from the dowel; it serves as a handle to hold the stock while it is being carved. Use a small inverted-cone burr in a flexible shaft to shape the five larger scrolls and to separate the different areas of the carving (see fig. 389). Round the center of the scrolls with a small, round burr. Finish the rosette with a #11 scalpel to sharpen the edges of the design and 220 grit sandpaper to polish the wood. When the rosette has been completed, put the dowel back in the lathe and cut the rosette free with a parting tool (see bottom, fig. 390). Be careful that the tool does not hit the edge of the spinning carving or it will chip off the points of the rosette.

After the rosettes have been glued into place, work can begin on the finials and finial posts. Cut the posts from 5/32"-square stock and glue them into place (see plans and fig. 403, p. 184). The post caps are 3/16" square and only 1/64" thick. Bevel the lower edge on all four sides and glue them onto top of the posts (see fig. 404, p. 184).

The finials are turned on the lathe using 5/16"-square stock (fig. 391). Figure 392 illustrates the finial turning done on the lathe (left) and the finished finial with the carved flame atop the urn (right).

The design is carved with a flexible shaft and a small, round burr after the basic shape, which looks something like the top of a belaying pin, has been turned on the lathe. Be sure to turn a 1/16" pin onto the bottom of the finial to hold it on the carcass. Technically, these finials should be removable, their pins set in a hole drilled into the finial post. This is not satisfactory in a miniature, however, because the finials can fall out and become lost on the floor or, worse yet, stepped on. The reason I say *worse yet* is I believe it is one thing to know my hard work is out there hiding somewhere, but to hold the shattered remnant in my hand is almost too much to bear.

The next step is to turn the four quarter columns. These columns and the center crest are the most difficult parts of this highboy. When you finish the fluting on the columns, you can consider yourself three-fourths of the way home. Figure 393 shows the upper column turned on the lathe. The ends of the column have been turned as though the piece was to be 360° around. Notice the lines in the center of the square blocks at either end of the turning. These lines divide the turning into four sections and are continued along the length of the column. Draw five equally spaced lines the length of the straight section of the turning on each of these quarter sections. These five lines will be the fluted area of one quarter column. Repeat this step on at least one other quadrant of the turning. I say at least *one other* because you may need an extra or two should things go astray. After the column has been marked, the lines must be scored over with a #11 X-acto knife (fig. 394) to cut the fibers of the wood. Rest the knife against the straight edge of the tool rest and, holding it at the same angle throughout, draw the blade along the length of the line. Go over the scored lines with a small, domed riffler file (fig. 395). Finish the fluting with 220 grit sandpaper. When

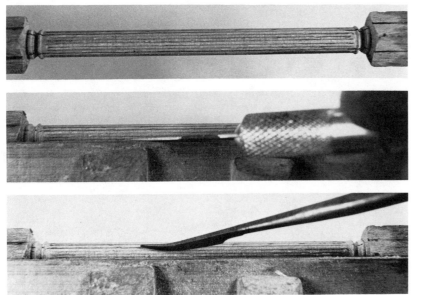

393. Turned column marked for fluting.

394. Score the fluting lines with a #11 X-acto knife.

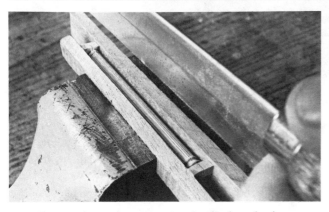

395. Use a domed riffler to shape the flutes.

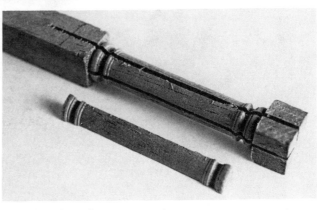

396. Cut a column into quarters in the bench vise.

397. Detail of the quarter column cuts.

you have completed the fluting, remove the column from the lathe, leaving the square end blocks on the turning. These flat surfaces will not only hold the column evenly in a bench vise but also serve as a starting place for the Zona saw. The initial cuts in the end blocks function in the same manner as the sides of a miter box, guiding the saw as you cut the column into halves and then into quarters (figs. 396 and 397). The quarter columns for the base are done in exactly the same fashion. Note that figure 397 is shown to illustrate the quarter-column cuts only; the fluting must be completed before the cuts are made.

The carving of the center crest on this Philadelphia Chippendale broken-pediment highboy is an extremely difficult task (fig. 398). The finished carving is only 1/32″ thick and in some places only 1/32″ wide, yet it must be strong enough to hold together and stand erect. Here I am at a loss for the helpful words that will instruct you in this procedure. I can give you a few tips, and then you are on your own. Choose your wood carefully; the grain must be tight and run in the direction of the smallest cuts. When you begin the carving, shape

398. Detail sketch of the center crest.

399. Rough carving on the center crest; note that the back of the crest is left flat for stability

400. Finished center crest.

401. Applying the back brace to the center crest.

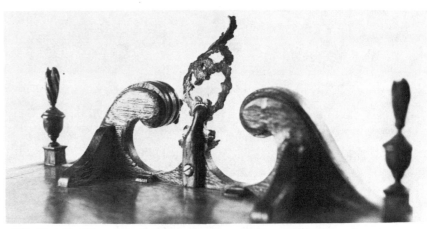

402. Side view of the highboy top showing the rake in the center crest.

403. Detail of the screw holding the removable center crest to the carcass.

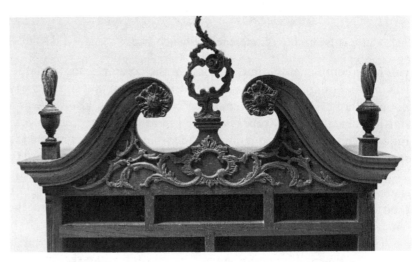

404. Top of the carcass ready for finishing.

the forward rake of the crest into the face of the block (fig. 399), but leave the back flat. This flat surface gives the work support while you carve the crest. Carve the design using the same tools used on the pediment carving (see figs. 384 and 385, p. 180). When the design is complete, carefully sand away the back of the block with a 1″ sanding drum until the carving is ¹⁄₃₂″ thick (fig. 400). The center crest is held to the miniature highboy by a brace that is screwed to

the back of the carcass. This brace allows the crest to be removed for packing, yet does not allow it to fall out if the highboy is picked up. As I stated earlier, the center crest and finials would be held by pegs in the full-size piece. Figure 401 shows the brace that is shaped to fit the lower portion of the crest and then glued into place. Figure 402 illustrates the forward rake of the crest beyond the front plane of the highboy. Figure 403 shows the back of the crest and the brace with a screw. Notice in figures 402 and 403 the shaping of the uppermost portion of the center crest. The completed top carcass should now look like figure 404.

The last construction project on the highboy is the making of the drawers. Because all of the drawers are made in the same manner, I shall describe the center drawer on the carcass base, which also includes a beautiful, carved fan shell and delicate, applied scrolled-leaf carvings.

The first operation on all of the drawer fronts is to shape the flange around the outer edge, (see chap. 12, fig. 265, p. 129, for dimensions). The flange begins $\frac{1}{64}''$ below the face of the drawer front, $\frac{1}{32}''$ in from the edge. The interior body of the drawer is also $\frac{1}{32}''$ in from the outside edge of the flange and $\frac{1}{16}''$ thick. When cutting the drawer sizes, remember only the interior body fits into the carcass, the flange butts against the front of the carcass. To cut the $\frac{1}{32}''$ flange in on the drawer face, use a straight burr on the shaper (see chap. 12, figs. 256, p. 127, and 266, p. 129). Round over the edge of the flange with a flat riffler file (fig. 405).

After the flange edges of each drawer have been rounded and the drawers placed in their proper opening in the carcass to be sure the fit is correct, the dovetail pins can be made on either end (see chap. 12, fig. 270, p. 130). As stated earlier, the center drawer on the lower carcass requires additional work (see fig. 411, p. 186). Figure 406 shows the shell carving roughed out in the drawer front, including the floral design in the center of the shell. Figure 407 shows the completed shell design and the $\frac{1}{64}''$ applied cutouts. Notice how the cutouts are exact duplicates of each other. These pieces were cut out as one piece in the manner described earlier (see pp. 175 and 176). Figure 408 illustrates the carving roughed in on the applied pieces using both an inverted-cone and a round burr. The finished drawer is shown in figure 409.

405. Round the edge of the drawer flange with a flat riffler.

406. Roughed-out shell carving on the center drawer.

407. Finished shell carving and rough-cut applied work.

408. Applied work carved with a flexible shaft and small burrs.

409. Applied carving after finishing with a #11 scalpel, rifflers, and sandpaper.

410. Center drawer pull carved from a piece of solid brass.

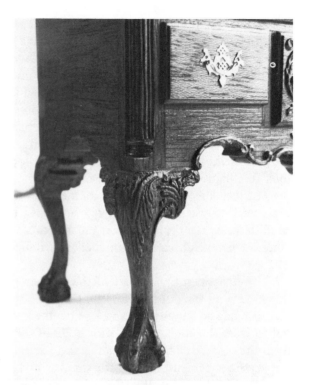

411. Detail of the leg and the pierced-brass hardware on the drawers.

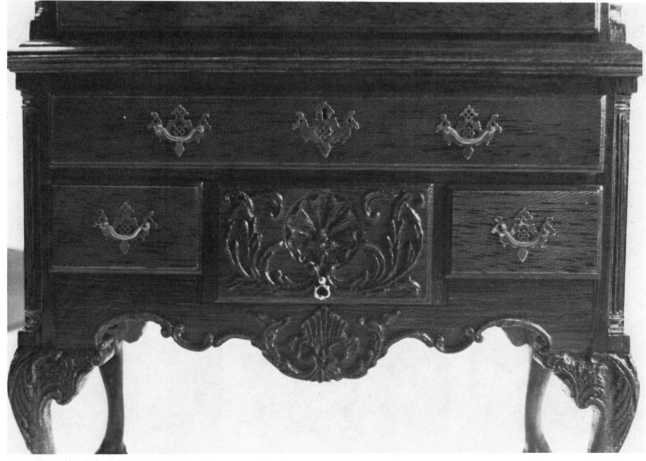

412. Detail of the pierced-brass hardware on the drawers.

Cut the 1/32"-thick drawer interior stock to size and dovetail the sides (see chap. 12, fig. 271, p. 130). When the dovetails are completed, cut the grooves for the drawer bottom and the rabbets for the back and assemble the drawers (see chap. 12, fig. 272, p. 130). This completes the construction of the Philadelphia highboy, and the finishing of the wood can begin. Chapter 6, pages 62 and 63, describes in detail the procedure for finishing the mahogany. Be sure the stain you use does not raise the grain of the wood and is of a warm brown tone. Fill the pores of the wood with a paste wood filler that matches the color of the wood. When the filler has been rubbed down and is dry, spray a sealer coat of varnish over the carcass and let it dry for two days. Follow this sealer coat with two or three coats of varnish sprayed on with an airbrush. If you must brush on the varnish, use a top grade and apply light coats, brushing in one direction only.

Figure 410 shows the pull for the center drawer, which has been carved from a solid piece of brass. Notice how the brass rod is held in a hand vise, and the pull is filed and polished before it is cut from the bar. This pull is attached to a small brass knob (fig. 412) that has been turned on the lathe.

The escutcheons for this piece are made in the same manner as described in chapter 5. Figures 411 and 412 show the finished drawers with their pierced-brass hardware.

As I promised at the beginning of the chapter, this Chippendale highboy is a challenging and rewarding project. Its construction has covered virtually every aspect of the art of creating furniture in miniature.

FEDERAL PROJECTS
1795-1815

→ *413.* Finished bracket-foot chest, three-quarter view.

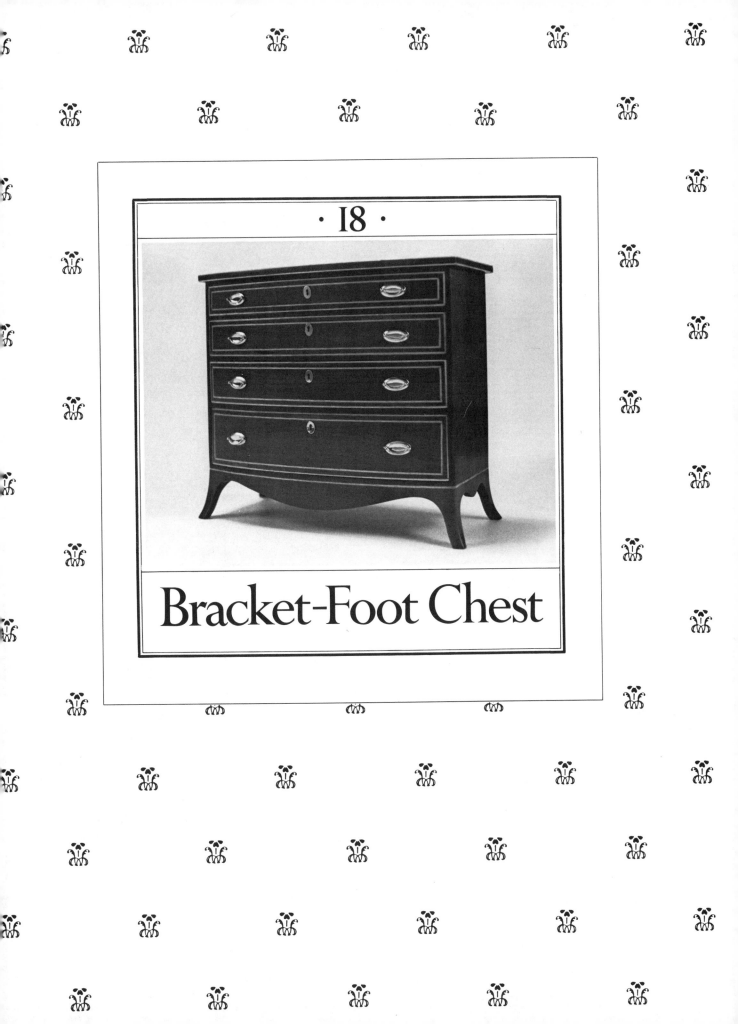

· 18 ·

Bracket-Foot Chest

Bracket-Foot Chest

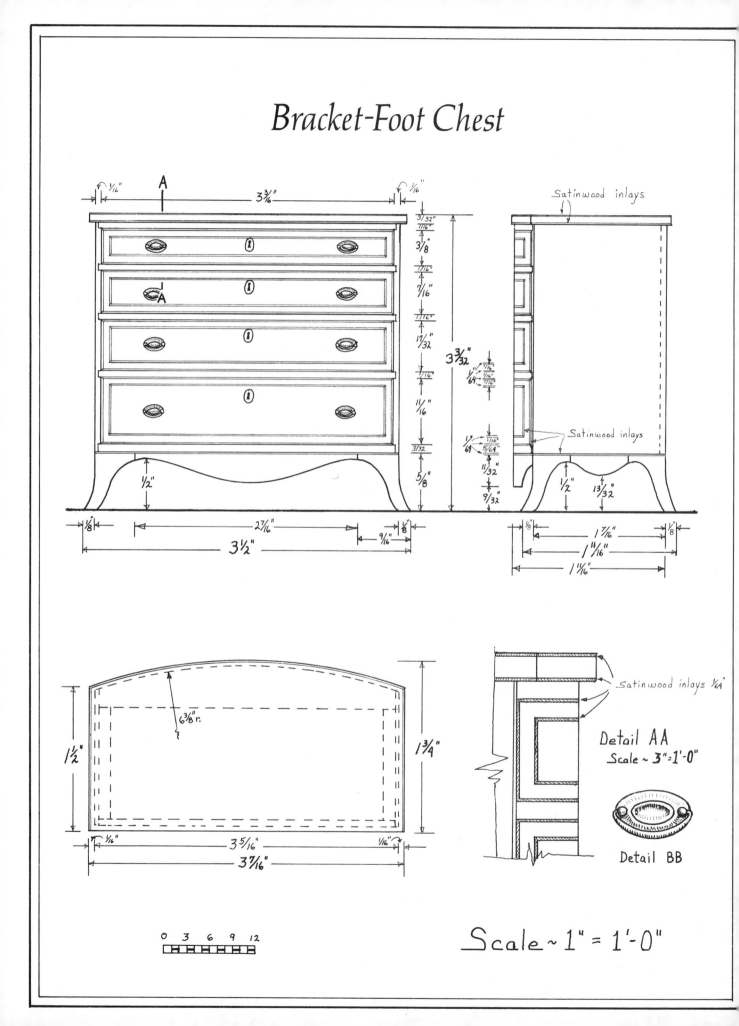

Satinwood inlays

Satinwood inlays

Satinwood inlays 1/64

Detail AA
Scale ~ 3" = 1'-0"

Detail BB

6 3/8" r.

0 3 6 9 12

Scale ~ 1" = 1'-0"

MATERIALS LIST

cherry or dark hardwood	thickness	width	length
2 sides	1/16″	1⁷/16″	2⅜″
1 top	3/32″	1¾″	3⁷/16″
1 carcass top	1/16″	1⅝″	3¼″
1 carcass bottom	3/32″	1⅝″	3¼″
3 drawer dividers	1/16″	⁷/16″	3¼″
1 back (can be constructed from several pieces)	1/16″	2⅜″	3¼″ (total)
4 bracket feet	⅝″	⅝″	⅝″
1 apron	5/16″	⅜″	2⁷/16″
2 side stretchers	⅛″	¼″	⅝″
1 rear stretcher	⅛″	⅛″	2⁷/16″
6 drawer glides	1/16″	⅛″	1⁵/32″
1 upper drawer front	5/16″	⅜″	3³/16″
1 second drawer front	5/16″	⁷/16″	3³/16″
1 third drawer front	5/16″	¹⁷/32″	3³/16″
1 bottom drawer front	5/16″	¹¹/16″	3³/16″

Drawer interiors are cut from 3/32″ softwood such as pine or basswood. Satinwood or holly wood is used for inlays in 1/64″ by 3/64″ strips. The length of the inlay strips needed totals approximately 100″.

This bracket-foot chest with its inlaid drawers and raised, stamped escutcheons must be made from a dark hardwood such as cherry, which has a natural finish dark enough to contrast with the inlays. Mahogany is too porous and cannot be used in this miniature, because the process of filling and staining the open-grain wood will darken the lighter inlaid wood.

To begin, rough-cut the stock listed in the materials list. The wood used for the inlaid areas can be either satinwood or holly in 1/64″ by 3/64″ strips.

The first step in the construction of the chest is to cut the five 1/16″-wide by 1/32″-deep dadoes in each side for the carcass top, the drawer dividers and the glides, and the carcass bottom. Use the plans to mark the location of each of these dadoes on the sidepieces. Set up the drill press as shown in figure 414, using an inverted-cone burr 1/16″ in diameter. Set the fence to the first mark and cut a dado into both sidepieces; then adjust the fence to the next mark and again cut a dado into both pieces. Continue until all five dadoes have been cut. Next, using the same machine setup cut a 1/32″-deep by 1/16″-wide groove on the inside back edge of each side for the carcass back.

The front of the carcass top, the three drawer dividers, and the carcass bottom must now be curved. Use the plans as a guide and cut a template from 1/32″ hardwood to use as a pattern to mark each piece of stock (see bottom, fig. 426). Notice that the template I have

414. Cut the dadoes for the drawer glides.

415. Check the depth of the front curved stretcher before cutting the length of the drawer glides.

used is cut on only one side. I cut the templates in this fashion to ensure that both sides of the arc are symmetrical. Trace around the curve in the template on half the stock, then flip the template over and trace around the same curve on the other half of the stock. For both segments of the arc to match, the template must be cut to the length of the piece you are marking. It is important that all the front curves exactly match each other when the chest is completed (see fig. 413, p. 191). After the curves have been cut and sanded to match, the drawer glides can be glued into the dadoes cut into the sides. The glides must be cut so the end of the curved drawer divider lines up with the *inside* edge of the carcass side when the back of the divider is butted against the drawer glide (fig. 415). When all of the glides have been glued into their proper place, the drawer dividers, carcass top, and bottom can be assembled with the sides (fig. 416). The basic carcass is now assembled and the back can be cut and glued into place. Be sure the carcass is square and the sides are perpendicular to the floor (fig. 416). Figure 417 shows the assembled carcass and the drawer glides. When the carcass is dry, the front edge of the sides must be beveled to match the bow of the front pieces. To accomplish this, place the front outside edge of the carcass on a sanding block covered with 220 grit aluminum oxide open-coat sandpaper. Carefully sand the edge until its entire length has been beveled so that it and the bowed front of the chest form one continuous curve (see figs. 417, 438, and 440, p. 200).

416. Basic carcass of the chest.

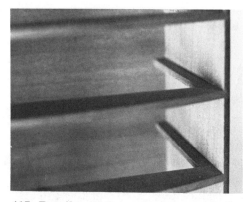

417. Detail of the stretchers and the drawer glides; note how the side of the carcass is beveled to continue the front curve.

The next step is the construction of the bracket feet. Figure 418 shows the stages involved (note the similarity to the construction of a cabriole leg). To cut the rear legs a template (far left, fig. 418) is traced onto adjoining surfaces of the leg block (center, fig. 418). These two patterns are then cut around on a jigsaw, leaving small amounts of stock uncut on each line to hold the pieces together until all the cuts have been made (fig. 419). The finished rear leg (right side, fig. 418) curves outward to both the rear and the side. The

418. Stages in the making of the bracket foot.

419. Detail of the jigsawed bracket foot showing tiny areas left uncut that hold the stock together.

shaping of the front leg is more difficult than that of the rear leg. Only one side of the leg, the one that curves toward the side of the chest, can be cut on the jigsaw. The front of this leg must be cut by hand to match the bow in the front of the cabinet. Figure 420 shows the difference between the front leg (at left) and the rear leg (at right). As you can see in figure 420, the front portion of the front leg could not be cut on the saw, which would follow the dotted line. To shape the front of this leg, first trace the arc of the bow front onto the stock. Also trace the flare of the leg using the leg template. The front must be shaped following both of these lines: the normal leg template on the side and the bow on the top. Use a ½″-diameter sanding drum and shape the surface. Occasionally, hold the leg against the carcass bottom to be sure the bow matches the chest front.

When the four legs have been cut out and shaped, the apron and stretchers of the base can be cut from the stock shown in the materials list. Figure 421 illustrates how each curved piece is cut from the block of wood. The plans and figures 422 through 425 show how the stretchers are shaped to match the bow in the front of the carcass and to the curve of the legs using the jigsaw and a 1″ drum sander. Notice how the area of the apron and side stretchers that curves downward from the frame has been sanded to a ³⁄₃₂″ thickness with a drum sander (see figs. 424 and 425).

420. Comparison of the bowed front leg (left) and square back leg (right).

421. Detail of how the apron is cut from the rough stock.

422. Detail of the completed bracket foot assembly (front).

423. Detail of the completed bracket foot assembly (side).

After the apron and the stretchers have been dry-fitted with the legs and checked against the lower portion of the assembled carcass to be sure they match, they can be glued together (see figs. 422 and 423). When the glue is dry, sand the base assembly to match the carcass exactly. When you are finished, the two assemblies should look as one, each being a continuation of the other (see figs. 439 and 440, p. 200). *Do not* glue the assemblies together at this time, we shall get back to them after the drawers have been cut.

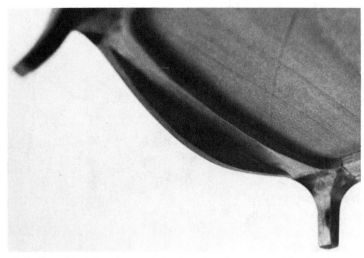

424. Detail of the front of the bracket foot assembly from underneath, showing the thickness of the apron board. Notice how the stock has been thinned where the apron bows downward.

425. Side view of the legs; notice how the side-piece has been reduced below the frame area.

The template used for the front curve of the carcass will be used for the curve of the drawers. Using the plans and the finished carcass as guides, cut ¹⁄₃₂″ off either end of the template, then check the curve of the template against the curve in the drawer dividers of the carcass. Correct the template if necessary to match these curves. The finished template is shown on the bottom in figure 426. Trace around the curve in the template on half the stock, then flip the template over and trace it on the other half of the stock (center, fig. 426). Do this on both the top and the bottom of the stock. The finished drawer front piece is shown at the top of figure 426.

When the curves have all been traced on the drawer stock, slide each piece of stock into the appropriate drawer opening in the carcass and check the stock both for fit and to be sure the curved lines you have just drawn match the bow in the face of the carcass. When they all fit and match, the dovetail pins can be made on the end of each drawer. Use an inverted-cone burr in a drill press (see chap. 4, pp. 43 and 44, for details).

426. Stages in the making of a bowed drawer front.

427. Sand the bow in the drawer front with a 1″ drum sander.

After the dovetail pins have been made, the curve can be sanded into the drawer fronts. Use a 1″ drum sander on a flexible shaft as shown in figure 427. Do not sand beyond the guidelines drawn on the top and bottom of the drawer. When you approach the line, check the curve against the curve in the carcass by putting the drawer into its proper opening. Remember the entire front of the chest should give the feeling of being one piece. When all of the drawers have been bowed to match the carcass and completely sanded with 220 grit sandpaper, the grooves for the inlay strip can be cut.

Figure 428 shows the shaper setup using an inverted-cone burr for cutting the groove into the drawer edge. The inverted-cone burr should project ¹⁄₃₂″ above the height of the shaper table and only ¹⁄₆₄″ beyond the shaper fence. This setup will produce cuts that are ¹⁄₆₄″ wide and ¹⁄₃₂″ deep in the front of the drawers. The only problem in shaping a groove in the curved surface of the drawer front is keeping the stock against the burr. To help keep the burr in the wood, draw a line on both the table and the fence of the shaper along the center line of the burr. These lines locate the area at which the curved front must be held flat on the table. To keep the stock against the shaper table on this line, the drawer front must be gradually rocked as it is moved through the burr (fig. 428). When all of the side cuts have been made, the shaper fence must be moved away from the burr slightly to allow for the gap caused by the bowed front (fig. 429). Once you have set the fence, it should remain the same for shaping the end grooves on all four drawers.

Before leaving the shaper, set the fence back to the original position used for the drawer sides (see fig. 428). This setup is used to cut the groove into the lower edge of the carcass assembly for the inlay between the carcass assembly and the base assembly (see figs. 438 through 440, p. 200). Do not cut a groove into the back of the carcass. The same shaper setup is also used to cut the upper and lower grooves for the top inlays (see fig. 437, p. 199), however the inverted-cone burr must be lowered to project only ¹⁄₆₄″ above the shaper table, thus cutting a ¹⁄₆₄″ by ¹⁄₆₄″ groove in both surfaces of the top. Mark the top curve on the top stock using the plans, the bow template, and the bow in the carcass top board as guides. Remember the top overhangs the carcass by ¹⁄₁₆″ on all four sides. When the top is curved and dry-fitted on the upper carcass for size, the ¹⁄₆₄″ groove is cut into the front and side edges of both the top and bottom surfaces. Do not groove the back of the top (see figs. 437, 439, and 440, pp. 199 and 200).

With the shaper work completed, the center inlay grooves can be hand-cut into the drawer fronts. From the outset I must caution you that this is a slow process that involves many carefully executed cuts with a #11 scalpel. To begin, lay out the area where the inlay is to go in pencil. Mark the ¹⁄₆₄″-wide grooves with a sharp pencil. Next, lay a flexible steel straightedge along one of the lines and lightly score over the outside edge of the pencil mark with a #11 scalpel.

428. Cut a tiny groove for the inlay on the drawer front edge on the shaper, using a small inverted-cone burr.

429. Adjust the fence away from the cutter to allow for the gap created by the curve in the drawer front. Cut the matching inlay groove on the end.

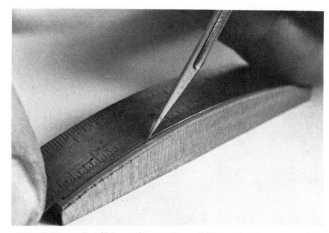

430. Use a flexible ruler and a #11 scalpel to cut the edges of the inside inlay groove.

431. Clean out the groove with a small, square riffler file.

432. Press glued strips of 1/32" holly wood into the grooves.

433. Use tape to hold the inlays in place until the glue is dry.

Make several passes with the knife, scoring deeper into the wood with each pass until the cut is 1/32" deep. Move the straightedge over 1/64" to the inside edge of the pencil line and score it in the same fashion with the scalpel (fig. 430). Continue this process until all of the lines on all four drawers have been scored. Carefully cut away the stock between the two scored lines with the knife. Do not cut outside the penciled areas or clean out deeper than 1/32". When all of the grooves have been roughed out, clean and flatten the bottom of each groove with a small, square riffler file that has been ground to a thickness of 1/64" on the end (fig. 431). The drawers, carcass, and top are now ready for the tiny strips of inlay.

Whether you use satinwood or holly for the inlay stock, it must be cut into strips 1/64" thick and 3/64" wide. Note that the width is 1/64" greater than the depth of the grooves. This extra width will give you some leeway, especially in the hand-cut grooves. Eventually the excess will be sanded flush with the drawer front. Custom-fit each strip to the length of the grooves in the drawer fronts. Apply glue to the back and sides of the strip and press the inlay into the groove (fig. 432). Do all of the inside inlays before doing the edge inlays. Glue the edge strips along the length of the drawer first and hold them in place with masking tape (fig. 433). I use the light-stick masking tape

sold at art supply stores. This type of tape adheres well but does not leave a gummy residue on the wood. When the top and bottom edge pieces are dry, the smaller endpieces are glued into place. The bottom piece in figure 434 shows a drawer front with the inlaid stock glued into place. Notice how rough the pieces of inlay look. The top piece in figure 434 shows a drawer after the inlays have been sanded flush with the drawer front and the edges. Be careful when sanding the protruding pieces of inlay, they can catch on the abrasive and tear off. Figure 435 shows the edge of a finished drawer. At this time cut the keyhole in the upper center of each drawer face (see fig. 413, p. 191). First, mark the location and shape of each hole with a pencil; then, drill a ⅟₆₄″ hole at the top and bottom of the keyhole. Next, square off the bottom hole with a #11 scalpel and connect the two openings by cutting away the center wood in a keyhole design.

When the drawer fronts have been sanded smooth with 320 grit sandpaper, the interior of the drawers can be constructed. See chapter 4, pages 43 and 44, for details if you are unfamiliar with the procedure. Figure 436 shows a finished drawer, including the dovetail joint and the stamped brass hardware (see chap. 5, pp. 54 and 55).

When the drawers are completed, the inlay strips can be glued into the upper and lower grooves of the chest top. Use tape to hold the gluing strip in place (see fig. 433). Sand the top inlays flush with

434. Detail showing the rough inlaid strips and the finished inlaid drawer front.

435. Detail of the drawer showing the edge inlay and the pins of the dovetail joint.

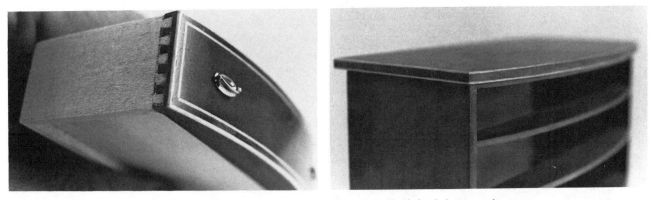

436. Finished drawer with the stamped-brass oval escutcheon.

437. Detail of the inlays on the top.

the stock and glue the top onto the carcass (see figs. 437, 439, and 440).

The final construction operations are the gluing of the inlay strip into the groove around the front and sides of the lower carcass and the assembly of the base onto the carcass (figs. 438 through 440). Glue the inlays into place on the carcass. When the glue is dry, sand the bottom of the carcass until the inlays are flush with the bottom, then glue the base assembly to the carcass. The two units must look like one. When the glue has dried, sand the inlay strip flush with the front and side of both the upper carcass and lower base assembly.

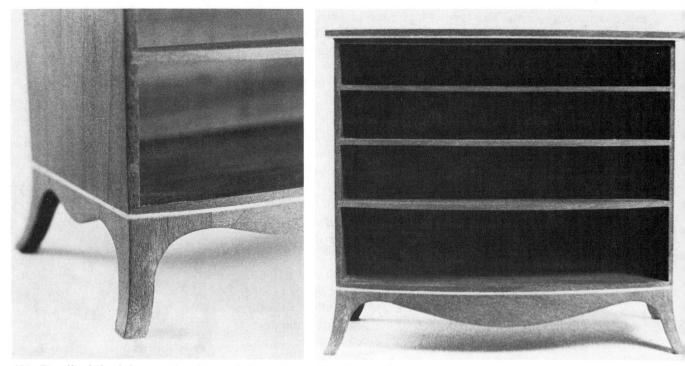

438. Detail of the inlay on the side and the apron. *439.* Finished carcass front.

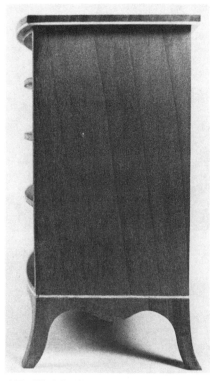

440. Finished carcass side.

The inlay strip that separates the two units now conceals the fact that there are two separate groupings glued together, and the chest has become one graceful unit.

When finishing the Federal chest do not attempt to stain the wood. The light satinwood or holly will absorb the stain, and the hours spent inlaying the tiny pieces will be all but lost. Sand the entire piece with 320 grit aluminum oxide open-coat sandpaper. Use a tack cloth on everything and then varnish.

When the varnish has dried at least three days, rub the surfaces that can be seen with rottenstone and rubbing oil until they shine with the glow of a hand-rubbed surface.

The hardware, including the tiny oval escutcheons around the center keyhole, is applied after the finishing of the wood has been completed (see plans, detail B-B).

⟶
441. Finished Pembroke table, leaves up.

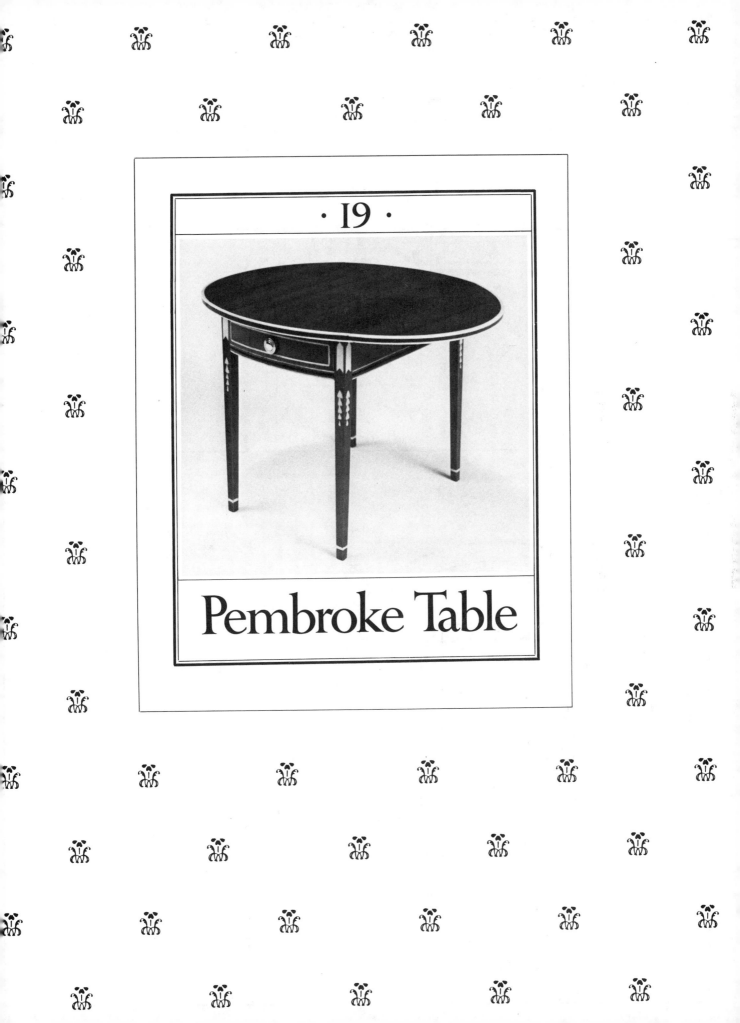

· 19 ·

Pembroke Table

Pembroke Table

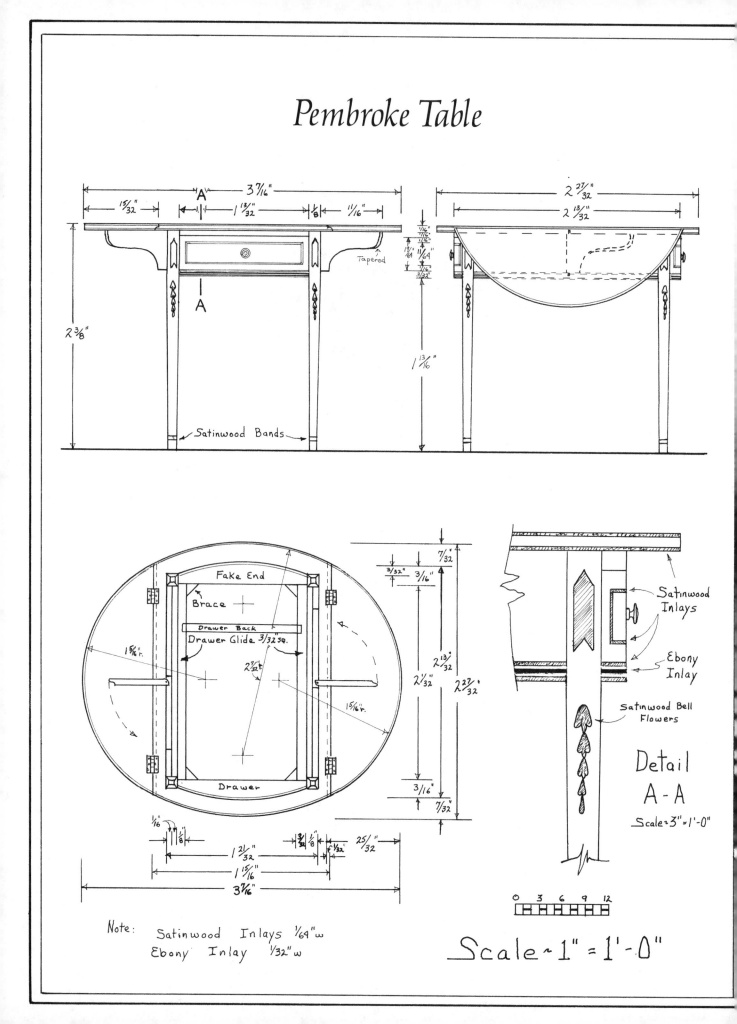

Tapered

Satinwood Bands

$2\frac{3}{8}"$

$3\frac{7}{16}"$

$1\frac{13}{32}"$

$\frac{15}{32}"$ $\frac{1}{8}$ $\frac{11}{16}"$

$2\frac{27}{32}"$

$2\frac{13}{32}"$

$1\frac{13}{16}"$

A

Fake End

Brace

Drawer Back

Drawer Glide $\frac{3}{32}$ sq.

Drawer

$1\frac{5}{16}"$ r.

$1\frac{5}{16}"$ r.

$2\frac{7}{32}$ r.

$\frac{7}{32}"$

$\frac{3}{16}"$

$\frac{3}{32}"$

$2\frac{13}{32}"$

$2\frac{1}{32}"$

$2\frac{27}{32}"$

$\frac{3}{16}"$

$\frac{7}{32}"$

$\frac{1}{16}"$

$\frac{1}{8}"$

$1\frac{21}{32}"$

$1\frac{15}{16}"$

$3\frac{7}{16}"$

$\frac{3}{32}$ $\frac{1}{8}$ $\frac{1}{32}$ $\frac{25}{32}"$

Note: Satinwood Inlays $\frac{1}{64}"$ w
 Ebony Inlay $\frac{1}{32}"$ w

Satinwood
Inlays

Ebony
Inlay

Satinwood Bell
Flowers

Detail
A-A
Scale ~ 3" = 1'-0"

0 3 6 9 12

Scale ~ 1" = 1'-0"

MATERIALS LIST

cherry or dark hardwood	*thickness*	*width*	*length*
4 legs	1/8″	1/8″	2 5/16″
4 inside and brace sidepieces	1/16″	23/64″	2 1/32″
2 lower (inlaid) side stretchers	3/32″	1/8″	2 1/32″
2 upper front and rear stretchers	1/16″	3/16″	1 13/32″
2 lower (inlaid) front and rear stretchers	3/32″	3/16″	1 13/32″
1 rear "fake" drawer front	3/16″	19/64″	1 13/32″
1 drawer front	3/16″	19/64″	1 13/32″
1 tabletop	1/16″	1 15/16″	3 1/4″
2 table leaves	1/16″	7/8″	3 1/4″
2 drawer glides	3/32″	3/32″	2 1/32″
satinwood or holly inlays			
1 piece for leg designs	3/64″	5/64″	12″
1 piece for stretcher, top, and leg banding	1/64″	3/64″	60″
ebony inlays			
1 piece for stretchers	1/32″	3/64″	12″

Drawer interiors are made from 3/32″ softwood, and drawer bottoms from 1/32″ softwood.

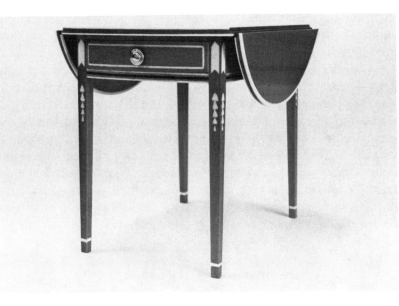

442. Finished Pembroke table, leaves down.

The style of drop-leaf table known as a Pembroke originated in England and is named after the Earl of Pembroke. The Pembroke table in this project has beautiful inlay work and a graceful, oval drop-leaf top.

The first step in the construction of this table is to rough-cut the lumber using the materials list as a guide. I suggest you use cherry or

443. Cut the taper in the leg on a circular saw.

444. Cut the design in the leg with an X-acto knife for the inlay.

some other dark hardwood that does not require staining or filling. The satinwood or holly, whichever you choose, inlays are almost impossible to stain around without also staining the inlays.

After the lumber has been sawed to rough size, the taper can be cut in the four legs. The taper is cut on a miniature circular saw using the jig shown in figure 443. The right side of this jig is cut perpendicular to the bottom edge, whereas the left side is cut at an 89° angle to the bottom edge. This 1° will be the taper in the leg, reducing the ⅛″-square leg to 3⁄32″ square at the bottom. The crossbar (fig. 443) is a brace for your fingers to push the jig through the saw. A small tapered stopblock is glued three-fourths of the way down the edge of the tapered side to hold the leg stock in position. When the jig is complete, adjust the saw fence so the cut will begin 9⁄16″ down from the top of the leg stock. This straight portion is necessary to keep the sides of the carcass square. Make the tapered cut on two adjacent sides. Note that the taper is cut only on the two inside edges of each leg.

With the tapers cut in all four legs, the inlay work can begin. Using the plans as a guide, mark the location of the upper geometric design and the bellflowers on the two straight sides.

The upper geometric design must be cut with a #11 X-acto knife. Be careful not to cut outside the pencil lines, as any scoring on the finished surface will show up as a permanent mar (fig. 444). When the borders of the design have been scored to a depth of 1⁄32″, the center stock must be removed with either the #11 knife or a small carving chisel. Make sure the edges of the opening are straight and the bottom flat. Figure 445 illustrates the stages in inlaying the upper geometric design.

After the openings on the four legs (eight in all) are cut out (top, fig. 445), matching pieces of satinwood or holly must be shaped to fit into the openings (center, fig. 445). This is a slow process of trial and error until an exact fit is obtained. Caution: do not press the fitted piece all the way into the opening unless glue has been applied, as you will ruin the leg attempting to remove it. Leave enough of the inlay to grasp with tweezers, so the piece can be removed. When the finished cutout has been glued into place, it should rise above the finished surface approximately 1⁄64″, just enough so it can be sanded flush with the surface of the leg (bottom, fig. 445).

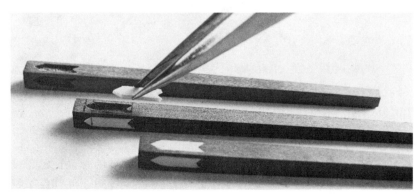

445. Stages in doing the inlay, top to bottom.

The opening for the bellflower design is cut with a small, round burr in a flexible-shaft machine (fig. 446). The design is hollowed out one flower at a time to a depth of ½₂″. When the openings are completed and the inner walls are straight, pieces of satinwood or holly for the inlays must be shaped to fit each of the openings. The piece of inlay stock should be fairly long with the design shaped on one end. Again, a trial-and-error process of shaping the design with files to fit the openings will be necessary. When the inlay fits perfectly into the cutout on the leg, apply glue to it and push it firmly into place. After the glue has set five or ten minutes, the excess stock can be cut off near the surface of the leg. Leave a tiny amount of extra stock raised above the surface to sand flush with the leg (fig. 447). When the upper leg inlays are complete, the groove for the lower leg banding can be cut. A ½₂″-diameter straight burr chucked into the drill press is used to make this cut (fig. 448). It is difficult to

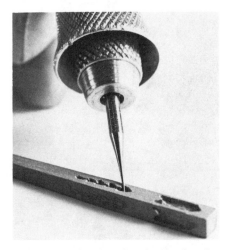

446. Rout the opening in the leg for the bellflower inlays with a flexible shaft and a small burr.

447. Bottom: Routed area for the inlays; *top:* completed leg.

distinguish in the illustration, but if you will look carefully you can see the push block to the left of the leg, which has been cut to the same 1° angle as the edge of the leg. This angled push block ensures that the groove will be cut parallel with the bottom edge of the leg. The finished groove should be ½₂″ wide, only ¹⁄₆₄″ deep, and cut around the circumference of each leg.

To apply the satinwood or holly banding, four ½₂″ by ½₂″ by ³⁄₃₂″-long pieces of inlay stock must be mitered to fit around the leg. Notice that the banding is ½₂″ wide and the groove only ¹⁄₆₄″ deep, the extra ½₂″ protrusion above the leg surface must be carefully sanded off until it is flush with the surface of the leg (see bottom piece, fig. 447).

With the legs completed, the upper carcass can be constructed. Figure 449 shows the stages in shaping the front and rear of the carcass. Before the ends of the carcass can be shaped, however, the dovetail pins must be made on both ends of the drawer front using

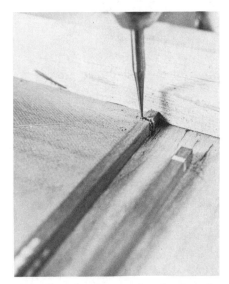

448. Cut the groove in the leg for inlay banding.

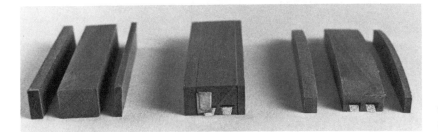

449. Stages in cutting the matching curve in the endpieces.

450. How the inverted-cone burr cuts the outside groove for the inlay.

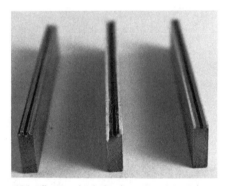

451. Edge detail of the grooves for the inlay.

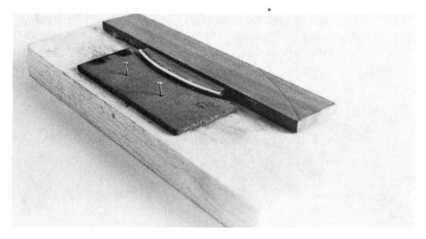

452. Stages in inlaying the sidepieces, *left:* grooves; *center:* rough inlays; *right:* final sanded piece.

the drill press and an inverted-cone burr. When the dovetail pins have been made, the upper stretcher, the drawer front, and the lower stretcher (left, fig. 449) are temporarily held together with double-faced masking tape or rubber cement (center, fig. 449), and all three surfaces are shaped as one. Cut a template, using the top view of the table on the plans as a guide, and mark the curved pattern on both end groupings. Use a 1″ drum sander to curve the face of each grouping, as shown in chapter 18, figure 427, page 196. When the groupings have been curved and well sanded with 220 grit sandpaper, the three pieces can be separated (right, fig. 449). The two lower side stretchers must now be cut so that all four lower stretchers can be inlaid at the same time.

The inlaying of two satinwood or holly strips and one ebony strip into the edge of a board that is only $\frac{3}{32}$″ wide is not as impossible as you might think. The trick, if it be a trick, is to line up the shaper correctly before any finished cuts are made. The way to accomplish this is to cut a few extra side stretcher pieces to be used as test strips while you set up each cut.

The first cut will be the center $\frac{1}{32}$″-wide groove for the ebony inlay. All three of the inlay grooves will be cut $\frac{1}{32}$″ deep into the stock. Use a straight-sided dental burr that measures $\frac{1}{32}$″ in diameter. Use the test strips and find the exact center of the board. When you are sure the cut will be exactly in the center of the $\frac{3}{32}$″ stock, cut all four stretchers. The two end stretchers will have to be rocked from left to right as they are pushed through the shaper, as shown in chapter 18, figure 428, page 197.

The cutting of the edge groove is much easier. Using the same burr, set up the shaper to cut a $\frac{1}{64}$″ groove in both edges of the stock (fig. 450). The finished shaped stretcher should look like the one in figure 451. The stretchers are now ready for the inlays. Figure 452 shows the three stages involved in inlaying the side stretchers. The center ebony strip must be exactly $\frac{1}{32}$″ wide and slightly thicker than the $\frac{1}{32}$″ depth. The edge strips of satinwood or holly are glued into the edge grooves with at least $\frac{1}{64}$″ of excess stock protruding above both the top and side edges (center, fig. 452). When the glue is dry, all three strips can be sanded flush with the stretcher stock using a

453. Jig to hold the curved inlay while gluing.

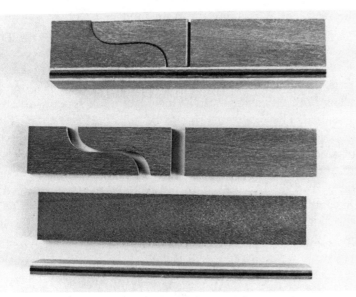

454. Pieces of the side assembly, *bottom:* finished inlaid strip, inner backing piece, and left brace and brace housing; *top:* finished side assembly.

sanding block covered with 220 grit aluminum oxide open-coat sandpaper (right side, fig. 452). To glue the inlay strip onto the curved end stretchers a matching curved jig must be made (fig. 453). This jig is cut to match the arc of the stretcher, the inlay is glued into place, and the stretcher forced against the matching curve of the jig by a backboard (top board, fig. 453). The stretcher is left in this jig until the glue on the inlay strip is dry. Be sure there is no excess glue between the stretcher and the jig before setting it aside to dry.

Figure 454 shows the different elements of the side assembly. The finished inlaid stretcher is shown at the bottom of the illustration. The second piece from the bottom in figure 454 is the inside board of the side assembly. The next group of pieces are the leaf brace and the brace housing. The two housing pieces are formed when the leaf brace is jigsawed out of a board matching the inside board. The housing pieces on either end of the brace are glued to the inside board, creating an opening for the bracket to set into (fig. 455). Round over both the inside and outside vertical edges of the brace and the upper inside edge of the curve with a ½″ sanding drum, the latter should form a finger groove to pull the brace out from the side (see figs. 455 and 458). Next, drill a hole using a #74 drill bit in the top and bottom of the brace centered in the rounded area of the edge. These holes are for the steel pins that will act as hinges for the leaf brace (fig. 455). Insert a small pin in each of the holes drilled into the brace, then dry-fit the lower stretcher against the side assembly. Place the brace in its proper closed position and mark the location of the hinge pin on the lower stretcher. Drill a hole the diameter of the hinge pin in this location on the lower stretcher, then glue the stretcher into place against the outer edge of the base housing assembly. Glue the drawer glide into position behind the lower stretcher. This completes the side assembly shown at the top of figure 454. Two of these are needed for the Pembroke table.

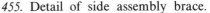

Fake end Inlays Finger grip Steel pins Inlays

455. Detail of side assembly brace.

The next step is to inlay the satinwood or holly strips into the drawer front and the "fake" drawer front. This is done using the procedure described in chapter 18, figures 430 through 433, page 198. Use figure 456 and the plans to aid in marking the location of each inlay in pencil. Use a flexible steel straightedge as a guide and score over both the inside and outside edges of each pencil line with a #11 scalpel. These two cuts should be ¹⁄₆₄″ apart (see chap. 18, fig. 430, p. 198). When all of the lines have been scored, cut away the ¹⁄₆₄″ of stock between the knife cuts, creating a groove ¹⁄₃₂″ deep. Flatten the bottom of the groove with the small, straight riffler described on p. 198. The drawer fronts are now ready for the ¹⁄₆₄″ by ³⁄₆₄″ inlay strips. Each strip of either satinwood or holly must be cut to fit the length of each groove and then glued into place (see chap. 18, figs. 432 and 433, p. 198). When the glue is dry, sand the strips of inlay flush with the drawer front (fig. 457).

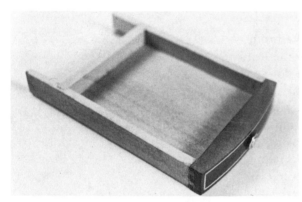

Drawer extension

456. Detail of drawer.

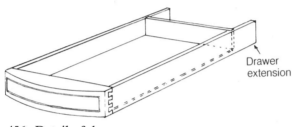

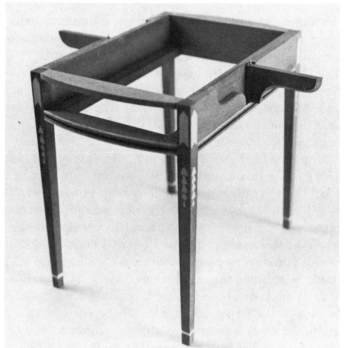

457. Drawer, notice the side extensions.

458. Finished carcass ready for the top.

The carcass of the table can now be assembled (fig. 458). First, glue the upper rear stretcher, the rear "fake" drawer front, and the rear lower stretcher together into one piece. This assembly can then be glued between two of the legs. Be sure the inlaid designs on the legs face outward and that the legs are parallel to each other and flush with the edge of the back curve. The front is assembled in the same fashion, with the exception of the drawer front. Place the drawer front in the assembly to be sure the spacing between the upper and lower stretchers is correct; however, do not glue the drawer front into the assembly. When the glue on both ends of the

carcass is dry, the sides can be assembled (fig. 458). The dovetailed drawer should now be assembled to fit into the carcass (see figs. 456 and 457). Notice the extensions at the rear of the drawer. These extensions keep the drawer flush with the front of the carcass and also allow access to the back of the deep drawer without its falling out. The drawer interior is constructed in the same fashion as described in chapter 4, pages 43 and 44, with the exception of the backboard. The backboard is held in a dado cut ⅜″ from the end of the drawer (see fig. 456). Cut this dado on the shaper using a ³⁄₃₂″-diameter straight burr.

The top of the Pembroke table consists of a top piece and two leaves cut in a graceful oval. The first operation in constructing the top is to cut the rule joint in the butting edges of the top piece and the leaves (fig. 459). The portion of the rule joint on the top piece edge is shaped with an inverted-cone burr and a flat riffler file, which is used to round over the lower edge of the groove made by the burr (right side, fig. 459). The leaf edge portion of the rule joint is shaped with a round burr (left side, fig. 459).

When the rule joint has been cut and the sections of the tabletop fit together perfectly, the pattern can be traced on the joined pieces. Notice that the pattern (fig. 460) has only one curved side, this is to ensure that the arc on both leaves is exactly the same. The pattern is traced on the top and one leaf, then flipped over and traced on the other leaf. Carefully jigsaw out the arc, then temporarily attach a scrap of wood to the pieces of the top to hold them in position while they are being sanded. Double-faced masking tape works very well for this operation. Smooth the edges of the top with a 1″ sanding drum (fig. 461). Sand the top of the assembly first with a 150 grit paper on a sanding block followed by a 220 grit sanding block (fig. 462). Always sand with the grain, never against it. Remember that for every stroke sanded against the grain it will take twenty strokes with the grain to remove it.

459. Rule joint.

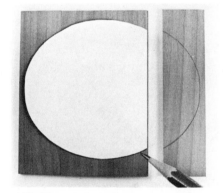

460. Trace the pattern on the top pieces.

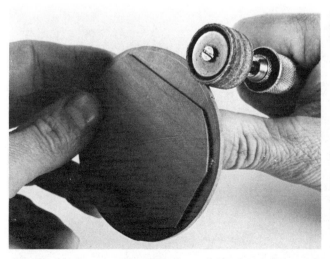

461. Sand the top after the pieces have been jigsawed out; notice the temporary board used as a brace.

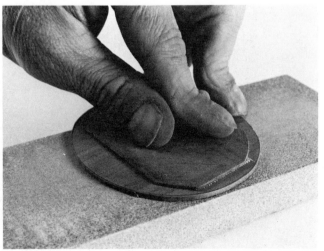

462. Sand the top pieces flush, always sand with the grain.

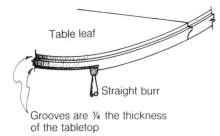

Table leaf

Straight burr

Grooves are ¼ the thickness
of the tabletop

463. Shaping the grooves in the table-top.

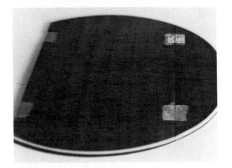

464. Top, showing the mortise cut-outs for the brass hinges.

When the top has been sanded, the 1/64″-by-1/64″ groove for the edge inlays can be cut into both sides of the top assembly. Use the same setup as was used for the stretcher edges (see fig. 463; see also chap. 18, fig. 428, p. 197). When the upper groove has been cut, the backing board must be removed and the lower groove cut into the top pieces. Glue a 1/32″ satinwood or holly strip into each groove. Use a jig similar to that shown in figure 453, which has been made to the proper shape to hold the strips on the leaf curve.

While the tabletop inlays are drying, the tiny brass hinges can be constructed. See chapter 5, figures 116 through 121, pages 55 and 56, for construction details.

When the top inlays are dry, they can be sanded flush with the tabletop and the edges. Figure 465 shows how the top must be dry-fitted against the carcass and the upper leaf brace pin to mark the location of the pin. Carefully drill a hole three-fourths of the way through the top, at the mark indicated by the pin. Next, check to be sure the length of the brace pin is not longer than 3/64″. To install the hinges on the underside of the tabletop, they must be mortised into each section (fig. 464). When the hinges have been fitted into the mortises, they can be glued into place with epoxy glue and then pinned with tiny brass brads. Be sure no glue gets into the hinge itself or into the rule joint on the table, or you may have to start the entire top over again, including the construction of the tiny hinges.

The top, including functional brass hinges, is now complete and can be attached to the carcass assembly. Make sure the upper and lower brace pins are in the holes drilled for them (fig. 466).

The last operation is the turning of the brass drawer pull (see fig. 467 and chap. 5, pp. 54 and 55).

The Pembroke table is now complete and ready to varnish and polish. Be sure the varnish does not gum up the tiny hinges. When

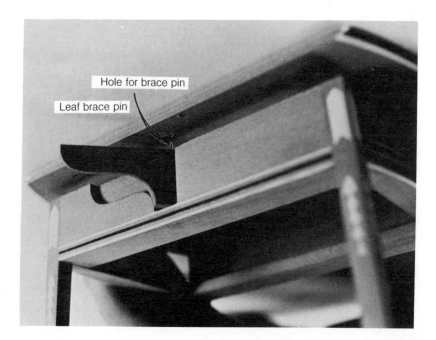

Hole for brace pin

Leaf brace pin

465. Detail of the top being set on the leaf brace pin; note the hole in the top for the brace pin.

the table has been finished with several coats of varnish, rub the surfaces with rottenstone and nonblooming rubbing oil until the piece has the soft glow of a hand-rubbed finish. If you have been patient, you should now have a beautiful inlaid Pembroke table to add to your collection of miniature furniture.

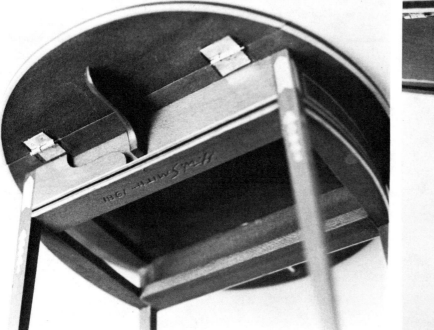

466. Detail of the assembled top and carcass.

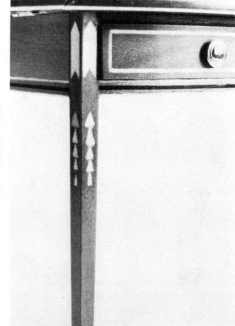

467. Detail of the turned brass knob on the drawer.

VICTORIAN PROJECTS
1835-1895

468. Finished pie safe.

· 20 ·

Pie Safe

Pie Safe

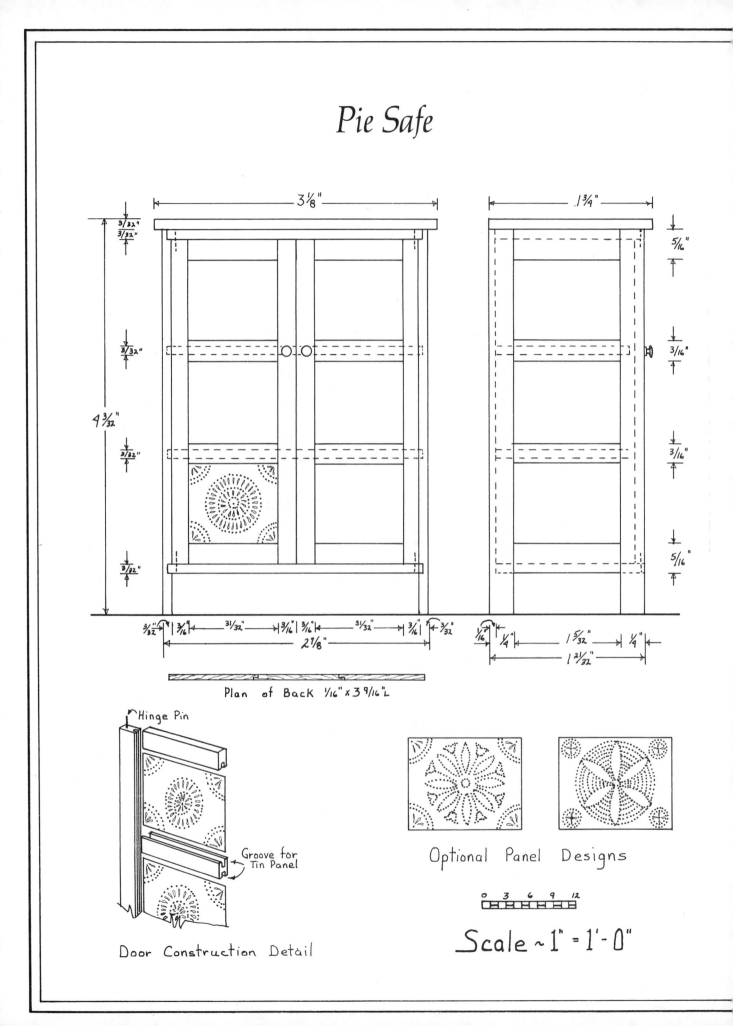

Plan of Back 1/16" x 3 9/16" L

Hinge Pin

Groove for Tin Panel

Door Construction Detail

Optional Panel Designs

Scale ~ 1" = 1'-0"

	pine	thickness	width	length
	MATERIALS LIST			
	12 panels (cut from 1 sheet of tin)	$8/1,000''$	$4''$	$10''$
SIDES	4 legs or sidepieces	$1/4''$	$3/32''$	$4''$
	4 top and bottom rails	$5/16''$	$3/32''$	$15/32''$
	4 center rails	$3/16''$	$3/32''$	$15/32''$
	2 top and bottom pieces	$15/8''$	$3/32''$	$13/4''$
	2 shelves	$17/16''$	$1/16''$	$13/4''$
	1 top	$13/4''$	$3/32''$	$31/8''$
	3 backs	$1/16''$	$1''$	$39/16''$
DOORS	4 door stiles	$3/16''$	$3/32''$	$33/8''$
	8 rails	$3/16''$	$3/32''$	$31/32''$
	2 knobs (turned from 3''-long dowel)	$1/8''$-diameter dowel, 3'' long		

The pie safe with pierced-tin panels was originally used during the Victorian era. The pie safe was designed to keep insects and small rodents away from the pastries and breads. The pierced tin allowed air to flow through the cabinet while keeping it free from vermin. However, it seems most of the surviving examples have a mousehole in them somewhere. To be authentic you might want to add a small hole in one of the doors.

The stock for this piece will be $3/32''$-thick basswood, pine, or any of the fruitwoods. The panels are made of tin, which can be purchased from most hobby shops. K&S Engineering #254 sheet tin is perfect, measuring $8/1,000''$ thick, $4''$ wide, and $10''$ long.

The first step is to lay out sixteen panels on the piece of tin with a scriber. There should be eight panels measuring $17/32''$ wide by $29/32''$ high and eight panels measuring $1''$ wide by $29/32''$ high. The pie safe requires only six panels of each size, however, the two extra will let you practice and provide a spare should you make a mistake. When the sixteen panels have been laid out, locate their centers by drawing, in pencil, diagonals connecting the opposite corners of each rectangle. Where the diagonals intersect, punch a small hole. To punch the design in the tin you will need two small metal punches. These can be made from a piece of hard, round $1/8''$-diameter steel—a nail will do. The first punch is nothing more than a very sharp awl. Round the metal of the punch to a point, using a grinder or a metal file. When it is sharp, you will find that the point has little ridges. Remove these ridges with a honing stone, followed by tripoli. This will polish the edge so the punch will not catch in the tin, making it difficult to remove. When the punch is polished, cut a $4''$-long piece of $3/8''$ dowel. Drill a hole in the bottom of the dowel the same diameter as the punch. Apply epoxy glue to the top of the metal punch and push the base of it into the hole in the end of the dowel. You

470. Detail of tin punch.

469. Punching the tin.

471. Darkening the tin panels.

now have created a tool that is easy to hold and control as you tap it with a hammer (fig. 469). To punch the complete design into the tin, you will need a second tool. It is made in the same manner, except that the end will be shaped like the point of a star. To accomplish this, grind the end of the punch down to a shape $\frac{1}{16}''$ long, $\frac{1}{64}''$ across the top, and tapered to a point at the bottom. Figure 470 will help you. The completed tool will punch the rays of the star-burst design. This wedge-shaped punch should be set in a dowel in the same manner as the awl. To lay out the design, two circles must be scratched in the tin with a compass (see fig. 469).

The first circle has a $\frac{3}{16}''$ radius, the second a $\frac{5}{16}''$ radius. It should be noted here that instead of using pencil lead in the compass, use something that will scratch the tin. When you have marked the center circles on the panel, punch a hole at the four corners of each rectangle. From these holes, mark two 90° arcs on each corner. The first arc should have a $\frac{1}{4}''$ radius and the second a $\frac{3}{16}''$ radius. See the plans. The design is now ready to punch. Start in the center of the rectangle on the first circle and punch a series of holes all the way around the circle (see fig. 469). Just inside this circle, punch out the eight points of a star, one at each point of the compass. On the second circle radiating from the center, punch a series of points quite close together (see fig. 473). The large, or $\frac{1}{16}''$, part of the punch should be facing toward the center of the design and the taper should be facing out. Finally, punch the holes in the larger 90° arc on each of the four corners and the three flares on the smaller arc.

Once all the panels have been punched out, they should be darkened or antiqued. The heat from either a propane torch or a butane cigarette lighter will do. Hold the metal in a pair of pliers and apply the heat evenly over the entire piece. The idea here is to darken the metal by heating it until it turns slightly bluish. Do not allow it to get red hot (fig. 471), but darken it just enough to remove the new look from the tin. Note that panels can be darkened either individually or as a group. When the piece has been heated to a uniform color, set it aside to cool. Later polish the metal with $\frac{4}{0}$ steel wool, just enough to remove any carbon from the steel. Cut the individual

rectangles out with a pair of sheet-metal shears. It is important that each of the pieces be cut exactly the same size and perfectly square, 90°, on all four corners. Check each set of six against the others to make sure each is the same height and width. Also check to make sure the panels are flat and not warped. If necessary, use a hammer and tap them until they are perfectly flat. The metal is stronger than the wood that composes the balance of the sides, and if the tin is warped it will warp the door or the side of the finished piece. Before leaving the pierced panels, there are a few things I should like to mention. Most of the original examples of pie safes had the sharp punched-out side facing out. Keep in mind the design I have given you is merely a suggestion. If you prefer, use your own design. Eagles, sunflowers, tulips, or stars are a few other patterns that can be used. See the sketches on the bottom of the plans.

With the panels completed, the construction of the carcass can now begin.

Cut the four leg posts, the side rails, the door stiles and rails, the shelves, and the top and bottom pieces. See the materials list. When the pieces are cut to size, set up your drill press as shown in figure 472, using a small saw blade such as Dremel makes. This tool is used to cut the grooves into which the tin panels are fitted. It is important to cut the groove exactly in the center of the 3/32″ stock so that either side can face forward. This greatly simplifies construction. As you can see from figure 473 the groove is cut on only one side of the posts and the top and bottom stretchers that form the outer edges of both the sides and the doors.

472. Cutting a groove.

473. Elements of a door.

When all of the pieces have been grooved, dry-fit each area to be sure everything fits snugly. You may have to remove small amounts from the tin panels to make sure the wood butts tightly.

I have found it much easier to sand and stain the small pieces prior to the final assembly so that any glue that may inadvertently get on unwanted areas will not show.

To assemble the sides and doors, apply a thin bead of glue to

each of the butt joints and along the edge of each tin panel. Lay the pieces out as in figure 473. First, press the rails and the tin panels together, making sure the panels are centered, then quickly push the side posts into place. Apply pressure to force the glue out of the joints. It is very important to make sure the entire construction is square and lies flat before the tack of the glue sets up. This means you will have to work quickly. If one section is pulling up, check the tin and if necessary bend it with your fingers until it no longer warps the piece. When everything is square and flat, set the piece under a block of wood and weight it down until the glue has dried.

In writing this book I have attempted to demonstrate the construction of pieces designed for people at all stages of proficiency in making miniature furniture. The construction of the paneled pie safe has been left quite simple to assist those who are just beginning to make miniatures. If you desire to upgrade this piece, each of the joints in the sides and doors can be held together by mortise-and-tenon joints rather than the butt joints described. Chapter 11, "Press Cupboard," figs. 208 and 209, p. 107, describes the technique involved in making these more complicated joints. Remember to add the length of both tenons to each rail measurement.

When the sides are completely dry, the three dadoes, the rabbet, and the groove can be cut into them. Remove the grooving saw from the drill press and replace it with a ⅟16″-diameter straight burr. This burr will make all of the necessary cuts in the side. Set the tool so the burr will cut to a depth halfway through the thickness of the ³⁄₃₂″ stock. The two blind dadoes are cut in the center of the two middle rails. To cut the blind dado, line up the right side of the pie safe so that the cutter stops ⅛″ from the front edge of the piece. Make a pencil mark (upper right, fig. 474) on the shaper fence to indicate where the cuts should end. Turn the side 180° and make a mark on the fence where the left side should begin. This will give you stop-

474. Cutting a blind dado.

475. Cutting a groove.

and-start marks for the right and the left panels. A square block of wood is used as a guide to push the sides through the cutter. Be sure to work from left to right, moving against the rotation of the burr. When the left-side cut has been completed, stopping ⅛″ from the edge, lift the cutter out of the groove and set the right side against the pencil mark on the fence. Adjust the blade until it is again cutting halfway through the thickness of the wood and push the stock through, moving to the left. It is extremely helpful if your drill setup has a depth-control screw. Now cut the first blind dado on the two opposite sides. Repeat this procedure on the lower rails and you have completed the four blind dadoes. To cut the rabbet across the top, set the rip fence so the cut is the exact diameter of the burr, and push each piece through, moving against the rotation of the burr. The groove down the back side (fig. 475) is cut with the same setup as the rabbet. You have now made all the cuts, with the exception of the dado at the very bottom of the piece. Before cutting this dado, it is important that the door be set against the side, lining the top of the door up with the bottom of the rabbet (fig. 476). Make a pencil mark on the side where the bottom board should be located. In other words you must make sure that the door will fit between the two cuts. The next step is to cut the shelves that go into the two blind dadoes and the top and bottom pieces. When the top and bottom are cut, mark the front of each ³⁄₃₂″ from the edges and half the thickness of the door with an awl (fig. 477). Drill the four holes for the hinge pins using a #74 drill bit.

The back of the carcass is made out of three ¹⁄₁₆″-thick strips. Be sure to cut the back large enough for a custom fit. Do not butt these boards together if you can avoid it. They will shrink and leave cracks. To avoid this, cut a narrow groove halfway through the side of each board and push them together to lap each other (see plans, back detail). When glued, these laps will make a strong and stable back.

With the back completed, begin gluing the carcass together. Glue the two shelves, the top, and the bottom to the sides. Make sure the holes you have drilled for the door hinges are in front. Use a square to make sure the piece is perpendicular and then glue the back on (fig. 478). Set this aside to dry.

On the lathe turn two small, ⅛″-diameter by ³⁄₃₂″-high mushroom knobs. Use an outside caliper to make sure that they match each other in both diameter and height. Be sure to turn a peg on the back of each to hold it to the door (see chap. 22, fig. 508, p. 235). Drill a hole in each door of the same diameter as the pegs. This hole should be near the upper divider. Finally, the knobs can be glued in place.

When the carcass is dry, set it front side down on a flat piece of sandpaper and carefully sand all the edges flush. Set the doors in place. Push sequin pins through the holes in the top and the bottom and into the door stiles to make the hinges (fig. 478). You are now ready to cut the top. The top is made from ³⁄₃₂″ stock and should

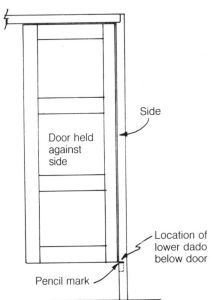

476. Location of the lower dado.

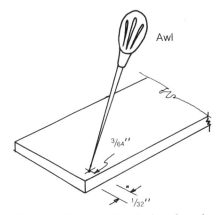

477. Location of the holes for the door pins.

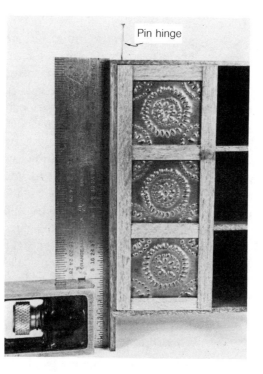

Pin hinge

478. Using a square on the carcass of the safe, with pin hinge indicated.

overlap about ³⁄₃₂″ on the two sides and the front. It will be flush in the back. Use Weldwood Contact Cement to glue on the top. Be sure to position the work exactly before applying pressure. It cannot be moved once contact is made.

The pie safe is now completed. Sand it lightly, use a tack cloth, and restain the entire piece. Make the corners darker than the flat surfaces to give the safe an old worn look. Allow the piece to dry, then lightly wax it with Goddard Wax. For details on finishing see chapter 6.

479. Finished center table.

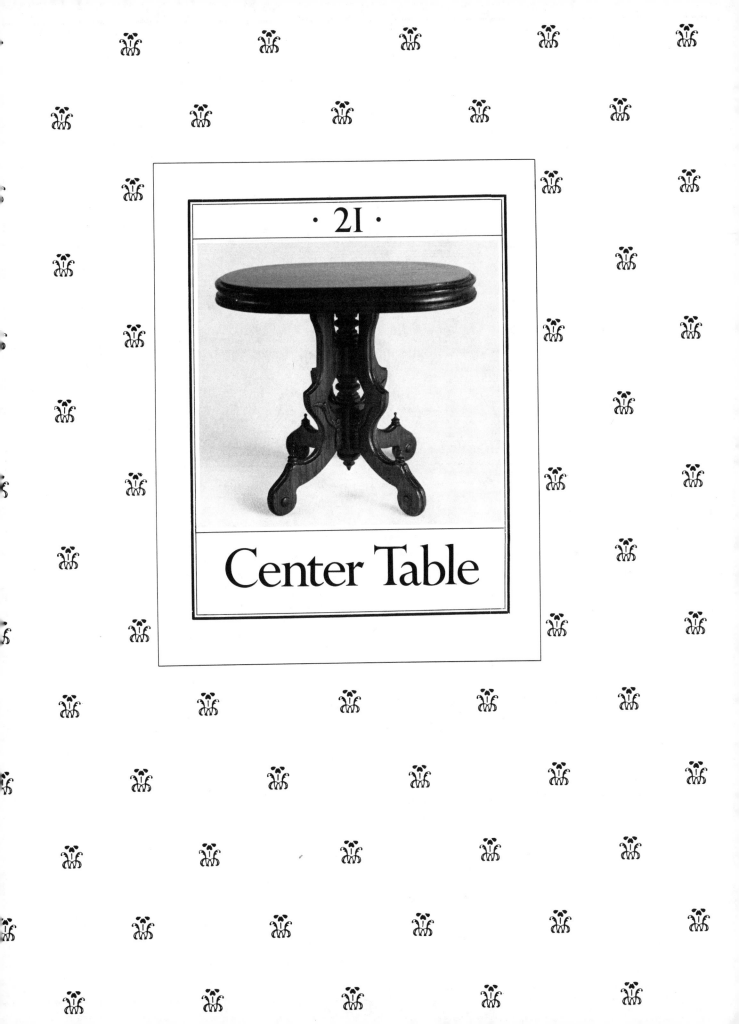

· 21 ·

Center Table

Center Table

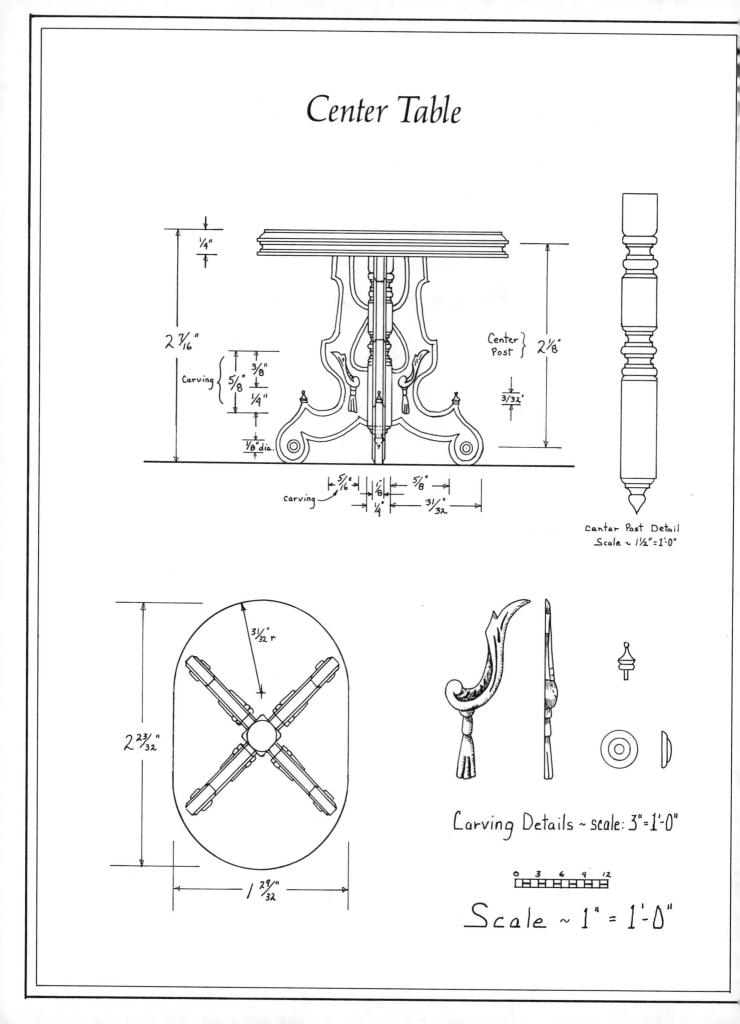

2 7/16"

1/4"

Carving { 5/8" 3/8" 1/4"

1/8" dia.

carving

5/16" 1/8" 5/8" 1/4" 31/32"

Center Post } 2 1/8"

3/32'

Center Post Detail
Scale ~ 1½"=1'-0"

31/32" r

2 23/32"

1 29/32"

Carving Details ~ scale: 3"=1'-0"

0 3 6 9 12

Scale ~ 1" = 1'-0"

MATERIALS LIST			
walnut	*thickness*	*width*	*length*
1 top	¼"	2"	3"
4 legs	⅛"	1⅛"	2½"
1 center post	¼"	¼"	2½"
8 bull's-eyes and 4 finials (turned from 3⁄16" dowel)	3⁄16"	3⁄16"	6"
8 carvings (cut from one 12"-long piece)	3⁄64"	½"	12"

Most Victorian homes had at least one center table. Many examples had marble tops; this piece, however, is made entirely of walnut.

The first operation is to rough out the major pieces of wood needed. Use the materials list, the plans, and figure 480 as guides.

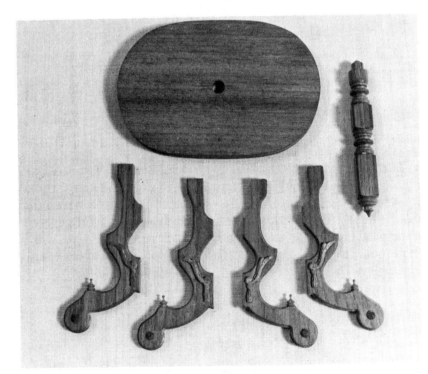

480. The pieces needed for the table.

After you have roughed out the piece, you can begin the detail work. The center post is a simple straight turning, so I shall only briefly repeat the lathe operations that have been taught in chapter 4, "Working with Wood," pages 37 through 39, and chapter 9, "Spindle Chair," pages 85 to 89.

First, mark off the round areas of the turning with a pencil. Place the stock in the lathe and, using a veiner, score over the pencil lines. Next, round the appropriate areas with a straight chisel. After filing the round areas smooth, indicate the turned design with a pencil.

481. Profile of the top of the table.

482. Cutting the top of the table on the shaper.

Use the enlarged detail on the plans as a guide. A small, straight chisel and a small, round chisel are used to rough out the design in the wood. Finish the turning with files and sandpaper. Be sure to turn the ³⁄₁₆″-diameter peg on the top of the post to secure it to the tabletop.

The next operation is to trace the top oval from the plans onto tracing paper and glue the tracing onto the ¼″ stock. A compass can be used instead of the tracing by marking the ³¹⁄₃₂″-radii, as indicated in the drawing. Carefully jigsaw out the oval shape. The more precise you are now the smoother the piece will work on the shaper. Use a large barrette file if necessary to true the edges so that the oval is a continuous flowing line. Set up the shaper as shown in figure 482 with a wheel dental burr protruding through a hole in a ⅛″-thick temporary shaper top. Figure 483 illustrates the different burrs used in cutting the top edge molding shown in figure 481. Finish the molding with rifflers and sandpaper.

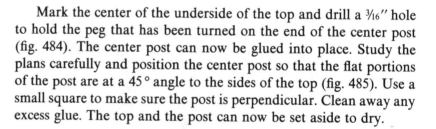

#20 wheel #5 wheel #8 oval burr Riffler

483. Burrs used in shaping the top of the table.

Mark the center of the underside of the top and drill a ³⁄₁₆″ hole to hold the peg that has been turned on the end of the center post (fig. 484). The center post can now be glued into place. Study the plans carefully and position the center post so that the flat portions of the post are at a 45° angle to the sides of the top (fig. 485). Use a small square to make sure the post is perpendicular. Clean away any excess glue. The top and the post can now be set aside to dry.

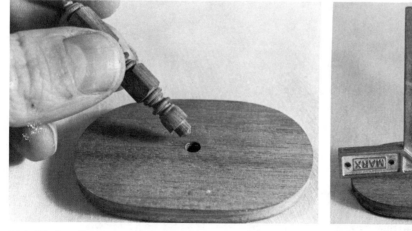

484. Fitting the center post into the tabletop.

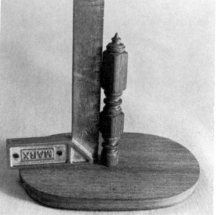

485. Using a square on the center post.

Using the plans, make a template of the leg design, then trace four legs onto the ⅛″ stock. Carefully jigsaw each out. Use files and sanding drums to clean and smooth the cuts. With the shaper set up as it was to do the top (fig. 482), use a round dental burr to shape the edge of the curved sides of the leg (fig. 486). Do not shape where the leg butts into the square portion of the center post. Clean the cuts with a round riffler file.

486. Detail of the shaping of the legs.

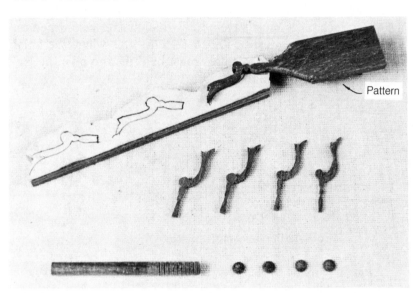

Pattern

487. Stages in making the applied carvings and turnings.

Next, make the tassels. Using figure 487 and the plans as guides, make a template of the tassel design out of ⅟₃₂″ maple stock. Be sure to leave an area at the bottom of the template to hold onto while you trace around it. Cut the piece of ³⁄₆₄″ stock into four 3″-long pieces. Apply household rubber cement to both sides of all but the top and bottom boards and allow it to set for five minutes. Carefully, align the edges of the four ³⁄₆₄″ pieces and press them together until you have a stack four pieces high. Now glue a piece of white paper onto the top board with the same glue. This piece of paper will receive the tracings of the pattern. It is much easier to see the lines when jigsawing out the design if they are on white paper rather than on the dark walnut. Cut out each stack of four tassels and carefully file them until they are uniform. When they are all alike, use a #11 knife and carefully pry the pieces apart. Rub them lightly over 220 grit sandpaper to remove any excess rubber cement and fasten them to a scrap board with double-faced masking tape. Be sure four are facing left and four are facing right. Now you can carve the designs using the carving detail on the plans. You will need a small round and a small inverted-cone dental burr and a #11 X-acto knife or #11 scalpel. I prefer the scalpel. When the carvings are finished and sanded, remove them from the tape by carefully prying them up with a knife. Each pair can now be glued onto each of the four legs. If you desire, the jigsawed pieces can be glued directly to the legs and carved in place. This is a bit more difficult to do. You must be very careful not to slip and carve the leg itself.

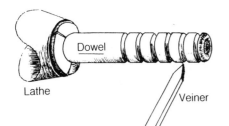

488. Detail of the method of turning the bull's-eyes.

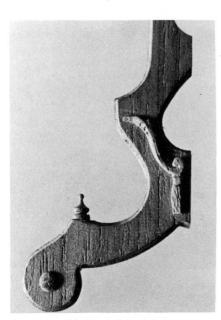

490. Detail of a finished leg.

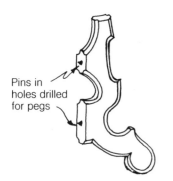

491. Pins inserted in a leg for correct marking of peg holes in the center post.

Figures 487 and 488 show the turning of the tiny bull's-eyes. Notice how the individual bull's-eyes have been scored with a small veiner before the separate turnings are done so they will all be the same size. Each is finished completely, then cut off so the next one can be turned. These can be glued into place as soon as they come off the lathe.

The finials on the lower legs are the most difficult part of this piece. Care must be taken to turn them to the same size and design (fig. 489). Each piece must have a tiny 1/32"-diameter peg turned on the bottom. The legs must be flattened in the area where the finial will go, and the center of this area must be drilled to take the 1/32" peg on the end of the finial.

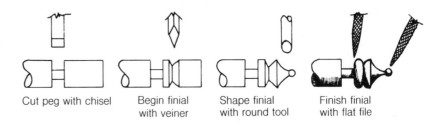

Cut peg with chisel Begin finial with veiner Shape finial with round tool Finish finial with flat file

489. Stages in turning the finials for the legs.

If you have made the legs correctly, they should all look like the one in figure 490. If so, glue them into place. There are two methods of doing this. The simplest is to butt-join the flat surfaces of the leg against the corresponding surfaces of the center post and the top with glue. The second method involves drilling a 1/32"-diameter hole in the two flat areas of each leg where they meet the square portion of the center post. Pins are then placed in these holes, which act as markers when the leg is pressed against the post. The protruding pins indicate the location of the pegs in the leg on the center post (fig. 491). Matching 1/32" holes are then drilled into the post where the leg pins have left their mark and 1/32" dowels are used to peg the four legs and the post together. This pegged joint is stronger than a butt joint.

Make sure you remove all of the excess glue from the wood. Glue will repel the finish, and the area it covers will not be stained.

Lightly sand the completed center table, use a tack cloth, and the table is ready to seal, stain, fill, and varnish. Follow the steps described in chapter 6, "Finishing," pages 59 to 63, and you will have a miniature Victorian table to treasure.

→
492. Finished washstand.

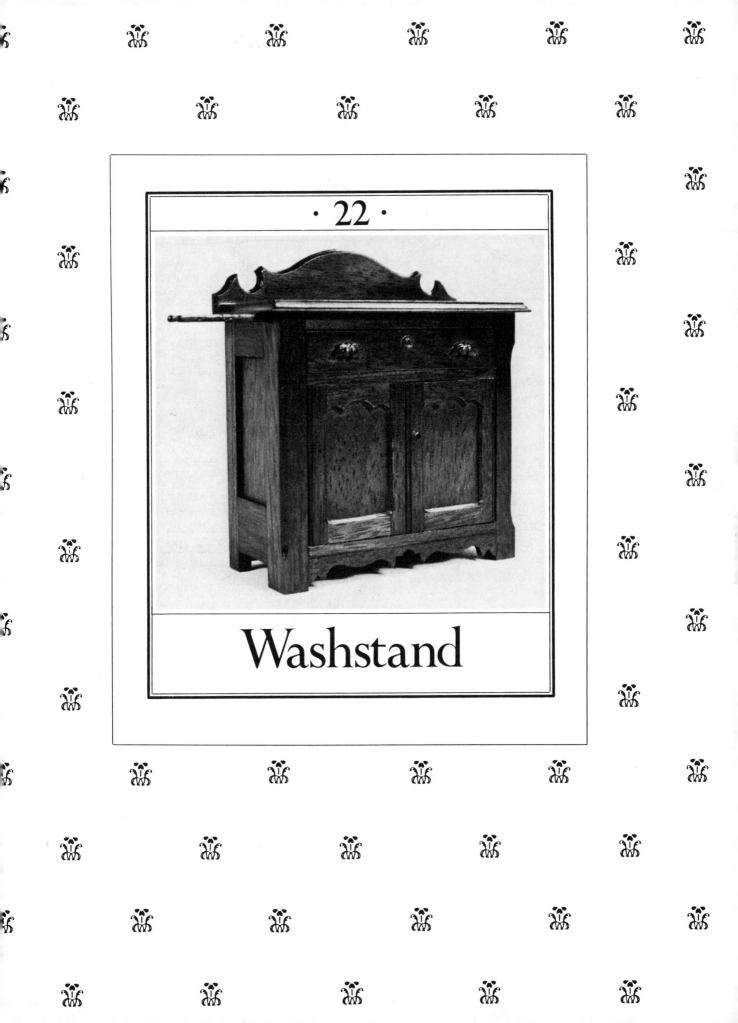

· 22 ·

Washstand

Washstand

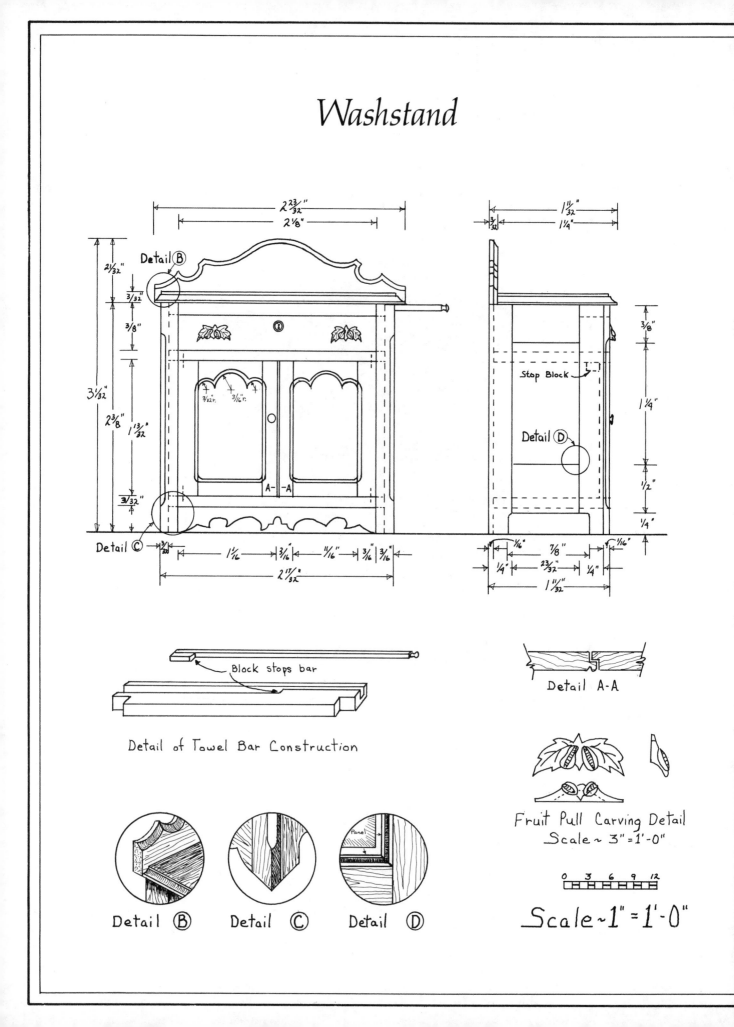

Detail ⒷB

Detail ⒸC

A—A

Stop Block

Detail ⒹD

Block stops bar

Detail of Towel Bar Construction

Detail A-A

Fruit Pull Carving Detail
Scale ~ 3"=1'-0"

Detail ⒷB

Detail ⒸC

Detail ⒹD

Scale ~ 1"=1'-0"

MATERIALS LIST				
	walnut	*thickness*	*width*	*length*
SIDES	4 posts	3/32"	1/4"	2 3/8"
	2 front facepieces	3/32"	1/16"	2 3/8"
	2 bottom rails	3/32"	1/2"	2 3/8"
	2 top rails	3/32"	3/8"	23/32"
	2 panels	1/16"	25/32"	1 9/16"
	1 top	3/32"	1 1/4"	2 23/32"
	1 backboard	3/32"	3/4"	2 23/32"
	1 top brace	1/8"	5/16"	2 11/32"
	2 shelves	3/32"	1 9/32"	2 11/32"
	1 towel bar	1/16"	1/16"	2 5/8"
	1 back	1/16"	2 15/32"	2 3/8"
	1 skirt	3/32"	3/8"	2 5/32"
	1 drawer front	3/32"	3/8"	2 5/32"
DOORS	4 stiles	3/32"	3/16"	1 13/32"
	2 lower rails	3/32"	3/16"	11/16"
	2 upper rails	3/32"	3/8"	11/16"
	2 panels	1/16"	3/4"	1 3/16"
	1 knob	3/32"	3/32"	1"
	2 pulls	3/32"	1/4"	1 3/4"
DRAWER	2 sides and 1 back	1/16"	3/8"	6"
	(cut from 6" piece)			
	1 bottom	1/32"	1 1/4"	2 1/4"

Drawer interior is of pine or basswood.

The washstand or commode, as the name implies, was used to hold a washbowl and a pitcher in the days before indoor plumbing. This piece is very charming, with its scalloped doors, delicate apron, and hard-carved fruit pulls. The towel bar on the side was used to hold the linens for drying hands and face.

The first step is to cut the rough stock of walnut wood to size using the plans and the materials list as guides. We shall begin construction with the sides, each of which consists of two side posts or legs, two rails, a beveled panel, and a front facepiece (fig. 493). Insetting the panel will require the cutting of a groove in the edge of the four pieces surrounding it. On the top and bottom rails the groove can run the length of the stock but on the side posts the groove must be only as long as the panel itself. This requires the same setup for a side groove as shown for the paneled cradle, chapter 8, figure 153, page 78. In this operation, however, the stop lines on the fence will not be the same distance on either side of the cutter. This is shown on the uppermost piece in figure 493. The groove ends 1/4" from the top of the leg groove (fig. 494) and 5/8" from the bottom. Use a small dental saw and remember to cut the left and right sides opposite each other.

493. Sidepieces.

494. Detail of the panel and groove in the side.

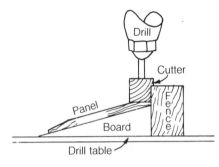

495. Setup for cutting the bevel.

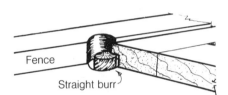

496. Cutting a groove in the back.

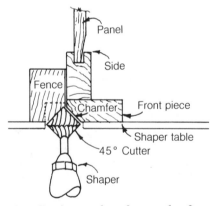

497. Cutting a chamfer on the front edge.

With the side pieces cut and grooved, they can be dry-fitted to check the size of the panel. Be sure the panel is large enough to fit into the grooves. The bevel is cut with a straight burr. First, a scrap of board is cut to the correct angle of the bevel and placed under the panel (fig. 495). This angles the panel so the straight burr can make a beveled cut. When the panels are finished, the side can be assembled (see plans, detail D). Be sure the bevel on the panels faces toward the inside of the carcass and the completed sides lie flat when placed on a level surface. The next operation is to cut a groove on the inside edge of the rear posts. This groove holds the washstand back and should be cut to half the thickness of the post and 1/16″ wide (fig. 496).

The front facepiece can now be glued onto the completed side (see plans, detail C). When the glue is dry, the decorative chamfer in the front edge should be cut. First, chuck a 45°-angle burr into the shaper. Next, mark the length of the chamfer on the washstand side. Now, hold the side against the shaper and mark the left and right stop lines on the fence. Make a test cut on a scrap board of the same thickness as the facepiece to be sure your measurements are correct. When the shaper is set up properly, make the finished cut on the leading edge of both sides (fig. 497).

Having completed the sides, the next step is to construct the top brace, which houses the towel bar (fig. 498). The brace is a piece of 1/8″-high by 5/16″-wide stock that has been grooved to accommodate the towel bar. The groove is made with two cuts on the shaper. The first cut, which runs the length of the brace, is 1/16″ deep by 1/16″ wide and 1/8″ from the front edge. The second cut, made 5/32″ from the front edge, is 1/16″ deep by 1/32″ wide and 1½″ long. This second cut restricts the movement of the stopblock on the bar, thus preventing the bar from being pulled out and lost. The brace must also be notched in the front corners to fit against the side facepiece (see plans, detail at left center).

The towel bar is a piece of 1/16″-square stock with a knob turned

498. Detail of the towel bar and top brace.

on one end and a scrap of ½₂″ by ¹⁄₁₆″ wood glued to the other end. This tiny piece of ½₂″ wood acts as a stop to prevent the towel bar from being removed (fig. 498).

The two shelves are cut from ³⁄₃₂″-thick stock. Mark the location of the holes for the hinge pins on each corner with an awl. These will be approximately ⅛″ in from either side and ³⁄₆₄″ in from the front edge (half the thickness of the door stock). Drill the holes with a #75 drill bit as shown in figure 499. The notches in the horizontal braces must be cut so the piece fits flush with the front of the carcass and butts against the vertical facepiece (fig. 500).

The last piece needed to assemble the basic carcass is the back. It is cut from ¹⁄₁₆″ stock and should fit snugly into the grooves cut into the sides. It is best to check the measurements for the back by dry-fitting the sides, the shelves, and the top brace before making any cuts. When the back is cut to size and everything is sanded, the carcass can be assembled. Figure 501 shows how the back fits into the side groove. Use a square to make sure the piece is perpendicular to the table and the sides are square with the back and front. While the carcass is drying, you can cut the templates for the top splashboard and the lower stretcher. With a pencil trace around the template, marking the walnut stock as shown in figure 502. Notice that only a half pattern is used. It is traced on one half of the stock, then flipped over and traced on the other half. This method helps ensure symmetry. Figure 503 shows the lower stretcher, or skirt, being jigsawed out on a power saw. Note how the spring hold-downs on the saw have been cut back, making it easier to view small pieces as they are being cut.

499. Drilling pinholes for the hinges.

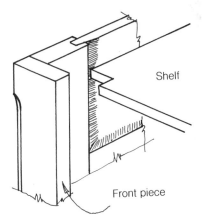

500. Detail of a notch in the shelf.

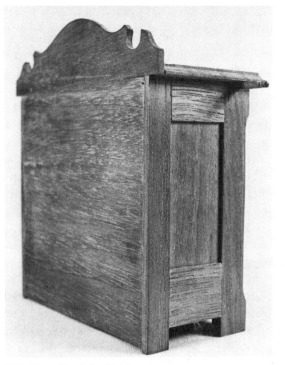

501. Detail of the back.

502. Tracing the splashboard pattern on the stock.

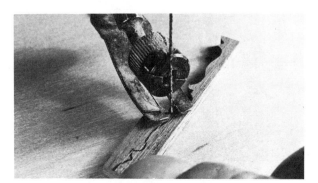

503. Jigsawing the skirt.

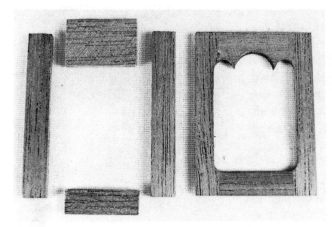

504. Stages in the making of the doors.

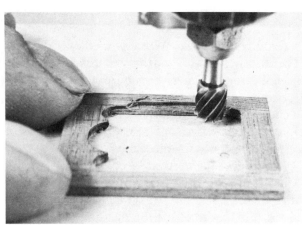

505. Cutting a groove in the door for a panel.

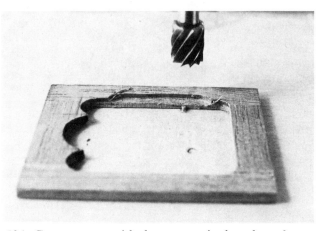

506. Groove setup with the cutter raised to show the pin in the drill table.

507. Cutting a cove on the front of the door.

The construction of the doors differs considerably from the methods used on the sides. The deep scallop in the top rail makes it difficult to cut a groove along the inside perimeter. Instead, the door stiles and rails are assembled, the glue allowed to dry, and then the scalloped design is jigsawed out of the top rail (fig. 504). With the sawing completed, the groove for the back is cut on the drill press. Figure 505 shows the drill press with a small, straight burr cutting the groove for the panel 1/16″ deep and 3/32″ wide. Figure 506 illustrates the same stage in the cutting operation, but with the burr raised so you can see the small pin set in a 1/8″-thick board temporarily attached to the drill, which guides the work. Once the groove is cut, a small round dental burr is used to shape the front cove (fig. 507). Notice how the shank of the burr is used as a guide while the head cuts the stock.

Two cuts must be made in the butting edges of the doors. Detail AA on the plans illustrates both cuts. The first cuts are opposing grooves, so the door's inner edges lap each other. The second cut is a small decorative groove scored in the right door to balance the crack where the doors meet. This groove can be made with a pointed burr

or, preferably, with a triangular riffler file held against a straight-edge.

To finish the doors, turn a mushroom knob on the lathe (fig. 508). When you have completed the turning, measure the diameter of the pin at the end of the knob and drill a hole for it in the right door (see plans). Note that you may put knobs on both doors if you desire. Glue the knob into place and sand the doors to fit the opening (fig. 509).

508. Turning the mushroom knob.

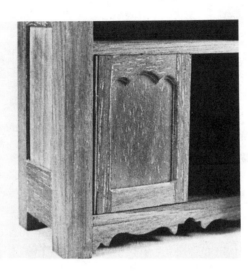

509. Detail of the assembled door.

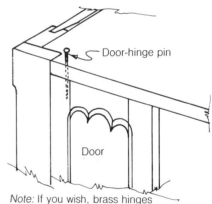

Note: If you wish, brass hinges can be used instead of the pins

510. Detail of the pin hinge.

The doors can now be hinged in place by pushing four hinge pins through the holes drilled into the horizontal pieces (fig. 510). Once the hinge pins have been pushed into the doors, the pin heads can be cut flush and the skirt glued in place. A small block of wood should be glued onto the bottom of the upper shelf to keep the doors from being pushed all the way in (see plans, side elevation).

The shaping of the top involves only three cuts. Follow the design shown in figure 511.

The top edge of the splashboard must now be beveled using the same setup as was used for the front of the doors (see fig. 507). When the splashboard and the top are cut and sanded, glue them together along the back of the top (see plans, detail B).

Before the top assembly can be glued onto the carcass, the towel bar must be put in place. This requires cutting a 1/16"-square opening into the side of the carcass for the bar to stick out of. This hole must line up exactly with the groove cut into the top brace. Check the bar to make sure it slides easily, then glue the top down. Be careful not to get any glue either in the towel-bar track or between the bar and the top. Center the top on the carcass and, as the glue sets, slide the bar to make sure it is free.

The final construction on the washstand is the drawer. The drawer slides on the center stretcher and fits flush with the carcass. The only difficulties are the dovetails and the carved pulls (fig. 512). Follow the instructions described in chapter 4, "Working with Wood," pages 43 and 44, for help in making the dovetail joint. Fig-

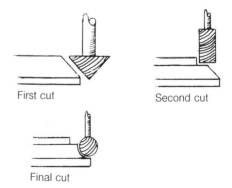

First cut Second cut

Final cut

511. Stages in the shaping of the top.

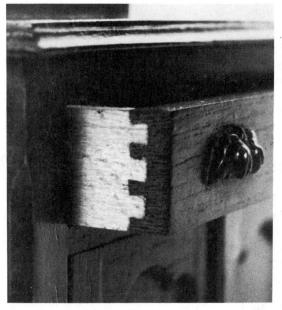

513. Cutting the groove for the drawer bottom.

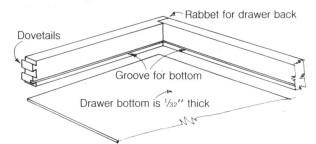

512. Detail of the dovetail.

514. Detail of the drawer cuts.

ure 513 shows the shaper and small straight burr being used to cut the groove for the drawer bottom. This groove must be cut on all four sides to a depth of one-third the thickness of the stock. Figures 513 and 514 show the rabbet joint at the rear of the drawer into which the back is set. After the drawer joints have been cut and checked, dry-fit the piece and make sure it slides easily in the carcass opening. If everything fits nicely, glue the drawer together.

Having assembled the drawer, you can now tackle the most difficult part of the washstand, carving the fruit pulls. Figure 515 illustrates the stages involved in carving these tiny pulls. At the lower left is the pattern; notice how it has been left on a long piece of stock. This serves as a handle while tracing around the design.

It is easier to cut out small pieces when the pattern can be easily seen; therefore, transfer the design to a piece of thin paper and glue it to the walnut. To ensure that both pulls will be the same, stack the

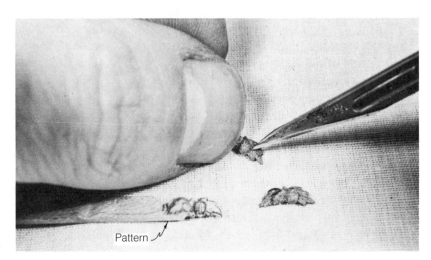

515. Detail of carving the pulls.

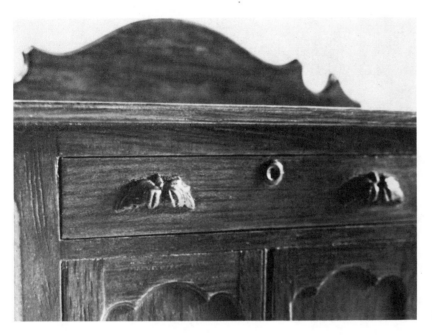

516. Detail of the drawer front.

wood together so that only one cut is made (see chap. 21, fig. 487, p. 227). Once the pieces have been cut out with either a power jigsaw or a hand fretsaw, they should be carved with a #11 scalpel. You can either hold them as shown in figure 515, which is very difficult, or stick them down on a scrap board with double-faced masking tape. To carve the pulls, separate the side leaves from the center fruit, then add detail. The drawing on the plans should help you. Sand the pulls lightly, then glue them in place. If you are in doubt about carving, see chapter 23, figures 535 through 541, page 247.

The final operation is to turn the walnut escutcheon for the key. This is done on the lathe from a piece of ³⁄₃₂″-diameter stock. Figure 516 shows a detail of the finished drawer front.

You have now completed building a beautiful Victorian washstand with hand-carved fruit pulls. Finish the wood as described in chapter 6, pages 59 to 63.

517. Finished balloon-back side chair, front view.
518. Finished balloon-back side chair, side view.

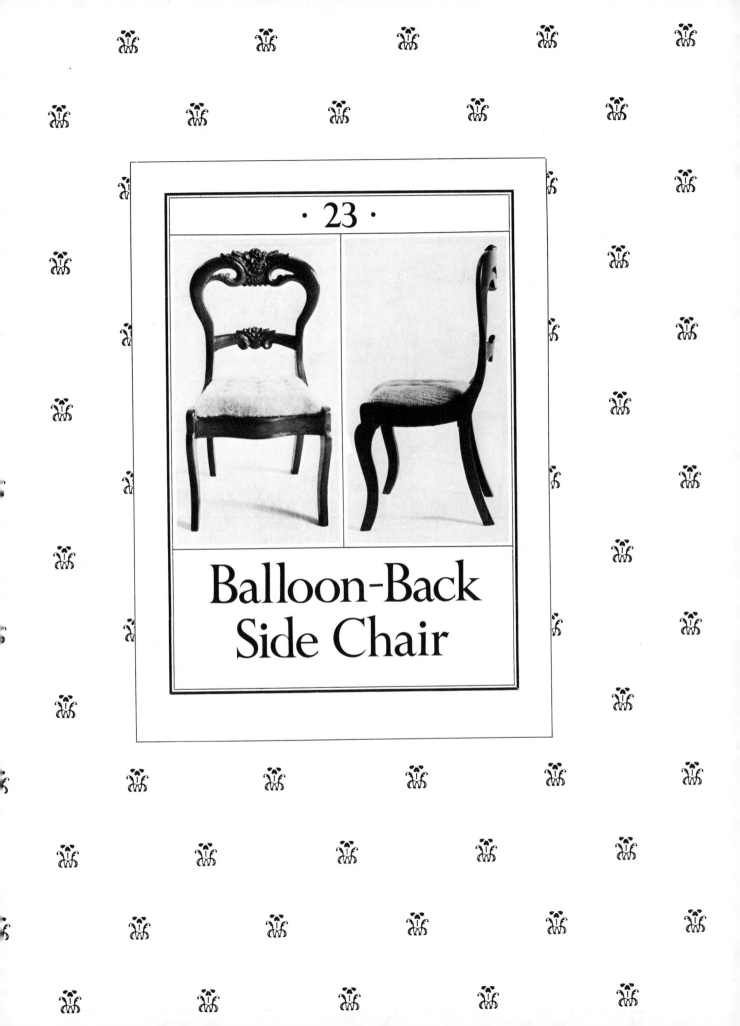

· 23 ·

Balloon-Back
Side Chair

Balloon-Back Side Chair

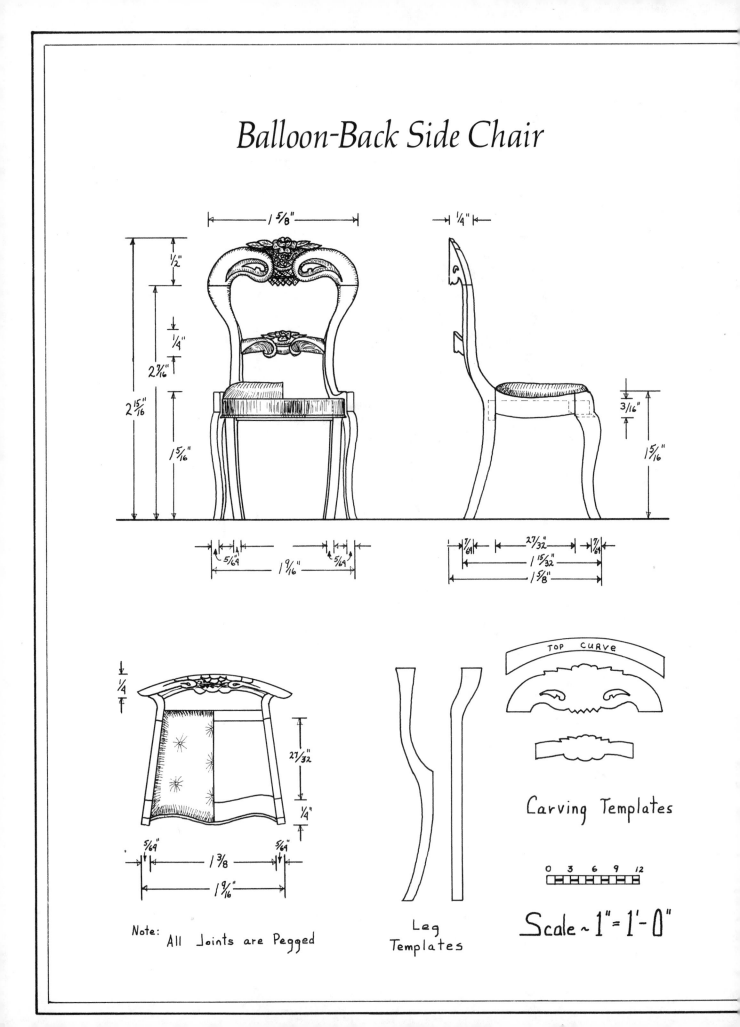

Note: All Joints are Pegged

Leg Templates

TOP CURVE

Carving Templates

0 3 6 9 12

Scale ~ 1" = 1'-0"

MATERIALS LIST			
black walnut	*thickness*	*width*	*length*
2 rear legs	7/16''	7/16''	2 7/16''
2 front legs	3/32''	3/8''	1 1/2''
2 side stretchers	3/32''	3/8''	27/32''
1 front stretcher	5/32''	3/8''	1 3/8''
1 front stretcher bead	1/32''	3/8''	1 3/8''
1 back stretcher	3/32''	7/32''	1 3/32''
1 center carving	1/4''	3/8''	1 1/16''
1 crest rail carving	5/16''	5/8''	1 7/8''
softwood			
1 seat approx.	1/8''	1 1/4''	1 3/8''

This delicate chair has always fascinated me. We have the original in our home and I felt compelled to copy it. The chair is made of walnut and is pegged together.

The first step is to rough-cut all of the pieces to size from as fine-grained walnut as you can find. Use the materials list as a guide.

Before any construction can begin, the two leg templates shown on the plans must be made. Several other templates are shown on the plans; however, unless you are making more than one chair these patterns can be transferred to the wood in one of the ways mentioned in chapter 4, "Working with Wood," pages 39 and 40. To make the templates, transfer the pattern onto a scrap of 1/32'' hardwood. Jigsaw out the design and true it up using files and sandpaper. I always find it difficult to hold the templates steady as I trace around them with a pencil. To remedy this, glue a piece of 220 grit sandpaper to both sides of the template. When the glue is dry, carefully remove the excess paper from around the pattern with a #11 knife. The sandpaper allows the template to grip the wood and will not slip when you are tracing around it.

With the template completed, the rear leg can be laid out. Figure 519 shows the basic stages in roughing out one of the rear legs.

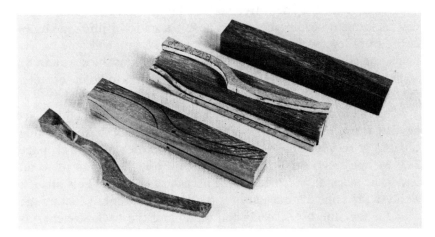

519. Four stages in the making of the rear legs.

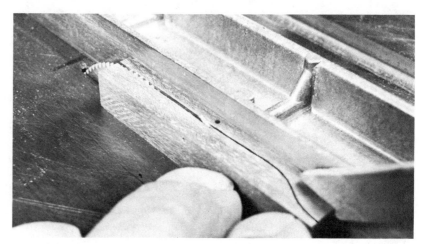

520. Sawing a rear leg.

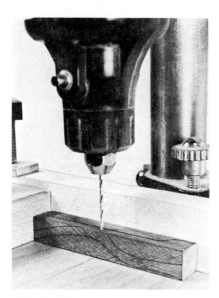

521. Drilling a rear leg.

It is important that the four sides of the ⅞₆″-square stock be parallel to each other. Trace around the templates on two adjoining sides as shown in the center of figure 519. Be sure you have both a left and a right leg before tracing the template onto the second piece.

The first cutting operation is along the straight portion of the front design. Set up the circular saw as shown in figure 520. The fence is set to the width of the leg. Because the design flares at the end, a pencil mark is made on the saw-table top (upper left, fig. 520) indicating where to stop the cut. The piece of stock is pushed through with a push stick until the leading edge reaches the line on the saw table; the stock is then carefully lifted out of the saw. Watch your hands. Always use push sticks and safety glasses.

Before the balance of the sawing can be done, the holes for the pegs must be drilled. I have found it much easier to drill into a piece of stock that is square than into the irregular shape of the design after it has been jigsawed out.

Drilling the holes for the side stretchers is relatively easy. The placement of the hole is marked on the stock, using the plans and the piece to be pegged as patterns. Then the drill fence is set and stopblock clamped in place as shown in figure 521. Always start each hole with an awl so the drill bit will not wander. Drill in ³⁄₃₂″ using a #67 drill bit. This drill bit will be used for all the peg holes.

The hole for the back stretcher is a bit more complicated. Note that the same procedure described here is used for drilling the holes in the front leg for the front-stretcher pegs. As you will note on the plans, the ends of the front and back stretchers must be cut at an 8° angle to create the taper in the chair. For the pegs to go in securely, the holes in the legs must be drilled at the same 8° angle.

The solution to the problem is quite simple. The drill table must be tilted 8°. However, most small drills do not have a tilting capability, so you must tilt the stock instead. See figure 525, page 243, for the setup for drilling an angled hole. The scrap of wood under the stock has been cut to the necessary 8° angle. This tilts the wood to the same 8° necessary for the peg to fit properly. Set up the drill for the side holes, using the plans and the back stretcher as

guides, and drill the peg hole. This hole can be drilled all the way through the stock. The peg may show in the finished piece. Remember, when you drill the legs, one is left and one is right, so be sure the location of the holes matches (fig. 522).

When the drilling is completed—two holes in each rear leg—the legs can be jigsawed out. As with a cabriole leg there is a trick to jigsawing out this compound cut. Figure 523 illustrates the procedure. As illustrated, no one line is completely cut. A tiny uncut portion, 1/32″ wide, is left to hold the stock together. When all the lines are cut with the exception of the 1/32″ sections, the tiny areas themselves can be cut or even snapped off, and out will come the rough leg. At this point the two legs will be close in design but more than likely not identical. To make them identical, line up the flat drilled area where the side stretcher will be pegged on each piece. Hold the two legs together at this point with a small clamp and sand the two until they match. This will true up the sides of the two legs. To match the front and back you must hold the curved area of the two pieces together, curved side to curved side, and slowly match each piece (fig. 524). This process will take a little time but is necessary for the back to fit together properly. Before rubber-cementing the two pieces of front leg stock together to be jigsawed out, mark where the side stretcher peg holes should go and drill them in each leg. Next, locate where the front stretcher pegs should go and drill the holes for them on the inside of the leg. These second holes must be drilled on the 8° angled board discussed earlier to allow for the taper in the chair (fig. 525). Do not drill all the way through the leg at either location, this will not only hide the pegs but also give you your left and right front legs.

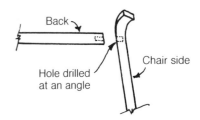

Back

Chair side

Hole drilled at an angle

522. Detail of the leg pegs.

523. Areas not cut on the leg to hold pieces together. The small double lines show where to *stop* the cuts in order to hold the pieces together.

524. Holding the legs together to sand them.

525. Drilling a front leg.

When the holes have been drilled, the two front leg pieces can be temporarily glued together using either rubber cement or double-faced masking tape. Be sure the side peg holes face each other against the tape and all the edges line up exactly. Use tracing paper to transfer the design from the side view on the plans to the stock. Glue the tracing in position on the top leg blank with rubber ce-

ment. Now the two legs can be jigsawed out as one piece, sanded to match, and then separated.

The two side stretchers are done in the same manner as the front legs. The pieces are temporarily joined together with tape or rubber cement. The ends are then drilled to match the peg holes in the legs. Finally, the pieces are jigsawed out, sanded to match, and then separated.

At this point we shall turn our attention to turning pegs on the lathe. Although I have discussed this operation in other chapters, I shall run through it again because I feel it is important that you become proficient in making small turnings.

Chuck a piece of ³⁄₁₆″-diameter stock about 6″ long into the lathe so that only ⅜″ is protruding. Set the lathe speed at 2,500 rpms.

The trick is to turn the very end down to a ¹⁄₃₂″ diameter. When the first ⅛″ of stock nearest the end is finished, turn the next ⅛″ of stock down to ¹⁄₃₂″, and so on until you reach the chuck (see chap. 11, fig. 235, p. 115).

Then open the chuck, move ⅜″ of new stock out, and begin again, turning down only ⅛″ at a time. When the ¹⁄₃₂″- diameter peg stock reaches an 1″ or so long, cut it off and start again. Keep this up until you have turned enough walnut peg stock to do the chair, 3″ or so should be enough.

You now have completed everything necessary to construct the two chair sides. Cut the proper length pegs and dry-fit the rear leg, the side stretcher, and the front leg together. Make sure all the joints fit well, then disassemble, apply glue to each part, and reassemble. Make sure the piece lies flat. Then apply ample pressure for a minute or so with your hands to ensure tack. Set both side assemblies aside to dry.

Cut the rear stretcher to its proper length at an 8° angle, then drill the holes for the peg into each end. These holes need not be at an angle, this was taken care of when you drilled the leg holes.

The last piece before we get to the carvings is the front stretcher. Figure 526 shows the several stages involved in making this piece. At the top you will notice that two pieces of wood are shown. The

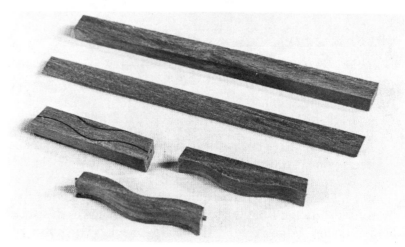

526. Stages in the making of the front stretcher.

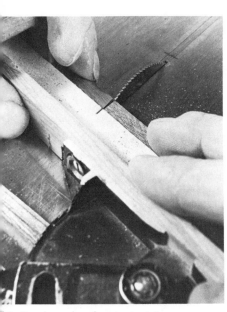

?7. Sawing the front stretcher.

528. Drilling the front stretcher.

529. Sanding the curve in the front stretcher.

upper piece is ⁵⁄₃₂″ thick and the lower piece is only ¹⁄₃₂″ thick. These two pieces must be temporarily glued together with either rubber cement or double-faced tape, so that they appear to be one piece. Cut the stock to a length of 1⅜″ at an 8° angle as shown in figure 527. Next, trace the curved design on the piece as shown in the center left of figure 526. Now the peg holes can be drilled into the ends as shown in figure 528 to match those on the front legs. Align the placement of the leg and the stretcher using the pin techniques shown in chapter 4, figure 71, page 40, "Working with Wood." The piece is now ready to be jigsawed out as shown at the center right in figure 526. Clean up the curve with a 1″ sanding drum as shown in figure 529, then separate the two pieces. Mark the surfaces that were butted together so they will not be reversed.

Sand the upper and lower curved edges of the ¹⁄₃₂″ piece to form a bead and then glue it to the bottom of the ⁵⁄₃₂″ piece, allowing it to stick out approximately ¹⁄₆₄″ as shown at the bottom of figure 526. After the glue has dried, use a 1″ sanding drum to put the curve in the back of the assembled piece.

At this stage the entire carcass, less the carving, can be assembled. Peg and dry-fit everything first. Make sure it all fits properly and the piece sits level, then glue the chair together as shown in figure 530 and let dry.

The two carved pieces, the crest rail and the splat, are what make this chair unique and give it its charm and delicate looks. To begin the carvings, first transfer the template designs to the rough-cut blocks of wood.

It is advisable to make the 8° angled cuts on either end of the splat before any jigsawing or carving is done. It is very difficult to make a true cut on an irregularly shaped piece. Test the rough stock

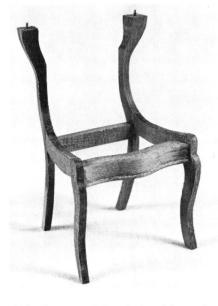

530. Carcass of the chair without the carvings.

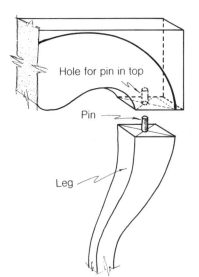

531. Detail of pegging the leg and the crest rail together.

532. Sanding the curve in the back.

533. Detail of the peg for the back on the rear leg.

between the front legs to be sure it is a snug fit. Now the splat design can be transferred to the rough block and jigsawed out.

The crest rail carving block can now be pegged. As before, the drilling for the pegs must be done while the stock has flat surfaces. The bottom portion of the design can be roughed out on the jigsaw, so the area where the legs and the crest rail meet is defined. Draw a set of diagonals across the rectangle just jigsawed out where the crest rail will meet the legs (see fig. 531). Drill a 1/32"-deep hole with a #67 drill bit where the two diagonals cross. This hole should be the center of that portion of the carving that will become the continuation of the leg (fig. 531). Now the crest rail carving block can be completely jigsawed out. To cut the pierced area in the design, drill a hole larger than the jigsaw blade in that area of the block. Disconnect the top of the jigsaw blade from the saw and insert the end of the blade through the hole. Connect the blade to the saw again and make the cut. The blade must be disconnected from the saw again to remove it from the pierced area. Repeat this on the second pierced opening.

When both carving blocks have been jigsawed out, they must be curved with a 1" sanding drum on a flexible shaft as shown in figure 532.

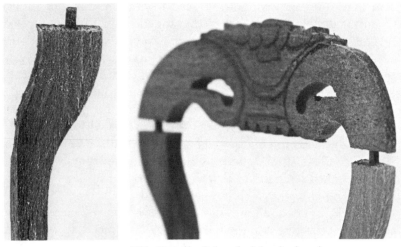

534. Detail of the chairback showing pegs.

At this stage the legs must be drilled and pegged (fig. 531). Find the center of the top of each leg by drawing corner-to-corner diagonals on the top. Drill a hole into the top of each leg approximately 1/32" or so deep using a #67 drill bit, then glue a peg into each hole as shown in figure 533.

Now the chair legs and the roughed-out crest rail carving can be dry-fitted together and sanded to become one graceful unit (fig. 534). When the three pieces fit as one, the crest rail can be removed from the legs and the finish carving begun.

Figures 535 through 541 demonstrate the carving of the rose and grape design. Figure 535 illustrates the jigsawed and curved rough crest rail with the basic design laid out in pencil. Figure 536 shows

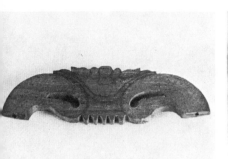

535. Pencil outline on the back.

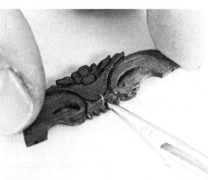

536. Roughing out the design with a #11 knife.

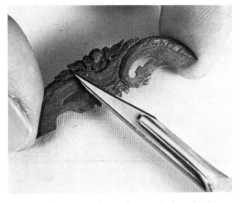

537. Rounding the edges of the design.

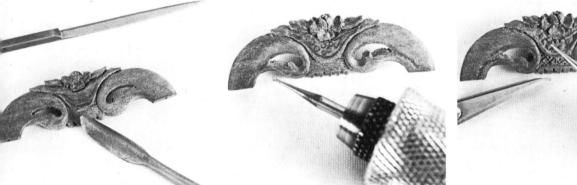

538. Cleaning the carving with files.

539. Adding detail with tiny dental burrs.

540. Carving grapes with a Foredom tool and a #11 knife.

the initial cuts being made with a #11 scalpel. Here the large areas of the design are roughly defined by a series of scoring cuts. Figure 537 shows the carving as the details are being more clearly defined. The individual leaves and the rose are beginning to take shape. In figure 538 files are used to smooth the rough areas and better define those areas yet to be carved. In figure 539 the curved areas around the pierced portion of the design are carved with a flexible shaft and small, round dental burrs. Figure 540 shows the use of the #11 scalpel and the flexible shaft with a tiny, round dental burr to carve the grapes and leaves below the rose. The knife has been used to carve the crosshatch design below the grapes, and a tiny dental burr was used to make the center holes.

When the carving is completed, 220 grit sandpaper followed by 320 grit sandpaper is used to clean and polish the design. Be careful not to round the sharp edges of the leaves and the rose (fig. 541).

The method used to carve the splat is identical to the method used for the carving of the rose and grape design on the crest rail.

When the carvings are completed, they can be glued into place. The crest rail carving is attached first. When the glue is dry, the lower part of the chair and the crest rail carving must be carefully

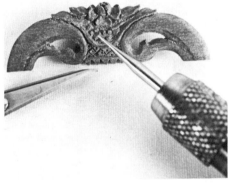

541. Sanding the finished carving.

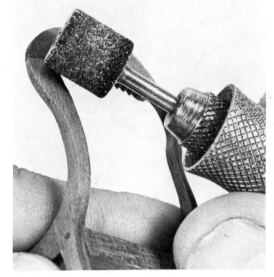

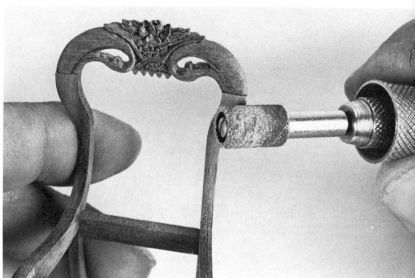

542. Sanding the back of the carving and the legs.

543. Rounding the front of the legs to match the carving on the back.

sanded to match (see figs. 517 and 518, p. 239). Figure 542 illustrates the use of a small sanding drum to unify the back while figure 543 shows the same tool used on the front of the chair. The final work is done with fine-grit sandpapers.

The last step in the construction of the chair is to glue the splat into place (see fig. 517, p. 239).

If you have been patient and thoroughly practiced those areas you have had trouble with, you should have just completed carving a beautiful and delicate Victorian balloon-back side chair.

Before we leave the chair, there is one other area of its design I should like to discuss. I shall not take the time or space to instruct you again on the finishing of the wood. Read chapter 6, "Finishing," pages 59 to 63, and follow the illustrations given there. I should, however, like to help you with the cushion for this chair. The simplest tufted seat is made from a solid block of basswood or even balsa wood. Cut the seat to match the seat opening on the carcass, but 1/32″ smaller all the way around to allow for the thickness of the velvet fabric. Try to use old velvet if at all possible. It has a finer weave and is a thinner material.

When the seat block has been cut to size and the front curve sanded, round the top edges (see chap. 13, fig. 292, p. 139). Next mark where you want the tufts to be and make a 3/16″ hole one-third of the way through the seat at each tuft. Now secure as many small pins as you have tufts and paint the heads to match the color of the velvet.

When the paint on the pins is dry, coat both the fabric and the wooden seat top and sides with Weldwood Contact Cement. Work quickly so you do not allow the glue to soak through the material. Keep the glue on only the back surface of the fabric. When the glue has set up (fifteen or twenty minutes), place the seat in the center of

the fabric and press the two together. Use your fingers to press the material into the tuft holes. Pull the fabric around the edges and cut off any excess. The four corners require special care in finishing. Pull the fabric down and cut off the excess (chap. 13, fig. 294, p. 139). Practice with scrap material until you get the idea. If the fabric weave is too open, it can be held on with white glue applied to the lower edge of the block (see chap. 13, fig. 293, p. 139).

When all the material is in place, use a pair of chain-nose pliers to push the painted pins through both the fabric and the wooden seat at the center of each tuft hole.

Grab the pins from underneath with the pliers and pull them snug against the velvet. When all of the pins are set, cut them off flush with the bottom with diagonal cutters. The bottom of the seat can now be covered with a scrap of black fabric and the seat is ready for the chair. Again, see figures 517 and 518, page 239.

→

544. Finished Renaissance Revival bed, front view.

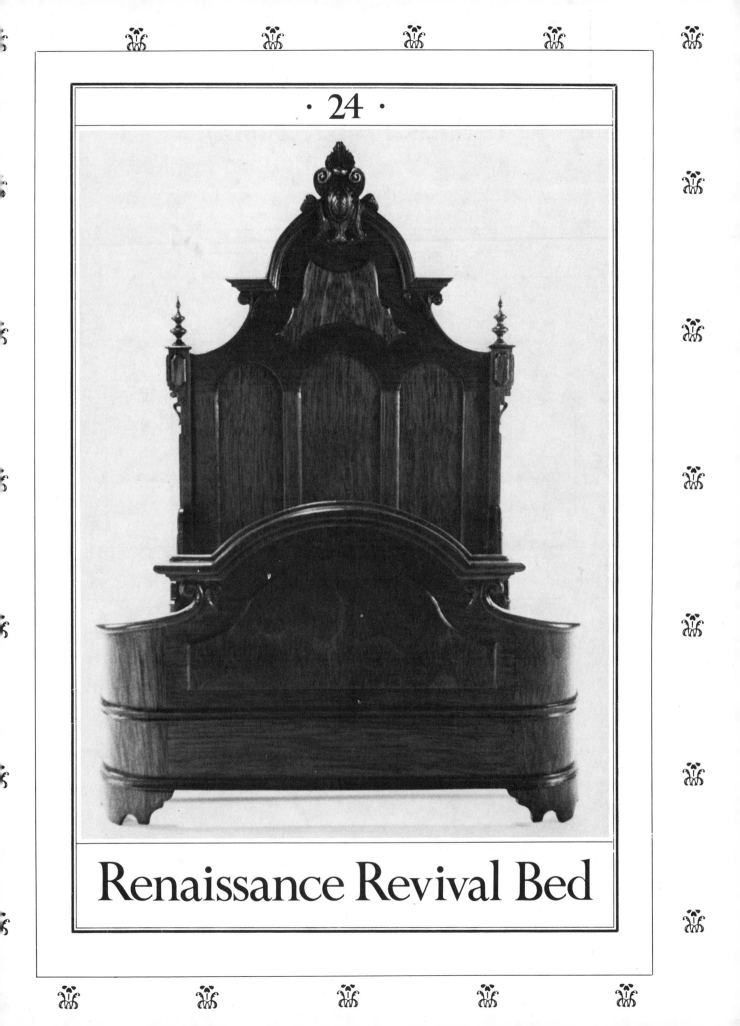

· 24 ·

Renaissance Revival Bed

Renaissance Revival Bed

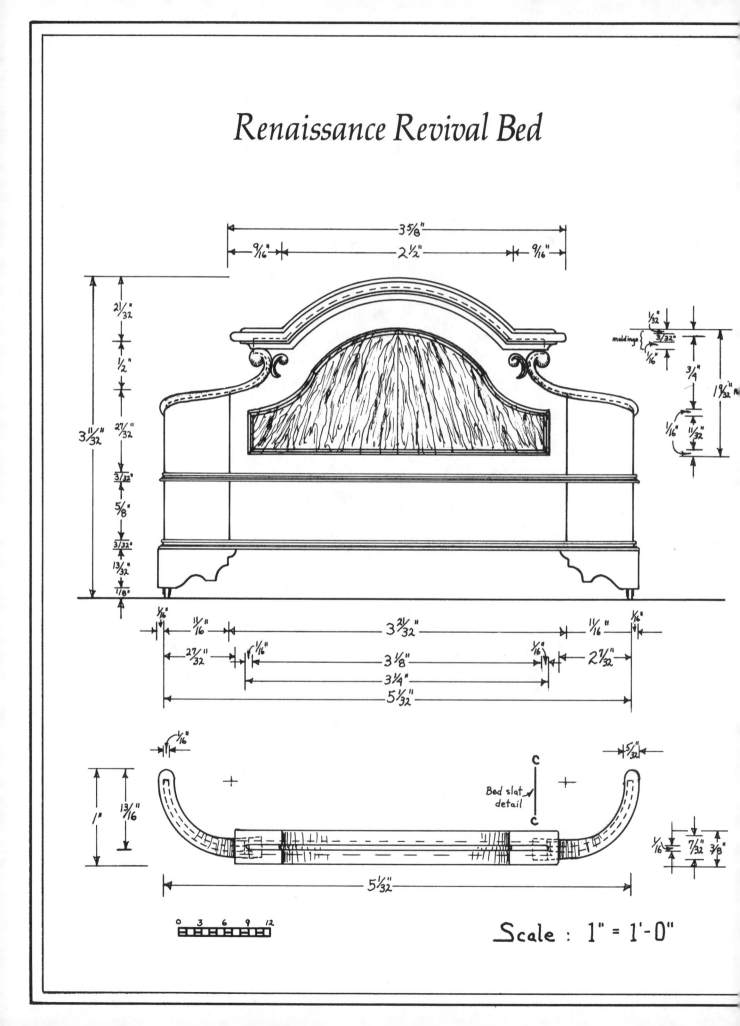

Scale : 1" = 1'-0"

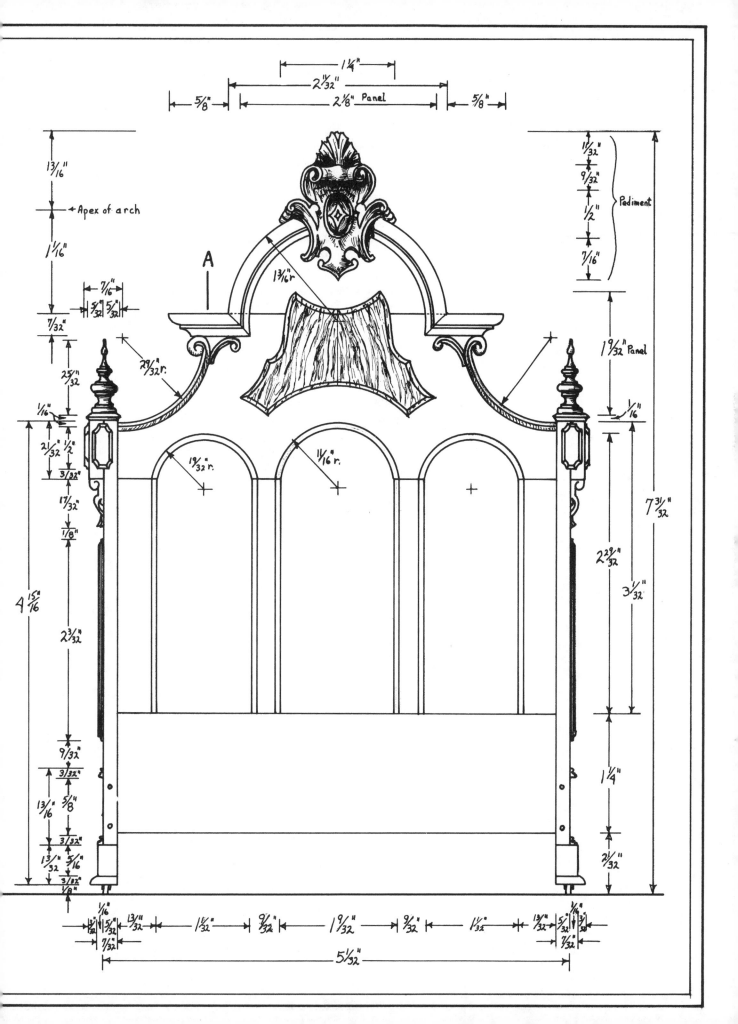

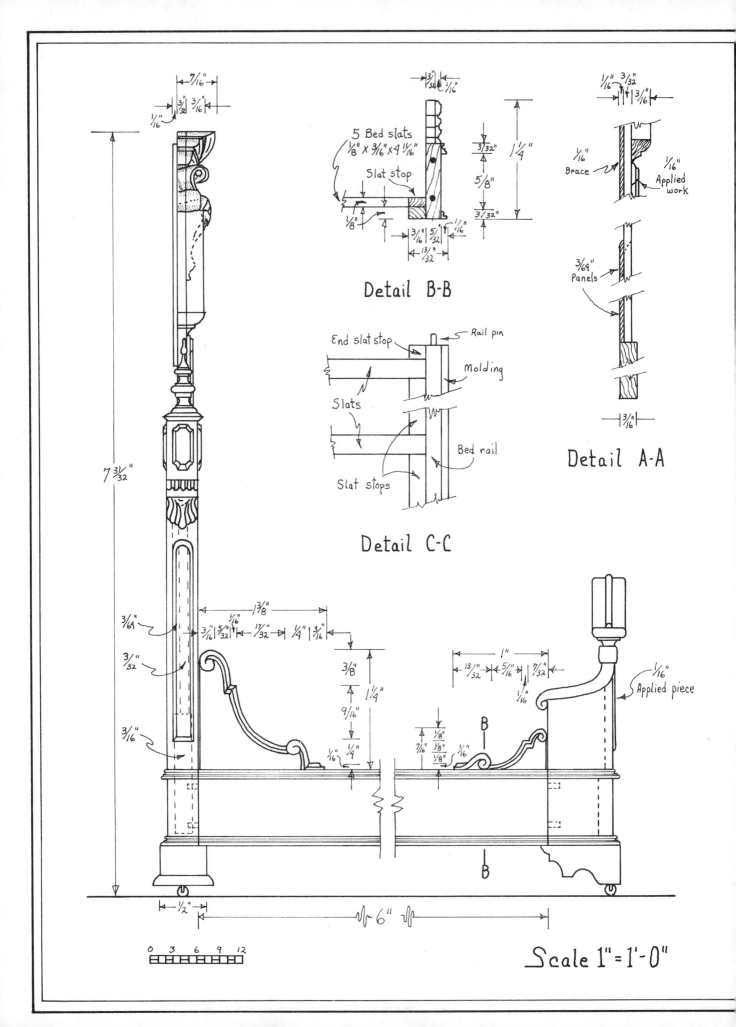

Detail B-B

5 Bed slats
$\frac{1}{8}$" × $\frac{3}{16}$" × 4 $\frac{11}{16}$"

Slat stop

Detail A-A

$\frac{1}{16}$"
Brace

$\frac{1}{16}$"
Applied work

$\frac{3}{64}$"
Panels

Detail C-C

End slat stop

Rail pin

Molding

Slats

Bed rail

Slat stops

$7 \frac{31}{32}$"

$\frac{3}{64}$"

$\frac{3}{32}$"

$\frac{3}{16}$"

Applied piece

B

B

$\frac{1}{2}$"

6"

Scale 1"=1'-0"

0 3 6 9 12

walnut	thickness	width	length
headboard			
1 top piece	3/32″	2″	2 3/8″
1 centerpiece	3/32″	1 3/4″	4 23/32″
2 center vertical members	3/32″	9/32″	2 7/16″
2 side vertical members	3/32″	1 3/32″	2 7/16″
1 bottom piece	3/16″	1 1/4″	4 23/32″
1 center panel	3/64″	1 7/16″	3 3/16″
2 side panels	3/64″	1 3/16″	3″
1 cartouche	7/16″	1 1/4″	1 5/8″
2 top arch moldings	3/16″	1″	2″
2 top side moldings (cut from one piece)	3/16″	1/4″	3″
1 applied panel (from 2 pieces)	1/16″	1 11/32″	2 1/8″
2 large carved scrolls	1/16″	1 1/4″	1 1/4″
2 small carved scrolls	1/16″	1/2″	1/2″
1 top center brace	1/16″	5/16″	2 1/8″
2 top side braces	1/16″	5/16″	7/8″
2 corner posts	5/32″	11/32″	4 15/16″
2 top post blocks	5/32″	11/32″	2 1/32″
2 bottom post blocks	7/32″	1/2″	13/32″
2 corner post carvings	5/32″	11/32″	17/32″
2 corner post caps	1/16″	7/16″	7/16″
2 finials	3/8″	3/8″	2 1/2″
4 small post panels	1/16″	7/32″	1/2″
2 large post panels	1/16″	7/32″	2 3/32″
1 bottom block molding (mitered to fit from 4″ piece)	3/32″	3/32″	4″
1 molding around bed (cut to fit each area from 48″ piece)	1/16″	3/32″	48″
side rails			
2 side rails	5/32″	13/16″	6″
2 slat supports	1/8″	3/16″	6″
5 slats	1/8″	3/16″	4 11/16″
4 end slat stops	1/8″	3/16″	1/8″
8 slat stops	1/8″	3/16″	1 3/16″
2 large scrolled wings	1/16″	1 1/4″	1 3/8″
2 small scrolled wings	1/16″	7/16″	1″
2 applied work, large wings	1/16″	1 1/4″	1 3/8″
2 applied work, small wings	1/16″	7/16″	1″
footboard			
1 upper center board	3/32″	1 7/8″	3 21/32″
1 lower center board	5/32″	13/16″	3 21/32″
2 sideboard curves	11/16″	11/16″	1 5/8″
2 feet	7/8″	7/8″	13/32″
2 top scrolled moldings	5/8″	1″	1 3/8″
4 applied scrolls	1/16″	3/16″	5/16″
1 applied panel (from 2 pieces)	1/16″	1 5/16″	3 1/16″
1 top arch molding	7/16″	3/4″	3 3/4″
2 top arch cove moldings	3/32″	9/16″	3 1/2″

Note: The decorative molding is cut from 1/16″ by 3/32″ stock that is 48″ long.

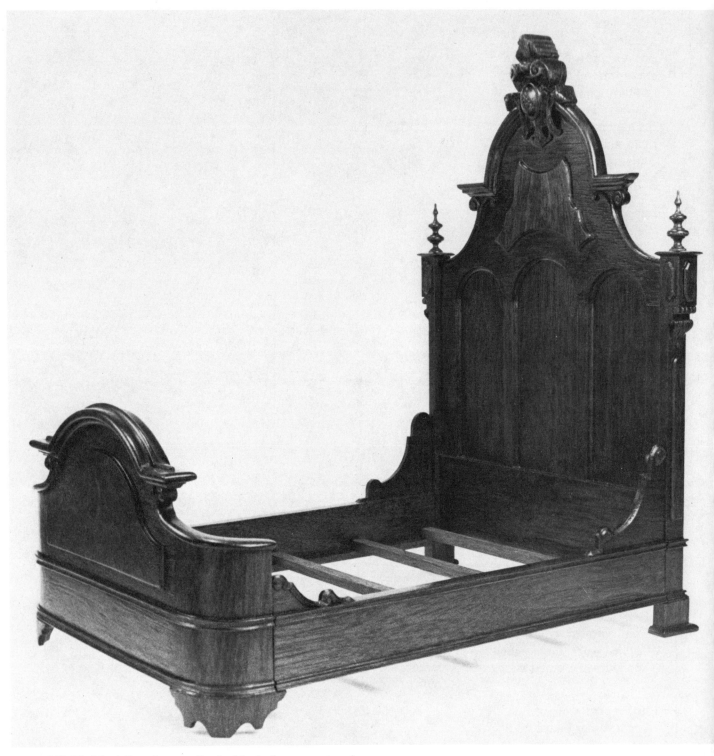

545. Finished Renaissance Revival bed, three-quarter view.

This massive Renaissance Revival bed in walnut is one of the most difficult pieces to construct in this book. The bed has a large carved cartouche, a curved molding, applied carvings, matched, grained panels, curved sides, and steam-bent molding. As is evident from the materials list, this piece should not be attempted until the other Victorian pieces have been mastered.

Because the materials list for this piece is so long, I suggest that you rough cut only the headboard pieces first. When the headboard is complete, the side rail pieces and then the footboard pieces can be rough cut. Use as close-grained walnut wood as possible.

Begin the Victorian bed headboard by gluing the $^3/_{32}''$- thick top piece and centerpiece together with a butt joint. The top piece should be centered on the $4^{23}/_{32}''$ length of the centerpiece. When the glue is dry, trace the top pattern taken from the plans onto the boards and carefully jigsaw out the design (fig. 546). Notice that the tracing paper on which the pattern was drawn has been rubber-cemented to the stock. Use a 1″ drum sander to true up the three concave arches and a large #2 cut barette file on the convex top arch. Be sure both sides of the design remain symmetrical.

The next step is to attach the two center vertical members on either side of the middle arch and the side vertical members on the outside of the side arches (fig. 547). These members create the tall arched openings for the inset panels. The inner edges of these openings must be shaped with a cove molding effect. Before the cove can be cut, a temporary brace must be attached to the bottom of the headboard assembly (fig. 547). This brace is held to the bottom of the vertical members with a tiny tack of Titebond glue. Just enough glue is used to hold the pieces together while on the shaper; remember that this board must be removed once the shaping is done.

546. Top headboard pieces with the outline tracing still attached with rubber cement.

547. Lower headboard arches being shaped on a shaper with a round burr; note the temporary brace at the base of the arches.

To shape the cove, use a $^1/_8''$-diameter round burr. The burr should protrude just enough above the shaper table to leave $^1/_{32}''$ of uncut stock on the lower edge of the arches (see chap. 22, fig. 507, p. 234). This $^1/_{32}''$ edge rides against the shank of the burr, controlling

548. Setting panels in open archways; note the braces on the top arch.

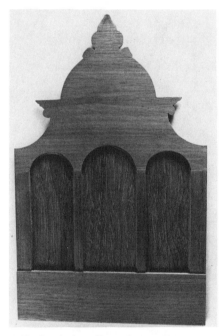

549. Basic headboard assembly.

550. *Bottom:* two pieces of matched figured, grained walnut; *top:* the pieces glued together and cut to shape.

the depth of the cut. Cut around the three sides of the openings as shown in figure 547. When the cove has been cut, it must be trued with a round riffler file and then sanded with 220 grit sandpaper. Do *not* round the upper edge of the cove. After the sanding is completed, the temporary brace can be carefully removed.

The headboard assembly must now be turned over and the three top braces cut and glued into place (upper portion of headboard, fig. 548). The ³⁄₆₄″ panels can also be cut, sanded, slightly rounded on the back edge, and glued in place. Do not get any glue on the front of the panels or the cove molding. Use a toothpick and remove any trace of Titebond glue. To complete the basic headboard, glue the ³⁄₁₆″ bottom piece into position. The assembly should look like figure 549 at this point.

The center applied panel is made from ¹⁄₁₆″ stock using figured, grained walnut. Once a piece of rough stock has been found that has a pleasing texture and design, cut two ¹⁄₁₆″ pieces, one after the other, from the same piece. The two boards, having been cut one after the other, should have almost identical grain patterns. Flip the patterns so they face or mirror each other (bottom, fig. 550) and butt-join them together with glue. When the glue is dry, the center panel design can be transferred to the stock and the design cut out on the jigsaw (top, fig. 550). The edge of the panel must now be shaped with a cove along the outer edge in the same fashion as the arched openings made earlier. Use the shaper setup shown in figure 547 and cut a cove with a ³⁄₃₂″ round burr (see center, fig. 553).

One of the unique features of this bed is the large scrolled carving or cartouche at the apex of the headboard top arch (fig. 551). This carving is done in the same manner as the carvings on the back of the Victorian side chair (see chap. 23, figs. 536 through 541, p. 247). Rough out the carving with a round burr in a flexible-shaft machine, as shown in figure 552, then continue the carving with finer burrs, a #11 scalpel, rifflers, and sandpaper as described in chapters 4, pages 46 to 49, and 23, pages 246 and 247. The finished cartouche should look like the one in figure 553. Use the plans and

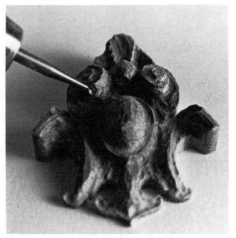

551. Detail sketch of the cartouche ornament.

552. Rough-cutting the design into the cartouche with a flexible-shaft machine.

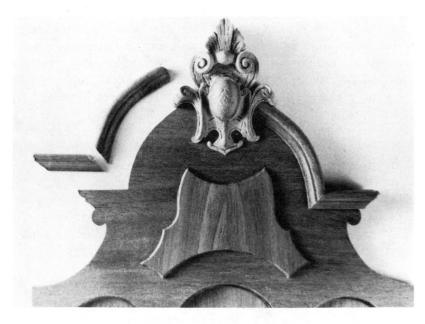

553. Finished cartouche and details of the top molding.

figures 544, 545, 551, 552, and 553 as guides. When the cartouche is complete, glue it into place on the headboard and carve the top area of the headboard itself to be part of the design. See the top of figures 549, 551, and 553.

Now the curved molding below the cartouche must be shaped. Cut the curved molding from the large pieces of ³⁄₁₆″ stock shown in the materials list. Lay the 1″ by 2″ pieces behind the headboard arch and trace around the top arc onto the molding stock. Carefully jigsaw out the top edge of the arc. You will now have an upper curve that matches the headboard curve; however, the molding must be only ¼″ wide. Use a ruler and mark ¼″ in several places along the edges of the arch, then connect these marks to make a matching inside curve. Jigsaw the inner arc out, and you will have a curved piece of ³⁄₁₆″ by ¼″ molding stock. The simple molding design is cut on the drill press using the setup shown in figure 554. Notice the pin

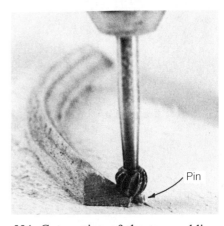

554. Cut portion of the top molding with a round burr; note the pin guide under the burr.

Pin

555. ¹⁄₁₆″ boards held together with rubber cement, to be cut on a saw as one piece.

556. Rough-carving the applied work with a flexible shaft and burrs.

557. Finishing the applied work with a #11 scalpel and rifflers.

558. Detail of the finished top of the headboard.

in the drill table that guides the work in the shaper. Guide the stock through the cutting burr slowly and keep the area being cut by the burr parallel to the edge of the table. On a curved piece of molding this requires feeding the stock from left to right on an arc that curves toward the rear of the table. Use the plans and detail A-A along with figures 553, 557, and 558 as guides. The molding is cut using a ³⁄₁₆″ round burr, an inverted-cone burr, and a flat riffler file. Be sure to cut the piece of straight (top side) molding at the same time.

Figure 553 shows the mitered molding on the left and the finished molding on the right. Notice how the upper end of the curved molding must be cut to match the area of the cartouche into which it sets. Match this area before you cut the miter on the other end of the molding. At this time the center panel can be glued into place as shown in figures 553 and 558.

The next step is to cut the applied scrollwork to go along the lower top curve. Figure 555 illustrates how several pieces of wood can be cut at the same time. In this case four strips of ¹⁄₁₆″ stock have been rubber-cemented together to form one unit. The scroll design is transferred from the plans to the stock, and all four pieces are cut out at once, not only saving time but ensuring that both sides are identical. Be sure the long, narrow portion of the cut is running with the grain of the wood. When the scrollwork has been jigsawed out, carefully separate the four pieces using a #11 scalpel. These tiny pieces must now be glued into place on the headboard, and the cove design cut in either side using a small, round burr and a flexible shaft (fig. 556). The two coves should be cut so that the tail of the scroll rises to a point on the leading edge (see plans, detail A-A). After the molding has been shaped with a round burr, a #11 scalpel is used to sharpen the edges of the upper scroll and separate the tail of the small scroll from the larger one (fig. 557). The finished, center portion of the backboard is shown in figure 558.

The next operation is to construct the two corner posts. Figure 559 shows the basic components on the left and the assembled post on the right. First, glue the blocks for the top of the post into place on the corner posts. The blocks for the bottom of the post are then attached to the base of the corner post. It should be noted that if this piece of furniture is to be moved about much, you may want to peg the bottom post block into place. The next step is to carve the design in the transitional piece under the top post block. Use the plans and figures 559, 560, and 562 as guides. When the carving is completed and glued into place (fig. 560), the post caps can be cut, tapered on both sides of all four edges, and glued into place (see figs. 561 and 562). Figure 561 illustrates the design of the turned finials. These are done on the lathe and are made from ⅜″-square stock. Be sure to turn a pin on the bottom of each finial with which to attach it to the corner post. Drill a hole of the same diameter as the pin on the finial through the center of the post cap and glue the finial into place.

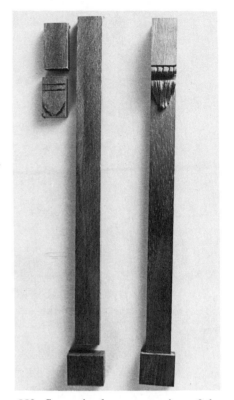

559. Stages in the construction of the headboard corner posts.

561. Side post finial.

562. Detail of the applied panels and the finial on the side post.

560. Detail of the side post carving.

The three applied panels on each post are cut from ¹⁄₁₆″ stock (see plans and fig. 562). The arc on the corners of the two top panels is cut with a large, round file. When the pieces have been properly fashioned, a small cove must be shaped on the outer edges (see plans and figs. 545, p. 256, and 562). This cove is cut on the shaper using the same setup as was used on the headboard arches and the center applied panel (see fig. 547, p. 257). The quarter-round molding at the base of the corner post is made from ³⁄₃₂″-square stock using a riffler file and a 220 grit sanding block. Notice that this molding does not go on the inside edge of the corner post (fig. 563). The two

563. Detail of the base of the side post.

small moldings shown above the post block in figure 563 are decorative moldings cut from 1⁄16″ by 3⁄32″ stock and go around the entire bed. The upper and lower moldings are identical and the distance between them is equal to the width of the side rail. Use the plans, detail B-B, and figures 563, 566, 568, p. 264, and 588, page 270, as guides in cutting the molding on the drill press. The design requires a small, round burr, an inverted-cone burr, and a straight riffler file. Be sure to cut extra molding to allow for mistakes, you do not want to have to set up the entire operation again for another 6″ of stock. When the molding is cut, miter the two strips on either post. Notice that the molding goes around the back of the corner post but not along the back of the headboard itself (fig. 563). This completes the construction of the headboard of the bed.

The next portion of this project is the side rails. Rough cut the stock using the side rails materials list.

After the 5⁄32″-thick side rails have been cut, glue the 1⁄8″-thick slat supports flush with the bottom edge of each side rail. Next glue the 1⁄8″-long end slat stops on top of the slat supports, one on either end of each support (see plans, detail C-C). The object of the stops is to hold the bed slats in their proper position under the mattress. Next place the eight slat stops, four on each slat support, spacing them so the gap between them is 3⁄16″, leaving an opening for the slats themselves to set down into (see plans, details B-B and C-C). Dry-fit the bed slats in position before gluing down the center slat stops. This completes the functional portion of the side rails; now the "gingerbread" can be added.

Figure 566 shows the large scrolled wing attached to the headboard end of each side rail. A similar but smaller scrolled wing is attached at the footboard end of each side rail (see fig. 588, p. 270). Both of these additions to the side rails are made in the same way, therefore, I shall describe only the larger of the two. Repeat the steps shown for the smaller pair.

The first step is to transfer the cutout design of the wing to the wing stock, using the plans as a guide. Next, using rubber cement or double-faced tape, temporarily hold the wing stock and the applied-work stock together to be jigsawed out as one piece. When the pieces have been cut out, carefully separate them. You now have two pieces of stock with the identical design on the upper edge (fig.

564. Stages in the construction of the side rail extension. *Left:* 1⁄64″ matched piece marked for applied cutout.

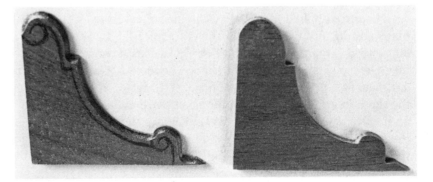

564). The left-hand piece in figure 564 will be the applied work, the right-hand piece is the wing itself. Before jigsawing the inside line of the applied piece, shape the outer edge of the scrollwork using a small, round burr and the shaper setup shown in figure 547, page 257. Now the applied piece must be carefully jigsawed out. Do not apply pressure to the area between the two scrolls; this arc is very thin and runs across the grain. When the piece is cut out, glue it to the side rail wing (top, fig. 565). The inner edge of the applied work is carved in the same manner as the applied work done on the headboard (see figs. 556 and 557, p. 260). Begin the inside area of the carving by cutting a cove to match the one cut on the shaper. Hold the flexible-shaft handpiece steady in your hand and remove only a tiny portion of the stock at a time. Be careful where the cuts must be made across the grain, the wood fibers are very weak in this area. The initial cuts are shown on the top example in figure 565. Use a small round burr to carve the center swirl in the top and bottom scrolls. Square off the edges where the molding makes right angles and at the end of the scroll swirls with a #11 scalpel (bottom, fig. 565). When the applied carving is completed, the finished wings can be glued into place (fig. 566).

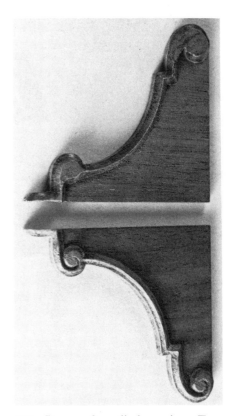

565. Stages of applied carving. *Top:* rough-shaped piece glued onto the side rail extension; *bottom:* finished piece.

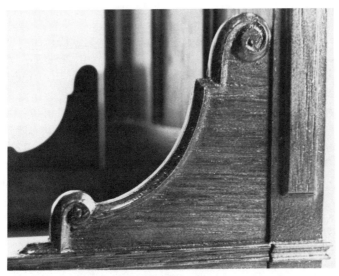

566. Detail of the finished side rail extension with carvings.

The next step is to cut out and carve the smaller footboard wing using the same technique as described above. When the four wings are glued into place, two 6″-long strips of the decorative molding can be glued in place on each side rail (see plans and fig. 566).

The headboard and the side rails are held together by pegs. These pegs are glued into the side rail and fit into holes in the headboard when the bed is assembled. First, drill two holes in each end of both side rails as shown on the plans. Next, in each hole place a small brad, which has been cut to protrude just beyond the edge of the stock (fig. 567). When the brads are in place, position the side rail in its proper location against the headboard post and apply

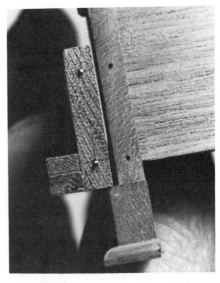

567. Brads in the side rail peg holes to mark their location on the headboard post.

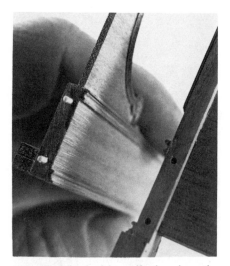

568. Finished side rail showing the pegs and the matching holes in the headboard.

pressure. The pressure on the side rail will force the brads into the headboard post, thus marking the location of the matching peg holes. Figure 567 illustrates the side rail at the left, and the marks made by the brads in the headboard post at the right.

The posts can now be drilled at the marked locations and the pegs can be glued into the side rail (fig. 568). This operation must be done on all four corners of the bed. This completes the side rail construction.

The last of the major components of this large bed is the curved footboard. Depending on how you have fared with the construction of the first components, you may be interested to know that the most challenging portion of the bed is yet to come.

To begin the footboard construction, rough-cut the pieces of stock listed in the materials list. Use the dashed line on the plans for the pattern of the upper center board and transfer it to the stock. I suggest using tracing paper, which is then rubber-cemented to the piece of walnut. Notice that the pattern goes partway into the side scrolls and the top arch piece on the plans; this is to allow for the groove that will be cut into those pieces so they will fit over the board. When the pattern has been transferred to the center board, jigsaw out the design and file the cutout so that both sides are symmetrical. The upper and lower boards can now be butt-joined together with Titebond glue.

The next operation is to shape the side curves from the $^{11}/_{16}''$-square blocks (left side, fig. 569). First, mark the $^{23}/_{32}''$ radius of the outer arc on the top and bottom of the stock, then indicate the $^3/_{32}''$ thickness of the upper section and the $^5/_{32}''$ thickness of the lower section of the arc on the adjacent sides of the block (left side, fig. 569). A 1''-diameter drum sander on a flexible shaft is used to cut away the excess stock on the inside and outside of the arcs (fig. 570). The finished piece is shown on the right side of figure 569. When the curved ends have been properly shaped, they can be glued to the ends of the center boards (see fig. 571). The center panel on the back of the footboard is made in the same fashion as the panel on the headboard. Strip two consecutive cuts of $^1/_{16}''$ stock from the same

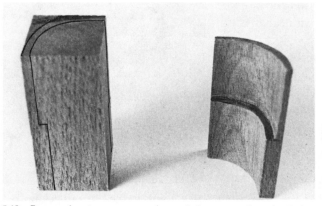

569. Stages in the construction of the curved end of the footboard.

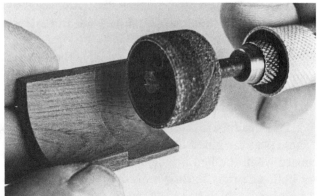

570. Shaping the curved end of the footboard with a 1'' drum sander on a flexible shaft.

piece of figured walnut. Butt-join the pieces together so that the grain forms a mirrored pattern and glue the joint. When the glue is dry, transfer the design from the plans to the stock and jigsaw out the pattern. Shape the edge of the design in the same manner as shown in figure 547, page 257. The panel can now be glued into the proper location on the face of the footboard.

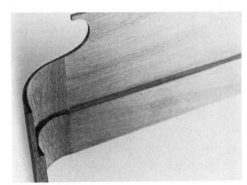

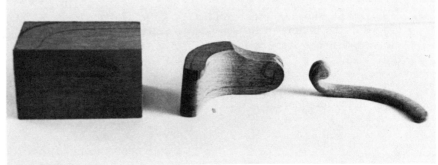

571. Curved piece glued to the footboard assembly.

572. Stages in the construction of the curved scrolled molding on the footboard.

After the glue has thoroughly dried, the top edge of the curved end pieces can be sanded to become a continuation of the center cut-out (fig. 571). The next operation is one of the most difficult in the construction of this bed. The scrolled moldings that finish the top of the curved endpieces are shaped from a block of wood ⅝″ high. Note: the block to the left in figure 572 is larger than actual size; use the size shown in the materials list. The first step is to shape a curve that will match the curve in the endpieces. This is done using the method described in figure 570. When the curve has been shaped, the sloping curve of the top area must be matched. This curve can be seen along the bottom of the piece in the center of figure 572. Once the rough shape of this curve has been cut, using the plans, the piece must be custom-fitted into the opening by a process of trial and error (fig. 573). When the curves are a perfect match, cut a groove

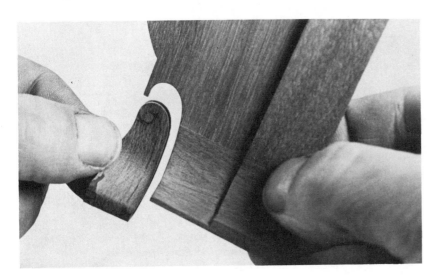

573. Custom-fitting the molding on the footboard.

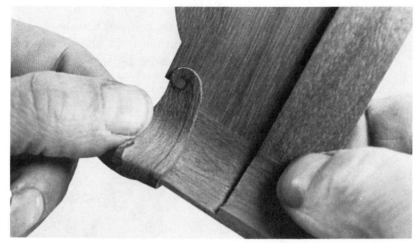

574. Detail showing the routed groove in the bottom of the scrolled molding that fits over the footboard top.

575. Rough scrolled molding shown in place on the footboard.

into the bottom of the stock so the piece will straddle the curved sideboard (fig. 574). To make this groove, set the stock into the cutout area to which it has already been matched and with a sharp pencil mark on either side the ³/₃₂″ width of the footboard. Score along these lines with a #11 X-acto knife, then carefully clean out the groove with knives and a flat riffler file (fig. 574). Slight alterations in the fit may be necessary once the groove is cut and fitted into place. The finished groove should fit like the one shown in figure 575. The final step in making the top scrolled molding is to cut out the upper portion along the lines taken from the plans and shown in figures 572, 573, and 575. Round the edges of the piece as shown on the right in figure 572. When the scrolled moldings have been glued into place, finish the scroll carving as described earlier in this chapter, page 260 (see fig. 580, p. 267).

The carving of the top arch molding is equally as difficult as the scrolled molding just completed. This piece must be custom-fitted against the top arc and then grooved to fit down over it, as described in figures 574 and 575. When the piece fits snugly over the arc (fig. 576), the upper portion can be jigsawed out. Use the plans as a

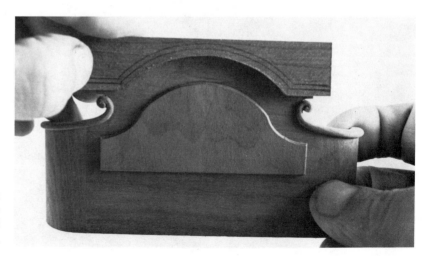

576. Matching the base of the top arch molding to the arch of the footboard before hand-carving; notice the matched figured, grained walnut applied panel.

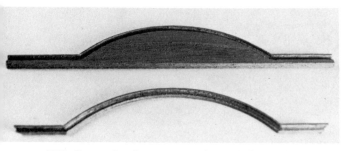

577. Stages in the construction of the finish cove molding.

578. Shaping the finish cove molding with a round burr; note how the work is guided against the pin in the table.

guide, tracing around the top of the bead (uppermost line in drawing). The top arch bead is carved from the same piece of wood as the top arch itself. See the pattern lines on the arch in figure 576. When the piece has been cut out, mark the 1/16"-wide by 1/16"-high bead in the center of the arch (see plans, side, back, and top views of footboard, and figs. 545, p. 251, 580, and 585). Score along both lines of the bead on the top to a depth of 1/16" with a #11 X-acto knife or scalpel, then remove the stock on both sides of the scored lines until the bead has been formed (see figs. 579 and 588, p. 270). When the top bead is completed, round the edges of the top arch, sand it smooth, and set it aside. The cove molding under the arch is also made from a single piece of wood (bottom, fig. 577). The top curve of the molding must be obtained by drawing along the bottom edge of the top arch. Trace the top arch curve onto both pieces of the cove molding stock and jigsaw out the upper portion of the design (top, fig. 577). Check both cutouts to be sure they fit exactly against the top arch molding. If custom-fitting is necessary, use a 6" #2 cut barrette file. When both pieces match the top arch molding, the cove can be cut. Figure 578 illustrates the setup on the drill press to make this cut. The stock is guided along a pin that protrudes slightly above the drill table surface directly behind the burr (see chap. 22, fig. 506, p. 234), while the round burr cuts the cove on the opposite side. When both coves have been shaped, carefully cut away the excess stock with a fretsaw. The finished molding should look like the piece shown at the bottom of figure 577. Now the top arch piece can be glued into place. Fit the cove molding under the top arch and mark where the miters should be cut at the two ends. Cut the miters with a #11 scalpel and glue the cove into place (figs. 579 and 580). Figure 579 shows the end cap that is made from two of the scraps of molding cut off the cove molding when the arched section was mitered. Miter these tiny pieces and glue them onto either end (fig. 579).

The four small applied scrolls are cut from 1/16" stock with a fretsaw (use the plans for the pattern), glued in place, and then carved in the same fashion as the headboard pieces (fig. 580).

The feet of the footboard are made in a similar fashion to the curved sides. Begin with a 7/8"-square block 13/32" high and trace the arc of the sides on both the top and bottom (left, fig. 581). After the

579. Detail of the top arch molding and the finish cove molding on the footboard arch.

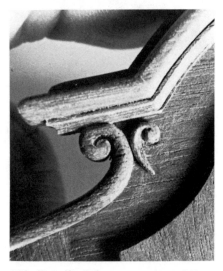

580. Detail of the top arch molding, the finish cove molding, the scrolled molding, and the small applied carving on the footboard.

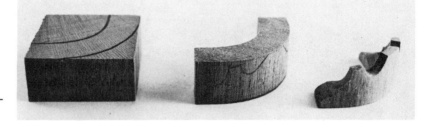

581. Stages in the carving of the foot-board leg.

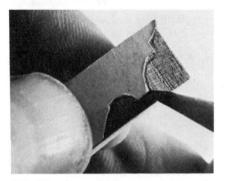

582. Tracing the pattern on the curved rear leg.

arcs have been established, use a 1″ sanding drum in a flexible-shaft machine to round the legs (center, fig. 581). Check the curves as you sand to be sure they match the curves of the footboard. Remember that the foot piece protrudes ⅛″ beyond the end of the footboard to support the side rail (see figs. 584 and 588) and ¹⁄₁₆″ around the outer curve. When the curves have been sanded and checked, use the plans as a pattern and make a template of the lower scallop on the foot. Trace around this template as shown in figure 582. Shape the design using a small, straight burr (fig. 583). When the design has been shaped, remove the excess stock from the lower two-thirds of the inside arc with a 1″ sanding drum and a #11 X-acto knife (see right, fig. 581, and fig. 584). The sanding will reduce the thickness of the lower portion of the foot to ³⁄₃₂″ while the upper portion that is to be glued to the footboard will remain ¼″ thick (figs. 584 and 585). Do not glue the feet to the carcass yet. Figure 585 shows the holes drilled into the curved sidepieces for the pegs in the rails. These holes are positioned in the same manner as described for the head-board (see figs. 567 and 568, pp. 263 and 264).

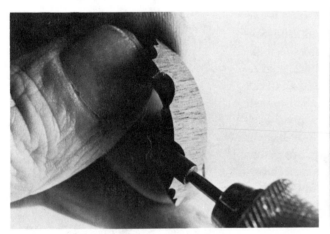

583. Shaping the rear leg with a straight finishing burr.

584. Finished leg attached to the footboard; notice how the leg hangs over the area where the side rail will attach.

The final operation in the construction of the Victorian bed is the curved molding that embellishes the lower portion of the footboard (see fig. 588). To make the pieces of molding follow the contour of the footboard, the wood must be steamed, bent around a form, and left to dry on the form.

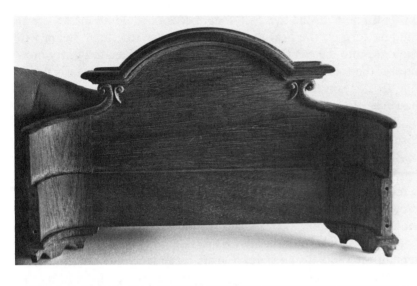

585. Inside view of the curved footboard showing the holes drilled for the rail pegs.

586. Curved footboard molding drying on the form after being steam-bent.

The first step is to make the form around which the molding will be shaped. A block of pine 1″ thick, 2″ wide, and 5¹⁄₁₆″ long will be used for the form. Use the bottom of the footboard as a pattern and mark the outside, convex surface onto the pine block. Round the ends of the block with a large drum sander, until the shape of the block matches the shape of the footboard. The block will look like the one shown in figure 586. The pine form should now be the same shape as the footboard, and therefore the molding shaped around the form will fit perfectly around the footboard.

There are several ways to bend woods, ranging from the elaborate machines used in industry to the crude wooden boxes connected to a drum of boiling water that I have seen along the Maine coast being used for emergency boat repairs. The method best suited for miniature work is to construct a double-boiler arrangement using a tall, covered pot and an empty three-pound shortening can. The can must be suspended above the water in the pot by a wire frame made from coat-hanger wire. Bend the upper ends of the frame over the edge of the pot, thus creating a cradle for the can (fig. 587). Using a sharp awl, punch several holes in the bottom of the can to allow the steam to enter. Put water in the pot, suspend the can

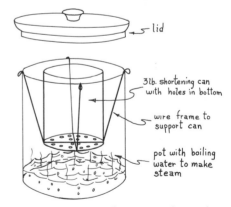

lid

3 lb. shortening can with holes in bottom

wire frame to support can

pot with boiling water to make steam

587. Apparatus for steaming the molding for the footboard.

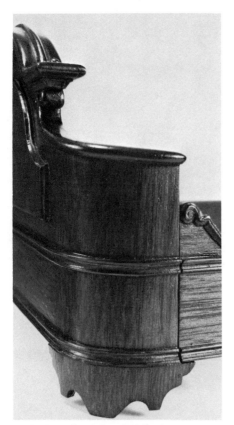

588. Detail of the finished footboard showing the steam-bent moldings.

on its frame with the two 6½″-long pieces of molding inside, cover the pot, turn on the heat and bring the water to a boil. Steam will then rise into the can through the holes. After fifteen to twenty minutes in the steamer, the wood should be supple enough to bend. If not, let it steam longer. Be sure to check the water level in the pot, however; do not let it boil dry.

Eventually, the wood will be pliable enough to bend around the form (see fig. 586). Hold the molding in place on the form with masking tape and set it aside to dry for at least two days.

While you are waiting, the feet can be glued to the footboard assembly. Be sure to leave ⅛″ on the end for the side rail and ¹⁄₁₆″ around the outside curve for the bent molding (fig. 588). When the molding is dry, glue it into place on the curved footboard. Be sure both ends match the molding on the side rails and that both pieces remain the same distance apart around the length of the footboard (fig. 588). Hold the molding in place with masking tape and let the glue dry for one full day.

The next day the tape can be carefully removed. Go slowly, you do not want to break the molding at this stage of the game. Sand the molding thoroughly with 320 grit sandpaper, as the moisture will have raised the grain of the wood.

The Renaissance Revival bed can now be given a final sanding, tack-clothed, sealed, stained, filled, varnished, rubbed, and waxed. Remember that most cabinetmakers agree that constructing the piece is half the work, and finishing it is the other half.

Choose the color of your finish carefully. Use a warm brown rather than a ruddy tone. Fill every pore of the walnut wood, do the process twice if necessary. Finally, do not use a glossy finish; use a satin varnish and hand-rub it with rottenstone to achieve the glow of an heirloom piece of furniture (see chap. 6, pp. 59 to 61).

Conclusion

The time has come for you to begin the different projects. Those of you who feel confident and are raring to go, get your safety goggles shined up, your pencils sharpened, and enjoy yourselves. The rest of you who may feel a bit hesitant about where to start: *don't panic.* I told you at the start that the projects were challenging, but the greatest challenge of all is getting started. Believe me: I know the feeling of looking at a beautiful piece of wood and being afraid to cut into it. Do not start the learning process with that lovely piece of wood; start with pine or basswood. Begin with some of the projects I showed you in chapter 4. Make a joint, a leg, or a drawer. Go slowly and do only a part of a piece at a time. Do not be afraid to piddle for a while, at least until you gain enough confidence to move on to bigger things.

Nothing worthwhile comes easily. I recall the story of the spider and king Robert the Bruce whenever I feel things are beyond my scope. The king and his troops were almost defeated. In desperation, he sat watching a tiny spider high above him. Time after time the spider tried to build its web and time after time it failed, yet it would not give up. The king watched the spider for a long time, then it finally succeeded. The king took heart from this example, gathered his bedraggled forces to try once again, and won his battle. If you are having trouble, *always* keep trying until you succeed. You, too, can win your battle if you have patience and work a bit at a time.

Occasionally, well-meaning friends fail to appreciate the significance of completing a small joint or a cabriole leg done as an exercise.

"What's the purpose?," they will ask. "Why only one leg?"

Don't be intimidated; *keep practicing* until you are comfortable with the tools and the methods. *You* will recognize what you have accomplished; that is all that matters.

Do each project to the best of your ability and do not worry about how I or anyone else would do it. This is a hobby—a beautiful, fascinating hobby. Enjoy it! Remember: no two people's work will ever come out the same. The fact that you have done the work with your own hands is all that is really important. Have fun!

In closing, it is my hope that this book will assist you in making heirloom furniture in miniature and that you will enjoy creating it as much as I have for almost twenty-five years.

Appendix: Tools and Suppliers

TOOLS

FOR MEASURING AND PATTERN MAKING
awl
caliper, both vernier and outside, or bowspring
combination square
compass
dividers
eraser
masking tape, double face and light stick
pencils, #2
rulers, 6″ and 12″
scissors with a short blade
square, 6″
tracing paper

FOR SAFETY
face mask or respirator for dust
goggles
paint or dusk mask
push sticks for saw

FOR CARVING, SHAPING, AND DRILLING WOOD
dental burrs

inverted cone round

finishing burrs

flame pear cylinder

inverted cones in the following sizes: #4/0, 0,
 4, 8, 12
round in the following sizes: #6/0, 4/0, 0, 4, 8,
 12, 16
fine cut such as cylinder, flame, and pear

drill bits, a set of #61 to #80 plus a few larger
 sizes
flexible-shaft machine and handpiece
rotary burrs, heavy duty: 45° angle, round, and
 cylindrical
sanding drums in ¼″ diameter, ½″ diameter, and
 1″ diameter with both coarse and fine sleeves
shaper (can be same tool as drill press)

FOR WORKING WITH METAL
brass brush
buffing wheels, either 1″ or 1¼″ in diameter
carbide-tipped scriber
center punch, spring-loaded
flux, any good grade, such as Tix flux
grinding wheels
hand buffs, felt or elkskin
jeweler's rouge, small cake
sandpaper, 400 grit and 600 grit wet-dry
sheet-metal shears
soap, Ivory
solder, any low-melt solder, such as Tix
soldering iron
tripoli, small cake

FOR CUTTING AND SANDING WOOD
circular saw such as a Unimat with metal cutting
 blade
files
 barrette, 6″ long in both #0 and #2 cut
 needle or escapement in both #0 and #2 cut in
 the following shapes: barrette, half round,
 knife, round, and square
 rifflers, assorted shapes in #2 cut
fret- or jeweler's saw frame and blades from 4/0
 to 10
jigsaw, either floor or bench type
knife, multipurpose
miter box of aluminum or maple
sandpaper, open-coat aluminum oxide, 100, 150,
 220, and 320 grit
saw, Zona, or #35 X-acto
scalpel, #11
X-acto blades and handle, #11 and #17

FOR GLUING

C-clamps, both large and small
contact cement for permanent bond
five-minute epoxy glue
Franklin Titebond or any aliphatic resin glue
hand vise
instant-setting adhesive
rubber bands
rubber cement for temporary bonding
spring clamps
toothpicks

FOR TURNING WOOD AND METAL

gravers: chisel, flat, knife, oval, round, and square
lathe and accessories
turning tools for small lathe work
wood chisels

FOR SHARPENING AND CLEANING TOOLS

Arkansas stone
honing oil
leather for stropping
machine oil, lightweight
slipstones
steel wool
toothbrush
WD-40, a lightweight oil in a spray can

FOR FINISHING

buffing wheels
carnauba wax or Goddard's Wax
cheesecloth
denatured alcohol
flannel cloth

gold leaf and size
Japan colors
jars for mixing paints and stains
paint thinner
paste wood filler
Q-tips
rags
sable brushes, ½″ and ⅝″ flat, plus #2 and #6
 round
sanding sealer
shellac
stains, oil base and/or non-grain-raising
tack cloth
turpentine
varnish, high grade, both satin and gloss

MISCELLANEOUS

anvil
bench pin
bench vise
dental probes
hammer, both ball-peen and brass
magnifier or loupes
mallet, either leather or wooden
pin vise
pliers
 5″-long chain-nose with smooth jaw
 4½″-long diagonal-flush cut
 5″-long flat-nose with smooth jaw
 5″-long round-nose
screwdrivers in assorted sizes
storage containers
toolbox
tweezers, 4½″ long, both straight and curved

SUPPLIERS

James Bliss & Co., Inc.
Route 128 (at Exit 61)
Dedham, Mass. 02026
 wood, small tools
 catalogue $2.00

Brookstone Company
Vose Farm Road
Peterborough, N.H. 03458
 small tools
 catalogue

Albert Constantine & Sons, Inc.
2050 Eastchester Road
Bronx, N.Y. 10461
 wood, tools, finishes
 catalogue $1.00

Dremel Manufacturing Co.
4915 21st Street
Racine, Wis. 53406
 Dremel Moto-Tool, lathe, and accessories

Emco-Lux
250 Fairwood Avenue
Columbus, Ohio 43207
 Unimat and accessories

The Enchanted Doll House
Manchester Center, Vt. 05255
 lumber, accessories, hardware
 catalogue $2.00

The Foredom Electric Co.
Bethel, Conn. 06801
 Foredom flexible shaft machines

Jarmac
P.O. Box 2785
Springfield, Ill. 62708
 small power tools

Midwest Products Co.
400 S. Indiana Street
Hobart, Ind. 46342
 precut wood
 catalogue $1.00

Garrett Wade Company Inc.
161 Avenue of the Americas
New York, N.Y. 10013
 tools
 catalogue $1.00

Wood Carvers Supply Co.
3056 Excelsior Boulevard
Minneapolis, Minn. 55416
 tools, finishes
 catalogue $2.00

Woodcraft Supply Corp.
313 Montvale Avenue
Woburn, Mass. 01801
 wood, tools
 catalogue $1.00

Glossary

Cross-references to other definitions in this glossary are set in *italic* type.

adhesive: A substance used to hold materials together by surface attachment.

airbrush: A small sprayer using compressed air to spray paint or *varnish* on a surface.

aliphatic resin glue: This is a liquid glue sold under many names, I use Franklin's Titebond. It is ideal for bonding wood, paper, and other porous materials where extra holding power is desired.

alloy: The combination of two or more metals.

anvil: A block of iron, usually with a horn and a hardened-steel face, against which metals are held for forming by hammering or forging.

applied carving: Used in this book to define those carvings that are cut out and then glued into place on the *carcass* or drawer (see illustration).

apron: A structural strip of wood, often having a cutout design, that runs horizontally under a tabletop, chair seat, or *carcass* (see illustration).

arbor: The shaft on which a saw blade rotates.

Arkansas stone: A natural, fine-grained oilstone used for sharpening tools.

aluminum oxide: An abrasive used on cutting wheels and abrasive papers.

awl: A pointed steel instrument used for starting holes and incising lines.

bail: A metal loop forming a drawer handle (see *escutcheon* illustration).

ball-and-claw: See *claw-and-ball.*

balloon back: A Victorian-style chairback (see Victorian Side Chair project).

ball-peen hammer: A hammer designed for working on metals, having a head with one end a flat surface and the other end hemispherical.

banding: A narrow band of *veneer* or wood applied along the edge of a tabletop or drawers.

band saw: A power saw with a blade consisting of an endless, toothed band mounted between two wheels.

barrette file: A one-sided flat file that comes to a point.

beading: A *half-round* rim molding.

bellflower: A carved or inlaid ornament that resembles bell-shaped flowers arranged vertically (see Pembroke Table project).

bench pin: A tapered wooden block usually attached to a workbench, used as a support when filing, sawing, and so forth.

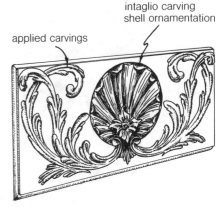

Applied carving

Apron on lowboy

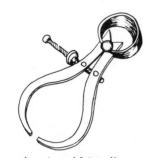

Bowspring (outside) caliper

Box joint on pliers

Bracket foot

bevel: An angled cut along the edge of a board, also a tool used for marking angles (see fig. 87, p. 44).

blank: An unfinished, metal stamping that requires further processing.

bombé: A swelling or convex surface. A piece of furniture with a bulging front and sides (see Chippendale Bombé Chest project).

bowspring caliper: A type of *caliper* that has two adjustable curved legs; there are two types: outside reading and inside reading (see illustration).

box-joint pliers: Pliers having a very strong, wobble-free joint, in which one side of the pliers is encased or boxed in the other side (see illustration).

bracket: A triangular supporting brace usually found at the junction of the legs and the *stretchers*.

bracket foot: A simple foot that curves out in two directions, found on chests and cased furniture of the eighteenth century (see illustration).

brad: A small, thin finishing nail measured by wire gauge.

brass: An *alloy* of copper and zinc used extensively for hardware.

broach: A sharp, multisided, tapered tool used to enlarge holes in metal.

broken pediment: The pediment of a highboy or the like that does not meet, or is broken at the apex (see Chippendale Highboy project).

buffing wheel: A disk made of cotton or muslin sewed in layers and used in polishing and buffing.

bull's-eye: On the Victorian center table described in this book, a decorative circular piece applied to either side of the table leg (see Victorian Center Table project).

burl: A swirl in the *grain* of wood, usually near a knot.

burr: A sharp or rough edge that occurs on metal after cutting or sharpening.

burrs: Small cutting tools that are available in numerous shapes and are fitted on a steel shank. They are used to carve or shape materials while rotating on a shaft.

butt joint: The joining of two pieces of wood by merely butting them together (see fig. 69, p. 40).

cabriole leg: A leg that curves outward at the *knee* and inward at the ankle in a *cyma curve* (see *cyma curve* illustration and fig. 101, p. 49).

caliper: An instrument used to measure inside or outside dimensions.

canted: Set at an angle rather than straight.

capillary action: A physical force through which liquids, when in contact with a solid, are attracted to the solid. This explains why *solder* and glue flow into a well-fitted joint.

carcass: The framework of a piece of furniture.

cartouche: An ornamental feature in the form of scrollwork (see Victorian Bed project).

casting: The process of pouring molten metal into a mold.

C-clamp: A metal clamp, often called a carriage clamp, shaped like the letter *C* with a flat-ended screw at one end.

center line: The center of an object on a drawing noted by ℄.

center punch: A tool, often spring-loaded, with a sharp point used to mark the center on a piece to be drilled.

center table: An oval or round table, finished on all sides, that can be used in the center of the room (see Victorian Center Table project).

centrifugal casting: The *casting* of metal in a rapidly revolving mold by centrifugal force.

chamfer: To remove, at a 45° angle, the sharp corners from the edge of a board (see fig. 86, p. 44).

check: A small crack or split running parallel to the wood *grain*.

Chippendale style: A style of furniture characterized by graceful lines and often rococo ornamentation, originated by Thomas Chippendale, an English cabinetmaker of the eighteenth century.

chisel: A blade set into a wood handle that is used for carving or cutting wood.

circular saw: A machine that cuts wood by the rotation of a circular blade toothed around its circumference.

claw-and-ball: A carved foot usually associated with the *Chippendale* period, whose design originated in China and represents a dragon's claw holding a ball or an egg (see fig. 101, p. 49).

close-grained: Having a fine or tight *grain*. A piece of wood in which the grain is not readily visible.

cock bead: A narrow, raised *beading* running along the edge of a surface for a trim (see *apron* illustration).

collet: A cone-shaped sleeve used for holding circular rodlike pieces. Collets are used on handpieces, small machines, and some *lathes*.

combination square: A steel rule that slides through a metal head at either a 90° angle or a 45° angle to the head. It can be used to mark right angles or 45° angles (see illustration).

compass: An instrument for drawing a circle.

contact cement: A neoprene rubber-based adhesive that is applied to both surfaces before bonding. No pressure is required to make the bond.

countersink: See *nail set*. Also to set a nail or screw below the surface of a wood to conceal its head. If the hole made by countersinking is large, it is filled with a wooden plug.

cross section: The illustration of a portion of an object cut off at right angles to the plan drawing to give a more comprehensive idea of its shape.

cup center: The *dead center* of a *lathe* held in the *tailstock*.

Cupid's bow: A double-*ogee* curve such as is seen on the crest *rail* of some *Chippendale* chairs (see illustration).

cutter: A hard piece of steel used to mill metals.

cyma curve: A reverse or double curve, from the Greek word for "wave" (see illustration).

Combination square

Cupid's bow

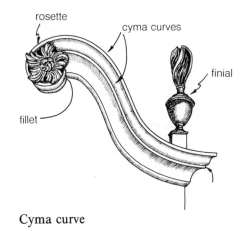

Cyma curve

dado: A groove cut across the *grain* of the wood (see fig. 72, p. 41).

dead center: A *pin* or cup on the *tailstock* of a *lathe* that holds the end of the rotating material *on center* (see *lathe* illustration).

deal: The English word for pine or fir wood.

die: A hard metal form into which metal is forced so as to conform to the shape of the die.

dished: Hollowed out or concave.

dividers: An instrument with a pair of sharply tapered legs for measuring the distance between two points.

dovetail: The *tenon* portion of a *dovetail joint* projecting from the end of a board (see fig. 83, p. 43).

dovetail joint: A fan- or dovetail-shaped *tenon* that forms a tight interlocking joint when fitted into the corresponding *mortise* (see fig. 83, p. 43).

drop finial: A turned ornament fastened to the bottom of an apron (see *apron* illustration).

dry fit: The process of assembling all of the components of a piece prior to applying glue to make sure all the pieces fit together properly.

ductility: The ability of a metal to be drawn out into a fine wire.

ear: An extension usually on the ends of a chair *rail* or the sides of a chair *splat* (see *Cupid's bow* illustration).

egg-and-claw: An elongated, oval variation of the *claw-and-ball* foot, usually found on pieces of furniture that have legs that end parallel to the floor (see illustration).

emery wheel: A grinding or polishing wheel made of the abrasive stone emery.

end grain: The crosscut section of a piece of wood perpendicular to the *grain* of the wood (see fig. 43, p. 29).

engraving: The decorative process of cutting or etching lines on metal by the use of engraving tools.

epoxy glue: An extremely strong two-part glue that is made by mixing equal parts of the resin and its hardener just prior to use.

escapement file: Similar to a *needle file* but with a smaller cutting surface and a long square handle (see illustration).

escutcheon: A metal, usually brass, plate surrounding a keyhole or under a drawer *bail* (see illustration).

fence: An adjustable bar mounted on the table of a tool to guide

Egg-and-claw foot

Escapement file

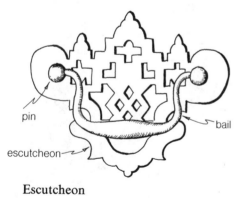

pin

bail

escutcheon

Escutcheon

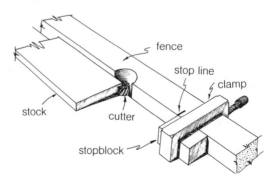

fence

stop line

clamp

stock

cutter

stopblock

Fence on shaper

the work. The name of the tool is usually added, such as "shaper fence" (see illustration).

ferrule: A metal ring used at the end of a table leg or tool handle to prevent the wood from splitting (see *parting tool* illustration).

figure: The pattern or design characteristics of some woods such as maple.

file card: A metal-bristled handle or a wire brush used to remove clogged particles from a file.

filler: A colored paste used to fill the pores of open-grained woods.

fillet: A narrow flat band that connects the curves in turnings or moldings (see *cyma curve* illustration).

finial: A turned decoration on the top of a chair post or a large piece of furniture (see *cyma curve* illustration).

flange: A projecting edge such as the *rabbet* at the edge of some drawers and doors. Sometimes called a lip (see illustration).

flattening agent: An ingredient used in finishes to reduce the gloss.

flexible shaft: A covered flexible shaft, driven by a motor, that rotates cutting or polishing tools.

flush: To make surfaces level with each other.

fluting: Parallel U-shaped grooves cut into a column or flat strip of wood to simulate a column (see illustration).

flux: A chemical, such as Tix flux, that assists the flow of *solder* by preventing *oxidation.*

fretsaw: A U-shaped saw frame with a handle at one end used to hold fret- or jigsaw blades for cutting.

gauge: A tool designed to mark or control measurements; also a unit used in measuring thickness.

gilding: Decorating with *gold leaf* or gold powders.

girth: The distance around the body of an object.

Goddard Wax: The brand name of a high-grade furniture wax.

gold leaf: Gold or a gold alloy that has been beaten into extremely thin sheets and is used for decoration.

gouge: A *chisel* having a U-shaped blade used for digging out wood or making a groove.

grain: The stratification or the direction of the fibers in a piece of wood (see fig. 39, p. 28).

graver: A hand tool made of high-carbon tool steel used for cutting into wood or metal. Its uses range from engraving metal to turning tools for a lathe.

grinding: The removal of metal by the use of abrasive wheels or disks.

grit: The coarseness of abrasive paper determined by the size of the abrasive particles on it.

groove: A channel running parallel to the *grain* of the wood (see fig. 73, p. 41).

half round: A 180° molding generally used to cover the joints in boards.

hand buff: A narrow wooden strip covered with felt or leather used for polishing metals (see illustration).

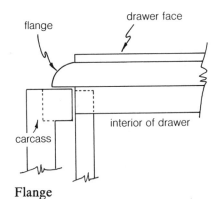

Flange

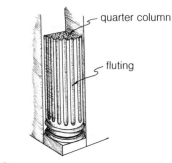

Fluting

Hand buff

hardwood: The wood of broad-leafed flowering trees, as distinguished from that of conifers. Hardwoods are generally preferred in fine cabinetmaking and often do not require the filling (see *filler*) of the grain. Some examples are ash, basswood, birch, boxwood, which is extremely hard, butternut, cherry, ebony, holly, mahogany, maple, oak, rosewood, and walnut. Although these woods are all considered hardwoods, some are harder than others. Chapter 3, "Woods," describes each of these woods in some detail.

headstock: The rotating driver on a lathe that turns the *spindle* (see *lathe* illustration).

Hepplewhite style: A style of furniture characterized by graceful curves originated by the eighteenth-century English cabinetmaker George Hepplewhite.

highboy: A tall two-piece chest of drawers supported on tall legs, with the lower section being larger and deeper than the upper section (see Chippendale Highboy project).

hollow-ground blade: A saw blade that has no set in the teeth but rather tapers toward the axis for blade clearance, producing a splinter-free cut.

honing: Grinding a steel surface against a *honing stone*. This stone leaves an almost polished surface.

honing stone: A natural or synthetic stone used in conjunction with a fine-grade oil to finish sharpened knives and *chisels*.

index head: A series of holes drilled into the spindlehead of a *lathe* to indicate the degrees of a circle.

inlay: Pieces of wood or other materials set into a surface to create a decorative design (see Pembroke Table project).

intaglio: A carving that is sunk below the surface on which it is carved (see *applied carving* illustration).

iris scissors: A small, delicate, high-quality scissors with blades that are smaller than the handle.

Japan colors: Finely ground, concentrated pigments suspended in *japan drier*, which causes them to dry rapidly to a hard, flat finish. Generally used for tinting paint, *varnish*, and lacquer.

japan drier: A blend of metallic driers and drying resins used in paint to ensure proper and thorough drying.

jig: A device that holds or guides the work or the tool.

jointer: A machine used to make joints in lumber.

kerf: The width of a saw-blade cut.

kiln-dried: Lumber dried in an oven to lower the moisture content and stabilize it.

knee: The upper part of a *cabriole leg* that curves out (see fig. 101, p. 49).

knee bracket: The side extension of the *knee* of a *cabriole leg* just below the *stretcher*. Also known as a shoulder piece (see fig. 101, p. 49, and Chippendale Highboy project).

knee leafage: The intaglio-carved design on the *knee* and *knee bracket* of a *Chippendale*-style *cabriole leg* (see fig. 101, p. 49).

laminate: To glue layers of wood together into one piece.

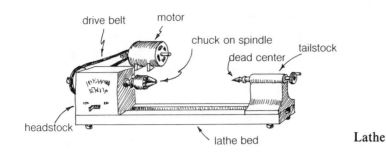

drive belt motor chuck on spindle dead center tailstock headstock lathe bed

Lathe

lathe: A machine for turning wood or metal so that it can be shaped (see illustration).

lowboy: A small dressing table mounted on legs (see Queen Anne Lowboy project).

malleability: The property of a metal that allows it to be formed by rolling or hammering without breaking.

mallet: A hammer with a head made of wood, rubber, or leather used to drive other tools such as chisels or wedges.

miter: An angle cut smaller than 90° (see fig. 81, p. 43).

miter box: An instrument for sawing a *miter*, consisting of a slotted two-sided box and a flat-bladed saw.

mortise: See *mortise-and-tenon.*

mortise-and-tenon: A joint used in furniture making and carpentry consisting of a mortise, or rectangular cavity cut in one board, and a tenon, or protruding shoulder, on the other board that fits into it when joined and pegged. They form a strong joint (see fig. 76, p. 42).

Moto-Shop: The brand name of a combination jigsaw, *flexible shaft,* and sander-grinder made by the Dremel Manufacturing Co.

Moto-Tool: The brand name of a small hand-held rotary machine made by the Dremel Manufacturing Co. This tool can also be clamped into several devices to do specific tasks.

mushroom knob: A small knob, usually of wood, in the shape of a round-topped mushroom (see *stile* illustration).

nail set: A short tapering steel rod that is used to *countersink* nails.

needle file: A small, narrow file made in a variety of shapes with a cutting surface that covers three-fourths of the tool's length (see illustration).

Needle file

nonblooming rubbing oil: A pure high-grade mineral oil, used with pumice powder and *rottenstone,* that does not leave a white film on the work.

ogee: A S-shaped or double-curved molding (see *cyma curve* illustration).

oil stain: A stain made from oil colors dissolved in turpentine or naphtha, which is basically a surface stain that will be wiped off when partially dry.

on center: The spacing of pieces from *center line* to center line rather than edge to edge.

open coat: An abrasive paper that has 70 percent of its surface covered with abrasive. It is less likely to clog than other abrasive paper.

Pad foot

Veiner or parting tool

Reeding

oxidation: The uniting with oxygen, as in burning or rusting.

pad foot: A variation of the *cabriole leg* made popular during the *Queen Anne* period of furniture design. The foot is characterized by a leg that swells out to a knotlike shape with a thick flat base (see illustration).

panel: A board set into a frame (see *stile* illustration).

parallel-jaw pliers: Pliers whose jaws open and close in parallel along their entire length, providing a square grip.

parting tool: A *chisel* with a double-ground edge forming a point in the center (see illustration).

patina: A mellow coloring that results from the natural wear and aging of wood and metal.

Pembroke table: A small drop-leaf table originally created for the Countess of Pembroke (see Pembroke Table project).

pilot hole: A hole drilled as a guide prior to using a metal or wood fastener.

pin: The *mortise* portion of a *dovetail joint* cut into the end of a board (see *escutcheon* illustration); another word for peg; the metal piece used to hold the *bail* to a drawer (see fig. 83, p. 43).

pin vise: A small *collet* chuck on a metal or wood handle used to hold small pieces or drills.

planer: A machine for smoothing and planing the surface of wood.

plating: The depositing of a thin coat of metal on another metal surface.

press cupboard: Generally, a richly carved double-bodied cabinet of the sixteenth and seventeenth centuries used to hold plates, wine, and so forth (see Press Cupboard project).

pumice stone: A spongy, porous volcanic rock ground into various degrees of fineness for rubbing down furniture.

punch: The movable part of a punch-and-die combination that forces the metal into the *die*.

push block: A piece of wood cut on all four corners usually at exactly 90° and used as a guide or a form of *miter* gauge to push work through a machine.

push stick: A piece of *hardwood* with a notch in one end used to push *stock* through a saw (see fig. 45, p. 32).

quarter column: One-fourth of a column, usually found set at the corner of a large piece of furniture (see *fluting* illustration).

quarter round: A convex molding shaped like one-fourth of a circle in *cross section*.

Queen Anne style: A style of furniture named after Queen Anne of England (1702–1714), characterized by simple curved lines, slender *cabriole legs,* and *pad* feet.

rabbet: A groove cut into the edge of a board so that another piece may be fitted to it to form a joint (see fig. 72, p. 41).

rail: A horizontal framing member that holds the sides of a piece of furniture together (see *stile* illustration).

rake: To slant or incline from the vertical as in the back of a chair.

reeding: A series of parallel, carved convex moldings that resemble reeds. The reverse of *fluting* (see illustration).

relief: Carvings or ornaments that are raised above the surface.

respirator: A shield for the nose and mouth that filters the air.

riffler: A small file with variously curved ends placed on a square handle and used to reach areas that would be inaccessible to a straight file (see illustration).

Riffler file

rip fence: The guide on a *circular saw* running the length of the table and used to guide the work through the blade.

rosette: A carved floral or rose-shaped ornament (see *cyma curve* illustration).

rottenstone: A very fine abrasive powder used to give furniture a high finish.

rouge: A polishing compound for metal made of powdered ferric oxide, grease, and stearic acid.

router: A machine used to cut grooves, make joints, or shape wood.

rpm: Abbreviation for "revolutions per minute."

rubbing oil: See *nonblooming rubbing oil.*

rule joint: This is usually a hinged joint used on tabletops. It is extremely strong, as the pressure on the leaf is transmitted to the main top beneath. The joint consists of a concave cut in the leaf and a matching convex cut on the main top (see fig. 459, p. 209).

runs: Drips or sags in a finish.

sable brush: An art brush made from the fine hairs of kolinsky tails. This type of brush holds its shape extremely well and does not leave streaks when applying *varnish* or paint to small areas.

sandpaper: Used in this book to mean any paper coated with an abrasive.

scale drawing: A working drawing in which one measurement or fraction thereof represents another measurement.

scriber: A metal- or diamond-tipped pencillike tool used for marking most surfaces.

scroll pediment: Also called swan-neck, a *broken pediment* formed by two S or *cyma curves* (see Chippendale Highboy project).

sealer: A wood finish that penetrates the wood fibers, expanding and hardening them so they can be sanded smooth, and also helps them to resist the penetration of stains.

shaper: A machine for cutting moldings or shaping (see fig. 35, p. 23).

shellac: A finish made from alcohol and the resinous lac produced by a scale insect from India.

shell ornament: A carved ornament resembling a seashell (see *applied carving* illustration).

Sheraton style: A style of furniture characterized by simplicity of form, straight lines, and classical decoration originated by the eighteenth-century English furniture cabinetmaker Thomas Sheraton.

shoulder piece: See *knee bracket.*

slipstone: A natural or synthetic sharpening stone that is rounded on both edges and tapered from thick to thin to permit the sharpening of various sizes of V- and U-shaped *gouges* (see illustration).

Slipstone

Spindle (vase-and-ball motif)

Splat (in the Chippendale style)

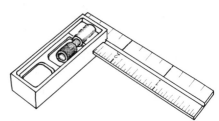

Square

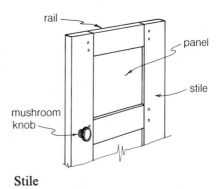

Stile

softwood: The wood of coniferous, or cone-bearing, trees. Softwoods are used as the prime woods in many country pieces and often as secondary woods in fine cabinetwork. A few examples are eastern white pine and spruce; basswood, although listed as a *hardwood,* is softer than some species of pine. Chapter 3, "Woods," describes some of these woods in greater detail.

solder: Any of various tin and lead *alloys* used to join heated metal parts when applied in the melted state.

soldering: The joining of metals by the use of *alloys* that melt at a lower temperature than the metals being joined.

soldering iron: A tool, usually electric, used to heat metal and thus to melt the *solder* into a joint.

spindle: A turned member, often tapered, used on chairs, sofas, and beds (see illustration). Also, the rotating drive member of a lathe (see *lathe* illustration).

splashboard: A decorative vertical board attached to the back of a washstand or commode top to protect the wall from splashes (see Victorian Washstand project).

splat: The centerpiece of a chairback (see illustration).

splits: Defects in lumber, caused by improper drying of the wood, in which the wood has separated along the direction of the *grain* (see fig. 40, p. 28).

spoon back: A chairback curved or spooned to fit the body, usually associated with the *Queen Anne* period (see Queen Anne Side Chair project).

sprue: That part of a casting that receives the metal and directs it into the mold cavity.

square: An L-shaped device used for marking right angles and to check that surfaces are square (see illustration).

stile: The vertical frame of a paneled door or a piece of furniture (see illustration).

stock: The standard size of any lumber.

stopblock: A small block of wood clamped to a tool's fence or table to restrict the movement of the piece of *stock* being machined (see *fence* illustration).

stop line: A line drawn on a tool's fence or table to indicate the area on the *stock* that should be machined. Similar in usage to a *stopblock* (see *fence* illustration).

stretcher: A bracing crosspiece on the legs of chairs, tables, or frames (see illustration).

Stretchers

tack cloth: A cheesecloth rag saturated with *varnish* to make it sticky enough to pick up dust.

tailstock: The adjustable endpiece of a lathe (see *lathe* illustration).

tang: The metal end of a tool that is inserted into the handle.

tapping: The forming of screw threads on a piece of *stock* by the use of drills and taps.

tarnish: The discoloration on metal caused by exposure to surface dirt and air.

temper: A condition produced in metal by heat treatment; also the hardening of the working end of a steel tool so it will hold its shape longer.

template: A pattern made of thin wood or metal that is used as a guide in marking work.

tenon: See *mortise-and-tenon*.

tilt-top table: A table having a round top that can be tilted from the horizontal to the vertical (see Chippendale Tilt-Top Table project).

tinning: Used in this book as the process of coating the point of a *soldering iron* with *solder* prior to use.

Titebond glue: An *aliphatic resin glue* made by the Franklin Glue Co. This is a strong, quick-setting glue for use on wood and other porous materials.

tripoli: A cutting compound mixed with grease, used on a *buffing wheel* or stick to remove surface scratches.

turning square: A piece of square *stock* used to make turnings, such as legs.

Unimat: The brand name of a universal miniature machine tool made by Emco-Lux with the features of a lathe, a drill, and a milling machine. This tool is a complete workshop and has many accessories available.

upright: A vertical member.

varnish: A transparent coating made from copal gum dissolved in linseed oil.

vase-and-ball motif: See *spindle* illustration.

veiner: A small V-shaped *gouge* used in wood carving and wood turning (see *parting tool* illustration).

veneer: Thin strips of high-quality wood, usually ⅟₂₈″ thick that are applied to a secondary wood *carcass*.

vernier caliper: An instrument with two L-shaped jaws, one of which is fixed, the other movable, that is used to measure either inside or outside thickness as read on the vernier scale. Most have an additional gauge to measure depth (see illustration).

viscosity: The ability of a material to flow, which varies with different materials, temperatures, and pressures.

vise: A tool consisting of two jaws, one movable and one stationary, used to hold the *stock* to be worked on.

warp: In lumber, that which is cupped or bent out of shape (see fig. 42, p. 28).

wash coat: Usually *shellac* thinned with five to seven parts of denatured alcohol, used to raise and seal the *grain* of *softwoods*.

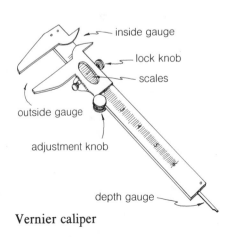

Vernier caliper

inside gauge
lock knob
scales
outside gauge
adjustment knob
depth gauge

waste stock: Used here in reference to that portion of the *stock* chucked in the *lathe*'s *spindle* and discarded when turning is complete.

wet-dry paper: Abrasive silicon carbide bonded to a black cloth paper that can be used either wet or dry.

whetstone: A hard stone, usually *Arkansas stone,* used in conjunction with whetting oil to sharpen tools.

working drawing: The complete plan from which a craftsman works. The majority of the working drawings in this book are scaled 1″ = 1′0″ (see *scale drawing*).

Zona saw: A very thin, fine-toothed handsaw used for splinter-free cuts.